Max Liebermann

From Realism to

Impressionism

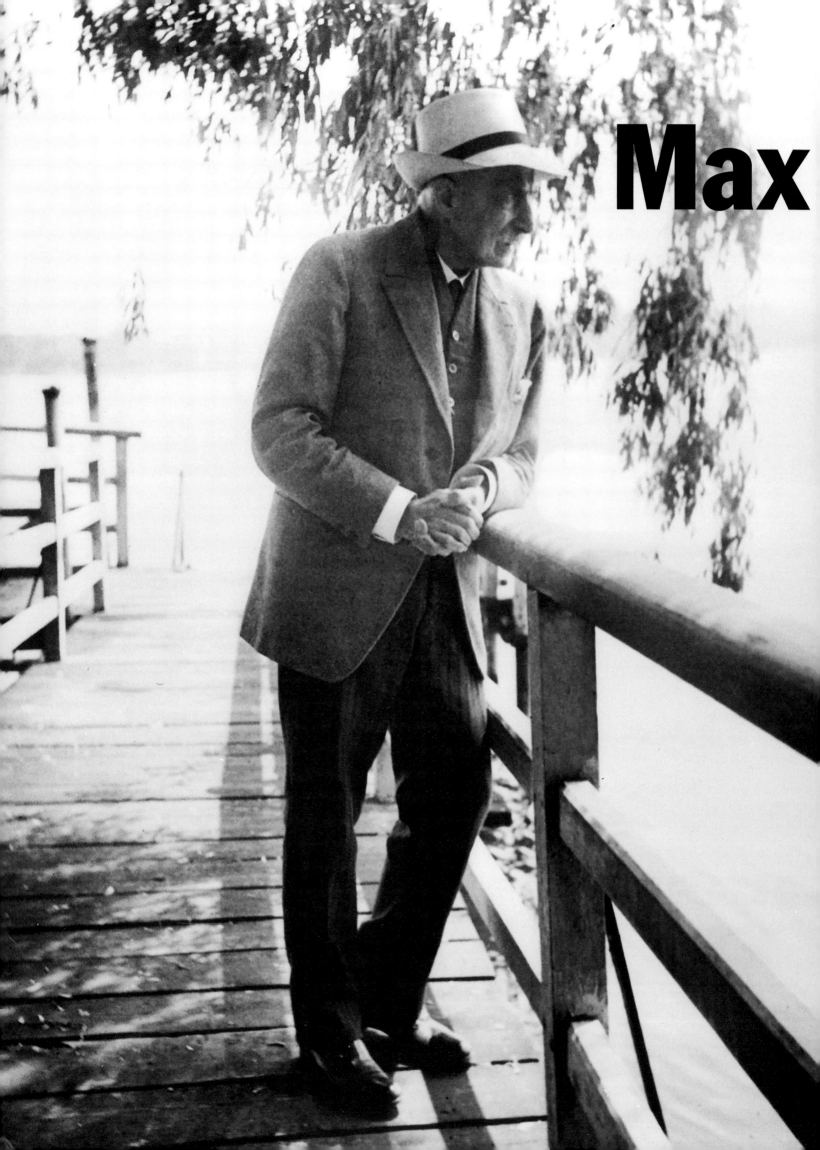

Max

Liebermann

From
Realism
to
Impressionism

Edited by

Barbara C. Gilbert

with essays by

Marion F. Deshmukh

Françoise Forster-Hahn

Barbara C. Gilbert

Mason Klein

Chana Schütz and Hermann Simon

Skirball Cultural Center, Los Angeles

Distributed by the

University of Washington Press

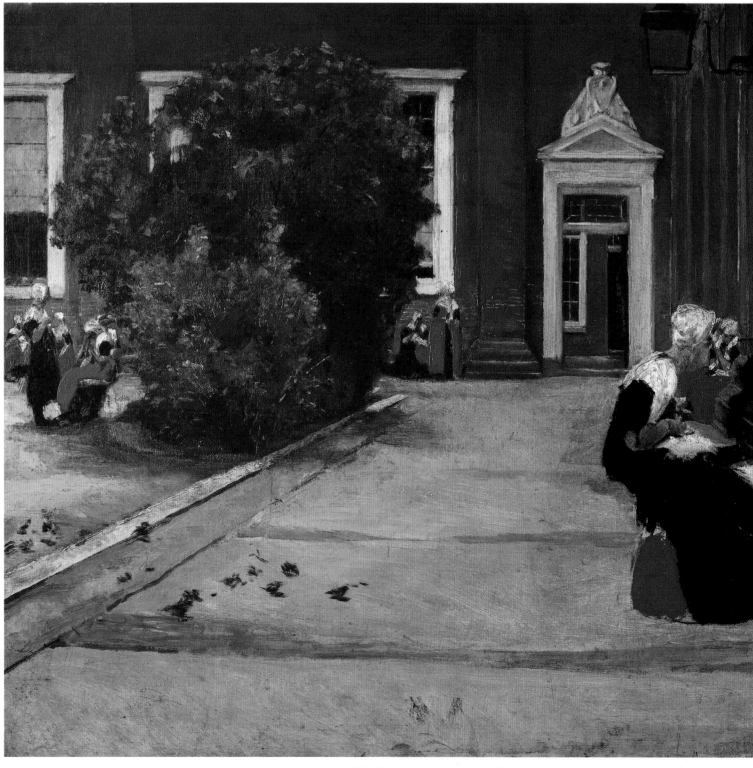

Study for Recess in the Amsterdam Orphanage — View of the Inner Courtyard, 1876. Nationalgalerie, Staatliche Museen zu Berlin

Contents

Donors

Max Liebermann: From Realism to Impressionism
was made possible by the following Lead Benefactors:

The Shapell/Guerin Foundation

Susanne and Paul Kester

Lee and Lawrence Ramer

The Skirball Foundation

Major support was also provided by:

Margo and Henry Bamberger

Consulate General of the Federal Republic of Germany, Los Angeles

Myna and Uri D. Herscher

Lufthansa Airlines

Marion and Rocco Siciliano

National Endowment for the Arts

Lenders

Bayerische Staatsgemäldesammlungen, Neue Pinakothek, Munich
Dallas Museum of Art
Deutsche Bank AG, Frankfurt am Main
Frye Art Museum, Seattle, Washington
Galerie Neue Meister, Staatliche Kunstsammlungen Dresden
The J. Paul Getty Museum, Los Angeles
Hamburger Kunsthalle
Jüdisches Museum Berlin
Judah L. Magnes Museum, Berkeley
Kaiser Wilhelm Museum Krefeld
Kunsthalle Bremen
Kunsthaus Lempertz, Cologne
Kunsthaus Zürich
Kunstkreis Berlin GbR
Kunstmuseum Winterthur
Leo Baeck Institute, New York
Los Angeles County Museum of Art,
 The Robert Gore Rifkind Center for German Expressionist Studies
Metropolitan Museum of Art, New York
Musée d'Orsay, Paris
Niedersächsisches Landesmuseum Hannover
Staatliche Kunsthalle Karlsruhe
Staatliche Museen zu Berlin-Preußischer Kulturbesitz, Kupferstichkabinett
Staatliche Museen zu Berlin-Preußischer Kulturbesitz, Nationalgalerie
Staatsgalerie Stuttgart
Städelsches Kunstinstitut, Frankfurt am Main
Städtisches Museum Gelsenkirchen
Stiftung museum kunst palast, Düsseldorf
Stiftung Neue Synagoge Berlin–Centrum Judaicum
Stiftung Stadtmuseum Berlin
Stiftung Weimarer Klassik und Kunstsammlungen, Schloßmuseum
Tate Collection, London
Von der Heydt-Museum, Wuppertal
Wallraf-Richartz-Museum-Fondation Corboud, Cologne

Private collections

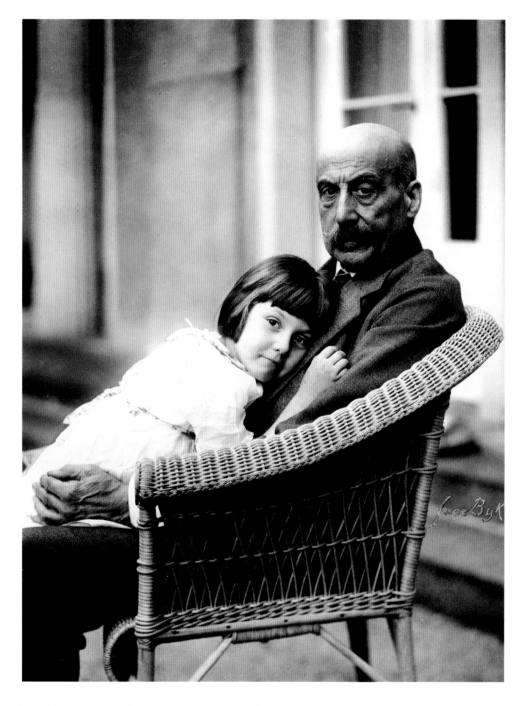

Max Liebermann with his granddaughter Maria at his villa in Wannsee, 1922

Why Max Liebermann at the Skirball Cultural Center?

THE SKIRBALL IS HONORED to present the first American exhibition of the greatest German painter of the twentieth century—whose career and life ended as the Holocaust era began with Hitler's issuance of the 1935 Nuremberg Laws making all German Jews into "non-citizens." Max Liebermann received public recognition by the Weimar Republic when he was appointed as the president of the Prussian Academy of Arts in 1920. Shortly after Hitler's accession to power in 1933, however, Liebermann was forced to resign from that post as a "non-Aryan," and his works were withdrawn from German museums. When he died two years later, little notice was taken by the German press. Hitler had succeeded in making Max Liebermann into a non-person, as those who "ethnically cleanse" must do first to those they intend to murder. In 1942, Liebermann's widow, Martha, having had her property seized and being summoned to report for transport to the concentration camp at Theresienstadt, chose instead the dignity of suicide. Are there lessons for us yet to learn from these experiences?

There is a striking parallel between the beginning of the German Jewish experience in 1671 with the arrival in Berlin of fifty families fleeing persecution in Vienna and the 1654 arrival in New York harbor of twenty-three Jews escaping persecution in Brazil. Each of these people sought to make a home that would be safe for themselves and their children. Liebermann did not live to see the Jewish hope for a safe home in Germany come to an end 274 years later with the death of six million Jews in the Holocaust. We can all reflect, 351 years later, at how the experiment in hope called America proceeds and consider what our personal responsibilities might be for its regeneration.

Liebermann was born in 1847 to a family that intertwined Jewish tradition, Prussian culture, and a liberal disposition. The Liebermann children studied a classical curriculum in public schools and attended courses in Jewish religion, French conversation, music, art, dance, and sports. Liebermann's parents and grandparents raised him to be fearless and truthful, to trust his own judgment, and to develop his own character and understanding. They instilled in him a tolerant, free, and positive outlook on life; an empathy and a sense of responsibility for the fate of others; discipline and persistence; an appreciation for nature's beauty; and a pleasant and polite—but not submissive—manner in conversation and writing.

Liebermann held fast to the values he inherited from his grandparents and parents. His concern for the marginalized is evident in many of his paintings. Furthermore, he often used his reputation in the art world to promote traditional Jewish and humanitarian values and to oppose censorship, intolerance, and injus-

tice. From the 1920s onward, Liebermann voiced his outrage in order to heighten awareness about the danger that Hitler posed for Germany. In 1933, Liebermann wrote to Hayyim Bialik, the national poet of the Jewish people, who was living in Tel Aviv:

> Like a horrible nightmare, the abrogation of equal rights weighs upon us all, but especially upon those Jews who, like me, had surrendered themselves to the dream of assimilation....As difficult as it has been for me, I have awakened from the dream that I dreamed my whole life long.

Jewish heritage teaches that each Jew has a responsibility to respect and contribute to society. In the 274 years since 1671, remarkable contributions by Jews—including Martin Buber, Albert Einstein, Leon Feuchtwanger, Sigmund Freud, Erich Fromm, Heinrich Heine, Franz Kafka, Otto Klemperer, Gustav Mahler, Jacques Offenbach, Leon Panofsky, Arnold Schoenberg, and Kurt Weill—shaped German culture and language. Max Liebermann, a widely respected artist in Germany and all of Europe, was part of that tradition.

Many German Jews aspired to be "more German than the Germans" and were prepared to step away from their heritage through conversion or secularization to achieve that objective. The Holocaust was a deadly betrayal of what they saw as a stable, reciprocal bargain with German society. As Liebermann wrote, the dream proved to be a nightmare in which life itself was denied.

The mission of the Skirball Cultural Center is to explore and understand the fusion of the uniqueness of the Jewish heritage and the uniqueness of the American experience. The Jewish experience in America has been neither simple nor trouble free; yet, America's democracy has prospered from its links to Jewish heritage. For example, the privileges of citizenship including liberty, justice, and equality, as expressed in the books of Leviticus, Numbers, and Deuteronomy, were given form in the U.S. Constitution. The law of the land continues to work toward securing these precious rights for all. America is strengthened by continuing to remember that as a nation we really are all in this together and that we as a nation need to respect and learn from each other if we are to preserve a humane society for all.

This exhibition is important to the Skirball Cultural Center because we believe that America expresses an idea different from that tested in Germany. In America, it is clear that each of us contributes most not by forgetting our personal heritage but by putting whatever endowments we have into a *common fund* for the creation of a democratic society in which *all* of us can be safe. From our beginning as a nation, we have recognized that the only way we were not going to hang individually was if we could find a way to hang together.

If Abraham Lincoln were confronted by knowledge of the Holocaust, I'd like to think that he might respond by saying something like this:

> Eleven score and nine years ago our fathers brought forth on this continent a new nation, conceived in liberty, and dedicated to the proposition that all men are created equal. We have tested, and continue to test, whether that nation or any nation so conceived and so dedicated can long endure. It is for us the living to be dedicated here to the unfinished work which they who fought have so far nobly advanced. It is for us to be here dedicated to the great task remaining before us—that from these six million honored Jews as well as many non-Jews who perished in Max Liebermann's generation, we take increased devotion to that cause for which they gave the last full measure of devotion; that we here highly resolve that these dead shall not have died in vain, that this heritage and this Nation under God shall have a continuing rebirth of freedom, and that government of the people, by the people, and for the people shall not perish from the earth.

Uri D. Herscher
President and CEO, Skirball Cultural Center

Director's Foreword

HE EXHIBITION that this catalogue accompanies, *Max Liebermann: From Realism to Impressionism,* is devoted to the remarkable art and life of German painter Max Liebermann (1847–1935), the premier artist in Berlin from the mid-1880s until the Nazi take-over in 1933 when his achievements were vilified and erased. Now in 2005, this exhibition and publication mark the first time Liebermann is the subject of an English-language monograph and major exhibition in a museum in the United States. Liebermann has remained virtually unknown to the American public despite his reputation among art historians, museum professionals, artists, and collectors here and abroad. In recent years, Liebermann's work has enjoyed a well-deserved renaissance in Germany, with the transformation of his villa at Wannsee (a short distance outside of Berlin) and his family home on Pariser Platz, which stands next to the Brandenburg Gate in the heart of Berlin, into small museums that celebrate his achievements. There have been several exhibitions of Liebermann's work in Germany in the last two decades and a number of publications. This landmark exhibition organized by the Skirball Cultural Center is the first to bring together more than sixty paintings and works on paper from both European and American collections and examine Liebermann through multiple lenses of art, politics, cultural identity, and history. This is the first international loan exhibition organized by the Skirball—a relatively young institution—and the first Skirball exhibition to travel to The Jewish Museum in New York, an institution graced by many years of history and achievement.

Barbara C. Gilbert, Skirball Senior Curator of Fine Arts, organized the exhibition. Her passion for Liebermann's work and her tenacity in tracking down the best material that could be assembled made this exhibition and publication possible. Dr. Gilbert has organized numerous exhibitions during her tenure at the Skirball including *Henry Mosler Rediscovered: A Nineteenth-Century American-Jewish Artist; Israel through American Eyes: A Century of Photography; Revealing and Concealing: Portraits and Identity;* and *George Segal: Works from the Bible.* As she writes in her introduction, this project has been a labor of love and it marks the capstone of a distinguished career.

The essays in this catalogue, taken as a whole, present a varied and illuminating exploration of Liebermann's life, artistic sources, and achievements, the nature of his high position in the German art world, and his identity as both a German and a Jew in the years preceding the Holocaust. Dr. Gilbert's introductory essay, "Max Liebermann: A Long and Fruitful Career," provides an overview of his creative and social development, his role in bringing modern art to Germany, and looks closely

at numerous works; Marion F. Deshmukh in "Max Liebermann and the Politics of Painting in Germany: 1870–1935" analyzes why Liebermann provoked controversy when today his art seems relatively tame thematically and aesthetically. Chana Schütz and Hermann Simon in "Max Liebermann: German Painter and Berlin Jew" explore Liebermann's unprecedented rise as one of the "ambassadors of German Jewry"—a person who stood at the center of artistic social life in Berlin and who championed artistic freedom and the authentic in art despite the escalating anti-Semitism surrounding him. Mason Klein has contributed an essay, "Gentleman's Agreement: Belief and Disillusionment in the Art of Max Liebermann," in which he discusses in-depth a specific group of works to make the case that Liebermann does his best work pre-1900 when he is expressing the core values of *Bildung* (high culture) as a German and a Jew, but before he begins to "paint like a Frenchman." Françoise Forster-Hahn in "Max Liebermann, the Outsider as Impresario of Modernism in the Empire" presents a view of Liebermann as a person who considered himself a revolutionary, moving in circles of artists, museum directors, critics, collectors, and publishers and close to the French Impressionist painters such as Degas, Manet, and Monet, whose work he collected avidly. Dr. Forster-Hahn presents Liebermann as a utopian visionary with a solid belief in the separation of art and politics. Suzanne Schwartz Zuber's timeline presents the biographical data of Liebermann's life in the context of art and culture, Jewish history, and world history.

Tish O'Connor, Brenda Johnson-Grau, and Dana Levy of Perpetua Press, Santa Barbara, have played a vital role in the creation of this catalogue, well beyond the scope of normal editorial and design work. Peter Kirby has produced a video for the exhibition that illuminates the life and work of Max Liebermann.

Dr. Gilbert and I are grateful to Joan Rosenbaum, Director, Ruth Beesch, Deputy Director for Program, and Mason Klein, Associate Curator, of The Jewish Museum for their encouragement of our efforts and their enthusiasm for presenting the exhibition at their institution. We thank all our Skirball colleagues for their expertise. Among them: Esther Yoo, Head Registrar, and her team of Joseph Saccomanno and Kanoko Sasao, who managed all the aspects of the loans, insurance, and transportation; Jeffrey Yoshimine, Director of Exhibitions, who designed the installation here at the Skirball and advised on many aspects along with his associates Tom Schirtz and Tom Duffy; Kathryn Radcliffe, Administrative Director for the Museum, who managed contracts and budgeting; Susanne Kester, Media Resources Coordinator; Frances Ozur, Curatorial Assistant, who originated the database that was relied on during the entire development of the exhibition; Claire Whitner, Exhibition Assistant, who was responsible for overseeing myriad tasks including translation, loan securement, photograph permissions, and written materials; Erin Clancey, Associate Curator, who provided assistance in securing contextual photographs for the catalogue; Stacy Lieberman, Director of External Affairs, and Assistant Directors Mia Cariño and Ann Cross, who developed the communications and marketing plan and also helped with the catalogue; Cary Meshul, Art Director, who designed the myriad print and promotional materials; Mia Pardo, Editor and Special Projects Coordinator for my office, who assisted with exhibition texts and other publications; Joe Seitz, chief engineer, and Lee Huey, Chief Financial Officer, who advised on many aspects; Pamela Balton, Special Assistant to the President, who developed the merchandising material for our Audrey's Museum Store; Adele Lander Burke, Vice President of Learning for Life, and Jordan Peimer, Director of Programs, who coordinated an engaging and expansive repertoire of illuminating public programs and classes complementing the exhibition; and Sheri L. Bernstein, Director of Education, whose department developed useful in-gallery materials, interpretive programs and classes for children and their families, and lively docent tours. More than 350 volunteers and docents donate their time to the Skirball, and we thank them for extending warm welcome and hospitality to all our visitors—a key aspect of our mission. Thank you to Deni Bernhart, Executive Assistant, for her tireless efforts in assisting on many aspects of the exhibition.

The Artist's Wife and Granddaughter, 1926 (Detail, Plate 58)

No exhibition or related educational programs would be possible without the support of donors who believe in the importance of bringing Max Liebermann's artistic and personal achievements to light for a new audience. Thank you to Jocelyn Tetel, Vice President of Advancement.

Uri D. Herscher, President and CEO of the Skirball Cultural Center, provided constant encouragement and support for this endeavor in every way possible. We are deeply indebted to him. Dr. Herscher's essay is a passionate reflection on Liebermann, on Germany in his time, and America in our time. It places Liebermann vividly in the context of the Skirball Cultural Center's mission, and encourages us to learn from Liebermann's example and apply these lessons to our actions in America today. We are enormously grateful to the Board of Trustees of the Skirball Cultural Center, chaired by Howard I. Friedman, who nurtured this project with enthusiasm and championed our efforts.

To all we extend our deepest gratitude. To Dr. Gilbert, I extend my personal congratulations and appreciation.

LORI STARR
Senior Vice President, Skirball Cultural Center
Director, Skirball Museum

Message from The Jewish Museum

THE JEWISH MUSEUM is the only venue in the United States in addition to the Skirball Cultural Center presenting the exhibition *Max Liebermann: From Realism to Impressionism*. We are delighted with this opportunity for Liebermann has been an artist of great interest to this museum over the past five years. We examined Liebermann's work in two recent exhibitions and publications: *The Emergence of Jewish Artists in Nineteenth Century Europe* in 2002 and *Berlin Metropolis: Jews and the New Culture, 1890–1918* in 2000. These exhibitions and their accompanying catalogues have been representative of a commitment by the museum over the last twenty-five years to examine the first generation of professional Jewish artists in Europe, America, and Russia in cities that were becoming part of the modern world. Beginning with *Max Weber: American Modern* in 1982, followed by *The Immigrant Generations: Jewish Artists in Britain* in 1983 and *The Circle of Montparnasse: Jewish Artists in Paris, 1905–1945* in 1985, we have examined the art-historical and social contexts for the emergence of these artists in a period of great economic and political change.

As Berlin emerged as a vibrant modern city in the Wilhelmine period, Liebermann was perhaps the most influential among those Jews who played a prominent role in shaping the city's cultural life. As a painter, collector, founder of the Secessionist movement, and President of the Prussian Academy, he was a figure of extraordinary accomplishment and public importance. As a Jew, his influence was exceptional. There is much to appreciate in the beauty and content of the works and much to consider in learning about the complex and unusual historical underpinning of this painter's life and time.

My congratulations to the Skirball Cultural Center's Senior Curator Barbara C. Gilbert, President and CEO Uri D. Herscher, and Senior Vice President and Skirball Museum Director Lori Starr, for their long-standing determination to create a major presentation of Liebermann's work for the American public. My thanks to The Jewish Museum Associate Curator Mason Klein for his curatorial integrity in retaining the depth and scope of the Los Angeles presentation as he reworked it for the smaller galleries of The Jewish Museum. Further thanks to Norman Kleeblatt, Susan and Elihu Rose Curator of Fine Arts, for the work he has done to ensure that Max Liebermann remains an artist always of interest to us, and to Deputy Director for Program Ruth Beesch, and Project Assistant Suzanne Schwarz Zuber, who were instrumental in ensuring the successful presentation and administration of the project.

Finally my deep gratitude to Ria and Mike Gruss for their long-standing enthusiasm for The Jewish Museum and for their particular support of the Liebermann exhibition with a generous gift from the Emanuel and Riane Gruss Charitable

Foundation. Added thanks for an equally important gift from the Skirball Foundation, whose support over the years has done much to strengthen the program of The Jewish Museum. We are deeply grateful for the generosity of both of these foundations and for the unflagging support of The Jewish Museum's Board of Trustees, whose involvement is critical to all that we accomplish.

JOAN ROSENBAUM
Helen Goldsmith Menshel Director

Curator's Introduction and Acknowledgments

I MADE MY FIRST TRIP to Berlin in 1997 as a courier for the painting *The Artist's Wife and Granddaughter*, 1926, by Max Liebermann, the only painting by the celebrated German artist in the collection of the Skirball Cultural Center. Little did I realize that it would mark the beginning of an eight-year-long journey—not only in learning about the artist and his work in depth but also in gaining some understanding of the role played by Jews in German society before the takeover by the National Socialists. The painting was to be included in one of three exhibitions held in Berlin in 1997 in celebration of the 150th anniversary of the artist's birth. The charming double portrait of Liebermann's wife and his granddaughter was first exhibited in Berlin one year after Liebermann's death in 1936 in a memorial exhibition initiated by Martha Liebermann with the help of art collector and leader of the Berlin Jewish community from 1933 to 1940, Heinrich Stahl, and director of the Berlin Jewish Museum, Franz Landsberger. The Berlin Jewish Museum was one of several Jewish cultural institutions established in 1933 in Berlin after Jews were prohibited from working or exhibiting in German art museums, and *The Artist's Wife and Granddaughter* was among the art works donated to the new museum by Jewish collectors in Berlin. Confiscated by the Nazis after the forced closure of the Jewish Museum in 1938, the painting resurfaced after the war. It came to Hebrew Union College in Cincinnati, Ohio, from the Jewish Restitution Successor Organization—a body that was established after World War II to distribute confiscated Judaica and art to museums, libraries, and synagogues around the world—making it one of a handful of paintings by Liebermann in American public collections. That Franz Landsberger was able to leave Germany to find refuge in the United States with the help of Hebrew Union College, where he served as the first curator of the Hebrew Union Museum (now Skirball Cultural Center), adds to the significance of the painting's history.

In 1997 the painting returned to Berlin for a re-creation of the 1936 exhibition titled *Max Liebermann: All that Remains are Pictures and Stories (Max Liebermann: was von Leben übrig bleibt, sind Bilder und Geschichten)* at the Stiftung Neue Synagoge Berlin–Centrum Judaicum, housed in the recently restored Neue Synagogue on Oranienburger Street. A little more than half of the sixty-nine paintings, pastels, and watercolors in the original exhibition could be located; the rest presumably were lost during the war. The curators expanded on the exhibition with the addition of two significant introductory sections: the history of the Liebermann family and Liebermann's role as a leader in the world of art politics in Berlin. While in Germany, I also viewed a large retrospective of Liebermann's paintings at the Alte Nationalgalerie, Berlin, and then visited the nearby suburb of Wannsee to see an exhibition on the artist's late garden paintings. While at Wannsee, I visited Liebermann's former summer villa, which was leased to a rowing club at the time

but has now been restored to its former beauty by the Max Liebermann Society. I also visited the nearby villa that had been the site of 1942 Wannsee Conference, where the elimination of the Jewish people had been planned. It was just a few doors away from Liebermann's former home.

The trip proved to be an eye-opener, introducing me in depth to the work of Max Liebermann, who was considered the leading artist in Germany during the late nineteenth and early twentieth centuries, and planting the seed of an idea for developing an exhibition and volume on Liebermann in the United States. Neither would have been possible without the guidance of the many curators, scholars, and collectors in Europe and the United States with whom I met over the last few years. I want especially to thank Matthias Eberle, esteemed author of the *catalogue raisonné* on Liebermann, who so generously shared information on sources of paintings for the exhibition, and Margreet Nouwen, one of Berlin's major authorities on the artist, who was willing to share her wealth of knowledge with me. I thank Anya Galinat, who introduced me to Berlin and took me to Wannsee. I am also indebted to the essayists to this catalogue who provided invaluable advice throughout the many stages of this project: Chana Schütz and Hermann Simon of the Stiftung Neue Synagoge Berlin–Centrum Judaicum; Mason Klein, Associate Curator, and Suzanne Schwarz Zuber, Project Assistant, of The Jewish Museum; Marion F. Deshmukh, Professor in the Department of History and Art History, George Mason University; and Françoise Forster-Hahn, Professor of Art History, University of California, Riverside. I am also grateful for the help from representatives of European consulates and cultural institutions in Los Angeles: Consul General Hans J. Wendler, Vice Consul Maria Steinhauser, and Deputy Consul General Norbert Kürstgens, of the Consulate General of the Federal Republic of Germany in Los Angeles; and Ute Kirchhelle, Director, Goethe Institute Los Angeles; and Laurent de Veze, former Cultural Attaché, and Géraldine Hebras at the Consulate General of France in Los Angeles. I am especially grateful to the private collectors who generously agreed to share their paintings with the public, in particular the many emigrés from Nazi Germany who brought Liebermann's paintings to America and used them as a springboard to share their very personal stories with me.

I thank the directors, curators, and registrars of museums worldwide who provided insight into the works of Liebermann and supported important loans to the exhibition: Reinhold Baumstark, Director, and Andrea Pophanken, Exhibition Organizer, Bayerische Staatsgemäldesammlung, Neue Pinakothek, Munich; Deborah Byrnes, Curator and Acting Director, and Donna Kovalenko, Collections Manager, Frye Art Museum, Seattle; Dorothy Kosinski, Curator, and Elayne Rush, Assistant Registrar for Loans and Exhibitions, Dallas Museum of Art; Friedhelm Hütte, Director of Corporate Cultural Affairs, and his assistants Liz Christensen, Carmen Schaefer, and Britta Färber, Deutsche Bank AG, Frankfurt am Main; Mathias Wagner, Curatorial Assistant, and Katrin Bäsig, Registrar, Gemäldegalerie Neue Meister, Dresden; Uwe M. Schneede, Director, Jenns Howoldt, Curator, and Meike Wenck, Registrar, Hamburger Kunsthalle, Hamburg; Scott Schaefer, Curator of Paintings and Acting Curator of Sculpture, and Emily Cartwright, Registrar, The J. Paul Getty Museum, Los Angeles; Terry Pink Alexander, Executive Director, Alla Efimova, Chief Curator, and Linda Poe, Registrar, Judah L. Magnes Museum, Berkeley; Inka Bertz, Head of Collections/Curator of Art, Sarah Canarutto, Assistant Deputy Director, and Gisela Märtz, Head of Collection Management, Jüdisches Museum Berlin; Martin Hentschel, Director, Sabine Röder, Curator, Kaiser Wilhelm Museum Krefeld; Wulf Herzogenrath, Director, Dorothee Hansen, Curator of Paintings, and Jutta Putschew, Registrar, Kunsthalle Bremen; Christoph Becker, Director, Karin Marti, Registrar of Collections, and Christian Klemm, Curator, Kunsthaus Zürich; Rolf Budde, Sammlung Kunstkreis Berlin GbR, Berlin; Dieter Schwarz, Director, and Ludmilla Etter, Registrar, Kunstmuseum Winterthur; Rolf Bothe, Director, Thomas Föhl, Curator, and Andre Schwarz, Exhibitions and Loans, Kunstsammlungen zu Weimar; Sigrid Achenbach, Graphics Curator, and Ingrid Rieck, Registrar, Kupferstichkabinett Berlin; Timothy Benson, Curator,

and Christine Vigiletti, Registrar, LACMA The Robert Gore Rifkind Center for German Expressionist Studies, Los Angeles; Renata Stein, Curator, and Miriam Intrator, Registrar, Leo Baeck Institute, New York; Silvia Freimuth, President, Max Liebermann Society, Berlin; Gary Tinterow, Engelhard Curator of European Paintings, Jim Voorhies, Associate Administrator, Department of European Paintings, and Cynthia Chin, Assistant Registrar, Metropolitan Museum of Art, New York; Serge Lemoine, Director, Sylvie Patin, Chief Curator, Laurence de Cars, Curator, and Caroline Mathieu, Head Conservator, Musée d'Orsay, Paris; Peter Wegmann, Director, Museum Oskar-Reinhardt am Stadtgarten, Winterthur; Heide Grape-Albers, Director, Meinolf Trudzinski, Senior Curator, and Thomas Andratschke, Registrar, Niedersächsisches Landesmuseum Hannover; Angelika Wesenberg, curator, SMPK Berlin, Alte Nationalgalerie; Klaus Schrenk, Director, Staatliche Kunsthalle Karlsruhe; Dr. Christian von Holst, Director, Christofer Conrad, Head of nineteenth Century Painting and Sculpture, and Peter Frei, Registrar, Staatsgalerie Stuttgart; Sabine Schulze, Director of Paintings of the 19th and 20th Centuries, and Ute Wenzel-Förster, Registrar, Städelsches Kunstinstitut und Städtisches Galerie, Frankfurt am Main; Reinhard Hellrung, Director of Collections, Städtisches Museum Gelsenkirchen; Bettina Baumgärtel, Curator of Paintings, Stiftung museum kunst palast, Düsseldorf; Dominik Bartmann, Director, Angelika Reimer, Curator of Paintings, Stiftung Stadt Museum Berlin; Stephen Deuchar, Director, and Samantha Cox, Assistant Loans Registrar, The Tate Collection, London; Sabine Fehlemann, Director, Antje Birthälmer, Deputy Director, and Brigitte Müller, Exhibition Manager, Von der Heydt-Museum, Wuppertal; and Rainer Budde, Director, Götz Czymmek, Department of Eighteenth and Nineteenth-Century Painting and Sculpture, Berni Cimera, Registrar, and Iris Schaefer, Conservator, the Wallraf-Richartz Museum-Fondation Corboud, Cologne.

This exhibition and catalogue would not have been possible without the help and support of my colleagues at the Skirball Cultural Center. I want to thank Uri D. Herscher, President and CEO, for his belief in the significance of the project when it was in its early stages and for his ongoing encouragement of my efforts. Lori Starr, Senior Vice President and Museum Director, was always there to provide advice and in-depth evaluation of all aspects of the exhibition and catalogue. I want to thank Dr. Toni Marcy, Paul Kester, and Alex Lauterbach for their help in translations, and Susanne Kester, who so carefully and diligently helped in tracking photographs for the catalogue. Finally, I thank my family who supported me from the very beginning and, in particular, my daughter Leila Gilbert, who insisted on accompanying me on two very demanding research trips to Germany.

BARBARA C. GILBERT
Senior Curator of Fine Arts, Skirball Cultural Center

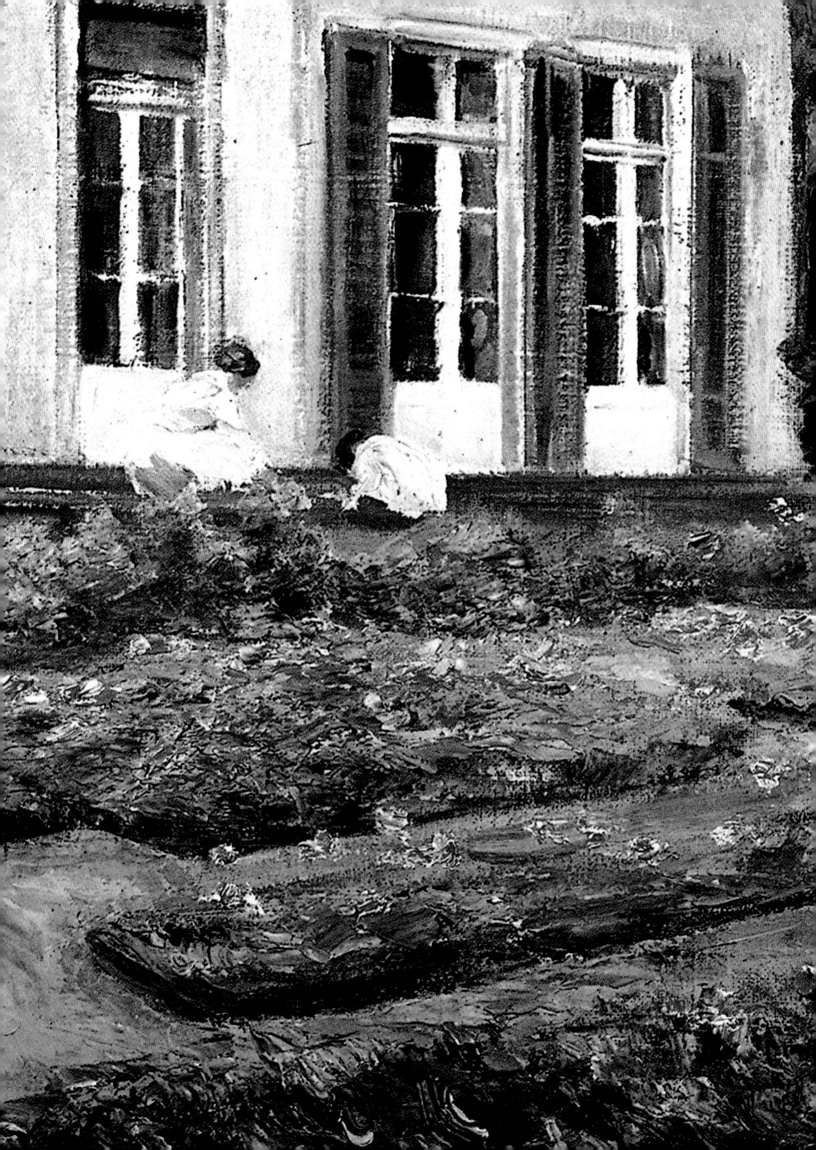

Max Liebermann:
A Long and Fruitful Career

BARBARA C. GILBERT

MAX LIEBERMANN (1847–1935), the leading artist in Berlin from the early 1890s until the Nazi takeover in 1933, was known later in his career for his singular approach to impressionism. Initially a realist painter following the dictum "paint what you see as you see it," his work at times transcended that nineteenth-century formulation and aspired to the more abstract realm of "pure painting," which in our time has earned him the moniker, "Manet of the Germans." Also prominent in the cultural life of Berlin, Liebermann was president of the Berlin Secession from 1898 until 1911 and, during the Weimar Republic, served as president of the Prussian Academy of Arts from 1920 until 1932.

Attaining these authoritative positions in the Berlin art world was possible for a Jew only during this brief period of modern German history. Descendent of a successful German Jewish family, Liebermann was a self-assured cultural leader who had the courage—even in the face of adversity—to speak out against intolerance and to defend his convictions. Liebermann's story is also marked by personal experiences of anti-Semitism, which culminate after the takeover of the National Socialists (Nazis) with the removal of many of his paintings from German museums and the denigration of his contributions to modern German culture.

Although occasional exhibitions displayed his work after the end of World War II, it was not until the late 1970s that scholars and curators began a serious reexamination of his important role in late nineteenth- and early twentieth-century German art. Since then, numerous exhibitions and publications have explored the facets of Liebermann's long and productive career.[1] Because he gained his first success in the 1870s, he was considered, by 1910, to be old-fashioned and possibly out of touch with the avant-garde, especially by the young generation of German expressionists. Even though some animosity had existed between Liebermann and many of these younger artists, elements of his free approach to painting can be seen in the expressionists' experiments with subject, color, and paint application. And Liebermann clearly adapted elements of their more subjective and emotional approach in some of his later work, the more obvious examples being his blending of human figures with nature and his use of compacted, dense color in many of his late garden paintings.

The Flower Terrace in the Wannsee Garden, Facing Northwest, 1921 (Detail, Plate 50)

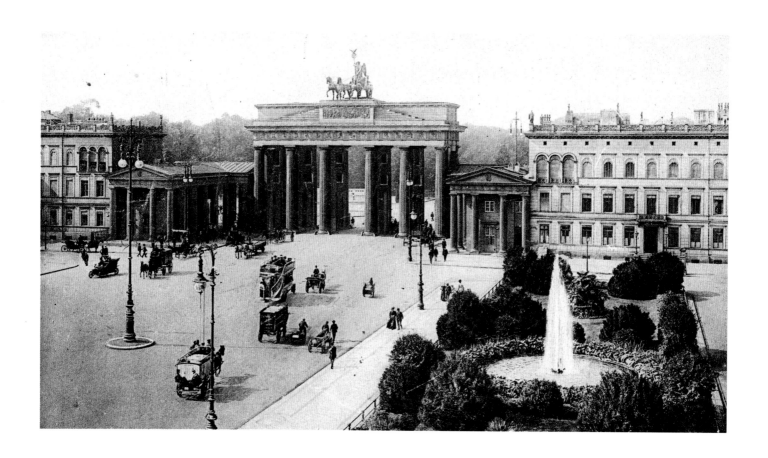

1.1 Pariser Platz, Berlin, 1905. Liebermann's house, at Pariser Platz 7, was located directly to the right of the Brandenburg Gate.

Why do I always return to [the subject of] poor people? …what led me was personal. I had a rich father and only knew wealth. Then I became aware of poverty, the disadvantaged, and the lowly. Well, that's when it happened…[2]

Born in Berlin on July 20, 1847, Liebermann was the second son of Jewish fabric manufacturer and merchant Louis Liebermann and his wife Phillipine (née Haller). He had two brothers, Georg (1844–1926) and Felix (1851–1925), and a sister Anna (1843–1933). The family had originally lived in Märkisch Friedland, a town north of Berlin in West Prussia. The Jewish community of Märkisch Friedland dated back to 1744, reaching its high point in 1812 with a population of 1,400. In 1815, as restrictions against Jews living in big cities were eased, the Jews began to move out toward Königsberg, Stettin, and Berlin. Joseph Liebermann, the artist's grandfather, brought his family to Berlin in 1823.

Joseph Liebermann started out selling textiles and then specialized in cotton printing, a process that previously had been almost monopolized by British textile factories. The family's business gradually expanded and became diversified, with the purchase in the 1860s of two large iron works, Wilhelmshütte and Dorotheen Works, in northern Silesia, an area that possessed an abundance of coal and iron, which had been annexed by Prussia from Austria in 1742.[3] Together the two factories employed about 800 workers, mainly poor and Polish. The inequity between the lives of the workers and the rich German business owners led to riots in 1873 in protest of Bismarck's anti-Catholic measures and surely were fueled by poor working conditions and low wages. On family vacations to the area, Liebermann recalled that he and his siblings and cousins were given freedom to explore the outdoors near the factories. As a child, he would not have known about the rebellion or been aware of the conditions in his family's factories, but perhaps his experiences there are reflected in the focus on labor in his early Dutch paintings.

By the 1880s the family had moved out of the textile business, and in the

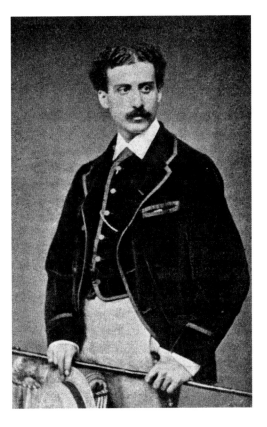

I.2 Max Liebermann at the age of twenty-five while a student at the Weimar Academy of Art, 1872

I.3 Drawings from Liebermann's first sketchbook, ca. 1865–1873: *a,* street scene; *b,* uniformed musician and typical city character. Pencil on paper. Private collection, on long-term loan to Kupfer-stichkabinett, Staatliche Museen zu Berlin

next decade Liebermann & Co. was active in banking. Their move from the textile trade to industry and then to banking was typical of successful German Jewish families at the time.[4] The artist's father was a multimillionaire by the 1850s, which allowed him in 1859 to purchase property at Pariser Platz 7 (Figure I.1), directly to the right of the Brandenburg Gate, the ceremonial center of Berlin. Max Liebermann was twelve when the family moved to this prestigious location. Years later, he refuted the assumption that their lifestyle was affluent, telling biographer Hans Ostwald that the three brothers shared a bedroom on the first floor of the building and that the additional flats in the building were rented out.[5] After the death of his mother in 1892, Liebermann moved back into the family home and inherited the property after the death of his father two years later.[6] The house at Pariser Platz became a powerful symbol of the artist's persona, serving as a venue for high-profile social events and more intimate meetings with publishers, writers, artists, dealers, and art collectors. In later years, his daily routine there demonstrated the two sides of his personality: although he lived in an elegantly furnished setting hung with paintings from his famous collection, most hours of his days were spent working in his modest studio on the top floor.

Liebermann's generation of German Jews had far greater educational and professional opportunities open to them than their parents did, who had to go into businesses open to them. Max was not a rebellious young man nor was he disrespectful of his father, but like many of his contemporaries, he had resources and time unavailable to his parents and grandparents to explore a variety of recreational and professional interests. His father's belief in discipline, hard work, and stability were at odds with Max's desire to find his own way in the world outside of the family businesses. Aware of his son's interest in art, his father nonetheless insisted that Max first receive an education in the classics, mathematics, and history at the Friedrich-Werdersche Gymnasium before making a final decision about an occupation.

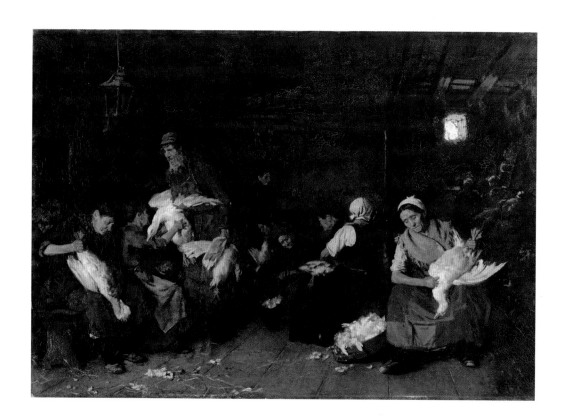

I.4 *Women Plucking Geese*, 1872.
Staatliche Museen zu Berlin,
Nationalgalerie

While at the gymnasium, Max took his first drawing lessons from Eduard Holbein (1807–1875), a now-forgotten artist who had studied at the Prussian Academy of Arts and supported himself primarily through portrait commissions, engraving, and teaching fledgling artists. The lifelike drawings of people at work and on the streets of Berlin in Liebermann's earliest known sketchbook reveal his interest in realistic depictions of his immediate surroundings (Figure I.3). His first known oil painting, *Portrait of Felix Liebermann*, 1865 (Plate 4), reveals that the young artist, by focusing on the beauty and sensitive demeanor of his younger brother, was already somewhat accomplished in portraiture. Drawing study heads from live models was a common method of instruction in German art schools; Liebermann probably gained his expertise through such exercises under Holbein's tutelage.

I had a brush and palette in my hands for the first time…and I had become a painter.[7]

Upon graduation from the gymnasium, Liebermann decided to pursue his studies in art—no doubt with financial support from his father. From 1866 to 1868 he received his first serious art training from Carl von Steffeck (1818–1890), the best-known horse painter in Germany. The instruction at the studio was based on that of the Paris ateliers, where students divided their time between drawing from live models and plaster casts. Liebermann recalled Steffeck's emphasis on the importance of learning to draw and his interest in works that displayed some observation of nature.[8] Steffeck, who had traveled to Holland in the 1850s where exposure to Dutch Old Masters had likely influenced his own aesthetic toward naturalism, passed his enthusiasm for seventeenth-century Dutch art to his student. Throughout his career, Liebermann reaffirmed his teacher's aesthetic views. The time spent with Steffeck can also be seen in Liebermann's mastery of depicting horses in movement, a motif to which he was drawn throughout his career. Wilhelm von Bode (1845–1929), an art historian and general director of all Prussian museums from 1906 to 1920, studied at Steffeck's studio at the same time as Liebermann. Bode, who was also working on his dissertation,

I.5 Mihaly Munkácsy, *Making Lint*, 1871. Hungarian National Gallery, Budapest

"Frans Hals and His School," played a major role in introducing Liebermann to both the themes and daring painting techniques of the seventeenth-century Dutch artist. In the next two decades, Liebermann copied more than thirty works of Hals, studying the artist's use of all-over color, his ability to portray the personality of his portrait subjects, and his choice of themes, which revealed Holland's long tradition as a free and open society.[9] Liebermann would later apply what he learned from Hals specifically in his realistic paintings of Dutch rural society and more generally throughout his career in his increasingly free and fluid approach to painting.

What a pleasure it must be for you in the evenings, to relax and engage in your favorite past-time, while a poor painter, after having stood before his easel all day, often asks himself if his activities were futile…whether his work will lead to any results at all. [10]

By 1868 Liebermann felt he had learned all he could from his Berlin teacher and decided to move on to one of the larger art academies in Germany. Düsseldorf and Munich were the leading German art centers at the time, but his parents preferred that he attend the Weimar Academy of Art, which had been established about ten years before by the Grand Duke of Saxe-Weimar. Weimar's proximity to Berlin may also have contributed to its selection. Liebermann's descriptions suggest that its method of teaching was similar to that of the other academies in German cities: students started with a traditional course of drawing from plaster casts and models and then selected an individual teacher who had expertise in an area of interest. Training at Weimar may have been somewhat more progressive than other more academically oriented German art schools. Because the academy's first director, landscape painter Stanislas Graf von Kalckreuth, emphasized landscape and genre painting, the school soon developed a reputation for naturalist landscape painting.[11]

When he first arrived at Weimar, Liebermann (Figure I.2) had wanted to work with the Belgian history painter Ferdinand Pauwels (1830–1904) but was assigned instead to an introductory class with Paul Thumann (1834–1908), a

history and genre painter who had recently been named a professor at Weimar after completing his studies there. Revealing the fledgling artist's typical lack of self-confidence, Liebermann struggled to find his own artistic voice. Writing to his brother Felix, he expressed his frustrations:

> My hope continues to wither, although I have always [realized perhaps] better [than] my colleagues that [training] indeed doesn't lead directly to abundant talent. In any case, I have decided to persevere with all my might. I must become a good painter. Thereby God commands.[12]

Although he worked with great diligence, he did not care for the assignments in the introductory class, mentioning specifically the chore of copying works by the German artist Lucas Cranach (1472–1553). During his second year, he was also disappointed with the instruction provided by Pauwels. He found the teacher cold and pedantic and the projects insipid—including one that required painting a couple in elegant eighteenth-century dress.[13]

Two teachers at Weimar had an approach to painting more relevant to him. The first, Charles Verlat (1824–1890), a student of Courbet, favored realism over the school's preference for history and mythology. His appointment as director of the Weimar Academy of Art in 1866 suggests that the institution was responding to more current directions in art.[14] The second, landscape painter Theodor Hagen (1842–1919), who had been a professor at the Düsseldorf Academy before joining the Weimar faculty in 1871, had an even greater impact on Liebermann's artistic direction. Only five years apart in age, the two developed a close relationship.

In the spring of 1871, Hagen took Liebermann to Düsseldorf where the young artist met the Hungarian Jewish realist painter Mihály Munkácsy (1844-1909) and saw his painting *Making Lint* (Figure I.5), a genre scene associated with the contemporary Hungarian struggle for freedom. Liebermann was attracted to both the subject—of peasant women making bandages for wounded soldiers from scraps of linen—and the style of Munkácsy's realistic portrayal: dramatic contrasts of dark and light made possible through the application of a dark undercoat of asphalt.

Although critics have long suggested that the everyday subject and execution of Munkácsy's painting had a direct influence on Liebermann's first major painting, *Women Plucking Geese*, 1872 (Figure I.4), current scholarship suggests that Liebermann's earlier trip to Holland had an equal if not greater influence on his subject matter and execution.[15] When the painting was displayed in Hamburg in 1872, Liebermann was praised for his skillful technique and the honest realism of his figures, but the positive reviews were greatly overshadowed by hostile and rancorous responses. Nonetheless, the painting was immediately acquired, passed through a succession of art dealers and the collection of the railroad tycoon Bethel Henry Strousberg, and ended up in the National Gallery, Berlin, in 1894. Liebermann clearly considered the painting a success: it was the first painting he submitted to the Paris Salon two years later.

Holland has rightfully been called the land of painting par excellence, and it is no accident that Rembrandt was Dutch. The fog that rises above the water and floods everything with a transparent haze gives the country a specifically picturesque quality. The watery atmosphere makes the hardness of the contours disappear and gives the air a soft, silvery gray tone [...] its beauty lies in its intimacy. And like the country, so are the people: never loud, no affect or banality.[16]

Liebermann took his first trip to Holland some time in 1871, although the exact dates and number are not documented.[17] The country became significant to the

1.6 *Women Cleaning Vegetables*, 1879. Museum der bildenden Künste, Leipzig. This is the third version of one of Liebermann's most popular early paintings.

development of Liebermann's oeuvre; his annual trips—from the 1870s until the outbreak of World War I—provided him with subject matter and painting techniques. He worked primarily in the western part of the country, but his images express his affinity for the Netherlands in its entirety. "Here I am a painter," he acknowledged, "here I made myself into one."[18] Liebermann's desire to find a simpler, purer rustic way of life may seem inconsistent with his urban bourgeois upbringing. In their search for rural subject matter, many late nineteenth-century artists traveled to remote regions throughout Europe; some of the most inspiring sites grew into artist colonies. Holland was particularly popular with young German artists, who had closer cultural ties there than they did with France, where most of these artist colonies were located. From the 1870s until about 1895, Liebermann focused on themes of everyday peasant life in such Dutch villages as Zandvoort, Dongen, Zweeloo, Laren, Delden, and Katwijk. In the mid-1890s he redirected his focus and turned to painting the leisure activities of the urban bourgeoisie at the beach resorts of Scheveningen and Noordwijk and at beer gardens, outdoor cafes, and the Amsterdam zoo.

As early as 1872, Liebermann established a pattern: travel to a distinctive locale in summer where he made preparatory drawings that would be used as the basis for paintings produced during the winter months in his studio. This method appealed to many artists of his generation, giving them the freedom to experiment with subject and execution in their drawings, which were usually transformed in the studio into highly detailed and meticulously finished paintings. During the summer of 1872, Liebermann spent eight weeks in Holland with the Berlin painter Ernst Tepper (1843–1890). In Scheveningen, he made drawings of the cramped quarters of ship navigators; then in Amsterdam, he made sketches of women scrubbing vegetables for canning. Both subjects were developed into paintings upon his return to Weimar. Even at this early stage in his career, there was a market for his work. *Women Cleaning Vegetables*, 1872, was so desirable that it was mistakenly sold twice in Antwerp, and Liebermann had to paint a second version to satisfy his collectors.

Self-Portrait with Kitchen Still Life, 1873 (Plate 1), was Liebermann's first self-portrait and the last painting he completed in Weimar before moving to

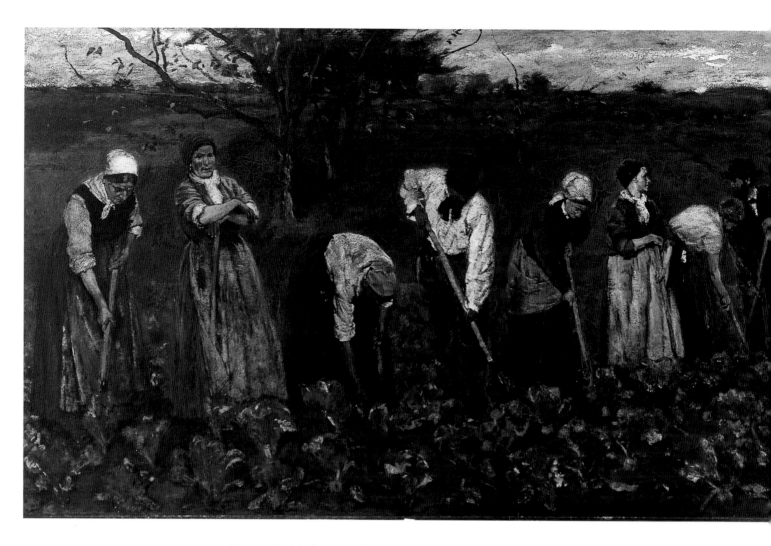

I.7 *Workers in a Turnip Field*, 1874/76.
Niedersächsisches Landesmuseum
Hannover

Paris. In his later self-portraits, he was usually shown in the act of painting, but here he presented himself in the guise of a cook—possibly because he was still conflicted about his potential success as an artist—standing behind a table laden with ingredients for a meal. The idea for the painting undoubtedly came from seventeenth-century Dutch still-life paintings that were given as wedding gifts. These depicted a profusion of food and sometimes a portrait of the happy couple. Liebermann's large painting, measuring almost three by five feet, is thought to have been a special present for his mother in honor of his brother Georg's wedding. It remained in the possession of the family until 1936. It has an engaging playfulness that resonates with shared jokes and family lore, from the abundance of food, acknowledging his mother's culinary skills, to the kosher seal on the chicken, affirming the family's observance of Jewish dietary laws.[19] *Self-Portrait with Kitchen Still Life* demonstrates Liebermann's early use of a strategy that he continued to employ throughout his career: looking to earlier artists for subject matter and formalist techniques and then transforming both to convey his own message. Several seventeenth-century paintings that combine a portrait and food have been suggested as direct sources: the lavish kitchen still lifes of Peter Aertsen or Frans Snyders or Jan Steen's double portrait *The Leyden Baker Arend Oostwaert and his wife Catherine Keizerswaert* in the Rijksmuseum.[20] At this stage of his career, Liebermann's borrowings from other artists were noticeably derivative: *Workers in a Turnip Field* (Figure I.7) is based on Courbet's *A Burial at Ornans, Potato Pickers*, 1874, is modeled on Jean-François Millet's painting of 1855 with the same title. Even during the early part of his career, however, he was able to transform what he learned from other artists into a completely new vision. One example is the large painting, *The Siblings*, 1876 (Plate 7), in which he made brilliant use of juxtaposition

and the application of colors along with the dramatic chiaroscuro effects that he learned from his close study of Hals. Much later in his career, he looked to paintings by Édouard Manet as the source for paintings of the outdoors, including *Country House in Hilversum*, 1901 (Plate 25), and *The Garden Bench*, 1916 (Plate 48).

At the end of 1873 I considered myself well enough developed [as an artist] to move to Paris. I was drawn here by Munkácsy, but it had more to do with Troyon, Daubigny, Corot, and above all Millet.[21]

By 1873 Liebermann felt prepared to strike out on his own. No longer a student, it was a time for him to come of age as an artist. A period of travel and exploration—known as the *Wanderjahre*—was customarily taken by German artists after their formal training. Deciding to try his luck in Paris, Liebermann lived there for five years, establishing his first studio on Rue La Rochefoucauld in Montmartre. His circle of friends was limited to German-speaking painters, including Munkácsy, who also settled in Paris in 1873, and the Czech painter Eugène Jettel (1845–1901). Because anti-German sentiment was strong so soon after the end of the Franco-Prussian War (1870–1871), he had little direct contact with French artists.

Vegetable Vendor – Market Scene, 1874 (Plate 5), painted early in Liebermann's residence in Paris, shows the merging of painting strategies from his studies in Weimar and from the art world of Paris. The composition treats a commonplace subject of poor people engaged in everyday activities: two women in an outdoor marketplace, which was located not far from Liebermann's studio. Both women are dressed in peasant attire: long dark dresses with scarves tied around their heads. The vegetable seller at the left wears a long white apron over her black dress and a red scarf around her neck. Standing before a darkened entry with arms akimbo, she entreats the woman at the right to buy her vegetables. Such narrative elements are unusual in Liebermann's oeuvre, which suggests that in this early work the artist was still searching for his own identity. The ruddy palette and strong contrasts of dark and light are reminiscent of Munkácsy. Similar peasant types are found in the paintings of Millet and Courbet.

Vegetable Vendor – Market Scene was commissioned by the Parisian art dealer Bernheime-Jeune for the initial stock of his gallery, which was established in 1874. Bernheime-Jeune at first featured Courbet and other realist painters[22] and was among the first to exhibit works by the French impressionists. A commission from such a discerning dealer indicates Liebermann's increasing stature. Presumably the painting remained with the original gallery until 1906 when Paul Cassirer, Liebermann's close colleague in the Berlin Secession, acquired it. *Vegetable Vendor – Market Scene* was first exhibited publicly in 1907 in the exhibition at the Royal Academy of Arts in Berlin in honor of Liebermann's sixtieth birthday, where it was shown as an example of his early, Weimar-related painting style.

Drawn to Paris by Munkácsy, Liebermann soon came under the influence of the Barbizon School painters: Constant Troyon, Charles-François Daubigny, Jean-Baptiste-Camille Corot, Gustav Courbet, and especially Jean-François Millet.[23] A generation older than Liebermann, this group painted in the village of Barbizon in the Fontainebleau Forest beginning in the 1830s. Because of their interest in painting the world around them and often working outdoors, they are considered precursors to the French impressionists. The French Academy disapproved of the Barbizon painters, and their works were frequently rejected by the annual Salon, the official government-sponsored art exhibition. At the Salon of 1872, however, Liebermann did see paintings by Millet, Courbet, and Ribot. Although he also spent the summer of 1874 in Barbizon, he never

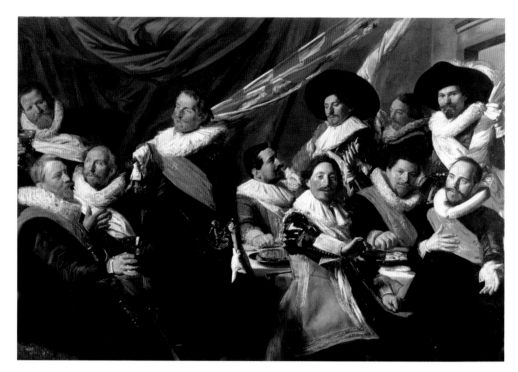

I.8 Frans Hals, *Banquet of the Officers of the St. George Militia Company*, ca. 1626/7. Frans Hals Museum, Haarlem. This was one of several paintings by Hals that Liebermann copied. His copy, of the man standing fourth from the left, was proudly displayed over the mantle in his home in Wannsee and can be seen in *The Artist Sketching in the Circle of His Family*, 1926 (Plate 57).

had the opportunity to meet the sixty-year-old Millet, who was vehemently anti-German and probably had little interest in young artists. Liebermann was drawn to Millet's glorification of everyday workers, to the poor and disinherited people who were slaves to the soil. One of Liebermann's biographers, Julias Elias, suggested that Millet's influence democratized Liebermann.[24] During the summer of 1874, Liebermann worked on two versions of the *Potato Pickers*, paintings that came closest to Millet's sensitive depictions of the hardships of rural labor and to French realism in general. Liebermann was also intrigued by Gustave Courbet's grand-scale realist paintings and, in particular, his famous *A Burial at Ornans*, 1849, showing the burial of an ordinary peasant in the artist's native village, which is seemingly attended by the entire community. Liebermann's first monumental painting, *Workers in a Turnip Field*, 1874–1876 (Figure I.7), with its complex interaction of peasants hoeing a field of turnips in the foreground of an expansive landscape, reveals the combined influence of Courbet's *A Burial at Ornans* and Millet's realistic depictions of peasants at their work. Throughout his career, Liebermann returned to images and ideas appropriated from the Barbizon painters: ocean and shoreline scenes reminiscent of Daubigny; groups of grazing sheep and cows tended by a lone shepherd that recall Troyon; and heroic laborers set in an expansive landscape, a motif that Millet developed par excellence.

Despite the attractions of the cosmopolitan art world of Paris and the supply of realistic subject matter in Barbizon, Liebermann's interest in Holland continued to intensify: both as a source for rural motifs and as an opportunity to study firsthand the painting techniques of Hals. Early in the summer of 1875, Liebermann returned to Barbizon for a short time and then went on to Holland, where he spent the rest of the season. Staying in Zandvoort to make studies of laborers at work, he made almost daily trips into neighboring Haarlem to see paintings by Hals on view at the city hall. Returning to Paris for the winter of 1875/76, he moved into a new studio on the Boulevard de Clichy. His visit to Holland in 1876 lasted five months; in Haarlem, he painted thirty studies of details from paintings by Hals. Liebermann was drawn to various aspects of Hals' work: his *alla prima* painting technique; his use of all-over color as opposed to the traditional use of isolated areas of local color; and his focus on humanistic themes, in particular, group portraits of regents of orphanages and old-age homes.

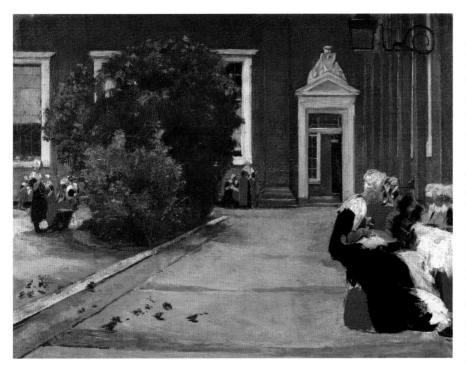

I.9 *Study for Recess in the Amsterdam Orphanage – View of the Inner Courtyard,* 1876. Staatliche Museen zu Berlin, Nationalgalerie

At this time, Liebermann was still searching for subjects from everyday life that would lead him to a unique artistic identity. While in Amsterdam during the summer of 1876, he happened upon a colorful and lively scene at the Citizen's Orphanage on Kalverstraat. His interpretation became the springboard for many of his subsequent paintings of Dutch labor. The girls' striking red-and-black uniforms—and the subject of social welfare—attracted Liebermann's eye.[25] His own family's support for the Jewish orphanage in Berlin, as well as Hals's portraits of the boards of similar venues, might have sparked his interest in exploring the subject.[26] Although his initial request to set up his easel in the inner courtyard was refused, Liebermann finally received permission through the auspices of Mr. Caramelli, a partner in the art dealership Buffa & Zoon who was also a regent of the Catholic orphanage.

Recess in the Amsterdam Orphanage, 1876, was a pivotal work in Liebermann's development as a plein-air painter. The uniformed girls sewing and chatting during a rest period offered a pictorial problem worthy of investigation. He set up his easel and stool in the middle of the courtyard reserved for the older girls to make this study (Plate 14) for the studio-crafted painting. The composition is enclosed on the right side and the rear by the red brick walls of the buildings, which are punctuated by white-framed windows that alternate with solid brick pilasters. At the rear wall is a large doorway surmounted by a triangular pediment that leads into the third courtyard, reserved for the youngest children. A large squared-off lawn area with two large shrubs on the left somewhat softens the hard architectural and paved surfaces. He first painted the architectural setting and then focused his attention on the young girls, who sit on the ledge of the building quietly at work. He gives his first, fresh impression of the scene, loosely defining the girls: their demure postures, the vivid red, black, and white of their uniforms, and their steady attention to handwork. So focused on capturing their clothing and positions, he left out such significant details as a bench to support the girl facing the wall—she seems to hover in midair. The shrubs are likewise loosely painted. Dappled light fills the courtyard and possibly prefigures Liebermann's later partiality for illuminating outdoor scenes with distinctive, mottled flecks of paint representing sunlight filtered through the branches of trees.

The painted sketch's history validates its importance in Liebermann's development. He kept it in his studio along with other studies for larger paintings. Thirty years after its creation, it was acquired by Bode, in exchange for a length of velvet fabric from East Asia that he had purchased in Italy for his wife.[27] First placed on view at the *German Centennial Exhibition (1775–1875)* in 1906 at the National Gallery, Berlin (see essay by Forster-Hahn, this volume), the painting was also part of solo exhibitions, including the Liebermann exhibition held at the Frankfurt Art Society in 1907 and the exhibition honoring the artist's eightieth birthday at the Prussian Academy of Arts in Berlin in 1927.[28]

In addition to numerous studies on the spot, Liebermann made a larger, more

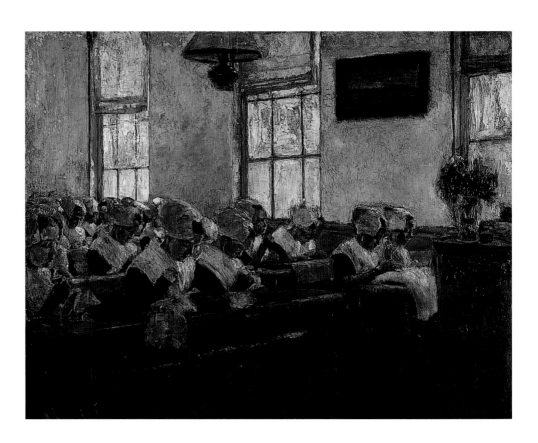

I.10 *Sewing School, 1876–77.* Von der Heydt-Museum, Wuppertal

detailed studio version of the painting in 1882 (Figure IV.2). His other studies of the girls at recess, along with his studies and finished paintings of the girls at work in their sewing class inside the orphanage, represent the beginning of his exploration of the subject of "still work," or needlework, which would play out in paintings of lacemakers, weavers, and others doing handwork. Back in his Paris studio, Liebermann used his studies of the girls in sewing class to experiment with the mathematical construction of light and space, which is seen in *Sewing School,* version two, 1876–77 (Figure I.10). These early plein-air studies of the orphanage earned Liebermann a reputation as a pioneer of modernism in nineteenth-century German art.[29] That same summer, Liebermann was taken on his first visit to the Jewish quarter of Amsterdam by the Dutch artist August Allebé (1838–1927). His visits to the Judengasse in part inspired him to take on the subject of Jesus in the temple with the scholars in 1878.

At the Swimming Hole, 1875–77 (Plate 6), was the last large painting that Liebermann finished in Paris and his first attempt at painting a large group of human figures, including several who are naked. Based on sketches he made at a beach at Zandvoort, the painting of a group of young boys—in various stages of dress and undress—is dense and somewhat awkwardly composed. The overall composition appears static because the focus is on the individual movement of each of the ten boys; no interaction between them is depicted. In an effort to create a painting that could compete with other large-scale entries to the Paris Salon, Liebermann tried to transform this subject from everyday life into something heroic and monumental.[30] Liebermann had reservations about its success and so preferred not to risk entering it into the Salon of 1877; he did exhibit the painting the same year in Amsterdam. Twenty-five years later, he returned to the subject, using the theme repeatedly to experiment with abstracted forms and a freely executed painting style.

From early in his career, Liebermann took various calculated steps to achieve success in the international art world. His years in Paris were fruitful to the development of his career. Throughout his residence there, his paintings were accepted into the Paris Salon: *Women Plucking Geese* (Salon of 1874); the eight-foot-wide *Workers in a Turnip Field* (Salon of 1876); and *Mother and Child*

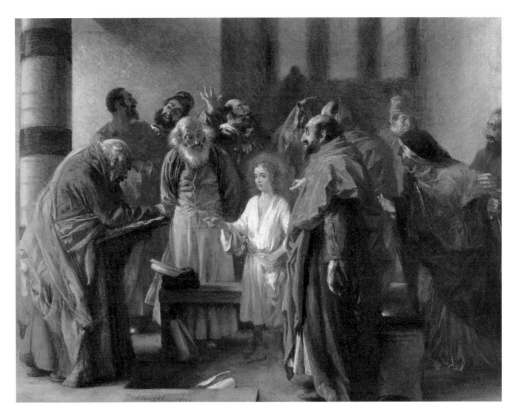

1.11 Adolph Menzel, *Twelve-Year-Old Jesus in the Temple*, 1852. Lithograph after 1851 painting. Kupferstichkabinett, Hamburger Kunsthalle. In comparison to Liebermann's true-to-life rendering of this story from the New Testament, Menzel portrays the scene in a traditional hagiographic style. The rabbis are depicted with stereotypical features and there is no exchange of ideas between them and Jesus.

and the second version of *Sewing School* (Salon of 1877). All fairly conservative paintings, they comported with more academically oriented paintings favored at the Salon in the era after 1870.[31] Long after he left Paris, he submitted entries to the Paris Salon from 1880 until 1882; in 1883, he was the only German artist invited to participate with the Cercle des XV, a international exhibition of artists organized by six French painters, including Jules Bastien-Lepage. Held privately at the Galerie Georges Petit, it also included artists from Italy, Spain, Sweden, England, and Russia.[32]

A short visit to Munich became a stay of almost six years.
—Eric Hancke, Liebermann's biographer[33]

Liebermann's move to Munich in 1878, at the suggestion of the well-known portrait painter Franz Lenbach (1836–1904), was motivated by his failure to achieve complete success in Paris and also by his desire to work among a community of fellow German artists. Munich offered opportunities comparable to those in Paris. In the last third of the nineteenth century, Munich was considered equal in importance to Paris in its support of the arts, a prominence that predated and at the time surpassed that of Berlin. The Neue Pinakothek, a museum for contemporary art, was opened to the public in Munich in 1853. The city was host to a pan-German exhibition of contemporary art in 1858; eleven years later, the first International Art Exhibition in Munich inaugurated a series of exhibitions of contemporary, particularly French, art. Although the Munich Academy of Art still promoted history painting in its curriculum, the influential circle of realist painters headed by Wilhem Leibl (1844–1900), who worked there in the 1870s, was changing the prevailing aesthetic. Liebermann rented a studio south of the train station on Landwehrstrasse and made friends with such established artists as Leibl and Lenbach and also such lesser-known artists as Fritz von Uhde (1848–1911), who like Liebermann was attracted to simple peasant subjects painted directly from nature, the animal painter Heinrich von Zügel (1850–1941), and the sculptor and architect Lorenz Gedon (1843–1883).

The first painting that Liebermann completed in Munich, *The Twelve-Year-Old Jesus in the Temple with the Scholars*, 1879, caused a public outrage when it was exhibited at Munich's third International Art Exhibition, because of its interpretation of a Christian subject by a Jewish artist.[34] Based on a New Testament story (Luke 2:46–47), the painting shows the young Jesus debating with the rabbis in the Temple in Jerusalem. Changing the setting from ancient Jerusalem to a seventeenth-century synagogue, Liebermann portrayed the figures as Orthodox Jewish men who might be seen at worship in his own time. Sources for the painting include drawings from his 1876 visit to the Portuguese Synagogue in Amsterdam and his more recent trip to the Scuola Levantina in Venice, along with drawings of live models in Italy and subjects he found in the Christian hospital of Munich. The painting, subsequently altered to placate his critics, is known only from a final preparatory drawing (Plate 10). It shows a barefoot young boy—with scraggly dark hair and a disheveled short garment—who gesticulates with his hands while in discussion with the rabbis who sit and stand before him.

New to Munich, Liebermann no doubt wanted to demonstrate his skills at history painting, by depicting an ancient story as a present-day event. Quite common during the seventeenth century, the theme was again popular. A lithograph of Adolph Menzel's 1852 version (Figure I.11) had been widely disseminated.[35] The non-Jewish artist Ernst Zimmerman (1852–1901) submitted a painting on the same subject to the same exhibition at which Liebermann's version was vilified. Reinhold Schlingmann, critic of the liberal *Berliner Tageblatt*, praised Zimmermann's painting for its emotional intensity, saying that it was "not as offensive as in comparison to Liebermann's Jesus."[36]

While the scandal that resulted from *The Twelve-Year-Old Jesus in the Temple with the Scholars*, 1879, was one example of growing anti-Semitism in Germany, the attention surrounding it and the support Liebermann got from fellow artists actually helped to advance his career. In retrospect, he described his feelings about the negative reaction to the painting and also the newfound encouragement he received from his Munich colleagues:

> I really would never have dreamed of such a thing when I painted that innocent picture. Today, no one is against that picture that was to become so troublesome to me. The clerics demanded that it be removed to the side [gallery] by the opening of the exhibition. Well, I was consoled by the approval of my colleagues. Lenbach and the entire jury, such as Fritz Kaulbach, Zügel, the sculptors Gedon and Wegmüller stepped up for me. People congratulated me on the picture—it is the best that has been painted in Munich in fifteen years.[37]

To escape the furor over the painting, Liebermann spent the summer of 1879 in Etzenhausen, a small village near Dachau.[38] When he returned to Munich, his paintings had safer subjects: scenes of the Dutch peasant genre and of urban social agencies. *Study for Old Men's Home in Amsterdam*, 1880 (Plate 15), an example of his continued interest in the subject of Dutch social service institutions, depicts a group of residents of a Catholic retirement home in Amsterdam that he saw from the window of a room in the Rembrandt Hotel. Liebermann painted three large versions of the theme and various studies of individual men and groups of men, all with an emphasis on blending the human figures with the garden setting.

In 1881 Liebermann met Jozef Israëls (1824–1911), the Dutch Jewish artist who was the leader of the Hague School. The two developed a lifelong friendship. Israëls' simple depictions of peasants and poor people—painted in a soft, atmospheric manner—had a significant impact on Liebermann. In *The Weaver*, 1882 (Plate 17), Liebermann used a more traditional, old masterly

approach to the painting of a family working together in their home. As opposed to the more fluid techniques in his paintings set outdoors, here the execution of forms is more linear; the composition is lit, like a stage set, through a window in the background, with dramatic contrasts of light and dark. *Dutch Farmhouse with Woman*, 1882 (Plate 18), is one of many examples of small, rapidly executed studies of peasant life that exhibit bold new juxtapositions of color and heavily impastoed paint surfaces.

His annual, extended visits to Holland were a respite from the hectic professional and social activities of his winter months in the urban centers of Paris, Munich, and later Berlin. The contrasts between city life and the simplicity of life in Dutch villages very likely influenced his respect for the seemingly utopian way of life of these poor people:

> A cow herder, servant girl, a young farm hand, and their master all sit together at the kitchen table and eat out of the same bowl. Everyone addresses each other familiarly like in a big family. There is no poverty here. My landlord tells me that two of the men receive free board. As a result, mankind is honest and believes in justice.[39]

I admire Berlin in Liebermann…Berlin represents energy, intelligence, rigor, lack of sentimentality, romantic excess, and an exaggerated reverence for the past, faith in modernism as the promise of the future, and cosmopolitanism in place of sentimental Teutonic bombast.—Thomas Mann[40]

Liebermann was a well-established painter by the time he moved back to Berlin to marry Martha Marckwald (1857–1943) in 1884. He no doubt believed he would be accepted in his native city as a successful artist. As a realistic genre painter, however, he was considered a renegade in the traditional art world of Berlin. Returning to Berlin a little more than a decade after German unification and the creation of the Empire, he found his cosmopolitan attitudes at odds with the positive, heroic, and classical cultural identity being promoted in the new nation. Almost immediately, he became embroiled in cultural politics.

The conventional tastes of Wilhelm II, who became emperor in 1888, Anton von Werner, director of the Royal Academy of Art, and Max Jordan, who served as director of the National Gallery, Berlin, from 1876 to 1895, dominated the growing art community in Berlin. With the help of Bode, however, two of Liebermann's major Dutch paintings were acquired by German museums: *Flax Spinners in Laren*, 1887 (Figure IV.4), a large-scale, poetic depiction of Dutch women and children at work in a factory, and *Women Mending Nets*, 1887–8 (Figure IV.3), a portrayal of women mending fishing nets on a beach. The former was a gift from the artist to the collection of the National Gallery, Berlin, in 1888; the latter was acquired by the Hamburger Kunsthalle in 1889 while Liebermann's friend Alfred Lichtwark was its director. Liebermann's decision in 1889 to help organize an exhibition of German art at the Paris World's Fair was met with contempt by the German government and its conservative supporters (see Forster-Hahn, this volume).

Taste is altered by every new aspiring genius: the artist imposes his concept of beauty on us, and we must obey whether we like it or not—and mostly we don't like it.[41]

The decade from 1890 to 1900 was pivotal in Liebermann's career. The artist adopted at times contradictory attitudes and allegiances, gaining official acceptance by the traditionally oriented art community, then defiantly supporting modern art. Events in his professional and personal life affected the direction of Liebermann's art making and brought him to full maturity as a painter.

Although he received a gold medal at the International Art Exhibition in Munich for *Old Woman with Goats,* 1890 (Figure IV.5), which was then acquired by the Neue Pinakothek in 1891, it took several years for Liebermann to be accepted and recognized by his colleagues in Berlin. His first major painting, *Women Plucking Geese,* 1872, was bequeathed to the National Gallery, Berlin, after the death of his father in 1894. In 1897 he was given a solo exhibition at the Royal Academy of Arts in honor of his fiftieth birthday; a year later, he was elected to the Academy with the titles of Painter, Professor, and Academician.

Despite this growing recognition, Liebermann joined the secession movements—"The Eleven" and the Berlin Secession—in this decade. Separatist movements—in Munich in 1892; Düsseldorf, Weimar, Dresden, and Karlsruhe by 1895; and Vienna in 1897—set the precedent for artists to secede from government-controlled official art organizations and annual exhibitions. The Berlin artists who joined together in 1892 as "The Eleven" were not controversial or avant-garde and did not share a particular style. Their goals in organizing exhibitions outside the official exhibitions of the Royal Academy of Arts and the Association of Berlin Artists were more commercial and practical; they opposed the large, crowded, and chaotic installations of the official exhibitions, preferring smaller venues that would allow visitors to more readily focus on individual works. Liebermann and Franz Skarbina (1849–1910), a Berlin painter of urban street life, were invited to participate because they were better known than the other artists in the group. After its first exhibition in 1892 in the Galerie Schulte, annual exhibits were held at the same gallery until they disbanded with the founding of the Berlin Secession in 1898. With sixty-five members, including women, the Secession was larger at its inception and better organized; it had a more solid financial footing from donations from members and patrons. The Secession had its own buildings—located on Kantstrasse and then on Kufurstendamm—where they presented continuous exhibitions. Liebermann and Walter Leistikow (1865–1908), a Berlin artist who specialized in impressionist landscape painting, served as president and vice president, respectively. The business side was managed by the art dealers and publishers Paul Cassirer (1871–1926) and his cousin Bruno Cassirer (1872–1941). Separate from the Secession, after 1901 Bruno Cassirer published the *Kunst und Künstler* journal and books on French impressionism, postimpressionism, and other foreign art.[42]

During this period, Liebermann's family life had also evolved. In 1892 after the death of his mother, he moved with his wife and daughter into his parents' home at Pariser Platz 7. He continued to work in a modest studio on Queen Augusta Street until he had a glass-roofed studio built on the top floor of his home.

Earlier schools taught that light was cold and shadows were warm; the Impressionists don't give a rap for these teachings and paint light and shade red, violet, or green,…wherever and however they see them.[43]

After his father's death in 1894 when Liebermann inherited a considerable portion of his wealth, he began to develop one of Berlin's most important collections of modern art with French impressionist painting as a focus. Although three of the now-famous impressionist exhibitions were held while he was living in Paris, there is no evidence that Liebermann attended them; instead, he was first exposed to French impressionism in Berlin through his participation in the 1880s in the circle of Carl and Felicie Bernstein, both of whom were born in Russia and educated in Germany. Carl Bernstein was a professor of Roman law at the University of Berlin, but because of his Jewish heritage, it was an unpaid and untenured position. Their collection, which included works by Manet, Degas, and Renoir, was purchased with the advice of Carl's Parisian cousin, Charles Ephrussi, an art

historian, collector, and the future editor of the French art periodical *Gazette des Beaux Arts*. In 1882, the Bernsteins brought a small but choice group of paintings by the leading artists of modern French art.

At their salon, Liebermann wrote in a memoir, "One would imagine himself in a Paris salon, the impression magnified by numerous foreign guests there."[44] At the weekly salon in their elegant home, which was located just across the street from Liebermann's studio, the Bernsteins gathered a group who shared an interest in French impressionist painting. In the circle were Hugo von Tschudi, assistant to Bode in the department of sculpture and later director of the National Gallery, Berlin; Alfred Lichtwark, who was on the staff of the Decorative Arts Museum in Berlin from 1881 until 1886 when he became director of the Hamburger Kunsthalle; Friederich Lippmann, director of the Berlin Kupferstichkabinett (Collection of Prints and Drawings) from 1876 to 1903; Ernst Curtius, director of the Antiquities Collection of the Berlin Museums, and his assistant Georg Treu.[45]

Liebermann had ongoing relationships with Parisian art dealers as he began to build his own collection of French impressionist and postimpressionist paintings during the 1890s. In 1896 he traveled to Paris with Hugo von Tschudi, who had recently been named director of the National Gallery, Berlin, to advise him in the purchase of Manet's *In the Conservatory*, 1879, for the museum. Liebermann did not return again to Paris until 1912, and most of his subsequent purchases of paintings by French artists were made through dealers in Berlin.

Liebermann very quickly amassed one of the most important collections of French impressionist painting in Berlin. He did not seem interested in acquiring a comprehensive collection but bought what interested him at the time and sold pieces as his taste changed, making it difficult to determine the size of his collection. As a practicing artist, his motivations for focusing on specific artists or even a particular painting differed from those of collectors who had no painting experience. His first purchases were works by German realist painters Adolph Menzel and Wilhelm Leibl, artists whose work related more to Liebermann's own paintings of peasant life. Liebermann gradually changed his focus to French impressionism with an emphasis on Manet and Degas. The other artists in his collection—Monet, Renoir, Pissarro, Sisley, Cézanne, and Toulouse-Lautrec—were represented by only a few works. Most were landscape paintings that had an impact on Liebermann's later paintings of the gardens at his summer villa. In a letter to his friend Georg Treu written on September 25, 1908, he referred to Monet's *Poppy Field*, 1875, a painting that he had recently received as a bequest from Felicie Bernstein, remembering: "We contemplated the painting often choked with emotion."[46]

Liebermann especially admired Manet whom he compared favorably even to his historical favorites Hals and Velázquez in his ability to enliven subjects from everyday life or contemporary events: "The extraordinary does not lie in his [Manet's] subjects. His gift was, like with any genuine painter, in his ability to paint what was old in a new way."[47] In a letter on September 26, 1898, to the Lübeck collector, Dr. Max Linde, Liebermann asserted: "One can probably have too much Manet but one can never really have enough."[48] True to his convictions, he owned more than twelve paintings by Manet, including such simple still lifes as *Bunch of Asparagus* (Figure I.12) and *A Melon*, both painted about 1880. He also prized more elaborate floral still lifes: *Peonies*, 1882, which he received from Carl Bernstein in exchange for painting a portrait of the collector, and *Crystal Vase with Roses, Tulips, and Lilacs*, ca. 1881, which also passed through the Bernstein collection, according to Liebermann's letter to Treu: "Fifteen years ago [in 1893] I acquired from [the art dealer] Paechter Manet's floral bouquet that had earlier belonged to Bernstein."[49] Other paintings by

I.12 Édouard Manet, *Bunch of Asparagus*, ca. 1880. Wallraf-Richartz-Museum, Cologne

I.13 Édouard Manet, *Rochefort's Escape*, 1880/1881. Kunsthaus Zürich

Manet in his collection included images of women in garden settings such as *Young Woman in a Garden*, 1880, which cost the artist 2,000 francs, according to Tschudi;[50] portraits in the outdoors such as *George Moore Sitting in a Garden*, 1879, *Mr. Arnaud on Horseback*, ca. 1875, and *Madame Manet in the Garden*, 1880; and even a painting of a contemporary historical event, *Rochefort's Escape*, 1880–1881 (Figure I.13), depicting the flight from prison of Henri de Rochefort (1830–1913), a leftist who was convicted for his anti-government writings and deported to New Caledonia in 1873. By the time Liebermann purchased the painting around 1900, Rochefort was a prominent anti-Dreyfusard, that is, a member of the anti-Semitic, right-wing faction in France during the time of the Dreyfus Affair. Neither the subject of the painting nor the opinions of the person portrayed seemed to bother Liebermann, who was interested in it as an example of Manet's history painting and because of the distinct brushstrokes, bold juxtapositions of color, and unfinished sketchlike surface.[51]

In Liebermann's collection were at least seven works by Degas; most were ballet subjects. He purchased *Dancers*, ca. 1893–1898, in 1904 and considered it so important that he called it "my Parthenon Frieze."[52] The painting of four ballerinas bent over, tying their shoes, had a place of honor in his villa at Wannsee (Figure I.14). Liebermann wrote the first of his monographic essays on Degas; it was published in 1896 in the avant-garde art journal *Pan*. Degas's experimentation with pastel, his use of daring perspective based on Japanese prints, and his technique of cutting off figures at the edges of his canvases—borrowed from the new medium of photography—influenced Liebermann's later works.

In the privacy of his home, Liebermann could indulge in the pleasure of close inspection of his collection over time, analyzing the methods and strategies used by the artists he admired and gradually adapting elements of what he learned into his own work. Paintings in his collection that had an unfinished, sketchy quality about them prompted him in the 1890s to try to remove the distinction between preparatory studies and finished works. To free up his painting technique, he began to apply paint with a palette knife and even with his fingers. His use of color vacillated between a new boldness and a lightening of the palette.

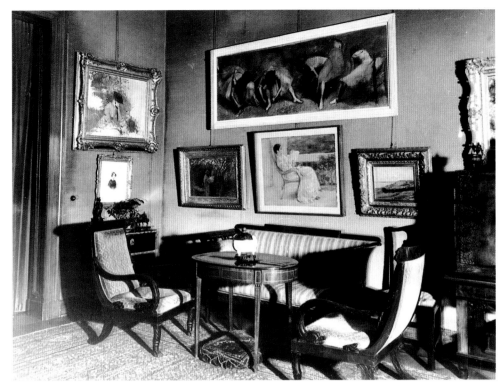

I.14 Living room of Liebermann's villa in Wannsee, 1932. On the wall to the left is *Young Woman in a Garden* by Édouard Manet. To the right over the sofa are: *Dancers* by Edgar Degas, *Manet Painting in Monet's Garden at Argenteuil* by Claude Monet, *Portrait of Martha Liebermann* by Liebermann, and *Dunes on the Seacoast* by Constant Troyon.

Impressionist color theory is based on the employment of bright prismatic colors. Instead of drawing forms or outlines or using the traditional contrast between light and dark to define forms, impressionist paintings are unified by light and the exchange of colored reflections. Liebermann was at first not convinced of the truthfulness of this color theory, telling his biographer Eric Hancke in 1894: "You know that the business of divided colors is all nonsense. I have seen it [many times]: nature is simple and gray."[53] According to Liebermann, the impressionists were not painting nature as they saw it by staying away from gray, brown, and black. He favored the approach of Frans Hals, whose selection of vibrant colors are juxtaposed with brown throughout a painting.[54] Once Liebermann began to collect French impressionist paintings in greater numbers and had a chance to study the paintings over time, he changed his opinion about the impressionist autonomy of color.[55] By the 1890s, light became an essential element in Liebermann's paintings. His distinctive way of fashioning dappled light as it falls to the ground, which at times radiates throughout an entire painting, is evident in *Beer Garden in Brannenburg,* 1893 (Plate 22), *Study for Parrotman,* 1900 (Plate 27), and in many paintings of his villa garden. He also started to work in the medium of pastel, which allowed greater spontaneity than oil paint. He continued his annual study trips to Holland but his familiar subjects gained a new freshness. Overall, his painting revealed a new approach—a reduction of objects, light, and movement to the simplest form, executed with concise but abstract brushstrokes. The change represented a new way of seeing for Liebermann and gave him the impetus to develop what was interpreted in his own lifetime as a unique German response to French impressionism. According to the art writer Julius Elias (1861–1927), "Liebermann was the founder of German naturalism and at the time made French impressionism German."[56]

In the 1890s, he experimented with such new themes as the leisure and recreational activities of middle-class urban society; his palette lightened; and his method of painting became increasingly loose and spontaneous. *Beer Garden in Brannenburg,* 1893, is a key example of Liebermann's growing ability to merge human forms with the natural environment. The subject presented itself

spontaneously when the Liebermann family was forced to stay in the village of
Rosenheim in Bavaria for three weeks on their way to Italy because their daughter became ill. Liebermann, who had no access to a studio during this interval,
painted outdoors; when the weather permitted, he traveled to the nearby village
of Brannenburg to paint the beer garden there. Because the subject is dominated
by the large canopy of trees, sunlight penetrates the branches; Liebermann shows
the effects of dappled light throughout the painting. At the left is an inn, a
simple one-story, white structure with blue-trimmed windows; to the right are
tables set in horizontal rows and filled mostly with men who are drinking, eating, and conversing. In earlier outdoor garden scenes, Liebermann had painted
close-up views that focused on individual details of the people. Here he gives
a sense of the entire environment, with quick brushstrokes defining equally
people, trees, ground, and flecks of sunlight.[57] His biographer Erich Hancke
saw the painting in Liebermann's studio before it was finished and realized that
the artist had painted it almost entirely directly from nature. In their discussions, the artist explained his approach to abstraction, stating that he started
with detailed drawings, which he then reduced to their simplest elements.[58]
Liebermann submitted *Beer Garden in Brannenburg* to the Salon of 1894 in
Paris; it was subsequently purchased for the Luxembourg Museum, which at
the time housed the French national collection of contemporary art.

Another example of Liebermann's fresh approach to subject matter and
execution is *The Artist's Wife at the Beach,* 1895 (Figure I.15, Plate 23), a
striking portrait of Liebermann's wife Martha seated in profile by the beach at
Scheveningen. She sits in a deck chair on the balcony of their hotel with a closed
book on her lap, seemingly lost in thought while gazing out over the beach
and water. Numerous elements emphasize the horizontality of the composition:
Martha's backward-leaning position in the chair, the balcony railing, and the
broad sweep of sky and beach in the background. A new, lighter palette is used
for the rose-colored fabric of her blouse, the bright gray of her long skirt, the
gold-colored sand on the beach, and the blue-gray of the water and sky. Long
brushstrokes of white highlight her clothing, while her dark hair, the black ribbon at her neck, the chair, and the balcony provide a dark contrast.

During this transitional period in the mid-1890s when Liebermann began

I.16 *Peasant Walking*, study, 1894. Kunstkreis Berlin GbR

I.17 Liebermann painting in Katwijk, Holland, 1894. *Man on the Dunes*, a painting lost in World War II, is on the easel, while the model stands in the background.

to choose subjects more relevant to his own life, he also continued to paint Dutch themes. In some cases, such as *Old Ship's Pilot*, 1890, and *Saying Grace*, 1890, he continued to paint his quiet, spiritual representations of indoor peasant activities closely tied to paintings by Jozef Israëls. In other paintings, the landscape elements became increasingly important. Notable among them are paintings with a monumental figure set in an all-encompassing landscape. *Peasant Walking*, 1894, his first large work to be painted totally out-of-doors, was destroyed during World War II and is known only from studies (Figure I.16). A photograph of the artist at work with a model in the dunes of Katwijk (Figure I.17) documents this method of painting. The subjects and formal composition were consistent with his earlier periods, but the execution had clearly changed—it was looser and more painterly. He became increasingly concerned with elements of light, atmosphere, and color that corresponded to the thick, green representation of landscape. Qualities of weightlessness, of atmosphere, and of lifelike warmth emanate from these paintings.

In my daily habits, I am a complete bourgeois: I eat, drink, sleep, and go for walks and work with the regularity of a church clock. I live in my parents' house where I spent my childhood, and it would be difficult for me to live elsewhere.[59]

Even with a wife and child, Liebermann continued his annual summer trips to Holland. Rather than stay in the small Dutch villages, however, in the 1890s he took his family to stay at the beach in Scheveningen in quarters equivalent to their lifestyle in Berlin; after 1906, they vacationed at the more remote seaside village of Noordwijk. Not one ever to be idle, Liebermann painted what was going on around him: intimate portraits of his wife and daughter, bathers on the beach, tennis players, horseback riders, and people walking on the dunes. All were painted in a free and spontaneous manner. An example of his new ability to merge the figures with the environment can be seen in *Horseback Rider on the Beach, Facing Left*, 1912 (Plate 35). Liebermann may have perceived these representations of his family's vacation activities as diversions from his more important work of honestly portraying Dutch peasant life. By the next decade, however, bourgeois urban life and leisure activities dominated his imagery.

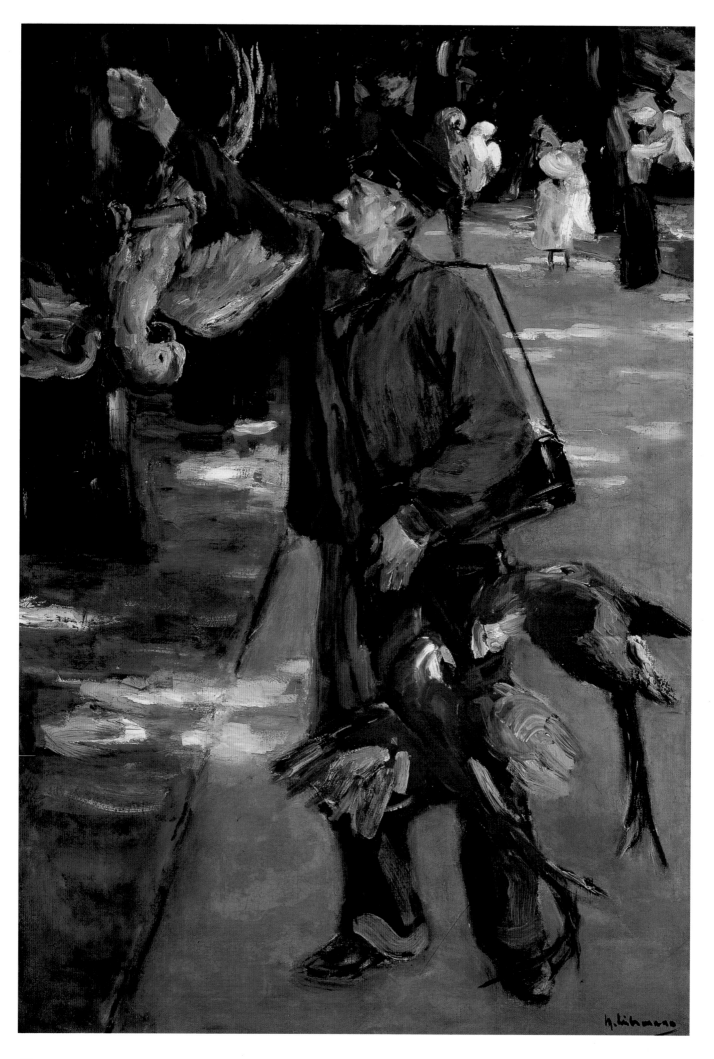

Although Liebermann was preoccupied by his duties in the Berlin Secession from 1899 until 1911, this phase proved to be the most adventuresome and experimental of his painting career. He had achieved his most inventive and exuberant body of work, in a series that explored aspects of painting beyond a direct portrayal of a subject. His series of paintings of the parrot keeper at the Amsterdam Zoo are stellar examples of his new coloristic, painterly, and exuberant bravura (Figure I.19).

Study for Parrotman, 1900 (Plate 27), is Liebermann's first and most spontaneous attempt at the subject. He shows the parrot warden in the foreground of what was called "Parrot Way" at the Amsterdam zoo. During the day, the colorful birds were brought out in the open and tethered to upright metal perches. At the end of the day, the warden gathered the birds and returned them to their cages. Liebermann has captured the scene at its most colorful moment; the warden holds two red and blue parrots tied to a carrier in his left hand, while he grasps a third parrot from its perch with his right hand. The painting as a whole is somewhat abstract and sketchy; the landscape elements and spectators at the rear seem hastily executed. These details are more fully articulated in later versions of the subject such as the 1902 painting in the collection of the Museum Folkwang in Essen (Figure I.18). Erich Hancke remarked about these paintings: "It is remarkable that he now selects such beautifully colored objects as exotic birds, since for a long time [he believed] that the world could not be gray enough for him."[60]

Another remarkable example of Liebermann's newfound bravura style is a series of paintings of the Jewish quarter in Amsterdam. In these paintings of 1905 to 1909, Liebermann returned to a subject he had explored briefly thirty years earlier. Hiring a room above the busy street, he sketched the swarming crowds engaged in buying and selling wares at a market set among old brick buildings punctuated by white-framed windows. While his location limited his view of the street, the paintings conveyed the changing colors and the action and movement below. In one version from 1905 (Plate 29), the scene is portrayed with a contrast of hot orange and deep blue-black. The people at the market, the laden carts, and the awning over the outdoor café in the far right are barely defined, yet give a sense of the bright sun over a busy street. An equally abstract, 1905 version of the same location (Plate 30), with its inky tones set off by the bright colors and brilliant white accents of the carts and clothing of the passersby, may have represented a cold, dark day. At times, Liebermann focused on specific details of the quarter, as in a painting from 1908 (Plate 31), in which he carefully delineated a close-up view of the market carts and shoppers.

In letters from Amsterdam, Liebermann described difficulties in painting the lively outdoor markets—rainy weather kept shoppers away and religious Jews were reluctant to have their portraits painted: "I will probably go spend some time in the Jewish quarter if the numerous holidays don't prevent me from work-

I.20 *Portrait of Albert Einstein*, 1925. The Royal Society, London

ing there. First the rain, then the religion. But, it will be fundamentally my fault if I do not work regularly. As the old Schadow [Wilhelm Schadow (1789–1862), director of Düsseldorf Academy of Art] said, 'The pencil is not dumb' when his students complained to him about their materials."[61] Another of Liebermann's biographers, the art critic Karl Scheffler, commented on the significance of the subject to Liebermann and, in particular, the new exuberance in his painting.

The new subjects did not only speak powerfully to the Jews, they not only represented something reminiscent of daily life in Holland or in Amsterdam, the neighborhood not only reminded Liebermann of their most honored painter, of Rembrandt, but rather all of the elements came together, nourishing Liebermann's artistic strength, which had reached a high point. These were subjects for a colorist and for the accomplished master of a type of shorthand that suggested the sensation of the entire milieu through the use of excited brushstrokes. Liebermann has never been more fresh, free, naïve or sensuous than during these years.[62]

This more experimental period of Liebermann's career coincided with his expanded role as an art theorist and writer. Each artist must look closely at the life around him, he wrote, and have the courage and freedom to interpret it from his own perspective: "Nature viewed by all artists according to their individuality remains fundamental—the alpha and omega."[63] Such an attitude allied him with the avant-garde and set him in opposition to the official, academic art community. Liebermann took advantage of his position in the Berlin Secession to promote his theories in speeches, in written introductions to Secession catalogues, in essays in art journals, and in books published by Bruno Cassirer.

When you make a mistake, the grass covers it the next day. But my mistakes are seen hanging on the wall for over a hundred years.[64]

Liebermann gradually evolved as a portrait painter: first, he depicted family members; next, he made informal portraits of colleagues; and finally, beginning in about 1908 until almost the end of his career, he painted scores of commissioned portraits. Family portraits from early in his career are careful, accurate depictions of sitters, but they lack the intimacy of family portraits from late in his life. His first painting in oil was *Portrait of Felix Liebermann,* ca.1865 (Plate 4), a bust-length, rather sensitive portrayal of the sixteen year old. Twenty years later his portrait of his uncle Benjamin Liebermann (Plate 20) is stiffly conceived, showing the business and civic leader with awards of distinction. A drawing of his father Louis Liebermann from 1891 (Plate 21) is the only remaining evidence of the now-lost double portrait of his parents painted in honor of their fiftieth wedding anniversary. Casual portraits of friends and colleagues from the turn-of-the-century art community, such as the painting of his colleague and fellow German impressionist, *Portrait of the Painter Lovis Corinth,* 1899 (Plate 41), reveal his increasing ability to capture the personality of his sitter.

Liebermann's first major portrait commission—to paint the portrait of Hamburg's mayor Carl Friedrich Petersen in 1891 (Figure I.21)—was another turning point in the artist's career. Alfred Lichtwark, director of the Hamburger

Kunsthalle and Liebermann's close friend and colleague, specifically wanted an artist who was not a traditional portrait painter. He correctly predicted that Liebermann would become the "portrait painter of the nation." In his portrayal of Petersen, Liebermann tried to merge the painterly *alla prima* techniques of Frans Hals with an in-depth characterization of the subject. Although there is no documentary evidence, Liebermann may have known examples of straightforward, realistic portraits by Édouard Manet that place a full-length standing figure in front of a neutral background. Liebermann portrayed Petersen in his full senatorial regalia: a fur-trimmed velvet robe, buckled shoes, tight leggings, a high white ruff, gloves, and a large hat. Unlike typical commissioned portraits, Liebermann's made no attempt to idealize or beautify the subject. The Hamburg community, known for its conservatism and preference for portraits that captured the class and prestige of the sitter, especially an image of an important civic leader, intensely disliked Liebermann's resulting portrait. Petersen himself loathed the portrait and used his authority to ensure that it would not be placed on public view. Consequently it was not hung in the galleries of the Hamburger Kunsthalle until 1905.

Despite the controversy surrounding his first official portrait, Liebermann subsequently completed more than two hundred commissions. His portraits, in oil and pastel, of many notable personalities include art collector Carl Bernstein (1892), realist playwright Gerhard Hauptmann (1892), the architect Hans Grisebach (1893) and his brother the writer Eduard Grisebach (1893), and the Lübeck art collector Dr. Max Linde (1897).[65] These were close friends or art colleagues; in the 1920s, he painted scores of businessmen. Before and after World War I, Liebermann also painted portraits of leaders in government, business, science, and industry—essentially a who's who of Berlin. Among his subjects were physicist and Nobel Prize winner Albert Einstein (Figure I.21); Wilhelm von Bode; author Theodor Fontane; the leading Berlin surgeon Dr. Ferdinand Sauerbruch (Plate 47); Liebermann's relatives, the industrialists Emil and Walther Rathenau; the composer Richard Strauss; and even the top leaders of the Weimar Republic, Prime Minister Otto Braun and President Paul von Hindenburg (Figure II.9). Over half of his portrait commissions during the Weimar Republic came from upper-middle-class Jews of Berlin.

Liebermann's approach to portraiture also expressed his belief in the honest and direct portrayal of the subject. He focuses on the individual without including trappings of status, profession, or particular interests; conveying the personality of the sitter was his goal. His process was simple: he would invite the sitter to his studio, have the person sit in the portrait chair, and then try to relax the sitter by engaging in conversation.[66] In order to capture the effect he wanted, many sittings were sometimes required. The artist reminded Dr. Sauerbruch, the artist's neighbor at Wannsee, that his "mistakes are hanging on the walls for a hundred years," an exchange that probably indicates that his sitter had become impatient. He probably referred to photographs when the sitter was not available.

Portrait of Bertha Biermann, 1908 (Plate 42), is one of his rare female portraits and one that he considered among his very best works. The portrait was painted four years after the death of her husband, Friedrich Ludwig Biermann, a partner in one of Germany's leading tobacco companies. Seated in an upholstered armchair in front of a neutral gray wall, Frau Biermann (1840–1930) is dressed in widow's garb and gazes directly out at the viewer. On her lap, she clutches a handkerchief tightly in her left hand; her right arm rests on the chair and her right hand touches her chin in an effort to support her head. She is clearly trying to hold still for the artist. Her black dress, gold-rimmed eyeglasses, and severe hairstyle, coupled with the serious expression on her face, give the

46

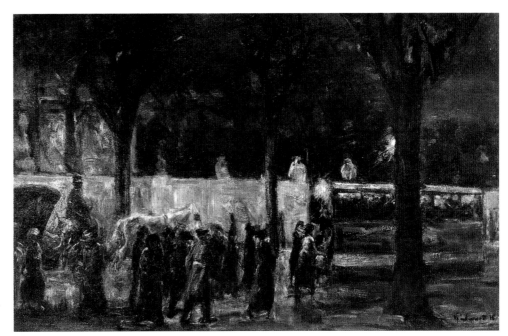

I.22 *Evening at the Brandenburg Gate,* 1916. Collection Deutsche Bank, Frankfurt am Main

impression of a stern, elderly woman. Liebermann expressed his satisfaction with the results of this portrait in a letter to the director of the Kunsthalle Bremen, Gustav Pauli, "The portrait of Frau Biermann was sent to Bremen today. Hopefully she and her son will like it. When it was seen in my atelier, it was considered as one of my best!"[67] The portrait was first put on public view at the exhibition of the Berlin Secession in 1908 where it received an admiring review from Karl Scheffler who wrote:

> How affectionate, how unassumingly heart-felt, how relentlessly civilized this humanity is recorded! It is represented beautifully, in such details as how the fingers spreading with the poignant despondency of suffering age only touch rather than support the cheek and chin, how the head tilts slightly in an excusatory manner, how the bashful and yet dignified naiveté of motherliness speaks through these eyes.[68]

I can only think about the war and draw concerning it.[69]

Liebermann could no longer travel to Holland after the outbreak of World War I and spent the summers from 1914 to 1918 in his new villa in the Berlin suburb of Wannsee. Like many other German citizens, he was strongly in support of the German cause when the war first broke out. During the first two years of the war, most of his art effort went into lithographic illustrations for Paul Cassirer's patriotic periodical *Kriegszeit Künstlerblätter* (Wartime Artist Newspaper) that was published—originally as a weekly and then later on a less regular schedule—from August 31, 1914, until March of 1916. The inexpensive newspaper presented liberal and patriotic views of artists to the general public.[70] Liebermann had previous experience as a printmaker, having worked in the media of etching and lithography. His earlier prints were first reproductions and then variations on paintings of Dutch peasant life; the images he drew for *Kriegszeit* were his few attempts at political illustration.

Throughout the brief existence of the newspaper, Liebermann contributed illustrations to *Kriegszeit* (Plate 36). In the first issue of August 31, 1914, he expressed the widely held optimism of the populace with the image of an ecstatic crowd in front of the imperial palace in Berlin responding to Kaiser Wilhelm II's declaration of equality: "I no longer know parties, I only know Germans" (Figure II.7). Later images displayed the heroism of the Kaiser and

I.21 *Portrait of Carl Friedrich Petersen,* 1891. Hamburger Kunsthalle

General Paul von Hindenburg and advancing troops. In 1915 when, like most of his fellow Germans, he realized that the war would not be won quickly, his subjects turned to fatalities on the battlefront and images of individual soldiers. Liebermann's contributions to *Kriegszeit* were rapidly drawn images comparable to his freely executed studies for paintings.[71] While Liebermann was the most regular artist-contributor to *Kriegszeit*, others who made lithographs for the newspaper included Käthe Kollwitz, Ernst Barlach, Max Beckmann, and the sculptor August Gaul.

During the war years, Liebermann painted rare examples of Berlin city life, an uncommon subject for him, with only a few hints of wartime hardships. Among them are an eerie, morose nighttime street scene near his home, *Evening at the Brandenburg Gate,* 1916 (Plate 37, Figure I.22); a light-hearted outdoor café scene that includes the image of a soldier in uniform, *Outdoor Garden on the Havel, Nikolskoe,* 1916 (Plate 38); and *Concert in the Opera House,* 1921 (Plate 40), which inaugurated a series of paintings in that venue.

My Little Castle by the Lake[72]

In 1909 Liebermann purchased a lot on the shore of the Greater Wannsee Lake in the suburb of Wannsee, a community of elegant

I.23 Liebermann in front of his villa at Wannsee, 1914

country homes southwest of Berlin on the way to the royal city of Potsdam. In the late 1860s, the suburb developed as a community of summer residences for upper-class Berliners, offering social opportunities for its wealthy residents and also a retreat from the growing ills of urban life. Prominent figures from the business, scientific, and cultural worlds had homes at Wannsee. Among Liebermann's immediate neighbors were the publishers Carl Langenscheidt and Ferdinand Springer; Johann Hamspohn, director of the major electric company AEG; chemist and industrialist Franz Oppenheim; and industrialist and art collector Eduard Arnhold, whose collection of German and French painting included some of Liebermann's most important paintings: *Old Men's Home in Amsterdam,* 1881; *The Bleaching Fields,* 1883; *Stevenstift in Leyden,* 1889; and *Parrot Alley,* 1902.[73]

When he purchased the property, Liebermann was over sixty years old and probably had less energy to make the annual summer trip to Holland. The many elegant country homes that he had seen on trips to Hamburg probably inspired him to build a comparable summer residence for his own family. Having a home out of the city could also give him some distance from the difficult situation and growing conflicts in the Berlin Secession. The death in 1908 of Walter Leistikow, who had been the driving force behind the establishment of the Secession and served as its corresponding secretary, created a major gap in leadership, and the disputes between Liebermann and some the younger generation of German expressionists became a constant annoyance.[74] Lastly, the

auben-
ang im Park

Die Villa mit Birkenallee,
vom Wannsee aus
gesehen

Heckenanlage inmitten
des Parks

Birken am Strande und
Blick auf den Wannsee

I.24 Four views of Liebermann's villa at Wannsee that appeared in the *Illustrirte Zeitung*, 1927

changes that were taking place in Berlin—especially the noises from automobiles and streetcars at Brandenburg Gate—made living in the city increasingly unpleasant for him.

The only lakeside lot available on the Greater Wannsee when Liebermann decided to purchase was pie-shaped, long, and relatively narrow. It represented a challenge to all involved in designing the house and gardens: Liebermann, his twenty-five-year-old daughter Käthe, his architect Paul Baumgarten, and his close friend Alfred Lichtwark, who was an expert in garden design as well as director of the Hamburger Kunsthalle. Liebermann was most interested in having a home that integrated the interior and exterior spaces and in particular wanted to have an excellent view of the lake from his dining room.[75]

Classic in style, Liebermann's house was somewhat conservative and a bit more modest than the more opulent neighboring homes. Lichtwark had a major influence on Liebermann's choice of architectural style, having taken the artist to visit elegant country villas in Hamburg with relatively simple façades at the street entry and more impressive ones facing the water. Liebermann's entryway led directly into the dining room, which was connected at the left to the salon and to the right to an outdoor loggia with murals painted by Liebermann.[76] There was a serving area and kitchen on the first floor and a stairway leading down to a cellar and up to the bedrooms and Liebermann's modest studio. Doors from the dining room led out to a patio where one could sit and look out at the lake. Beyond the patio were two flower terraces and a lawn that extended out to the water. To the left of the lawn are three small, hedge-enclosed areas organized on a single axis and to the right a long path punctuated by a series of birch trees (Plate 49).

Once the landscape-planning process began, Liebermann realized its potential for his art and played a leading role in determining the overall design, the placement of discrete areas, and the color scheme of the plants. The original plan of the gardens closely followed Lichtwark's writings on modern garden design.[77] Opposed to ersatz picturesque gardens that gave the impression of an unplanned, natural environment, Lichtwark preferred a more controlled and geometrically designed space. In Liebermann's garden, a series of individual outdoor spaces functioned almost like separate rooms: the patio off the dining room, the loggia, the flower terraces with small areas for seating at either end, and the three rectangular hedge gardens. The garden on the street side of the

LINDENKARRE

COLOMIERSTRASSE NR. 3

AM GROSSEN WANNSEE NR. 42

GÄRTNERHAUS

WOHNHAUS

NUTZGARTEN BLUMENGARTEN VORPLATZ GARTEN-TERRASSE BLUMEN-TERRASSE BIRKENWEG

I.25 Reconstructed plan of Liebermann's gardens at Wannsee in 1927, drawn by Reinald Eckert, 1994.

house was a large, hedge-enclosed space with three pairs of equal-sized planting areas bisected by a pathway leading to the front door and a small garden house just inside the entry gate.

The actual types of plants used in the garden also adhered to Lichtwark's garden theories. There were primarily hardy indigenous types of plants such as the geraniums that bloomed annually in the flower terrace, agapanthus, or "lily of the Nile," in large planters, boxwood hedges that delineated the enclosed garden spaces, and rose bushes. On the street side of the house, there was a mingling of fruits and vegetables with seasonal flowering plants; when in bloom, this garden appeared more casual and abundant than the garden facing the lake.

Liebermann's gardens took on a major role in his paintings after 1916, eventually becoming an ever-expanding world for him. The property was not large, yet his paintings projected a sense of expansiveness: a tub filled with the blue starburst of lily of the Nile, a flower bed brimming over with red geraniums, a blaze of yellow. Liebermann painted the various areas of his garden countless times, yet each painting was distinct and individual. In a sense, the paintings of the various sections of his garden became a series that encouraged further experimentation with color, light, and the dissolution of form. In the first paintings of his garden, he seemed interested in documenting the general plan of each of the spaces; in later paintings, discrete details are painted in an increasingly abstract manner.

Flower Terrace in the Wannsee Garden, Facing Northwest, 1921 (Plate 50), was the part of the garden he painted most often. The artist, positioned at the lower left, gives an oblique view of the flower terraces filled with blooming geraniums that take up over two-thirds of the painting. Two female figures dressed in white are barely distinguishable on the patio: at the right is the artist's granddaughter Maria who crouches on the terrace and her nursemaid who bends down next to her. The façade of the house—with its distinctive yellow walls, white doors, and green shutters—provides a bright contrast to the dark interior of the house and to the mass of green trees on the adjacent property to the far right.

Liebermann painted the enclosed hedge area many times. *The Circular Bed in the Hedge Garden with a Woman Watering Flowers,* 1925 (Plate 54), shows Liebermann's gardener watering flowers in the flower bed located in the center

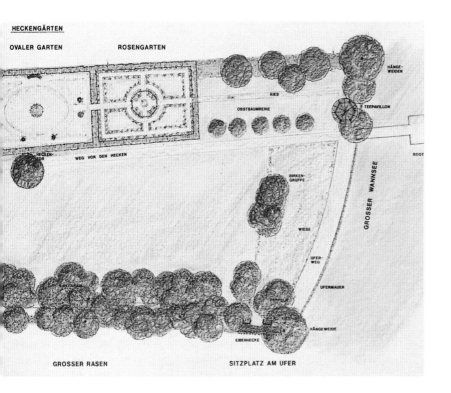

1.26 Liebermann in the loggia of his villa in Wannsee, 1914. Behind him can be seen one of the murals inspired by the Villa of Livia in Prima Porta, Italy, which he saw on a trip there in 1911.

of the first hedge garden; the woman with her spray of water almost blends into the environment. The painting is subsumed in color: the purple flowers in contrast with the varying greens of the hedge, trees, and lawn.

The Garden Bench, 1916 (Plate 48), is one of Liebermann's most private and intimate paintings.[78] A very small area of the garden appears to be a large park. The woman on the bench looking out over the lawn to the lake is thought to be his daughter. The forms have no linear contours, but rather the figure blends with the garden environment.[79] *Kitchen Garden in Wannsee, Toward the Southeast,* 1923 (Plate 51), depicts lush flowers in bloom in the street-side garden. Red, pink, and white flowering plants are placed next to an oblique angle of the garden path, with masses of green trees in the background. No sky is apparent, but the garden is bathed in sunlight.

Liebermann's paintings of his garden environment often evoke comparisons with works by other artists of the time, especially Monet's paintings of his gardens at Giverny. Liebermann was well aware of Monet's garden paintings—he owned two: *Manet Painting in Monet's Garden in Argenteuil,* 1875, which depicts a rented home in the Paris suburb of Argenteuil where Monet lived before moving to Giverny, and *Poppy Field,* which Liebermann inherited from Felicie Bernstein. There are similarities between the experiences of the two artists: their personal involvement in planning their gardens as subjects for their paintings; their creation of compelling works based on relatively small, controlled areas; and their dogged persistence in painting the same subject with varying interpretations. Emotionally, however, the men were opposites. Volatile and unpredictable, Monet was often displeased with his paintings and would sometimes stop working altogether. Always a punctual, systematic, and fastidious worker, Liebermann seldom deviated from his daily painting schedule. Personable and social, he was eager to welcome visitors.

Several of Liebermann's German colleagues also painted garden scenes: fellow German impressionists Lovis Corinth and Max Slevogt and other colleagues from the Berlin Secession such as Fritz von Uhde, Wilhelm Trübner, and Walter Leistikow. Familiar with the most recent paintings of their colleagues, they certainly influenced one another. Parallels can also be drawn with the vibrant close-up views of flowers by Emil Nolde, the younger German expressionist painter who was Liebermann's harshest and most outspoken critic.[80]

I.27 *The Atelier in Wannsee*, 1932.
Private collection

The Weimar Republic, established after the German Empire was defeated in World War I, offered the possibility of a tolerant society with equality for its citizens. The new democratic republic was, however, plagued from the very beginning: by the harsh terms of the peace treaty, by controversies among the many political parties, and by an unstable economy. Yet, for many Germans like Liebermann, it offered a new hope. On October 1, 1920, Liebermann was unanimously elected president of the Prussian Academy of Arts by its senate, a position that would have been unthinkable for a Jew under the Kaiser.

Founded in Berlin in 1696, the Royal Academy of Arts—renamed the Prussian Academy of Arts during the Weimar Republic—was patterned after academies in Rome and Paris. The Academy had three primary purposes: to honor the achievement of artists, to provide academic art education, and to advise the state on art-related matters. Originally a single body of artists, it was divided into two sections—art and music—in 1833. In 1926 Liebermann was responsible for the addition of a section for literature. Members were nominated for life by the government or by the members of a particular section. The president of the academy, who was a part-time civil servant, was elected by the entire membership for a term of three years.[82] Liebermann served as president of the Prussian Academy of Art for an unprecedented period of twelve years until he was forced to step down in 1932 and was named honorary president. While serving as president, he successfully instituted some liberal changes: greater diversity in the artists selected for membership and represented in its exhibitions and the inclusion of women. Yet, he was always contending with conservative factions, which became increasingly powerful.[83]

During the years of the Weimar Republic, Liebermann also held a prominent position in society. For example, in 1927, he was commissioned to paint the portrait of President Paul von Hindenburg. In addition, on the occasion of his eightieth birthday, the Prussian Academy of Arts held a large exhibition of his work and he was named an honorary citizen of the city of Berlin. During this period, Liebermann spent his summers painting at Wannsee but returned to Pariser Platz in the fall, where he concentrated on portrait commissions.

Throughout my long life, I have sought to serve German art with all my strength. It is my conviction that art has nothing to do with politics or descent. I can, therefore, no longer belong to the Prussian Academy of Arts, whose respectable member I have been for more than thirty years and whose president I have been for twelve, because my point of view is no longer valid.[84]

When Adolph Hitler was named chancellor on January 30, 1933, many Jews thought it was only a temporary setback. Liebermann, because of his ongoing struggles with the reactionary, anti-Semitic members of the Academy during his presidency, sensed that their attitudes reflected a much broader and more malevolent situation. A famous anecdote tells of a meeting at the Café Kranzler on Unter den Linden with an acquaintance, who remarked that Liebermann

did not look well and asked whether he had been eating enough. Liebermann's oft-repeated retort about his constantly being sickened to the point of vomiting because of Hitler and the sounds of the marching brown boots aptly describes the state of affairs in Germany.[85]

The government quickly moved from a republic to an extreme, right-wing nationalistic dictatorship that actively promoted virulent anti-Semitism. As early as 1933 a process of Aryanization was instituted, which removed Jews (non-Aryans) from all aspects of commercial, cultural, educational, and governmental activities. The Prussian Academy of Arts was under the jurisdiction of the Ministry of Culture and its members and senate were considered civil servants. Käthe Kollwitz and Heinrich Mann were removed for signing a petition in support of the Social Democrats and Communists.[86] At the time, Liebermann was honorary president, having stepped down in 1932; he resigned his membership on May 7, 1933. Two days after his resignation and just one day before the book burnings of May 10, 1933, Liebermann had the foresight to send twelve paintings from his collection under pretext of loaning them to an exhibition for safekeeping in the Kunsthaus Zurich.[87]

As Jews were increasingly excluded from public activities and institutions, they responded by establishing their own separate cultural institutions. Liebermann participated in the newly established Jewish Museum. During the last two years of his life, Liebermann was forced by the situation to consider the role of Judaism in his identity.[88] He became intrigued by the notion of "Jewish art," as is documented in various discussions he had at the Jewish Museum Association.[89]

An outburst of creativity sustained him in his last five years of life. His paintings became increasingly loose and sketchy, a change due in part to his age. Finding refuge at this house in Wannsee, he painted his beloved gardens and home there, *The Atelier*, 1932 (Plate 60). His portrait of his neighbor, Dr. Sauerbruch, 1932 (Plate 47), is considered one of his most important. He also painted some strikingly insightful self-portraits, such as the one, *Self-Portrait with Brushes and Palette*, 1933 (Plate 3), which he donated to Berlin's new Jewish Museum, and the last iconic one painted for an exhibition in December of 1934 in the Leicester Gallery in London (Plate 61). *Return of Tobias*, 1934 (Figure I.28), a story of a blind man whose eyesight is miraculously restored with the return of his son to the family home, reveals that he even dared to return to biblical subject matter. Its theme of homecoming and renewal coincided with Liebermann's newfound belief in Zionism, which he expressed in a letter dated August 12, 1931, to Meir Dizengoff, the mayor of Tel Aviv.[90] The loose manner of painting in these last works reveals the waning strength and vitality of a person defeated by both old age and pessimism.

In an effort to call attention to the patriotism of German Jews, in particular the twelve thousand Jews who died fighting for Germany in World War I, he created a lithograph, *To the Mothers of the Twelve Thousand*, ca. 1935 (Plate 62), showing a woman standing by the grave of her son. The print's production was sponsored by the Reichsbund Jüdischer Frontsoldaten, a national organization of Jewish soldiers who had fought on the frontlines of World War I, with the hope that the publicity would protect Jewish war veterans from the recently established laws against Jews. Liebermann became more and more depressed as the situation for Jews in Germany worsened. Near the time of his death in 1935, he told his last visitor, "I no longer look out the windows in this room—Believe me, I would prefer to die today than tomorrow."[91]

Liebermann died on February 8, 1935, and was buried three days later in the family plot in Berlin Jewish Community Cemetery on Schönhauser Allee. (See Schütz and Simon, this volume.) Had the political situation been differ-

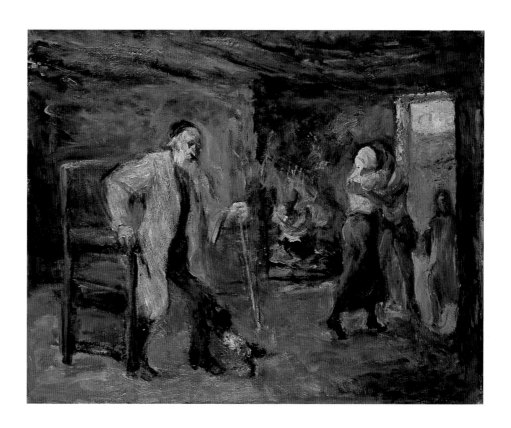

ent, a person of his prominence in society would have had a massive public funeral. Liebermann's death was barely mentioned in the press, and the funeral was small and relatively private. The only non-Jews in attendance were Käthe Kollwitz and Dr. Sauerbruch. The Jewish community paid tribute to the late painter on the first anniversary of his death with a memorial exhibition at the Jewish Museum in 1936. The exhibition was curated by Franz Landsberger, who had been on the faculty of the University of Breslau until he was forced to leave his position after the passage of the Nuremberg Laws. Landsberger became curator of the Jewish Museum in 1935 and subsequently left Germany with the help of Hebrew Union College in Cincinnati, where he served as the first professional curator of the Hebrew Union College Museum (now the Skirball Museum).

From 1933 to 1945, the National Socialists confiscated paintings from Liebermann's entire body of work from private collections and museums. The exact circumstances of the seizures and the locations of many works are unknown. His paintings were all removed from view in museums and galleries. Twenty-eight paintings were deaccessioned from public collections; others were put in storage by curators and directors. The National Gallery, Berlin, primarily held examples of nineteenth-century paintings by Liebermann, which were not as suspect as his more modernist paintings. These were put in storage where they survived the Nazi period and World War II. Some of Liebermann's impressionist paintings from after 1910 were designated "degenerate," a few were included in the Nazi's *Degenerate Art* exhibition of 1936, and two were sold at auction in Switzerland.[92] Many of his smaller works, studies for major paintings or paintings from his Wannsee period, were in private collections. About one-third of these cannot be located and are listed as "missing," "destroyed in the war," or "unlocated" in Matthias Eberle's catalogue raisonné of Liebermann's paintings and oil studies, which was published in 1995 and 1996.

After Liebermann's death, his widow Martha suffered through the increasingly harsh existence that beset Jews in Berlin. Their daughter Käthe Riezler emigrated to New York with her husband and daughter in 1938, but Martha did not want to leave Berlin because her husband was buried there. By the time

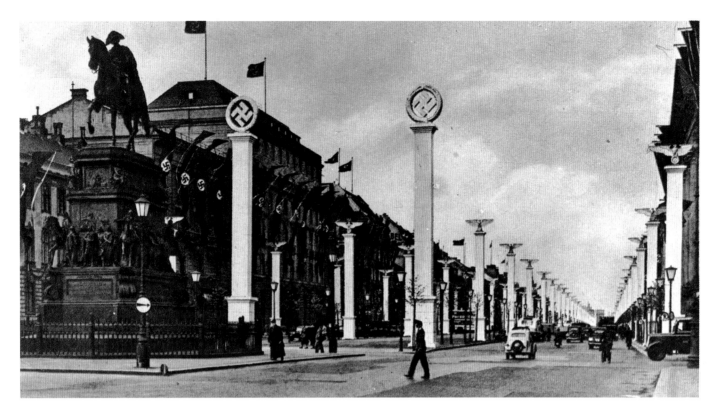

I.29 Unter den Linden, 1936. This major boulevard led from Liebermann's home on Pariser Platz. This photograph shows the decorations for the 1936 Olympics.

she changed her mind, it was too late: Jews were no longer able to get exit documents. She had lost all of her property and possessions and was barely able to survive by selling the few artworks that remained. On January 20, 1942, Liebermann's Wannsee villa was confiscated by the Nazis. It was used to house guests at the infamous Wannsee Conference of 1942, where planning for the "Final Solution," which called for the total annihilation of the Jewish people, took place. Five days after she received a deportation order for the Theresienstadt concentration camp, Martha Liebermann died on March 3, 1943, after taking an overdose of sleeping pills.[93]

THE LEGACY OF MAX LIEBERMANN

During the late 1930s and early 1940s, Liebermann's work was known in countries outside of Germany. Soon after the artist's death, Karl Schwarz, the former director of the Jewish Museum, Berlin, organized a memorial exhibition in Tel Aviv in February of 1935, including primarily graphics and drawings, to introduce and pay tribute to Liebermann as a leading Jewish artist. An exhibition presented at the Tel Aviv Museum's Diezengoff House in 1943 included more than 130 works, primarily on loan from German émigrés who had found refuge in Israel. An exhibition was held at the Bezalel National Museum in Jerusalem on the tenth anniversary of the artist's death in 1945.[94] The artist sent his last *Self-Portrait*, now in the collection of the Tate Gallery, to an exhibition of paintings and drawings at Leicester Gallery in London in 1934. An article honoring the artist's one hundredth birthday was published in 1947 by Leo Koenig, who noted that only Jews now remember this once-famous German artist.[95]

While Liebermann had little contact with the United States during his life, examples of his artwork, most of which were brought by émigrés, were now and then on view. In 1936, there was a small exhibition of prints from a private collection at the New York Public Library. The Schoenemann Galleries in New York exhibited twenty small paintings in 1940, mostly later works including landscapes of Wannsee and self-portraits, as well as seventy photographs of Liebermann's major paintings. In 1944, Otto Kallir, owner of Galerie St.

paintings as *Flax Spinners in Laren*, *Women Mending Nets*, *Sewing School*, and *Jewish Quarter of Amsterdam*; a year later, he exhibited a complete collection of Liebermann graphics.[96]

After World War II and the division of Germany, Liebermann's paintings gradually made their way back to public view. Paintings that had been saved were again hung in museums; some paintings that had been deaccessioned were reacquired. For example, *The Twelve-Year-Old Jesus in the Temple with the Scholars* was restored to the collection of the Hamburger Kunsthalle. Both the style and content of Liebermann's paintings were subject to opposing opinions regarding their value and meaning. His early realist paintings were placed in the context of socialism and Marxism and were praised in the German Democratic Republic (East Germany). In the Federal Republic of Germany (West Germany), he was admired primarily as an impressionist. Numerous exhibitions and publications have now thoroughly explored Liebermann's role in late nineteenth- and early twentieth-century art; he has again become a major figure in the history of German art.[97]

A hard-working, prolific artist, Liebermann painted hundreds of paintings over the course of his long career. More than one-third—many studies for major extant works—cannot be located and presumably were lost or confiscated during World War II. Yet, there are enough surviving works to provide a fairly thorough understanding of his development as an artist. Various exhibitions and publications and have provided a reappraisal of his contributions to the history of modern European art. In his lifetime, he was often viewed through the lens of German nationalism and condemned for his open acceptance of French modern art. It is clear now that what he was attempting in his art—in both his early realist paintings and his twentieth-century impressionist paintings—was not at all outrageous but very much in keeping with contemporary trends. Impressionism, in particular, is now understood as an international movement that influenced artists throughout Europe and America. Liebermann's keen interest in French impressionist painting, in particular through his collection, helped to pave the way for the acceptance of modernist painting in Germany.

Among his greatest contributions was his role in the cultural politics of his time and his forthright promotion of diversity and freedom in the arts. Regardless of his own preferences, he believed artists should not be excluded from exhibitions or arts organizations because of stylistic, thematic, or conceptual differences. Liebermann consistently used his position of authority in both the Berlin Secession and the Prussian Academy of Arts—not always with success—in support of tolerance.

Liebermann's role as a leader in art institutions was unique for a Jew in his time. While many Jews became artists in the nineteenth and early twentieth centuries in Europe, Liebermann was the only one who was able to rise to such a lofty, governmental position. As such, he was perceived by the non-Jewish world as a representative of Berlin Jewry, a role that he took seriously. While sometimes vilified for it, he always affirmed his close ties to his family and the Jewish people. The legacy of Liebermann's humanity is as important as his role as a painter. As a risk taker and a traditionalist, he seemed to embody two opposing human attributes and leveraged them to achieve success in life and art. An extremely honest and direct person, he was willing to speak out regarding his beliefs and he supported diversity and tolerance beyond the world of his profession.

The life of Max Liebermann expresses perfectly the clash of cultures that coincided with the emergence of the modern in Germany. Taking advantage of new freedoms for Jews in Germany and his own remarkable talent, he was able to rise to unprecedented success in the world of art, but anti-Semitism frequently marred his achievements. His promotion of internationalism in art

enriched his nation's culture, but it also brought him censure and distrust. His pride in his beloved country led him to promote freedom for all artists, but the rabid nationalism of Nazis took it away for all who did not fit their definition of "German." The aftermath of war divided Germany and left him and his achievements in the shadows. Now they can be fully appreciated once again.

NOTES

1. See Selected Bibliography.

2. "Warum ich mich den armen Leuten zugekehrt? [Sagen wir, es war die Reaktion - wie sage ich nur, die programmassige! Dem Süsslichen nun endlich wieder mal das Herbe, dem historischen das Moderne entgegenzustezen! Nein,] was mich leitete, das war Persönliches. Ich hatte einen reichen Vater und kannte nur den Reichthum. Da fiel mein Blick auf die Armuth, und die Geringen und Niedrigen. Nun, da geschah es." Heinrich Lee, "Max Liebermann," *Allgemeine Zeitung des Judentums,* June, 1891, 297. Quoted in Margreet Nouwen, "Malheimat Holland," *Max Liebermann: Der Realist und die Phantasie,* eds. Jenns E. Howoldt and Birte Frenssen (Hamburg: Hamburger Kunsthalle, 1997), 15.

3. In 1872, Liebermann's uncle Adoph commissioned Adolph Menzel to paint a realistic picture—*The Rolling Mill,* 1872–73, National Gallery, Berlin—of a factory he owned briefly at Königshutte in Silesia, which was probably very similar to the two other factories owned by Liebermann & Co. The huge canvas gives a sense of the immensity of the factory and the number of workers. It is one of the first paintings of this type to document conditions for factory workers. See Claude Keisch and Marie Ursula Reimann-Reyher, *Adolph Menzel, 1815–1905: Between Romanticism and Impressionism* (New Haven and London: Yale University Press in association with the National Gallery of Art, Washington, D.C., 1996), 379–385.

4. W. E. Mosse, *Jews in the German Economy: The German-Jewish Economic Élite, 1820–1935* (Oxford: Clarendon Press, 1987), 40–41.

5. Hans Ostwald, *Das Liebermann-Buch* (Berlin: Paul Franke Verlag, 1930), 46.

6. His older brother Georg, as the first son, would customarily have inherited his parents' home, but since he was the only son to work in the family business, it can be assumed that he inherited the business while Max got the family residence. Georg Liebermann had been married for twenty years when his father died in 1894 and already had established his own household. Felix, the youngest brother, earned a degree in medieval English history. In 1880 he married Cäcilie Lachmann (1860–1943), and they had a home at Bendler Strasse 10 where they lived for many years. Max Liebermann's sister, Anna, was also settled in her own home by the time of her father's death.

7. "Zum erstenmal hatte ich Pinsel und Palette in der Hand....und ich war Maler geworden." Ostwald, *Das Liebermann-Buch,* 62.

8. "Max Liebermann, Erinnerungen an Karl Steffeck," in Gunter Busch, *Max Liebermann: Maler, Zeichner, Graphiker* (Frankfurt am Main: S. Fischer, 1978), 106–107.

9. Barbara Gaehtgens, "Holland als Vorbild," *Max Liebermann: Jahrhundertwende,* ed. Angelika Wesenberg and Sigrid Achenbach (Berlin: Nicolai and SMPK, 1997), 83–88.

10. "Ach, wie wohl muss Dir des Abends sein, wenn Du, aller Sorgen ledig, zu Deiner Lieblingsbeschäftigung griefen kannst, wärend so ein armer Maler, mach dern er sich den ganzen Tag vor der Staffelei geschunden hat, sich oft sagen muss, dass all sein Tun umsonst war....ob seine Arbeit überhaupt je zu einem Resultat führen wird." Liebermann, letter from Weimar to his brother Felix, April 8, 1869, Max Liebermann, *Briefe,* ed. Franz Landsberger (Berlin: Schocken Verlag, 1937), 11.

11. Holly Prentiss Richardson, "Landscape in the Work of Max Liebermann" (PhD diss., Brown University, 1991). Available in film copy from University Microfilms Internatioanal, Ann Arbor, MI), 13–17.

12. "...Meine Hoffnung schrumpft immer mehr zusammen, obgleich ichs immer noch besser habe als meine Kollegen, die allerding nicht gerade an überflüssigem Talent leiden. Jedenfalls bin ich entschlossen, mich mit Aufbietung aller meiner Kräfte durchzuarbeiten. Ein guter Maler muss ich werden. Damit Gott befohlen." Ostwald, *Das Liebermann-Buch,* 104.

13. Ostwald, *Das Liebermann-Buch,* 90ff.

14. Liebermann's studies at Weimar were briefly interrupted in 1870 by the Franco-Prussian War; although he was excused from military service because of a poorly healed broken arm, he did serve as a medical volunteer to the Prussian troops.

15. Ulf Häder, *Der Jungbrunnen für die Malerei: Holland und die deutsche Kunst am Vorabend der Moderne 1850–1900* (Jena: Glaux, 1999), 127.

16. "Mit Recht hat man Holland das Land der Malerei par excellence genannt, und es ist kein Zufall, dass Rembrandt ein Holländer war. Die Nebel, die aus dem Wasser emporsteigen und alles wie mit einem durchsichtigen Schleier umfluten, verleihen dem Lande das spezifisch Malerische. Die wässerige Atmosphere lässt die Härte der Konturen verschwinden und gibt der Luft den weichen silbrig-grauen Ton [...] In der Intimität liegt seine Schönheit. Und wie das Land, so seine Leute: nights Lautes, keine Pose oder Phrase." Quoted in Margreet Nouwen, "Malheimat Holland," 19.

17. Ulf Häder, *Der Jungbrunnen für die Malerei*, 128.

18. "Hier bin ich Maler, hier möcht' ich's sein." Nouwen, "Vom "Apostel des Hässlichen" zum Porträtmaler des Bürgertums,"11. The art historian Max J. Friedlander (1867–1958), a specialist in Early Netherlandish and Dutch painting who also wrote about Liebermann in the 1920s, recognized the contrasting nature of Liebermann's lifestyle, saying "Liebermann lived like a burgher in Berlin and as a painter in Holland." Quoted in Barbara Gaehtgens, "Holland als Vorbild," 83.

19. Chana C. Schütz, "Max Liebermann as a "Jewish" Painter: The Artist's Reception in His Time," *Berlin Metropolis: Jews and the New Culture, 1890–1918* , ed. Emily D. Bilski (Berkeley: University of California Press, 2000), 161.

20. Birte Frenssen, "Self-Portrait with Kitchen Still Life," in *Max Liebermann: Der Realist und die Phantasie*, 75.

21. "Nun hielt ich mich, Ende 1873 für reif genug nach Paris überzusiedeln. Munkácsy zog mich mächtig an, aber noch mehr taten es die Troyon, Daubigny, Corot, vor allem aber Millet."Report from Gustav Pauli, June 9, 1911, Kunsthalle Bremen Archiv. Quoted in Matthias Eberle, *Max Liebermann, 1847–1935: Werkverzeichnis der Gemälde und Ölstudien*, vol. 1, *1847–1899* (Munich: Hirmer, 1995), 14.

22. Eberle, *Liebermann*, 70.

23. Eberle, *Liebermann*, 14.

24. Julias Elias, *Max Liebermann zu Hause* (Berlin: Neue Kunsthandlung, 1921). Quoted in Eberle, *Liebermann*, 11.

25. Erich Hancke, *Max Liebermann, sein Leben und seine Werke* (Berlin: B. Cassirer, 1914), 112.

26. Miriam A. Dytman, "Zur Geschichte der Familie Liebermann," *Was vom Leben übrig bleibt, sind Bilder und Geschichten: Max Liebermann zum 150* (Berlin: Stiftung Neue Synagoge Berlin—Centrum Judaicum, 1997), 60.

27. Françoise Forster-Hahn, *Spirit of an Age: Nineteenth-Century Paintings from the National Galerie, Berlin* (London: National Gallery Company, 2001), 179.

28. Eberle, *Liebermann*, 121ff. The Academy's name was changed from Royal Academy of Arts after the fall of the Wilhelmine Empire.

29. Bernd Küster, *Max Liebermann: ein Maler-Leben* ([Hamburg]: Ellert & Richter, 1988), 41.

30. Matthias Eberle suggests various sources from Greco-Roman and Renaissance art for the individual figures: the boy in the center pulling on his shirt is based on Michelangelo's *Dying Slave* sculpture, which the artist could have seen in the Louvre; the boy seated on a bench putting on his shoe in the right background resembles the famous Greek Hellenistic sculpture *Boy with a Thorn in his Foot,* which an artist with his classical training would probably know from small plaster casts. The balanced symmetry of the composition, with its careful orchestration of the movements of the young boys, recalls the classical format of Italian Renaissance painting. Eberle, *Max Liebermann*, 104.

31. For a detailed analysis or the decline of the Salon and the establishment of alternate opportunities for exhibitions during the time period that Liebermann was in Paris, see Patricia Mainardi, *The End of the Salon: Art and the State in the Early Third Republic* (Cambridge and New York: Cambridge University Press, 1993).

32. Eberle, *Liebermann*, 144.

33. "–aus dem kurzem Besuch wurde ein Aufenhalt in Münich von fast sechs Jahren." Ostwald, *Das Liebermann-Buch*, 126.

34. See Schütz and Simon in this volume for an account of the controversy and the changes Liebermann made to the painting.

35. Claude Keisch and Marie Ursula Riemann-Reyher, *Adolph Menzel 1815–1905: Between Romanticism and Impressionism* (New Haven and London: Yale University Press, in association with National Gallery of Art, Washington, DC, 1996), 52. Menzel exhibited his version of the subject at the Christmas Exhibition of the Academy in Berlin, where it was well received—probably because of his stereotypical, Orientalized portrayal of the rabbis.

36. Stefen Pucks, "Max Liebermanns Frühwerk im Spiegel der deutschen Kunstkritik," in *Max Liebermann: Der Realist und die Phantasie*, 60.

37. "Das hatte ich mir wirklich nicht träumen lassen, als ich das unschuldige Bild malte! Heute hat doch kein Mensch was gegen das Bild, das aufrichtig von mir empfunden worden war. Bei Eröffnung

der Ausstellung wurde seitens der Klerikalen verlangt, es sollte von seinem Platz entfernt warden. Na, mich tröstete die Ansicht meiner Kollegen über das Bild. Vor allem waren Lenbach und die ganze Jury, wie Fritz Kaulbach, Zügel, die Bildhauer Gedon und Wegmüller, für mich eingetreten. Man gratulierte mir zu dem Bildes. Es sei das beste, das seit fünfzig Jahren in Münich gemalt sei." Ostwald, *Das Liebermann-Buch*, 128f.

38. Eberle, *Liebermann*, 16.

39. "Am Küchentisch sitzen Kuhhirt, Mädchen, Knecht, Herrschaft alles beisammen and essen aus derselben Schüssel. Alles duzt sich wie eine grosse Familie. Armut gibt es hier nicht. Wie mein Wirt, der im Rat ist, mir erzählte, werden zwei Männer auf Armen-Kosten erhalten. Infolgedessen ist die Menschheit bieder und rechtdenkend." Liebermann, letter dated in error "1879." Quoted in Ostwald, *Das Liebermann-Buch*, 110, and Eberle, *Liebermann*, 16.

40. "In Liebermann bewundere ich Berlin, ...Berlin, das ist Energie, Intelligenz, Straffheit, Unsentimentalität, Unromantik, das Fehlen jeder übertriebenen Ehrfurcht vor dem Vergangenen, Modernität als Zukünftigkeit, Kosmopolitismus als Abwesenheit germanischer Gemütsfeuchte." Thomas Mann writing about Max Liebermann in *Kunst und Künstler* 25:10 (1927), 372–374. Quoted in Peter-Klaus Schuster, "Max Liebermann - Jahrhundertwende," *Max Liebermann: Jahrhundertwende*, 43.

41. "Jedes neu aufstrebende Genie ändert de Geschmack: der Künstler zwingt uns sein Schönheits-Ideal auf, ob wir wollen oder night - und meistenteils wollen wir nicht, weil das Neue ein Umlernen nötig macht - wir müssen ihm gehorchen." Liebermann, the catalogue of the Berlin Secession Exhibition 1902, in *Gesammelte Schriften von Max Liebermann* (Berlin: B. Cassirer, 1922), 262–262.

42. See Peter Paret, *The Berlin Secession: Modernism and Its Enemies in Imperial Germany* (Cambridge, MA and London: Harvard University Press, 1980) for an in-depth account of the establishment, development, and demise of the Berlin Secession.

43. "Die Schulvorschrift lehrte: das Licht ist kalt, der Schatten warm; die Impressionisten pfiffen auf diese Lehre und malten Licht und Schatten rot, violett oder grün, ...wo und wie sie es Sahen." Liebermann, "Degas," in *Gesammelte Schriften*, 74.

44. "Man glaubte sich in einem Pariser Salon, welcher Eindruck vielleicht doch dadurch erhöht wurde, dass man stets ausländische Gäste bei ihnen traf." Liebermann, "Meine Erinnerungen an die Familie Bernstein," in *Gesammelte Schriften*, 124.

45. Holly P. Richardson, "Landscape in the Work of Max Liebermann," 1991, 240ff.

46. "Wir betrachten das Bild oft mit Rührung." Quoted in "Anhang: Zeitliche Abfolge der Bilderwerbungen französischer Impressionisten," *Max Liebermann und die französischen Impressionisten*, eds. Tobias G. Natter and Julius H Schoeps (Düsseldorf: DuMont, 1997), 249

47. "...das Aussergewöhnliche [leight] nicht in seinen Sujets leigt. Manets Kunst beruht also, wie die eines jeden echten Malers, in seiner neuen Auffassung." in "Ein Betrag zur Arbeitsweise Manets," *Max Liebermann, Vision der Wirklichkeit: ausgewählte Schriften und Reden,* ed. Günter Busch (Frankfurt am Main: Fischer Taschenbuch, 1993), 83.

48. "Aber Manet kann man wohl zuviel, aber nie genug haben." Quoted in Annegret Janda, "Max Liebermanns Kunstsammlung in seinen Briefen. Versuch einer Chronologie," in *Max Liebermann und die französischen Impressionisten*, 235.

49. "...vor 15 Jahren erwarb ich von Paechter das Manet'sche Blumenbouquet, das früher Bernsteins gehörte." Quoted in "Appendix," *Max Liebermann und die französischen Impressionisten*, 246.

50. Hugo Tschudi, letter to the dealer Durand-Ruel, October 23, 1897. Quoted in *Max Liebermann und die französischen Impressionisten*, 247.

51. G. Tobias Natter, "Rocheforts Flucht," *Max Liebermann und die französischen Impressionisten*, 220.

52. "Das is mein Parthenon-Fries!" Franz Landsberger, "Erinnerungen an Max Liebermann," *Berlinische Notizen* 304 (1973): 3. Quoted in "Anhang," *Max Liebermann und die französischen Impressionisten*, 249.

53. "Wissen Sie, das mit den zerlegten Farben, das est alles Unsinn. Ich habe es jetzt wieder gesehen, die Natur est einfach und grau." Quoted in Hancke, *Max Liebermann, sein Leben und seine Werke*, 328.

54. Hancke, *Max Liebermann, sein Leben und seine Werke*, 328ff.

55. See *Max Liebermann und die französischen Impressionisten*.

56. "Liebermann ist der Begründer des deutschen Naturalismus und hat zugleich den französischen Impressionismus deutsch gemacht. Julius Elias, "Max Liebermann im Urteil seiner Zeitgenossen," *Kunst und Künstler* 15:10 (1917), 483–486. Quoted in *Max Liebermann und die französischen Impressionisten*, 36.

57. Eberle, *Liebermann*, 402f.

58. Hancke, *Liebermann*, 302.

59. "Ich bin in meinen Lebensgewohnheiten der vollkommenste Bourgeois: ich esse, trinke, schlafe, gehe spazieren and arbeite mit der Regelmässigkeit einer Turmuhr. Ich wohne in dem Hause meiner Eltern, wo ich meine Kindheit verlebt habe, und es würde mir schwer werden, wenn ich wo anders wohnen sollte." Quoted in Ostwald, *Das Liebermann-Buch*, 34f.

60. "es ist auffallend, dass er sich nun so schönfarbige Objekte, wie die bunten exotischen Vögel es sind, wählte, er, dem lange Zeit die Welt nicht "assez gris" sein konnte." Quoted in Hancke, *Liebermann*, 403. Beyond its role in the artist's development, the 1901 version has a provenance of interest. Henry P. Newman, a Hamburg art collector, purchased the painting in 1911; it was inherited by his wife after his death in 1917. The family fled Nazi Germany in the 1930s and found refuge in Brazil. They had left their art collection behind with non-Jewish members of their family, who then sent it to them after the war. The painting became a poignant reminder of their former life.

61. "Ich werde von hier aus wohl noch auf einige Zeit ins Judenviertel, wenn nicht gerade die vielen Feiertage mich hindern, dort zu arbeiten. Erst der Regen, dann die Religion. Aber im Grunde wird es wohl an mir selbst liegen, wenn ich nicht ordentlich gearbeitet habe. Wie der alte Schadow sagte: "Der Bleistift ist nicht dumm", wenn sich seine Schüler über das Material beklagten!" Liebermann, letter to Hermann Struck (1876–1944), a Berlin artist and fellow Jew, September 7, 1907, *Briefe*, 33.

62. "Die neuen Motive sprachen nicht nur mächtig zu dem Juden, sie stellten nicht nur etwas wie einen Extrakt des Holländischen, Amsterdamischen dar, die Stadtgegend erinnerte Liebermann nicht nur lebendig an den am meisten von ihm verehrten Meister, an Rembrandt, sondern es fand sich in dem Motiv auch alles zusammen, um der auf einem Höhepunkt angelangten Kraft Liebermanns die Nahrung darzubieten, wonach sie eben verlangte. Es waren Motive für den Koloristen und für den nun vollendeten Meister einer Kurzschrift, die mit erregten Pinselzügen Empfindung eines Ganzen suggestiv hinschreiben sollten. Nie ist Liebermann frischer, freier, naiver und sinnlich kräftiger gewesen als in diesen Jahren, wo er seinen sechzigsten Geburtstag doch schon feierte." Karl Scheffler, *Max Liebermann* (Munich: R. Piper Verlag, 1922), 157.

63. Liebermann, letter to Albert Kollmann, February 20, 1895, Berlin Landesarchive. Quoted in Jenns Howoldt, "Erst die Auffassung der Natur macht den Künstler: Die neuniger Jahre," in *Max Liebermann: Der Realist und die Phantasie*, 186.

64. "Wenn Sie 'n Fehler machen, dann deckt ihn anderntags der jriene Rasen. Aber'n Fehler von mir sieht man über hundert Jahre an de Wand häng'n." Liebermann's comments to the surgeon Ferdinand Sauerbruch, who complained about the long sittings required for his portrait, reveal his sardonic wit. Ferdinand Sauerbruch, *Das war mein Leben. Eine Biographie* (Munich: Taschenbuch, 1993), 330. Quoted in Eberle, *Liebermann*, 1232.

65. Margreet Nouwen, "Vom "Apostel des Hässlichen" zum Porträtmaler des Bürgertums," *Max Liebermann: Jahrhundertwende*, 239ff.

66. Nouwen, "Vom "Apostel des Hässlichen" zum Porträtmaler des Bürgertums,"241.

67. "Das Porträt der Frau Biermann is heute früh nach Bremen spediert: Hoffentlich gefällts ihr und ihrem Sohn auch dort. Die ist im Atelier sahn, fanden es eins meiner besten!" Liebermann, letter to Gustav Pauli, March 10, 1908, Archives of the Kunsthalle Bremen. Quoted in Eberle, *Liebermann*, vol. 2, 716.

68. "Wie teilnehmend, wie herzlich voraussetzunglos, wie höflich schönungslos is diese Menschlichkeit doch erfasst!. Wunderschön ist es wiedergegeben, wie die mit der rührenden Verzagtheit des leiderfahrenen Alters sich spreizenden Finger Wante und Kinn mehr nur berühren als stützen, wie der Kopf sich gleichsam entschuldigend neigt, wie die verlegene und doch würdevolle Naivität der Altmütterlichkeit aus diesen Augen spricht..." Kurt Scheffler, "Berliner Sezession" *Kunst und Künstler* 6:9 (May 1908), 366. Quoted in Eberle, *Liebermann*, vol. 2, 716.

69. "Ich kann nur noch an den Krieg denken und darauf Bezügliches zeichnen." Liebermann, letter to Max Sauerlandt, November, 1914. Quoted in Jenns E. Howoldt, "Die Gartenbilder und ihr zeitgeschichtlicher Hintergrund," in *Im Garten von Max Liebermann* (Hamburg: Hamburger Kunsthalle and Berlin: Nationalgalerie, Staatliche Museen, 2004), 13.

70. Paret, *The Berlin Secession*, 236ff.

71. Jay Clarke, "Construction of Artistic Identity in Turn-of-the-Century Berlin: The Prints of Klinger, Kollwitz, and Liebermann" (PhD diss., Brown University, 1999). Available from University Microfilms International, Ann Arbor.

72. "mein 'Schloss am See,'" Liebermann, letter to Fritz Stahl, July 25, 1922, *Briefe*, 54.

73. Klaus-Henning von Krosijk, "Die Colonie Alsen, eine Kulturlandschaft zwischen Berlin und Potsdam," in *Zurück am Wannsee: Max Liebermanns Sommerhaus*, eds. Nina Nedelykov and Pedro Moreira (Berlin: Transit Buchverlag, 2003), 14–26, 49.

74. Paret, *The Berlin Secession*, 204–216.

75. Nina Nedelykov and Pedro Moreira, "Die Baugeschichte," in *Zurück am Wannsee: Max Liebermanns Sommerhaus*, 52.

76. See Angelica Wesenberg, "Die Idee vom Garten und von der Gartennatur: Das wieder endeckte Wandbild der Loggia,"in *Im Garten von Max Liebermann*, 39–49, for a complete discussion on the wall murals by Liebermann in his loggia.

77. Alfred Lichtwark, *Makartbouquet und Blumenstrauss* (Munich: Verlagsanstalt für Kunst und Wissenschaft, 1894) and *Blumenkultus. Wilde Blumen* (Dresden: G. Kühtmann, 1897).

78. Eberle, *Liebermann*, vol. 2, 923.

79. Eberle, *Liebermann*, vol. 2, 923. Soon after it was completed, the painting was included in the exhibition honoring the artist's seventieth birthday and purchased in the same year by the National Gallery, Berlin.

80. Their longstanding enmity resulted when Nolde's painting *Easter* was among eighty-nine paintings by German expressionists rejected by the jury of the Berlin Secession. In response, Nolde sent a letter with anti-Semitic undertones, calling Liebermann's work kitsch and weak and asserting that the Berlin Secession was in a state of decay. The letter was eventually made public, and the controversy ended with Liebermann stepping down as president of the Secession. See Roland März, "Max Liebermann – 'ein Torwart der modernen Malerei'?" in *Im Streit um die Moderne: Max Liebermann. Der Kaiser. Die Nationalgalerie* (Berlin: Nicolai and SMPK, 2001), 37ff.

81. "Was ich für Kunst vom neuen Volksstaat erwarte? Nichts und alles: Freiheit!" Quoted in Ostwald, *Das Liebermann-Buch*, 18.

82. Paret, "The Enemy Within," *German Encounters with Modernism 1840-1945*, (Cambridge, UK, and New York: Cambridge University Press, 2001), 189.

83. Paret, "The Enemy Within," 190, 195f.

84. "Ich habe während meines langen Lebens mit allen meinen Kräften der deutschen Kunst zu dienen gesucht. Nach meiner Überzeugung hat Kunst weder mit Politik noch mit Abstammung etwas zu tun, ich kann daher der Preussischen Akademie der Künste, deren ordentliches Mitglied ich seit mehr als dreissig Jahren und deren Präsident ich zwölf Jahre gewesen bin, nicht länger angehören, da dieser mein Standpunkt keine Geltung mehr hat...." Liebermann, May 11, 1933, *Jüdische Central-Verein-Zeitung* of Berlin. Quoted in Bernd Schmalhausen, *"Ich Bin doch nur ein Maler": Max and Martha Liebermann im Dritten Reich* (Hildesheim and New York: Olms, 1994), 54.

85. "Ick kann jar nich so viel fressen, wie ick kotzen möchte." Quoted in Julius H. Schops, "Max Liebermann, die Nazis and das Scheitern der deutsch-jüdischen Symbiose," in *Max Liebermann und die französischen Impressionisten*, 43.

86. Paret, "The Enemy Within," 135, 147 n. 35.

87. Annegret Janda, "Max Liebermanns Kunstsammlung in seinen Briefen," in *Max Liebermann and die französischen Impressionisten*, 240.

88. See Schütz amd Simon, this volume.

89. Hermann Simon, "Max Liebermann und des Berliner jüdische Museum," in *Was vom Leben übrig bleibt, sind Bilder und Geschichten*, 11.

90. *Briefe*, 59.

91. "Ich schaue nie mehr aus den Fenstern dieser Zimmer [...] Glauben Sie mir, ich möchte lieber heute sterben als morgen." Quoted in Bernd Schmalhausen, "Geachtet und geeehrt –geächtet und verfolgt: Max und Martha Liebermann im Dritten Reich," in *Max Liebermann and die französischen Impressionisten*, 51.

92. Stephanie Barron, *Degenerate Art: The Fate of the Avant-Garde in Nazi Germany* (Los Angeles: Los Angeles County Museum of Art, 1991), 143, 162.

93. Bernd Schmalhausen, "Geachtet und geeehrt –geächtet und verfolgt: Max und Martha Liebermann im Dritten Reich," 53f.

94. Chana Schütz, "Max Liebermann in Eretz Israel," *Was von Leben übrig bleibt, sind Bilder und Geschichten*, 140f.

95. Leo Koenig, "Max Liebermann," *New Life* 1 (August 1947): 7, 19.

96. Maude Riley, "Max Liebermann," *Art Digest*, May 1, 1945.

97. See Françoise Forster-Hahn in this volume for a discussion of various perceptions of Liebermann in postwar Germany and recent attention to his work.

Catalogue of the Exhibition

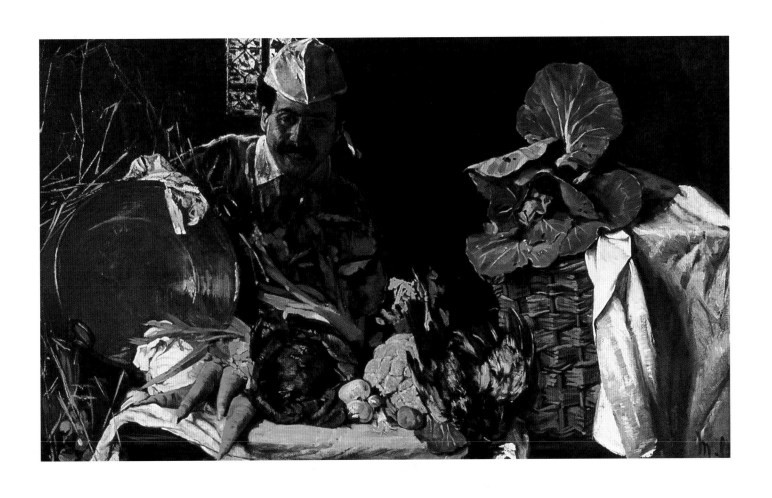

PLATE I

Self-Portrait with Kitchen Still Life, 1873

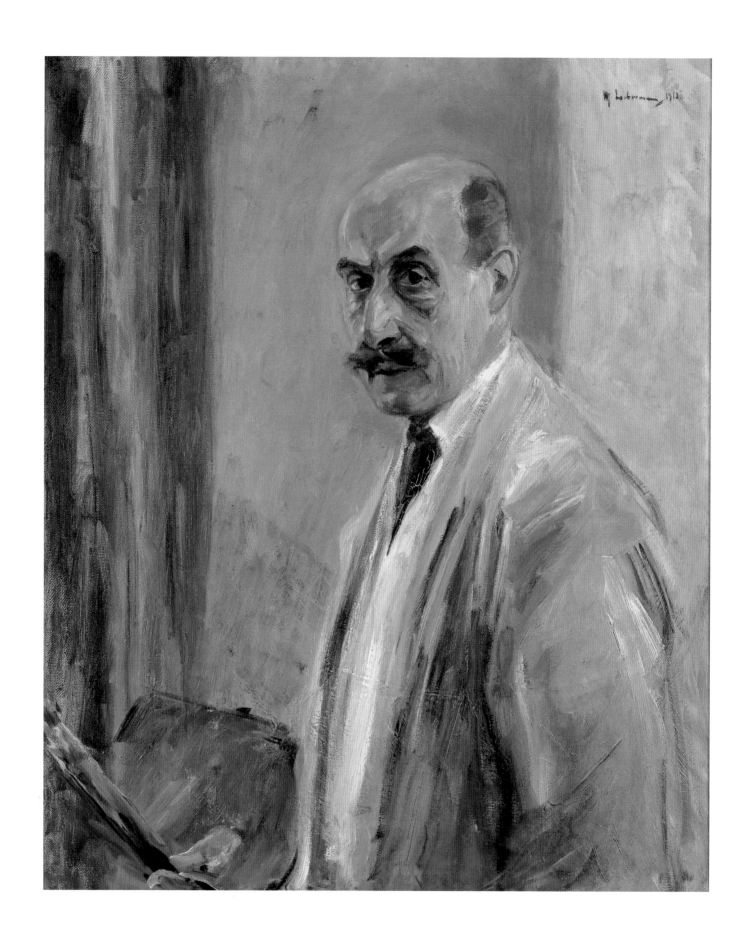

PLATE 2

Self-Portrait with Brush and Palette, 1913

66

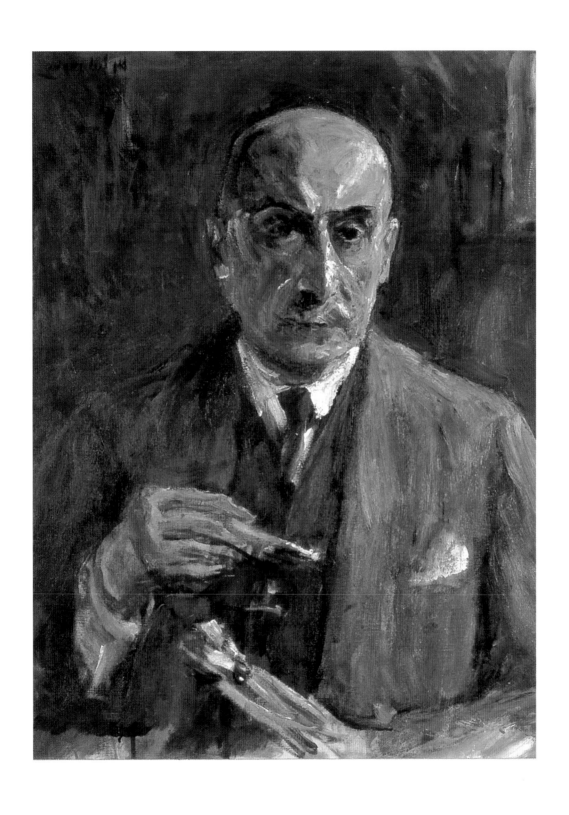

PLATE 3

Self-Portrait with Brushes and Palette, 1933

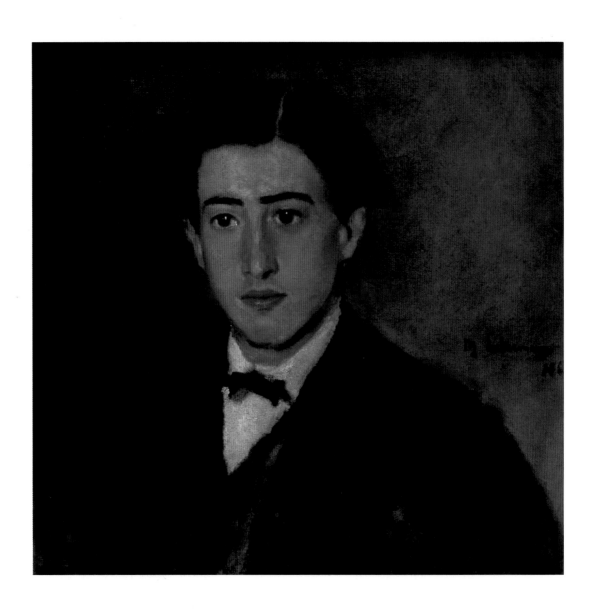

PLATE 4

Portrait of Felix Liebermann (1851–1935), ca. 1865

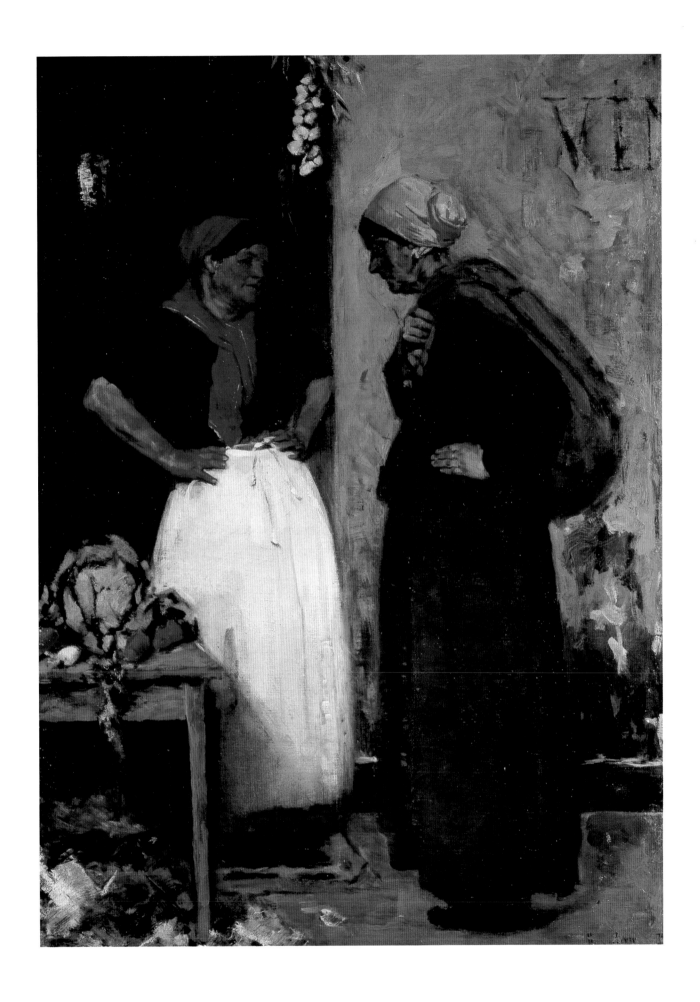

PLATE 5

Vegetable Vendor — Market Scene, 1874

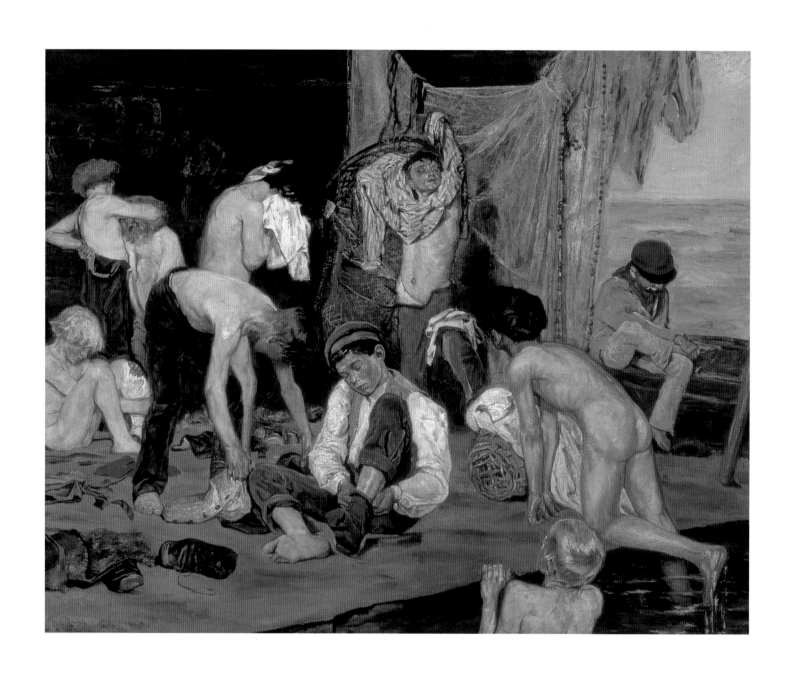

Plate 6

At the Swimming Hole, 1875–77

PLATE 7

The Siblings, 1876

PLATE 8

Table with Pieces of Meat, 1877

Plate 9

Old Woman with Cat, 1878

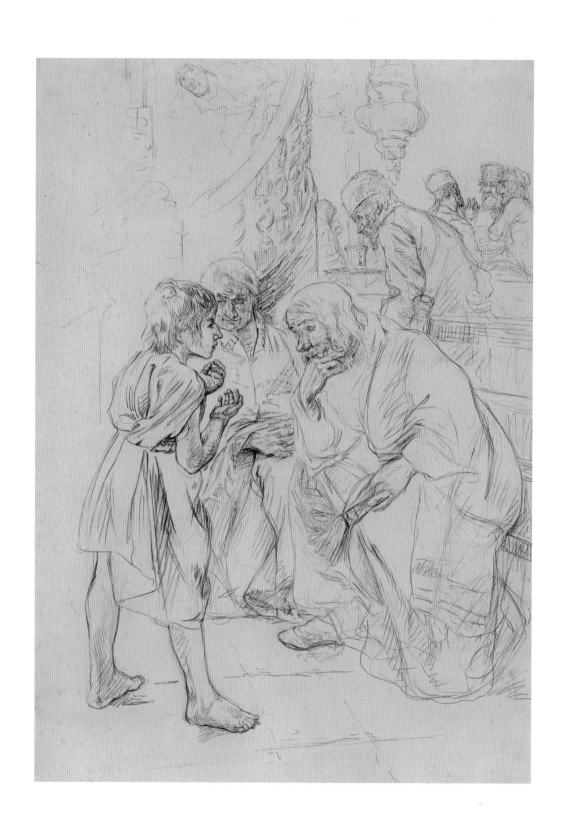

Plate 10

The Twelve-Year-Old Jesus in the Temple with the Scholars, 1879

PLATE 11

Study Head of a Man (Sephardic Jew with a Prayer Shawl, Facing Left), 1878

PLATE 12

Study for Samson and Delilah, 1894

Plate 13

Samson and Delilah, 1910

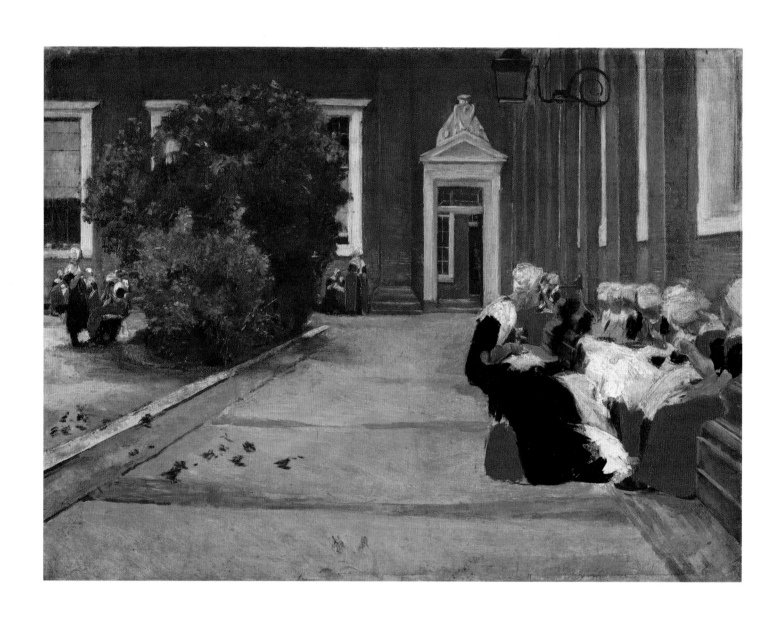

PLATE 14

Study for Recess in the Amsterdam Orphanage – View of the Inner Courtyard, 1876

PLATE 15

Study for Old Men's Home in Amsterdam, 1880

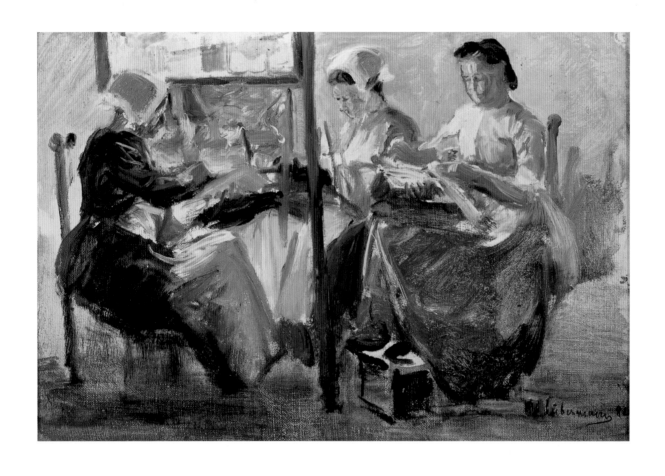

PLATE 16

Brabant Lacemakers – Study with Three Figures, second version, 1882

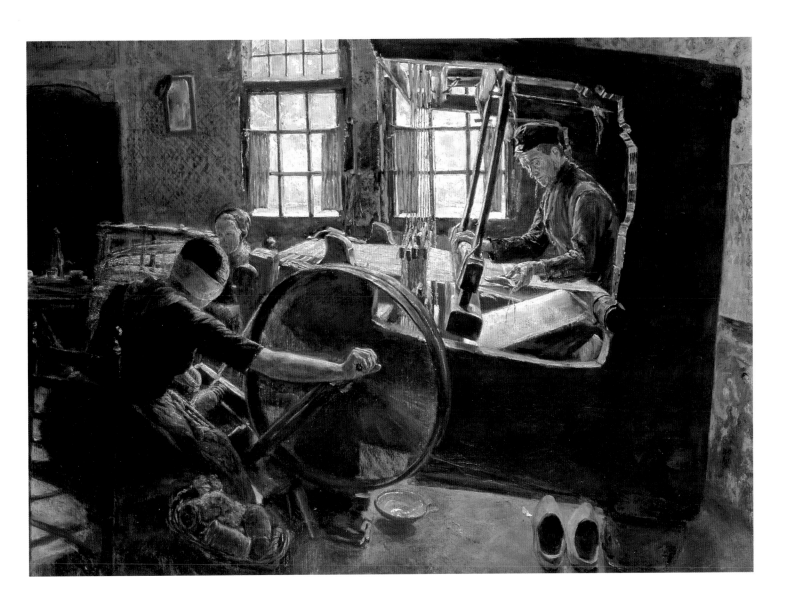

PLATE 17

The Weaver, 1882

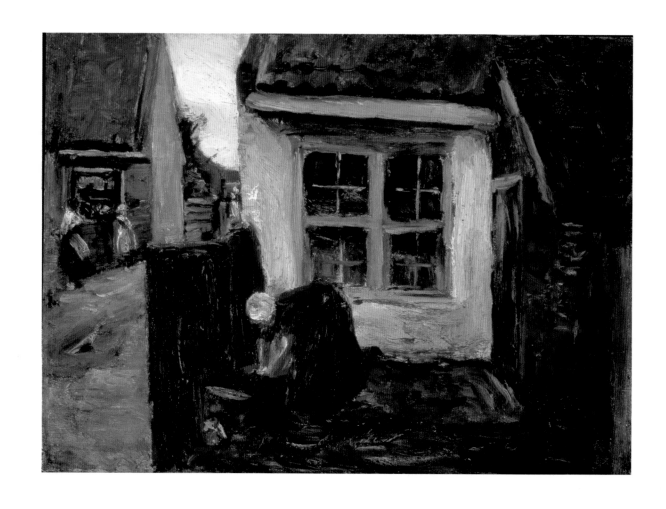

PLATE 18

Dutch Farmhouse with Woman, 1882

PLATE 19

Girl Sewing with Cat – Dutch Interior, 1884

PLATE 20

Portrait of Privy Councilor Benjamin Liebermann (1812–1901), 1887

Portrait of His Father Louis Liebermann (1819–1894), 1891

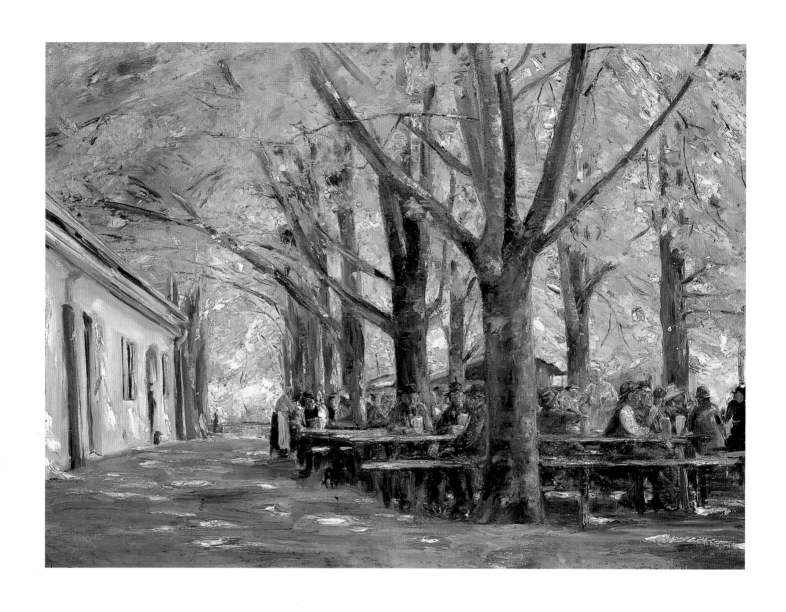

PLATE 22

Beer Garden in Brannenburg, 1893

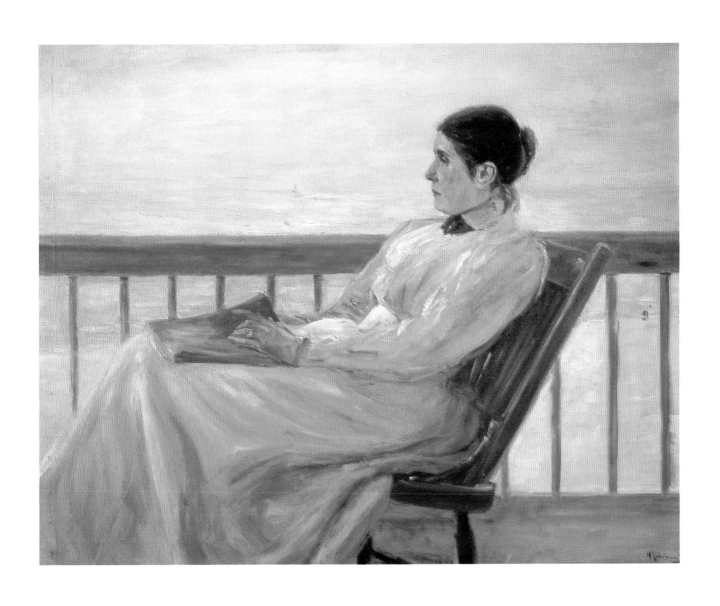

PLATE 23

The Artist's Wife at the Beach, 1895

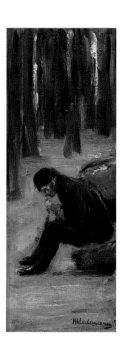

PLATE 24

Winter, 1898

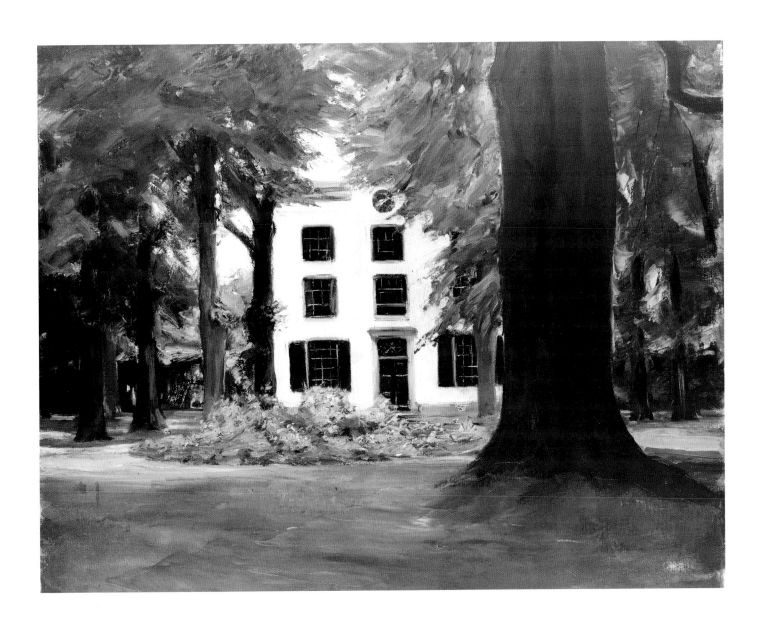

PLATE 25

Country House in Hilversum, 1901

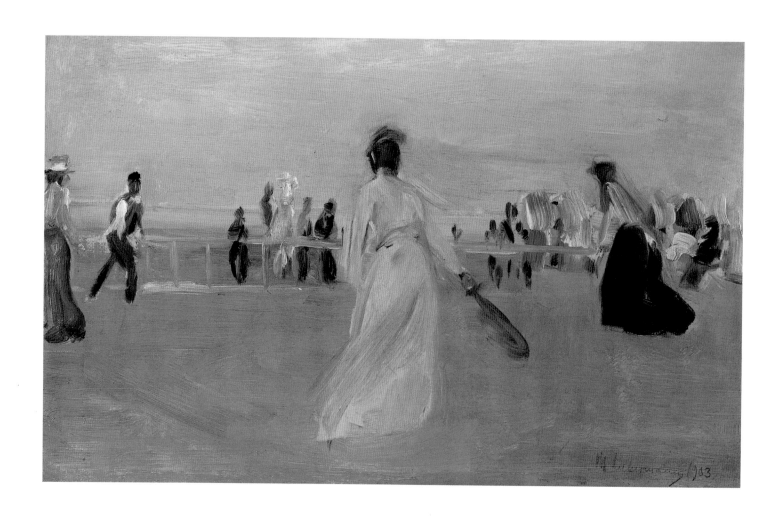

PLATE 26

Tennis Game by the Sea, 1901

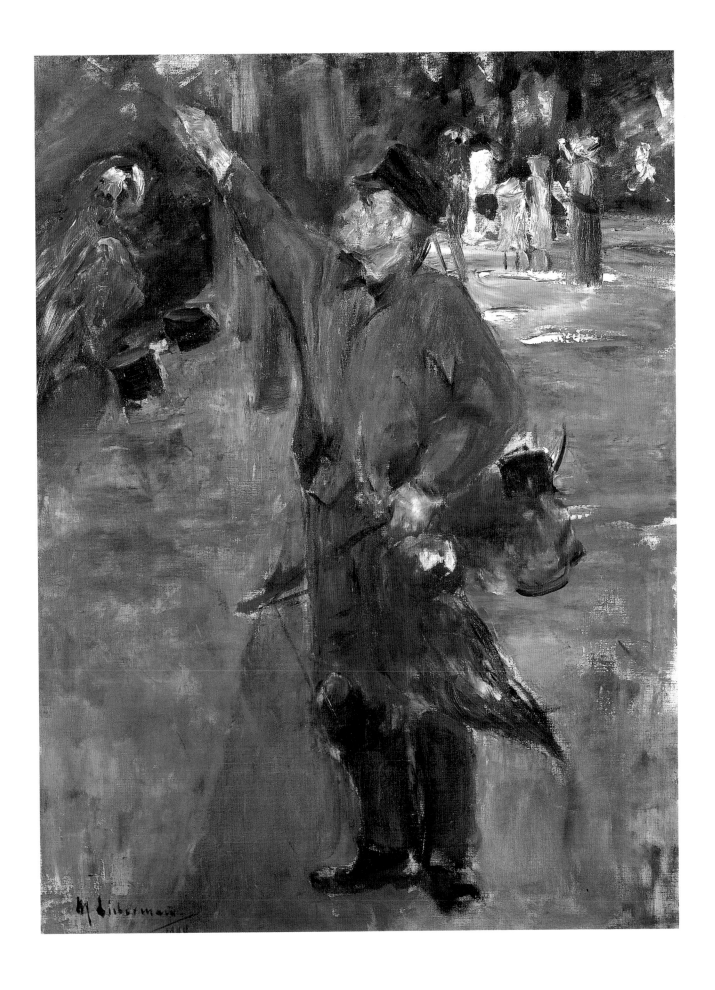

Plate 27

Study for Parrotman, 1900

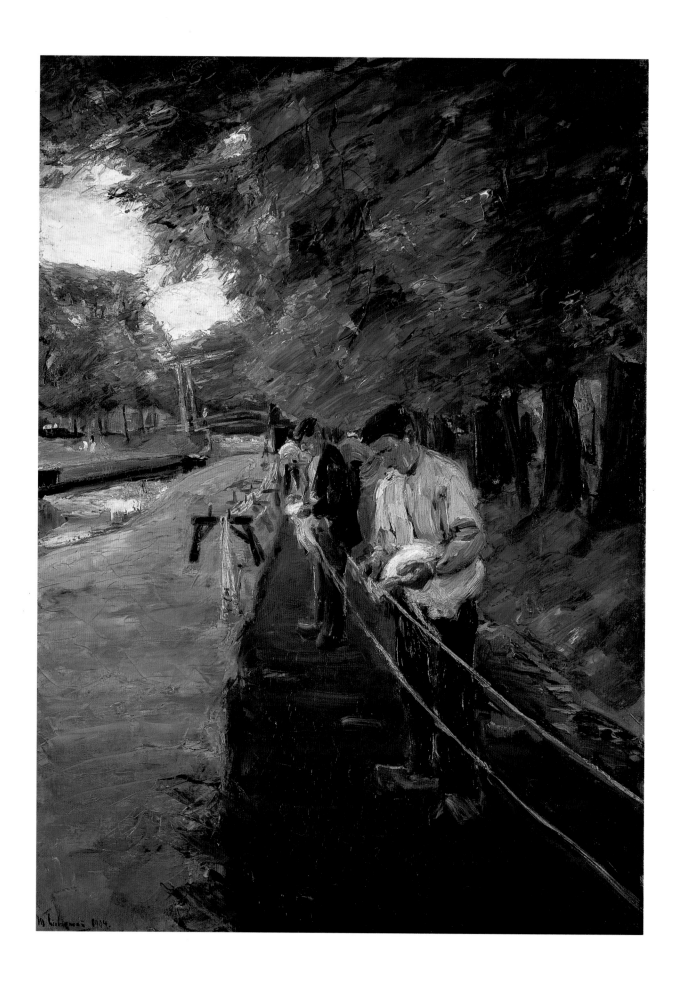

Plate 28

Ropewalk in Edam, 1904

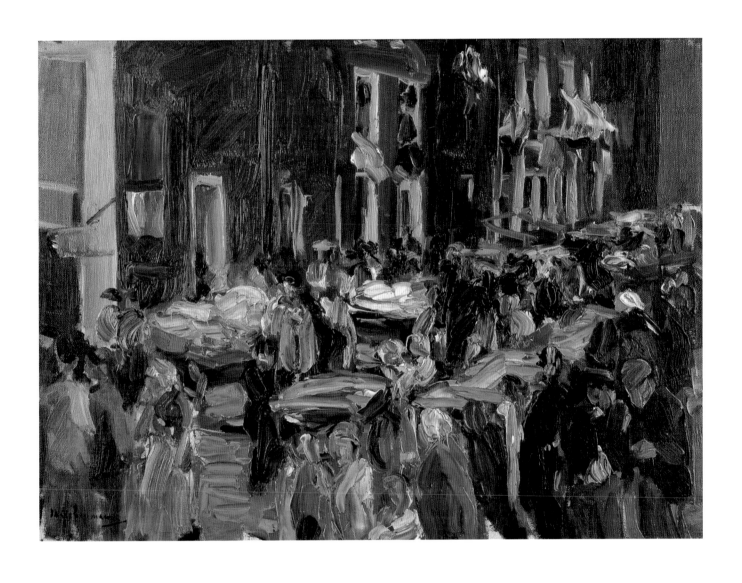

PLATE 29

Jewish Quarter in Amsterdam, 1905

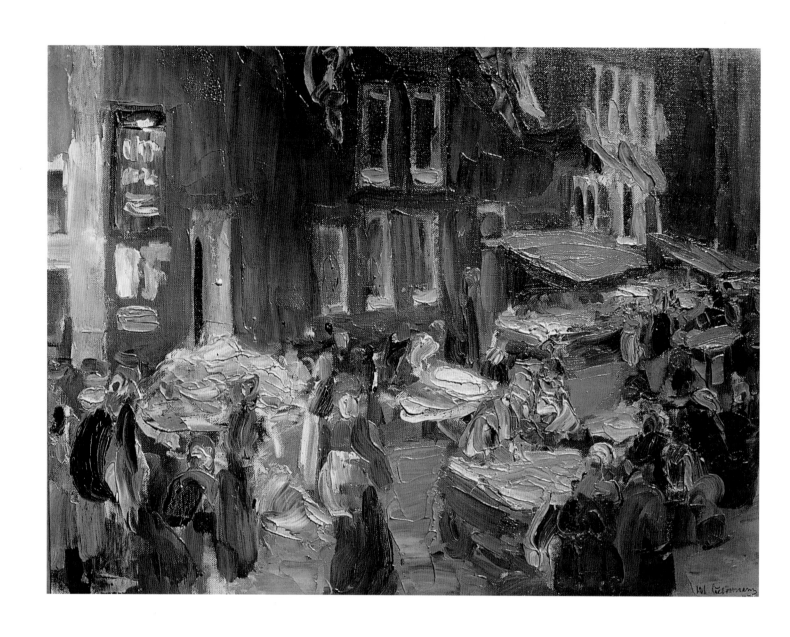

PLATE 30

Jewish Quarter in Amsterdam, 1905

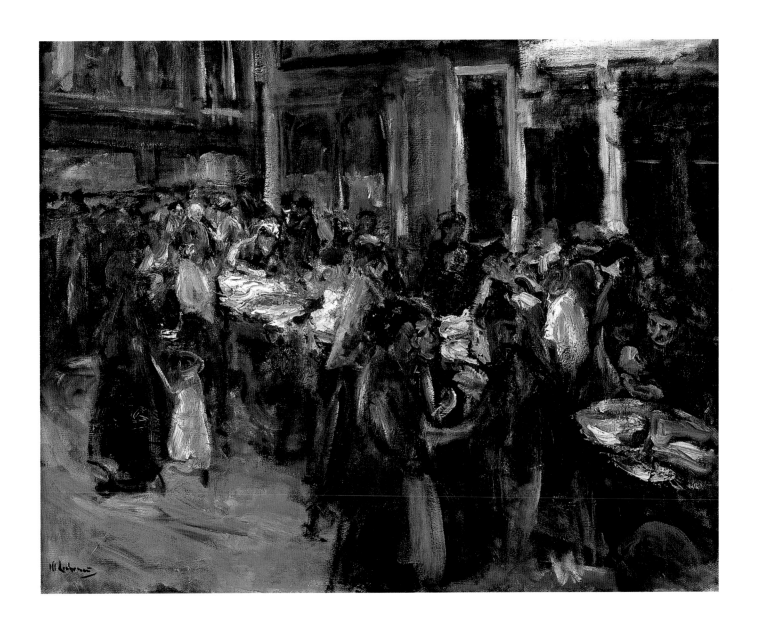

Plate 31

Vegetable Market in Amsterdam, 1908

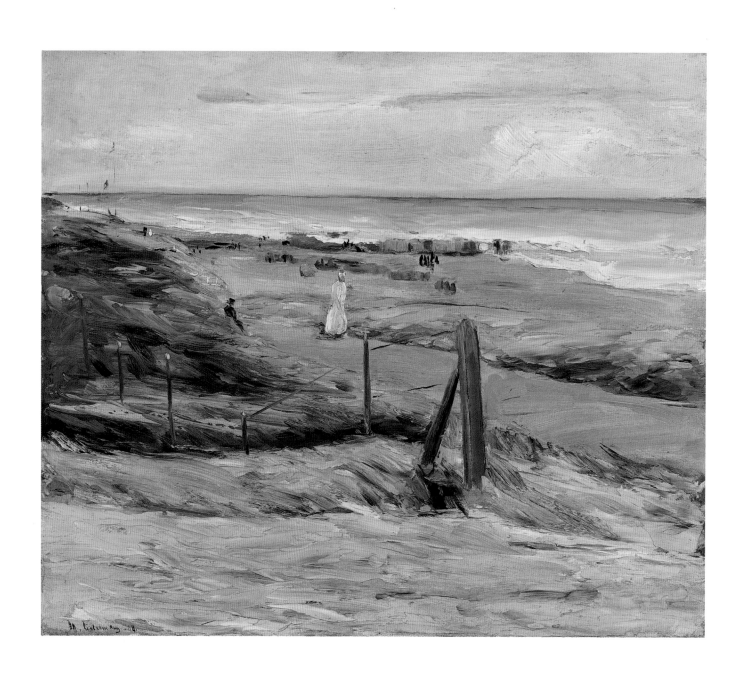

PLATE 32

Promenade on the Dunes at Noordwijk, 1908

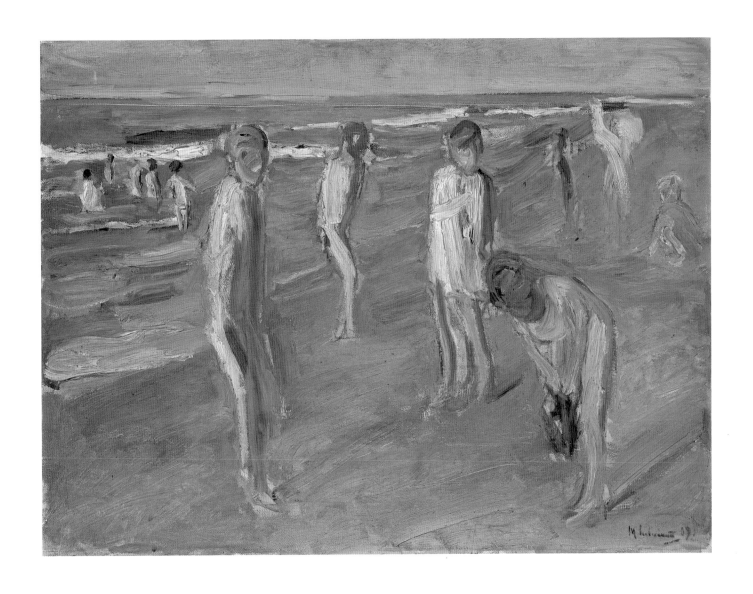

Plate 33

Bathers, 1909

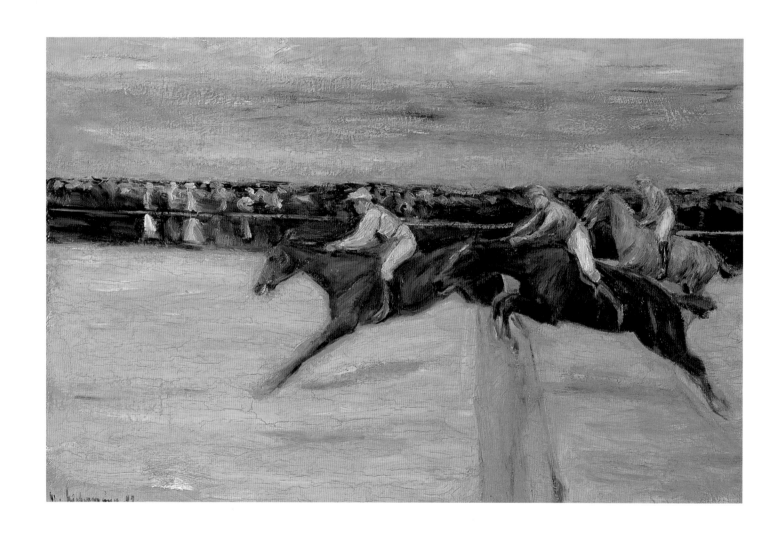

PLATE 34

Horserace at Cascina, 1909

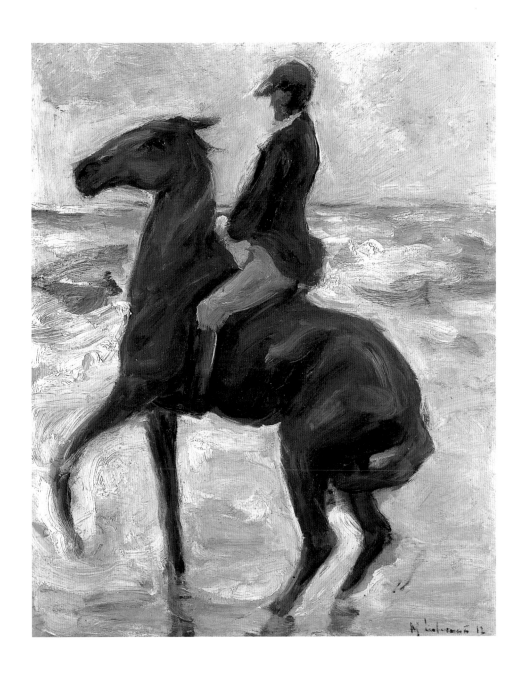

PLATE 35

Horseback Rider on the Beach, Facing Left, 1912

"March, march, hurrah!" (j)

"The Samaritan!" (g)

"The Kaiser" (b)

"To my beloved Jews" (c)

PLATE 36
Selections from *Kriegszeit Künstlerblätter*, 1914–1915

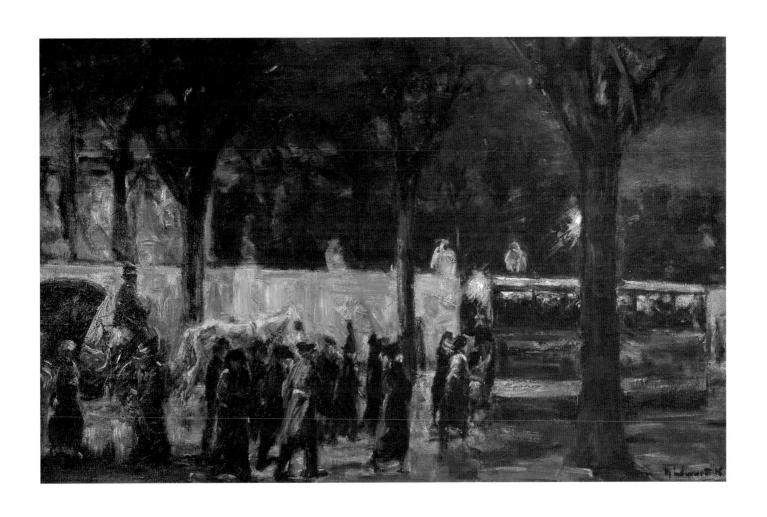

PLATE 37

Evening at the Brandenburg Gate, 1916

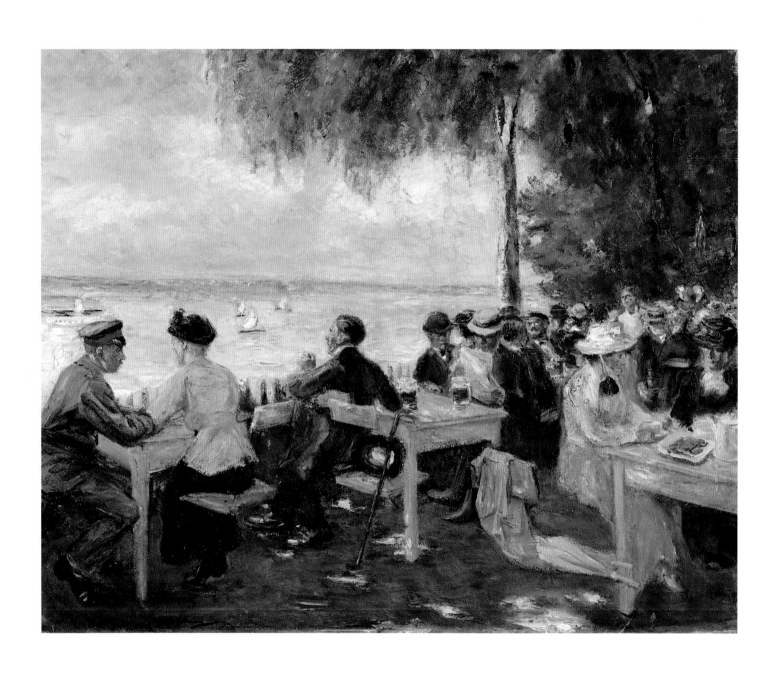

PLATE 38

Outdoor Garden on the Havel, Nikolskoe, 1916

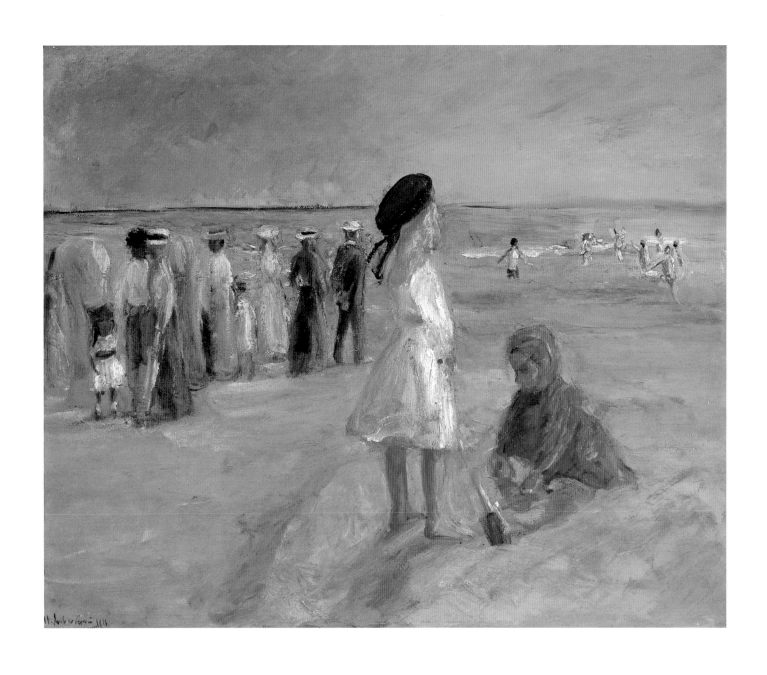

Beach Scene in Noordwijk, 1916

PLATE 40

Concert in the Opera House, 1921

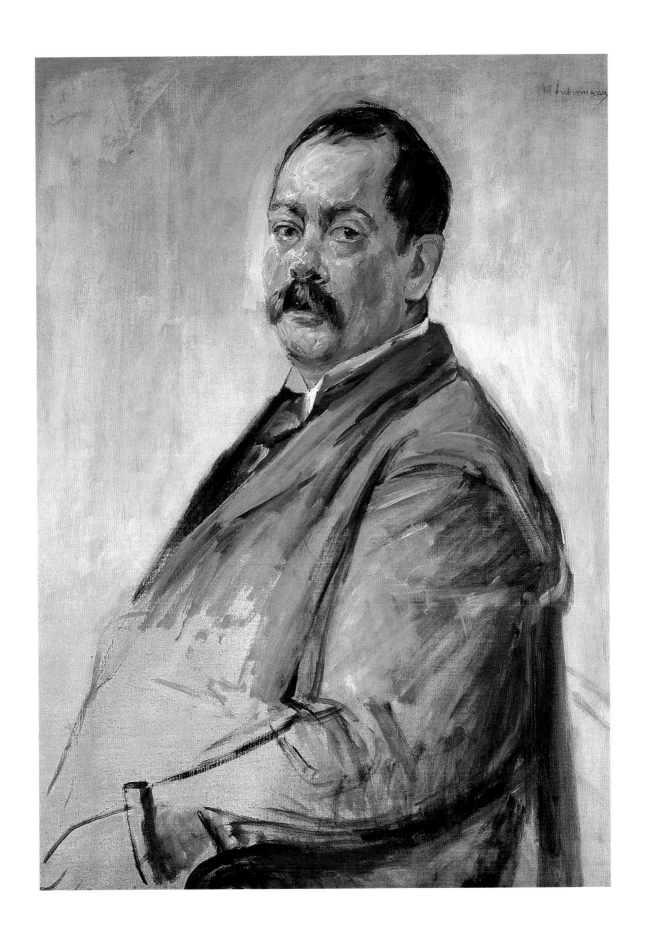

PLATE 41

Portrait of the Painter Lovis Corinth (1858–1925), 1899

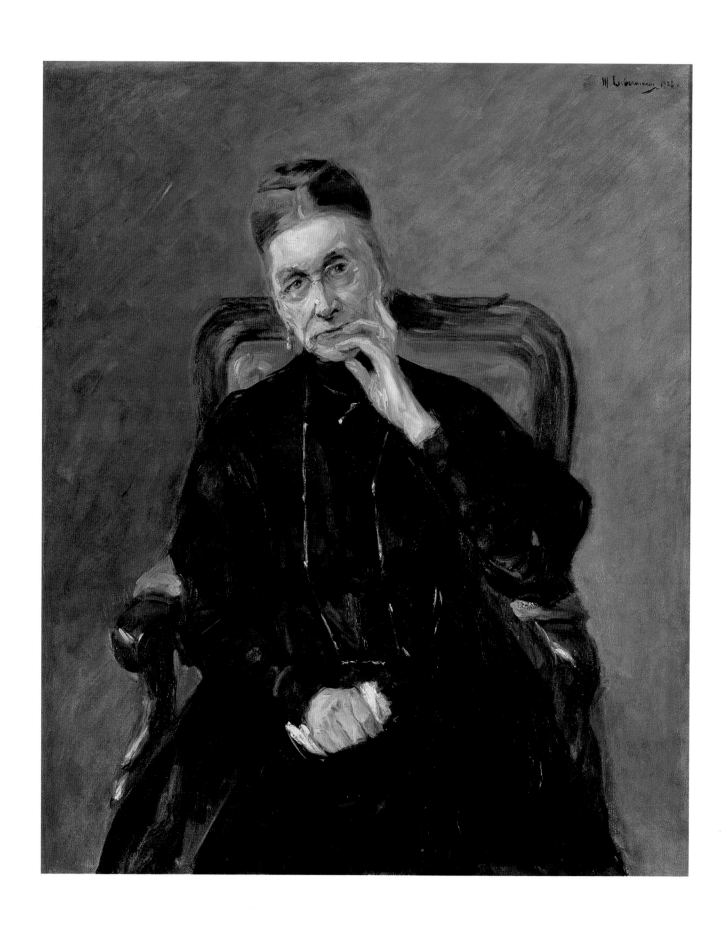

PLATE 42

Portrait of Bertha Biermann (1840–1930), 1908

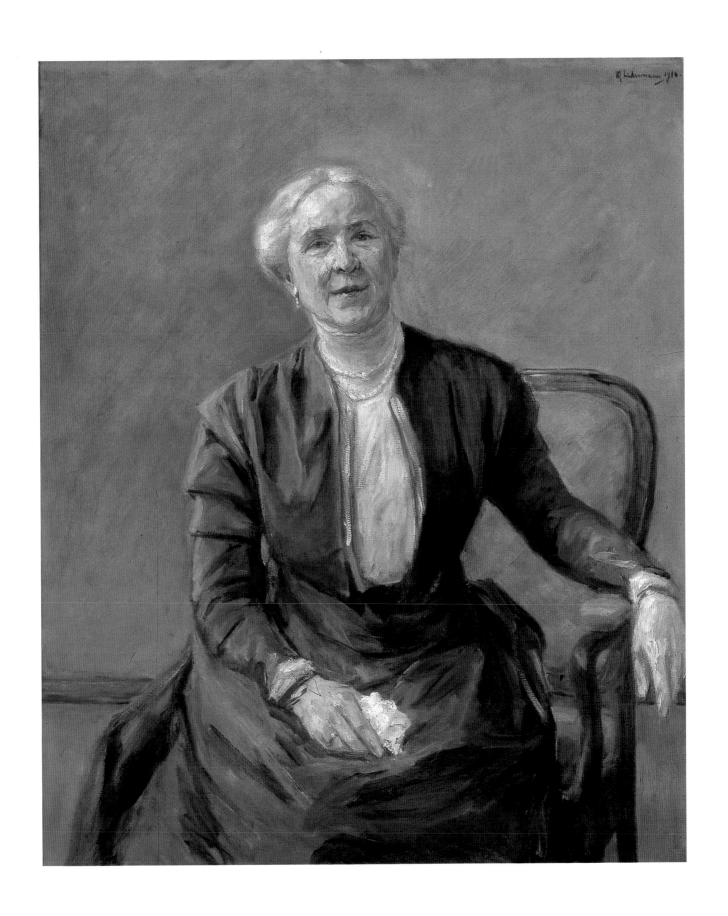

PLATE 43

Portrait of Adele Wolde (1852–1932), 1910

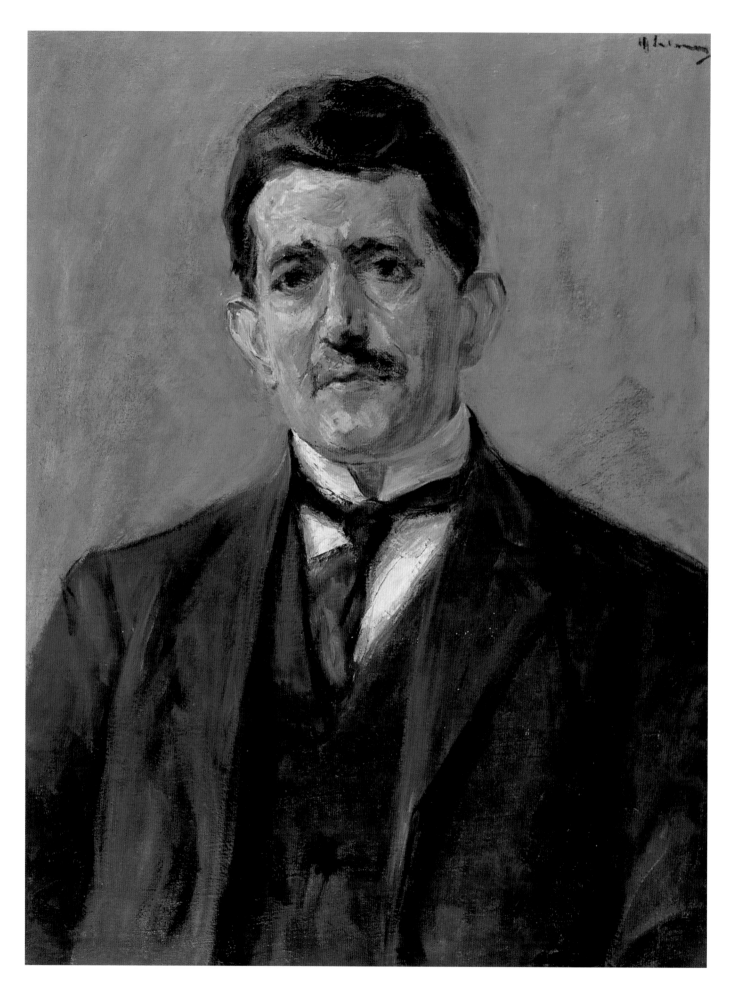

PLATE 44

Portrait of the Publisher Bruno Cassirer (1872–1941), 1921

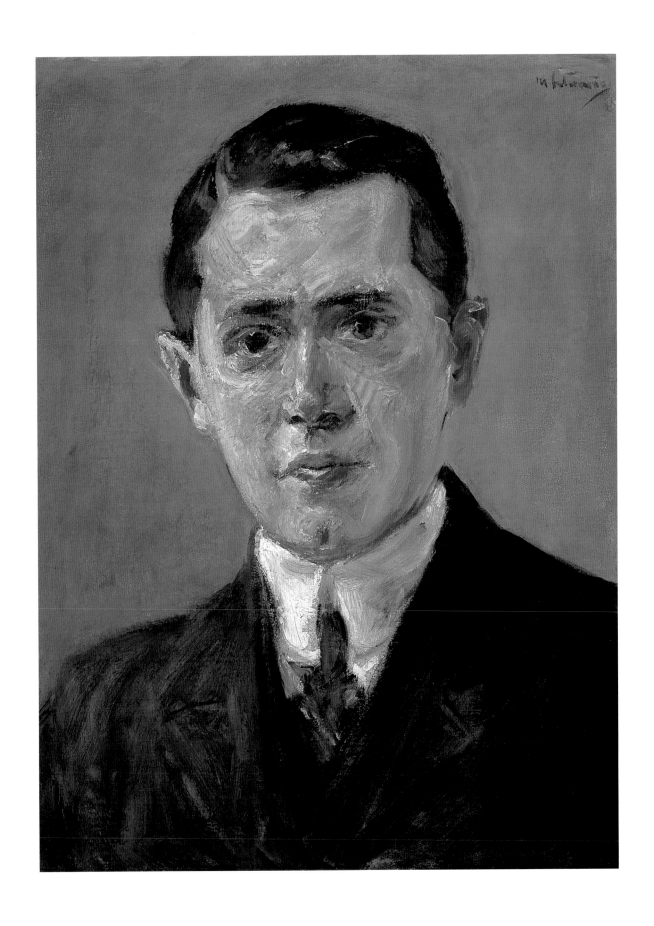

PLATE 45

Portrait of Siegbert Marzynski (1892–1969), 1922

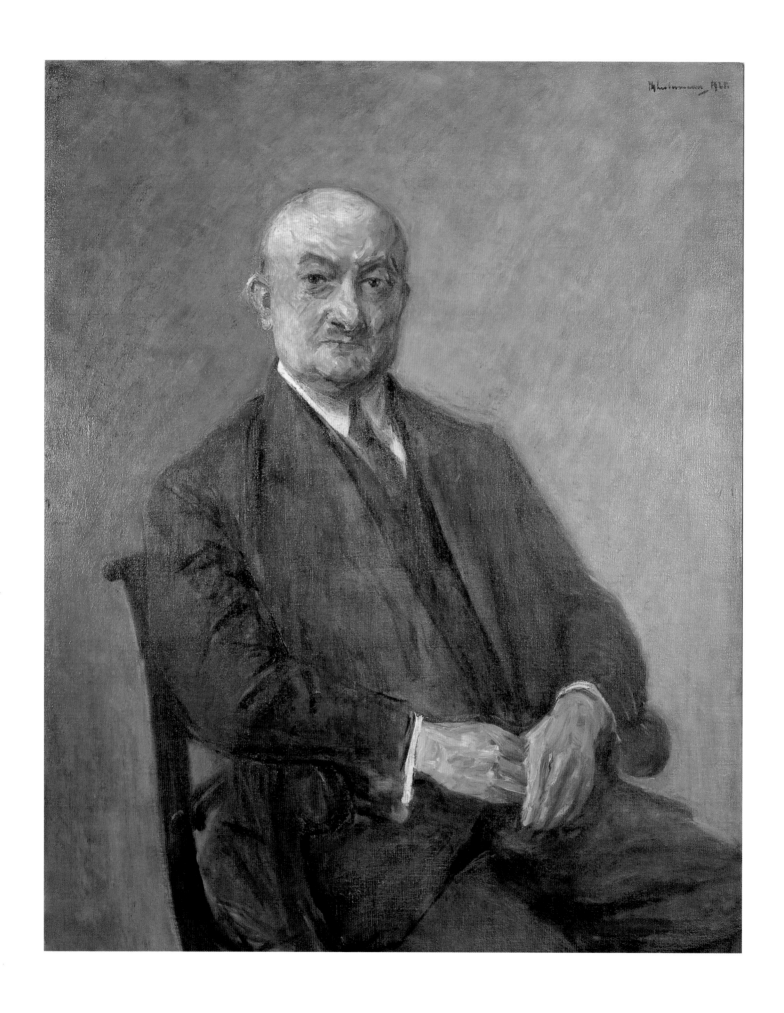

PLATE 46

Portrait of Heinrich Stahl (1868–1942), 1925

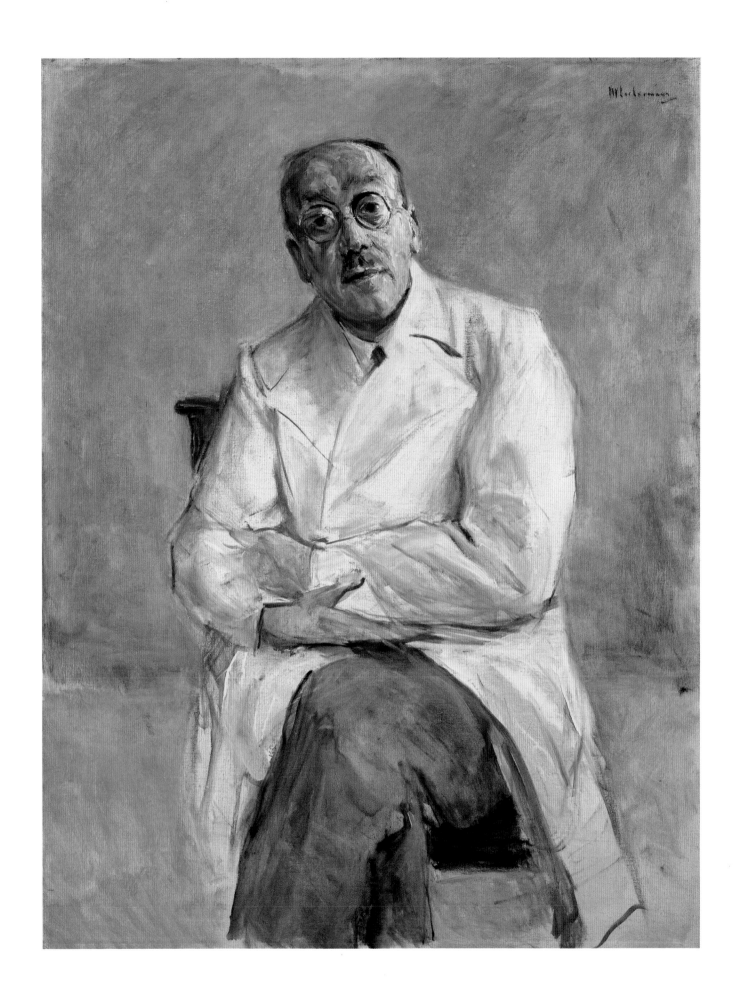

PLATE 47

Portrait of the Surgeon Dr. Ferdinand Sauerbruch (1875–1951), 1932

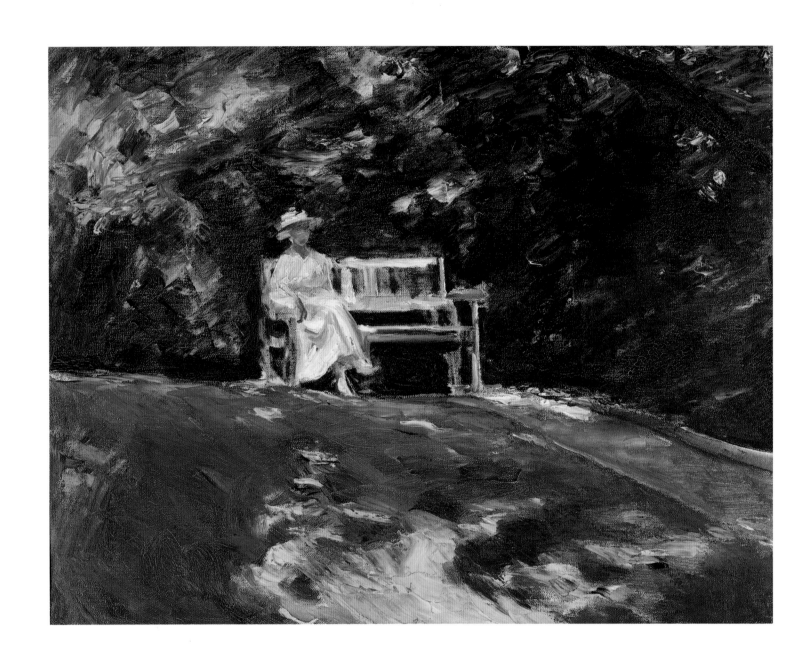

PLATE 48

The Garden Bench, 1916

112

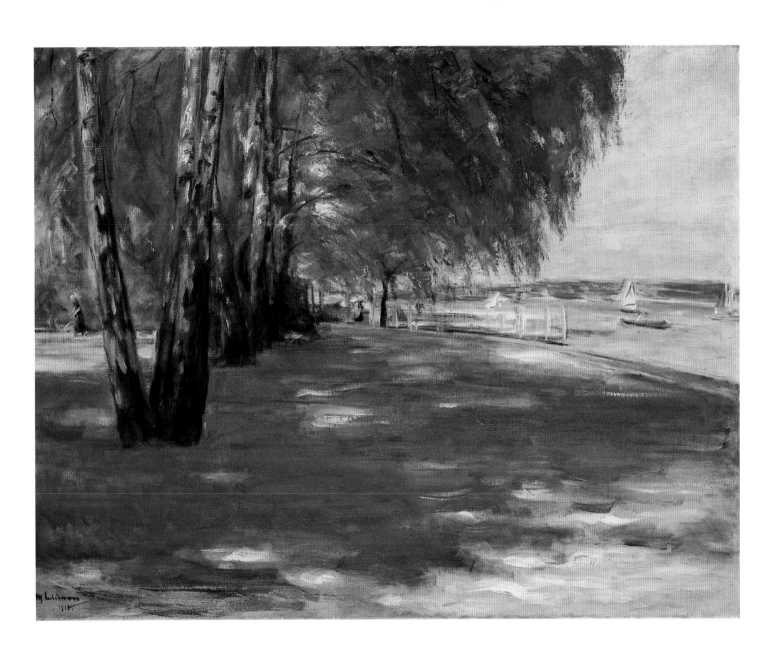

PLATE 49

The Artist's Garden in Wannsee: Birch Trees by the Lake, 1918

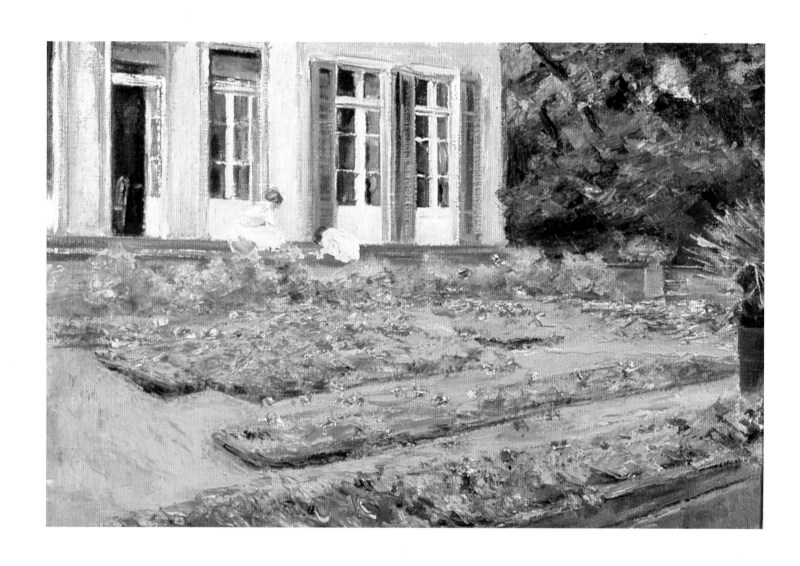

PLATE 50

The Flower Terrace in the Wannsee Garden, Facing Northwest, 1921

PLATE 51

The Kitchen Garden in Wannsee, Toward the Southeast, 1923

Plate 52

Cabbage Field, 1923

PLATE 53

Flower Terrace in the Wannsee Garden, Facing East, 1924

PLATE 54

The Circular Bed in the Hedge Garden with a Woman Watering Flowers, 1925

PLATE 55

Circular Flower Bed in the Hedge Garden, 1927

Plate 56

Tree-Lined Avenue with Two Horseback Riders, 1922

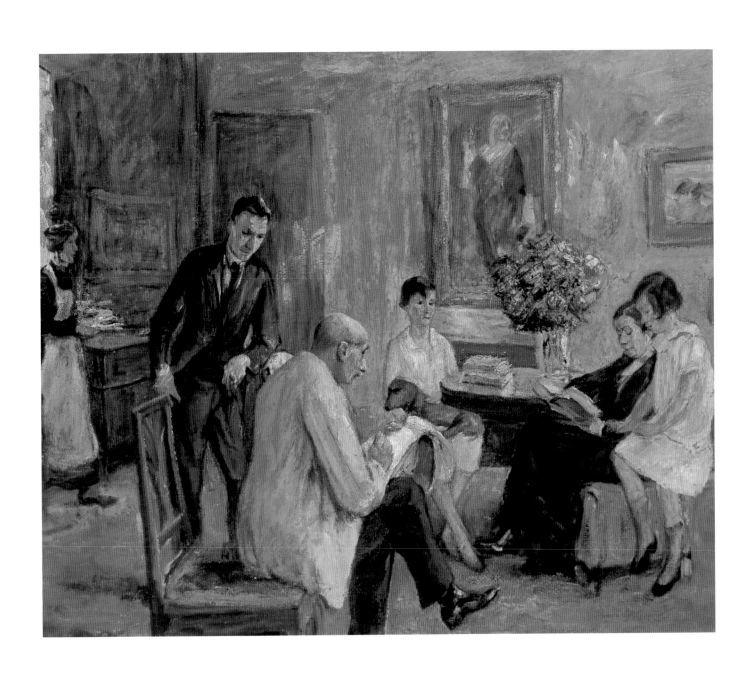

The Artist Sketching in the Circle of His Family, 1926

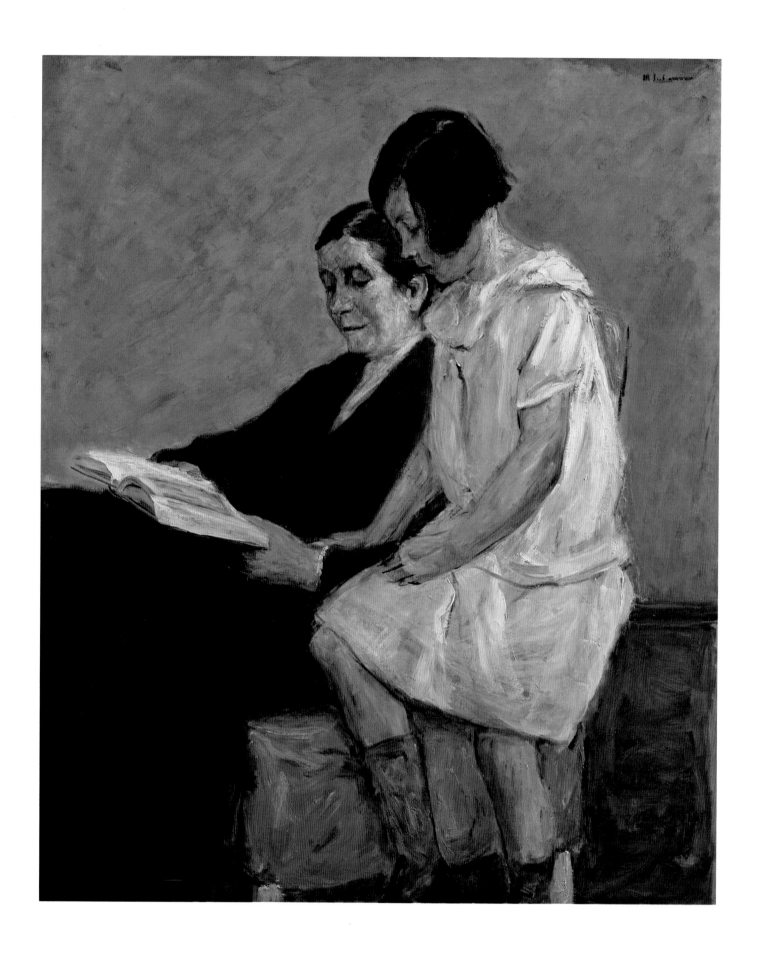

PLATE 58

The Artist's Wife and Granddaughter, 1926

PLATE 59

Self-Portrait in a Straw Hat, 1929

PLATE 60

The Atelier in Wannsee, 1932

124

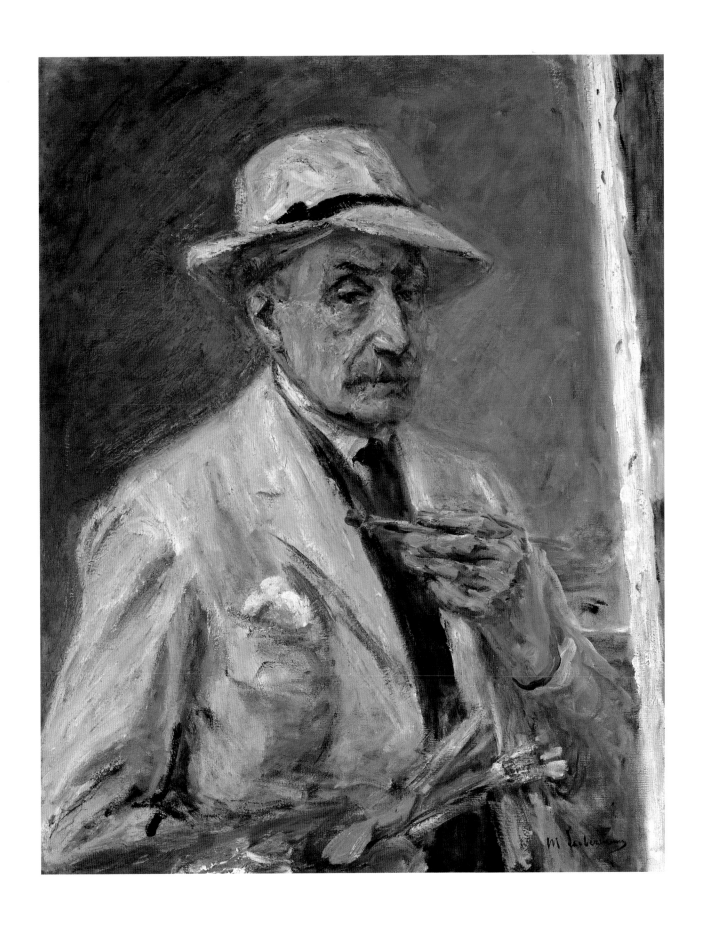

PLATE 61

Self-Portrait in Smock with Hat, Brush, and Palette, 1934

DEN MÜTTERN DER ZWÖLFTAUSEND

PLATE 62

To the Mothers of the Twelve Thousand, ca. 1935

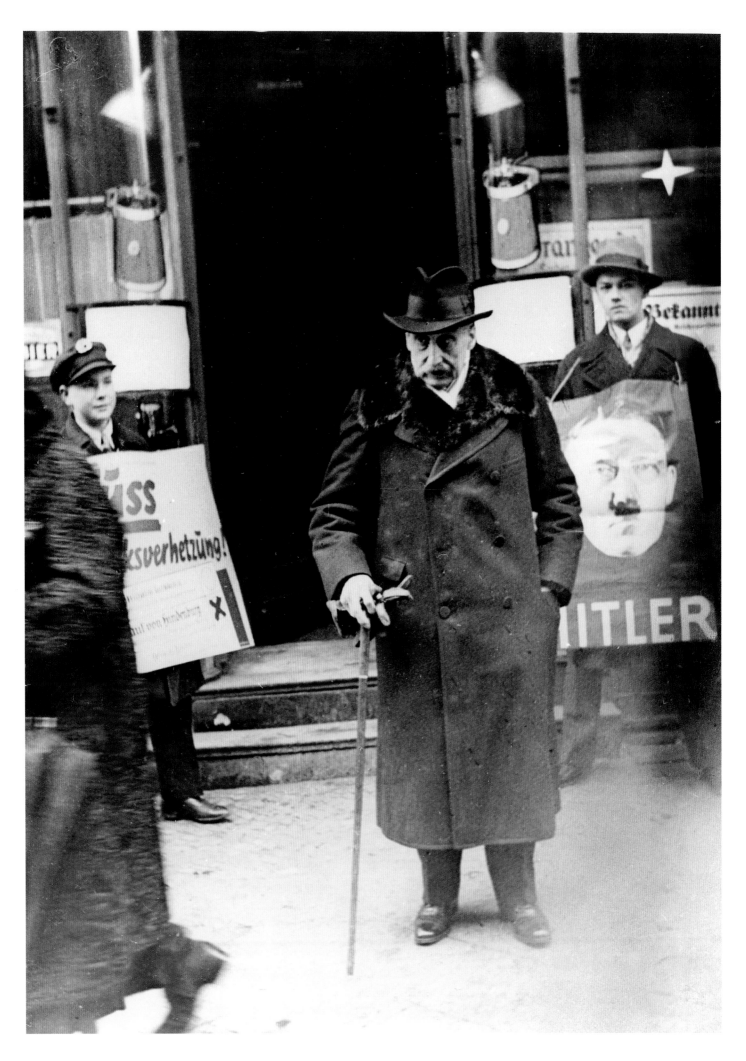

Max Liebermann and the Politics of Painting in Germany: 1870–1935

Marion F. Deshmukh

I detest...dilettantism in politics as much as in art.[1]

TWO PHOTOGRAPHS taken in the twilight of Max Liebermann's life and career tellingly reveal the fascinating story of art and politics during Germany's first half-century (Figures II.1, II.2). One shows Liebermann's unquestioned cultural prominence and power during the 1920s. In it, he mounts the steps of the Presidential Palace in 1927 to paint the portrait of Germany's president Paul von Hindenburg. As Liebermann makes his way to the government building, two guards stand at rigid attention. The other was taken during the critical election in 1932, just before the National Socialists (Nazis) came to power. In this image, a Nazi storm trooper flanks Liebermann as he exits the polling place, and the artist's worried expression anticipates the troubled years ahead for him and his coreligionists. This essay will describe Liebermann's tumultuous and often controversial relationship to the wider developments in Germany during the periods of the Empire, the Weimar Republic, and Nationalist Socialist rule.

In an odd twist of fate, Liebermann's life and career paralleled that of Germany's political rise and fall from the 1840s through the 1930s.[2] Liebermann was born in Berlin, then the provincial capital of the principality of Prussia, a quarter of a century before the modern nation of Germany was formed. As a young man in his late teens and early twenties, he witnessed the wars of unification under the leadership of Otto von Bismarck, Prussia's prime minister and later Germany's chancellor. Three wars—against Denmark, Austria, and France during the 1860s and in 1870–71—brought together various independent principalities including Bavaria, Saxony, Baden, and Württemberg into a unified German national state.[3] For the next forty years, the Prussian kings assumed the title of German emperor. For the first seventeen years of Germany's unified existence, Wilhelm I reigned as Prussian king and German emperor. In 1888 his son, Friedrich III, ruled for a few months before his death from cancer at age fifty-seven. Friedrich's son, the erratic Wilhelm II, became Germany's last monarch at age twenty-nine. He ruled over a rapidly urbanizing and increasingly prosperous country until his forced resignation in 1918.

The new national capital, Berlin, with about 865,000 inhabitants, was especially transformed during the first decades following unification in 1871.[4] The population grew to more than two million, excluding the suburbs, by the turn of the century. Many commentators proudly extolled the city's modernity and energy, its cosmopolitan atmosphere and its ever-changing architectural landscape, boasting that it ranked among the world's great cities and proudly

11.1 Max Liebermann leaving the polling station, 1932

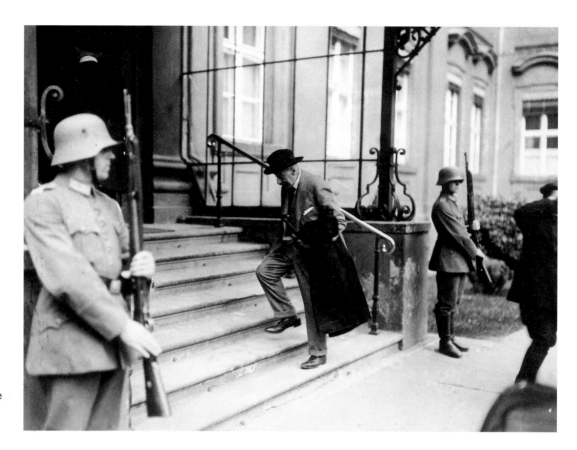

II.2 Liebermann entering the presidential palace to paint the portrait of President Paul von Hindenburg, 1927

labeling it a *Weltstadt* (world city).[5] Observers often praised Liebermann with similar adjectives, suggesting that his sharp, often sarcastic wit, his vitality, and his urbanity mirrored the turn-of-the-century Berlin. Others, however, including Liebermann's own cousin, Walther Rathenau, lamented that because of rapid, often unplanned growth, Berlin had, by the early twentieth century, lost its sober architectural and intellectual dignity. Around 1800, Berlin had seen the rise of literary and philosophical salons and the construction of impressive neoclassic buildings dominated by the architecture of Karl Schinkel.[6] By 1900 Berlin seemed to mimic the appearance of Chicago, sprawling and industrial, but without a refined character. Liebermann's attitudes toward his hometown alternated between the two points of view. He proudly recognized Berlin's and Germany's increasing prominence on the world stage and wanted his art to highlight what he perceived to be the best of German culture. His varied professional activities demonstrated his desire to see the German capital's growth not simply in numbers of inhabitants or commercial expansion but through the proliferation of cultural institutions and activities.[7]

Germany's forty years of growing prosperity and power ended abruptly with its defeat at the hands of the allies in 1918 and the forced abdication of Kaiser Wilhelm II. Street clashes and political unrest caused parliamentarians to temporarily take refuge in the small town of Weimar in order to draft a constitution. Weimar symbolized the golden age of Goethe and Schiller, for these two prominent eighteenth-century writers had resided there.[8] To the liberals drafting the constitution, Berlin represented the home of the conservative emperor who had led Germany to military humiliation and disaster. The new regime, which along with other liberal and inclusive policies granted the franchise to women for the first time, returned to Berlin in 1919, but the republic's name remained "Weimar" until its demise in 1933.[9]

By the end of the World War I, Liebermann had entered the seventh and eighth decades of his life. Despite his advanced age, the painter now occupied one of the most prominent positions within the artistic world during

the Weimar Republic—president of the Prussian Academy of Arts from 1920 to 1932, a position to which he was repeatedly reelected by the government and his colleagues although the term of office normally lasted only two years.[10] Liebermann's presidency of this elite institution would have been inconceivable before 1914. The painter's relationship to the monarch had been strained at best and, on occasion, hostile.[11] As a liberal, a Jew, and a modernist painter, Liebermann symbolized to the emperor and to cultural conservatives all that was problematic. In republican Germany, Liebermann represented new and progressive cultural currents. When Liebermann died at the age of eighty-seven in 1935, he was terribly saddened by the course of events that saw Germany decline from a great power in 1900 to a rabidly anti-Semitic totalitarian state beset by a catastrophic economic depression in the 1930s. Liebermann not only witnessed these changes but also often served as a lightning rod for the cultural wars raging between conservatives and liberals.

MODERNISM VS. THE EMPIRE

To comprehend Liebermann's unique role as an outsider and insider within German society as well as his views toward the various regimes, it is crucial to understand Germany's rapid political and economic changes, for good and for ill, during his lifetime. What was Liebermann's own political orientation during this period? The artist made few public statements about politics. Most came during interviews with reporters or biographers. When queried about his political ideas in 1925, the artist noted that even in old age, he stood by the views that he had held for decades: "The first impressions and observations remain. I do not enjoy conversing with politicians."[12] Liebermann also wrote: "Is it not surprising that because I was born in 1847, my political and social outlooks were and remained those of the 'forty-eighters'? Even though unfortunately I have often been reminded of the opposing [point of view], I believe that every citizen is equal before the law, as is stated in the constitution."[13] His occasional statements could make a convincing case that the artist's painting and politics were totally separate. One of his comments is most revealing: "I never involved myself in politics. Politics is an art like any other, demanding serious study."[14] Similarly, Liebermann also remarked: "I detest the coffeehouse and beer-hall politicians and dilettantism in politics as much as in art."[15] Yet, these ambiguous statements have left open the reasons why critics during the imperial period often saw Liebermann's selection of his subject matter and styles of realism and impressionism as politically radical.

Before the wars of unification brought the German states together, the revolutions of 1848 convulsed continental Europe, a year after Liebermann's birth.[16] Revolutionaries called for enlarging the restricted franchise of the voter to include the educated urban middle classes. Critics of the status quo demanded the expansion of civil liberties and supported German political unity. Delegates to the failed Frankfurt parliament of 1848 believed that a united Germany would be more economically prosperous than the fragmented collection of independent states. The more radical elements wanted to eliminate entirely the system of ruling aristocrats, to set up a democratic republic, and to rid the peasantry in rural Germany of the burdensome taxes that had impoverished them. Some extreme groups called for a communist revolution; while exiled in England, Karl Marx and Friedrich Engels had published, in January of 1848, the *Communist Manifesto,* which called for the working class to dismantle the capitalist system based on private property. The numbers committed to radical revolution were, however, tiny at that time. Marxism had to wait a generation before a growing number of German workers would perceive its allure.

II.3 Anton von Werner, *Inauguration of the Reichstag at the City Palace in 1888*, 1893. Deutsches Historisches Museum. 1888 was called the "Year of the Three Emperors," because Wilhelm I's death was followed so closely by his son Friedrich's passing and the ascension of his grandson, Wilhelm II. In this subdued scene of the royal opening of the parliament, black crepe can be seen draping the windows and walls in the city palace.

Liebermann's statement about being a "forty-eighter" can be variously interpreted. Perhaps he meant to align himself with the politics of a revolution that had intended to reshape Europe. It is more likely that the artist subscribed to the liberal and rather moderate political values held by the parliamentary participants who tried, unsuccessfully, to craft a liberal constitutional state in 1848.[17] He certainly did not subscribe to radical socialism. Indeed, Liebermann could be defined as a gentle critic, one who had misgivings about the stratified and hierarchical governmental system in mid-nineteenth century Prussia and, later, imperial Germany. After unification in 1871, the nation had a hybrid system of universal manhood suffrage and the parliament had limited powers. On the provincial level, the Prussian legislature was governed by a three-class voting system, which overwhelmingly favored the wealthy over the poor and the rural elites over the urban workers. Throughout the imperial period, progressives called for this class-based franchise to be altered or eliminated. Fundamental changes to the system only occurred as a result of Germany's military defeat in World War I.[18] In a letter to his brother Felix from Zweeloo, Holland, in 1879, Liebermann expressed his admiration for rural Dutch society, noting that seventeenth-century painters such as Jacob van Ruisdael (1628–1682) and Meindert Hobbema (1638–1709) had depicted its unchanging characteristics. He noted with admiration that "cattle herders, girls, young boys, and gentlemen sit together at the kitchen table…and eat out of the same bowl. Everyone uses the familiar 'you' as one large family."[19] This seemingly egalitarian lifestyle of rural Holland appeared to be in stark contrast to the rigid class system of nineteenth-century Prussia and its royal capital, Berlin. Yet, the painter was adverse—in painting and in politics—to cataclysmic change or revolutionary unrest.[20]

For a brief time in his youth he claimed to have admired the socialist organizer and charismatic orator, Ferdinand Lassalle, who was killed in a duel in the mid-1860s. Lassalle was a socialist who wanted to see a rapprochement—rather than unending conflict, as espoused by the Marxists—between the national state and society. He also vigorously endorsed universal suffrage and the direct vote.[21] His reputed spellbinding oratory may have been what

II.4 *Potato Pickers in Barbizon,*
1874. Stiftung museum kunst palast
Düsseldorf

entranced the young Liebermann. Rather than an early flirtation with mid-century revolutionary socialism, Liebermann's fascination with Lassalle was perhaps more aesthetic than political: the artist found the socialist "radiantly handsome like a young god and so popular that everyone recognized him on the street"[22]

Without the economic prosperity fueled by political unification, the role of most artists, Liebermann included, would have continued as it had during the middle decades of the nineteenth century. During this time, several provincial art unions and academies, such as those of Düsseldorf, Munich, Weimar, Dresden, and Berlin, all competed for German and international students.[23] The academies of Düsseldorf and Munich eclipsed that of Berlin, until its status as capital of the Empire started attracting industry, immigrants, and a greater variety of cultural offerings to the city. Although Munich was Germany's second city, its artistic reputation remained supreme, although Berlin increasingly was seen as an up-and-coming cultural rival to the Bavarian city.[24] By the turn of the century, the growth and proliferation throughout Germany, but especially in Berlin, of alternative artistic venues displaying and selling contemporary art served Liebermann well.[25] He rose to become not only one of Germany's leading modernist painters but also one of Germany's artistic impresarios during the period (1890–1918) through his tenure as president of the Berlin Secession, his frequent essays in avant-garde publications, and his many speeches at exhibition openings, the latter given wide press coverage in the feuilletons of the day. As his admirer Hans Ostwald observed, "Basically [Liebermann] had only one goal, to break down the barriers that prevented Berlin from becoming an international art center."[26] In many ways, Liebermann ultimately saw his desire become reality. By the 1920s, Berlin rivaled Paris and London as a center of the international art market and the cultural avant-garde. This artistic ascendance occurred despite Germany's catastrophic military defeat in World War I, the economic hardships of hyperinflation, frequent regime changes, and political attacks from the left and the right.

Liebermann's statement that "politics is an art" and that as a political "dilettante" he avoided politics was disingenuous.[27] He was very engaged, though

in the larger cultural context rather than in party politics, during the periods of the Empire and the Weimar Republic. For much of his early career from the 1870s through the turn of the century, Liebermann's critics often labeled the painter a socialist for his portrayals of peasants and rural labor. Many observers have wondered, then and now, why Liebermann, city born and bred, would be drawn to the rural countryside and to images of peasants planting potatoes, weaving cloth, or struggling with recalcitrant goats. Critical interpretations have varied. Because the artist did not idealize the tedious and repetitive work required in farming and herding, contemporary admirers saw Liebermann's peasants as objectively rendered. Because the artist did not paint peasants anecdotally, as had genre painters of the early nineteenth century, conservative critics saw Liebermann's versions as sympathetic, which emphasized their potential for radical politics. In his paintings of old men and orphans of the 1870s and 1880s, he combined two features that are generally associated with modernism. First, the scenes are not idealized but seem to project an unmediated and objective study of life on the margins of society. Second, Liebermann rendered his observations using the latest painterly techniques and based on apparently spontaneous plein-air drawings and paintings. Liebermann's technique was not the polished smoothness seen in the typical academic paintings of the period. His canvases' surfaces appeared rough and unfinished, allowing the paint to be an integral part of the artist's process of working.

More socially conscious critics on the left, however, faulted Liebermann for failing to depict the misery of the countryside. Instead, Liebermann's peasant paintings privileged the notion of "work," which the artist considered ennobling, irrespective of the type of labor. This signature concept links Liebermann to his aesthetic mentor, the mid-century French realist Jean-François Millet. Both artists presented working peasants—or weavers at their looms or orphans engrossed in sewing, in Liebermann's case—as dignified. Liebermann claimed that work itself was a process of self-mastery: "If men can individually and alone work well and succeed, so that seems to be the most desirable goal."[28] These early images of peasants engrossed in the activities of pre-industrial rural life meant to contemporary conservative critics that the painter must be a political radical. Why else would the artist desire to paint such economically marginal groups in a matter-of-fact, even noble way that, while not idealizing their activities, certainly did not portray them unsympathetically? It is important to stress here that Liebermann's deep belief in work as a calling, as an almost religious duty required of all, regardless of rank, came closer to explaining his fascination with Dutch peasantry than any beliefs in organized radical politics.

The growing socialist movement worried the government. "The socialist labor party presented German society with a radical alternative to existing norms": socialists were thus seen as enemies of the new state because they called for a republic headed by workers and promoted the international brotherhood of the working classes.[29] Anti-socialist legislation was first passed in 1878 and was regularly renewed until 1890. Liebermann was a lifelong liberal, not a socialist. Yet even moderate liberalism was seen as potentially dangerous in the new Germany.

Through its undeniable role in engineering German unification, Prussia dominated the new German nation. After the victorious wars of unification, Prussian military and diplomatic institutions essentially were transformed into the new imperial institutions for all of Germany. The official culture developing after 1870 tended to be equated with that of the Hohenzollerns, that is to say, the Prussian royal court of Wilhelm I and later Wilhelm II. The many portraits of military officers and nobility by the court's favorite, Anton von Werner, personified this Berlin-based aristocratic culture. The polished photographic realism

of his paintings of recent German history embodied this new, invented tradition (Figure II.3).[30] In addition, hundreds of spectacularly large monuments—such as the Wilhelm I equestrian ensemble in Koblenz, the Bismarck monuments, and the memorials to Hermann, the ancient Germanic warrior seen as a hero for his defeat of the Romans—were all somewhat artificially constructed to promote a sense of shared history and patriotism.[31] Given the federal structure of the new nation, German regionalism did not disappear after 1871; regional peculiarities and distinctive cultural legacies remained.[32] Imperial culture, fostered and encouraged by the Prussian government and court, was, however, superimposed on the various German states.[33] Despite the long histories and unique and distinctive cultures of individual states, the invention of a national art could, it was believed, create a sense of collective identity.

Debates frequently raged over what was to constitute a national style for the new Germany. Stone sculpture, government buildings, plays, monumental paintings and prints—depicting triumphalist scenes and transcendent moments—were all used to manufacture a new German aesthetic and forge a national culture. The decade of the 1870s saw the creation of the cult of the hero: in politics, Otto von Bismarck; in music, Richard Wagner; in painting, Anton von Werner, the official court painter, and Franz von Lenbach, the official portraitist. Adolph Menzel, a painter whose varied oeuvre ranged from the history of Frederick the Great to the Revolution of 1848 and who is still acknowledged as one of the key figures in German art, was given a hero's funeral upon his death in 1905.[34] The quest for the heroic continued in the reign of Wilhelm II, who very consciously attempted to immortalize his grandfather—even linking his image to that of the medieval emperor, Charlemagne. In a spectacular culmination of monument building, four hundred new memorials to Wilhelm I were built in 1897.[35]

In contrast, Liebermann's peasant paintings were not majestically heroic or nostalgically romantic (Figure II.4). Even worse, in the view of his critics, the artist painted in an imported style, one introduced from the hated enemy, France. Liebermann's realism definitely displayed an aversion to sentimentality and false pathos, whether romantic or chauvinistic. Liebermann vehemently disliked the polished, near photographic virtuosity of the official court art made by von Werner and other such artists, but he also objected to the sentimentality of the genre paintings popular among the emerging middle-class industrialists who would become Liebermann's most ardent patrons after the turn of the century.[36]

After the turn of the century, he turned from paintings of rural Holland to images of the middle classes at leisure. Yet, his work continued to remind his critics of the artist's foreign influences—in this case, the art of the French impressionists. Because Liebermann was Jewish in a nation that prided itself on being Christian, the fact of his religion added to the sense that his art was foreign. Liebermann's own desire to establish not only a German reputation but also an international one caused his patriotism to be repeatedly questioned. In July 1882, eleven years after the end of the bitter conflict with France, French artists invited Liebermann to represent Germany at an upcoming international show. Ecstatic over this recognition, he wrote to his brother:

> Yesterday I received the most pleasant news that has yet come to me. Six of the most famous French painters have organized an international exhibition for January of the following year, to which 20 painters have been invited. [There will be] six Frenchmen and 14 foreigners—Italians, Spaniards, Swedes, Englishmen, and Russians. As the only German invited to exhibit, this will be a far greater honor than the earlier exhibits organized by art dealers [Menzel and Knaus were the only artists selected then].

This invitation proves to me that artists especially acknowledge my paintings. And if I do not again receive a medal, then this is because of political reasons."[37]

That Liebermann's French colleagues admired the painter, hardly more than a decade after the Franco-Prussian War, was reason enough for conservative Germans to question the painter's loyalty.

His Judaism, his commitment to modernity, and his internationalism all affected attitudes about Liebermann. Early critics characterized Liebermann's paintings as among the "ugliest examples of human degradation."[38] His role as a cultural organizer and promoter of modernism and his internationalism were seen as conflicting with German nationalism. This growing disparity between Liebermann's aesthetic and the officially promoted culture is a crucial feature of the painter's biography. Wilhelm II abhorred the modernist painters and tried, occasionally unsuccessfully, to stem their growing popularity. While Wilhelmine Germany was in many areas an authoritarian state, even the highest officials could not always intervene in the politics of art, in part because culture was generally the sphere of individual provinces rather than the national government. But when the emperor, wearing his crown as the King of Prussia, wanted to intervene as a cultural critic, he gladly did. For example, Wilhelm II relished approving the awarding of medals at exhibitions or signing off on purchases of artworks by Prussian state museums and the commissions for buildings. His decisions then affected the artistic community and public art—including Liebermann personally on several occasions.[39]

Liebermann had lived and studied abroad, then moved to Munich in 1878, where he remained for almost six years, content in the congenial atmosphere and large community of artists. Liebermann ultimately returned to Berlin following his engagement and marriage to Martha Marckwald in 1884. By the mid-1880s when he moved back to Berlin, the painter's reputation in Munich and Paris had preceded him. He had already achieved notoriety through exhibitions and critical press reviews as one of the more visible German artists of the time.[40]

Four years after his return to Berlin, Liebermann's French colleagues asked the painter to invite fellow German artists to exhibit at the 1889 World's Fair in Paris. As Liebermann chose which German artists were invited to participate, the selection unquestionably reflected his aesthetic sensibilities. Like-minded modernists of the time, such as Gotthardt Kühl and Wilhelm Leibl, were represented with six paintings each, and Liebermann also submitted six of his own paintings. Also included were Lesser Ury, Fritz von Uhde, and Wilhelm Trübner.[41] Conservative painters and those unable or unwilling to send paintings dismissed the German section as unrepresentative and mediocre.[42] By organizing a group exhibition for this celebration of the French Revolution's centennial, Liebermann's loyalty was again questioned. The government prohibited Prussian state employees, such as academy artists, from exhibiting at the Fair (where the great attraction was the newly constructed Eiffel Tower). Neither the royal family nor Bismarck saw any reason for German artists to associate themselves with the commemoration of the republican ideologies of the French Revolution. Liebermann, however, had no qualms about exhibiting because he desired to promote international fraternalism rather than national rivalries. This large exposition offered a venue for publicizing German aesthetic modernism. Many Germans continued to consider France as an enemy and a rival, however, and many French viewed Germany in the same manner. Fewer than twenty years after its founding, Germany was a still fragile state. Divisions between south and north, rural and urban, industrial and agricultural, modernity and tradition, conservatives and liberals, and the increasing lure of socialism to a growing working class, all threatened to sunder the nation's tenuous union.

At the time of the 1889 World's Fair in Paris, the young emperor had recently ascended the throne. Known to have opinions on virtually every topic, Wilhelm II had an abiding interest in the arts, which has been documented since the 1890s and continues to fascinate scholars to this day. He supposedly once remarked that if he were not emperor, he would have liked to have become a sculptor.[43] He personally became involved—some say meddled—in architectural projects, museum acquisitions, and art exhibitions. He also enjoyed designing and drawing.[44] He saw himself not primarily as a patron of art—commissioning or purchasing individual works as had been the European royal tradition for centuries—but as a monarch fostering national culture through granting prizes and fellowships to deserving artists, awarding medals, and donating artworks to the nation. His most conspicuous donation was thirty-two groups of statues commemorating his Hohenzollern ancestors placed along the Siegesallee in 1901 (Figure II.6).[45] "I am always of the opinion that the wealthy should contribute something with their money, so it gives pleasure to others," the emperor later explained. "I don't do as so many other aristocrats do—collect expensive works of art and hide them in their palaces. I do not collect. I donate money for my people toward further creativity and create artworks that will give pleasure."[46]

Liebermann's opinion about this royal donation of statues of the emperor's ancestors echoed that of many progressive cultural critics. Liebermann and the emperor were neighbors—the painter lived in an impressive home adjacent to the Brandenburg Gate, near the Tiergarten (a large park on the western edge of the city center). Wilhelm resided in the imposing City Palace a few blocks away on the majestic central avenue, Unter den Linden. Liebermann dismissed the emperor's gift by remarking that he needed to wear "blue goggles" to obscure the view of the statues from his home when looking down toward the Tiergarten.[47] At the turn of the century, when Liebermann wished to construct a glass-walled studio on his roof and applied for a construction variance, Wilhelm II vehemently objected to what he considered a blemish on the city landscape. The artist ultimately was able to build his atelier. The tense relationship between two very opinionated men offers a perspective on the politics of culture in imperial Germany. During the 1890s, after he ascended the throne, Wilhelm II realized that modern art engaged itself with international aesthetic ideas from France and other European countries. As Berlin galleries began to display modern art more frequently, the emperor tried, on occasion successfully, to fight the growing, perceived threat of modernism by vetoing awards and disapproving museum purchases.[48] In contrast, moderation was the hallmark of Liebermann's politics. Civil liberties meant more to the artist than any specific form of government.[49] The emperor represented both authoritarianism and cultural ostentation, which the painter vehemently disliked. On the occasion of the twenty-fifth anniversary of his ascension to the throne, Wilhelm II stubbornly refused to allow the Berlin

II.6 Postcard of the *Siegesallee* (Victory Boulevard), 1905. The boulevard was dedicated by Wilhelm II in 1900.

Secession, the artists' group intimately tied to Liebermann, to participate in the celebrations. Germany's declaration of war in 1914, however, altered dramatically the relationship between the conservative, outspoken monarch and the liberal artist.

WAR AND ITS AFTERMATH

Following Germany's military defeat and a few short months after the creation of the Weimar Republic in 1919, a newspaper interviewed Liebermann about his stance during the war. He acknowledged that he had signed the famous "Declaration of 93 Intellectuals," supporting the war effort:

> Today in any case I would have first carefully examined [the Declaration] before I signed it. At the beginning of the war, one did not ponder long; one was solidly behind one's country. I, of course, know that the socialists have a different point of view. For them, there were neither Frenchmen, Belgians, nor Germans; for them there were only men. I have never been a socialist, and will not become one in my old age. My entire upbringing took place here and I have lived my entire life in this house, where my parents lived. And the German fatherland lives in my heart as an undying idea.[50]

Thus Liebermann considered himself a German patriot and this attitude prevailed especially during the watershed period of World War I.[51] During the war's opening days in 1914, Liebermann expressed his deeply felt love of country and national enthusiasm through his art.[52] He was not alone. Like scores of other intellectuals and artists, he affirmed the rightness of Germany's cause and signed the famous ("infamous," some would say) "Declaration of 93 Intellectuals."[53] The manifesto defended Germany's violation of Belgian neutrality when its imperial armies swept through that small country on their way to the western front in northern France.[54] It implored the allies to "Have faith in us! Believe that we shall carry on this war to the end as a civilized Nation, to whom the legacy of Goethe, Beethoven, and Kant is just as sacred as its own hearths and homes."[55] Liebermann's dealer and close colleague, Paul Cassirer, founded a wartime journal, *Kriegszeit Künstlerblätter*, which initially supported the war wholeheartedly. Liebermann created a series of graphic works for it. In several sketches, German enlisted men are furiously riding horses ready to attack the

II.7 "In Front of the Royal Palace on August 4, 1914." *Kriegszeit Künstlerblätter*, August 31, 1914

enemy. In a famous early drawing, Liebermann captured the feeling of anticipation when the emperor declared war on August 4, proclaiming from the City Palace that he "knew no [political] parties, only Germans" (Figure II.7)[56] For his wartime efforts, Liebermann was awarded the Red Order of the Eagle, Third Class, on the occasion of his sixtieth birthday. "Until now I have been completely unsullied by Prussian orders," a bemused Liebermann wrote to Max Lehrs, the Dresden Museum's curator of prints. "From now on in art also, there are no parties for his majesty."[57]

World War I plunged Europe into the bloodiest war in its history, with approximately half a million German casualties each year of the conflict.[58] The exigencies of war forced the royal Prussian house to make grudging concessions to liberals and liberal ideas. Most significantly, the Prussian three-class voting system, which had given the propertied classes more representation in the provincial legislatures, was modified to direct suffrage after pressures from the political left in 1917.[59]

Five years before the war, Liebermann had built an imposing summer home on the Wannsee, an affluent lakeside colony outside of Berlin inhabited by the capital's wealthy notables, not unlike the coastal summer "cottages" of Long Island, Rhode Island, and Maine built by American industrialists during the Gilded Age.[60] The outbreak of World War I and wartime travel restrictions prevented Liebermann from summering in Holland as he had since his student days in the 1870s. The aging Liebermann never again returned to Holland to paint. The bitterness of the war and its aftermath weighed heavily upon him: "Will I not be certain to find an 'Ententist' [allied countries who fought the Germans in World War I] among my old acquaintances who would feel sorry for me…? First of all, the quiet tranquility, this genuine appreciation of nature and art we can only find at home. Until we rediscover ourselves, we must renounce travel, even to neutral [countries]."[61] For the next fifteen years, his late landscapes originated in the colorfully planted gardens of his Wannsee villa rather than along the windswept coastline or the countryside of Holland.[62]

Liebermann recognized the importance of international cooperation and contact in an increasingly globalized age. Like many of his generation, he took pride in the strength and growing prestige of a united Germany. The shaky new Weimar Republic embraced the elderly painter as a symbol of liberalism. It was hoped that liberalism would renew the wounded national pride by replacing the strident chauvinism of imperial Germany with a gentler and more progressive version of patriotism. When Liebermann was queried by the socialist newspaper *Vorwärts* about his expectations for the future of art in the new, but unsettled political environment, he replied, "Nothing and everything: Freedom! But artistic freedom is not anarchy. Art is knowledge. Art is autonomous. Let each artist do his best, then he will also benefit the people."[63] To Liebermann, then,

II.8 Members of the jury for the fall exhibition of the Prussian Academy of Arts reviewing submitted works, 1927. From the center to the right: Phillipp Franke, August Kraus, Käthe Kollwitz, Max Liebermann, Fritz Klimsch, and Ulrich Hübner.

art must remain independent of politics, whether those of conservative monarchs or of socialist parliamentarians. The artist never wavered from this belief.

Those on the political left and right did not greet Liebermann's above-the-fray perspective happily. The cultural mix in Berlin during the Weimar Republic is often portrayed as exhilarating: the graphics of George Grosz, the theatrical world of Kurt Weill and Bertold Brecht, and the cinema of Fritz Lang. It could also, however, be characterized by the frequent clashes between the forces of extremism and moderation. Art and art exhibitions became contentious battle-grounds during the 1920s, even though Liebermann tried to use his office as president of the Prussian Academy of Arts to "create freedom for the arts in general, protect them against political interference, and increase tolerance for experimentation on the part of the public and of the artists themselves."[64] Controversies broke out repeatedly over a variety of cultural issues, from the organization of museum exhibitions to academic appointments, which had been closed to progressive artists. The press regularly covered these heated and often acrimonious disputes.

Before the war, impressionism had been seen as an integral part of the avant-garde. The emperor and his conservative allies had been adamant in not using government funds to purchase Liebermann's paintings for the National Gallery in Berlin. The Liebermann paintings that found their way into the museum were invariably private donations.[65] After 1919, however, what had been thought to be avant-garde and progressive was now seen as historic and mainstream, if not actually retrograde. This attitude was demonstrated by Ludwig Justi, director of the National Gallery, in his plans for the new exhibition spaces in the Crown Prince's Palace, the National Gallery's annex that contained the latest work of living artists. The annex also housed recent artistic movements, beginning with the more politically progressive painters. By the mid-1920s, impression-ist paintings were moved back to the old National Gallery, and expressionism was seen as the embodiment of the new German aesthetic: "In the way that he installed the work in the [Crown Prince's Palace], Justi created a narrative of German art that began with the accepted art of the Academy and the Secession and reached its apex—both literally and figuratively—in Expressionism."[66]

II.9 *Portrait of President Paul von Hindenburg*, 1927. Staatliches Museum Schwerin

Controversies within the Prussian Academy of Arts under Liebermann's leadership also arose over offering membership to expressionist artists. Initially Liebermann rejected enlarging the number of artists.[67] But by the middle of the decade, even expressionism as an avant-garde movement gave way to new stylistic challenges, such as "New Realism" and abstraction.[68] Debates over style spilled over into political disagreements. Liebermann attempted to steer a moderate and relatively enlightened course between the factions. For example, he endorsed Otto Dix's grim and provocative portrayal of trench warfare, despite right-wing attacks on the Cologne Museum for purchasing the painting.[69] In addition to his support of Dix, he recommended several avant-garde painters to membership in the Academy, including the expressionist Max Pechstein and the leftist graphic artist Käthe Kollwitz.[70]

Liebermann's moderation did not sit well with those on either end of Weimar's fractious political spectrum. In 1927, the year Liebermann painted his portrait of Hindenburg (Figure II.9), both the right- and left-wing extremists vociferously attacked the artist for having the audacity to paint the Prussian general. The communists accused Liebermann of being a secret militarist. On the far right, the Nazis repeatedly condemned Liebermann in their anti-Semitic newspaper, the *Völkischer Beobachter,* leveling death threats at him because the artist personified "the most sinister international conspiracy" against Germany and German culture (Figure II.11).[71]

In the immediate postwar years, the country suffered through a disastrous hyperinflation as well as political instability brought about by communist and right-wing attacks on the government. Political opponents blamed the moderate left regime for the nation's economic woes and attempted to overthrow the regime on several occasions. The most famous attempt occurred during the 1923 Munich Beer Hall Putsch when the Nazis planned to march on Berlin and forcibly take over the government. Its failure led to Adolf Hitler's trial and his short imprisonment in the Landsberg prison, where he dictated his infamous memoir, *Mein Kampf,* to his secretary, Rudolf Hess. By the middle of the decade, however, Germany's economy was on the mend and political extremism appeared to be in retreat.[72]

HONORS AND DISHONOR

On the occasion of his eightieth birthday, accolades extolling Liebermann and his lifelong role in promoting artistic modernism dominated newspapers and magazines. Other celebratory events in 1927 included the staging of a retrospective exhibition at the Prussian Academy of Arts of a hundred major works by the artist and an exhibit of his drawings at the Paul Cassirer Gallery. The city of Berlin awarded its native son an honorary citizenship, and he received the highest civilian order, Pour le Mérite, together with the Shield of the Eagle. The first of the photographs mentioned at the start of this essay was taken that year. It shows Liebermann as he enters the Presidential Palace, carrying his overcoat and what appears to be a sketchbook (Figure II.2). The commission—to paint Paul von Hindenburg's portrait for a provincial museum in Hannover—dramatically suggested that as the grand old man of German painting and current president of the Prussian Academy of Arts, the artist personified the Weimar Republic's desire to bring conservatives, moderates, and liberals together into a "republic

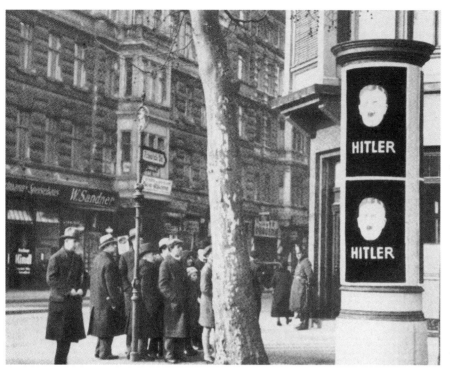

II.10 Friedrichstrasse, 1932

of reason."[73] The portrait itself shows Hindenburg sitting stiffly in sober civilian dress. A film produced for Liebermann's birthday that same year shows the artist energetically at work. In it, Liebermann is rapidly sketching, revealing a mastery of drawing that belies his years.[74]

These birthday tributes and honors were consistent with the steady stream of admiring journalists, artists, and historians from all over the world who frequently paid respects to the elder statesman of German art during the 1920s and early 1930s. In 1928, for example, a young American journalist, Louis Lochner, visited the painter. "We are leaving the diseases of the period immediately following the world war behind us," Liebermann told Lochner during the interview. "There is a general return to sanity, to rationality. Now that more stable conditions prevail, we also find art becoming reasonable again."[75] Like so many others at the time, the artist entirely misjudged the future.

The second photograph discussed at the start of this essay was taken five years later and depicts the slightly stooped painter leaving his polling place in the spring of 1932 (Figure II.1). The five years between the two photographs saw Germany (and the world) plunge into economic depression, rising unemployment, and governmental crises leading to the imposition of martial law. The two most prominent candidates competing for the office of president were Paul von Hindenburg and Adolf Hitler, the right-wing extremist leader of the Nazi party. The war hero Hindenburg had been elected as the candidate of the political right after the death in 1925 of the first president, Friedrich Ebert, a Social Democrat. Facing a humiliating run-off after the first round of polling, Hindenburg now sought a second seven-year term as the candidate of the moderates. It was a telling and unfortunate moment in German history when an authoritarian Prussian general now represented moderation and political stability for many Germans, including Liebermann. Hitler, whose portrait can be seen in the photograph on a poster board worn by an ardent supporter guarding the polling entrance, personified radical change and dreaded uncertainty.

Although Hindenburg ultimately defeated Hitler in the 1932 elections by a margin of 15 percent, winning 53 percent to 37 percent, the victory was hollow. In the second election held in the summer of 1932, the Nazis scored their largest electoral success, garnering over one-third of the popular vote.[76] Since the Weimar Republic's multiparty system precluded any party achieving an absolute majority in the frequently held elections between 1919 and 1933, the Nazi rise from obscurity to undisputed prominence as the largest political party within a decade was astounding.[77] As a result, in January of 1933, Hindenburg invited Hitler to join the government as chancellor.

A month after Hitler's appointment, the parliament building mysteriously caught fire, allowing the Nazis to declare a national emergency. The last election, held a week after the fire, brought the Nazis 44 percent of the popular vote. With conservatives joining their ranks, the party held an absolute majority in the parliament. The new majority promptly issued laws banning opposition parties, the first step on the road to dictatorship and the destruction of Germany's Jewish

II.11 "Jews in Art," an anti-Semitic photo collage, from Joseph Goebbels, *Das erwachende Berlin* (Munich: F. Eher), 1934.

community, of which Liebermann was one of its most visible representatives. The evening of Hitler's appointment as chancellor on January 30th brought his ecstatic supporters out to celebrate their victory. From early evening until after midnight, uniformed paramilitary groups, including the storm troopers, marched through the Brandenburg Gate. From his house located nearby, the artist could hardly ignore the marching, the torchlight parades, and the noisy shouts that continued for hours. It was then, with the Nazis on the verge of power, Liebermann scornfully remarked, "I cannot eat as much as [I] want to vomit."[78]

Hitler's coming to power in 1933 meant that the world of Liebermann's nineteenth-century liberal political views was slated for extinction. As a Jew, as a political moderate, and as a modern painter, Liebermann represented to the Nazis all that was "alien and un-German."[79] Liberalism as a form of progressive politics could not adequately respond to the cataclysmic events of recent history. The horrific casualties of World War I, the rise of communism, Stalinism, fascism, and national socialism all demanded extreme political responses that liberals were unable or unwilling to provide. As Germany and the world tumbled into economic despair, liberal ideas of free markets and laissez-faire capitalism unrav-

eled. In early April of 1933, the Nazis launched a boycott of Jewish shops. On May 8, Liebermann resigned from the Prussian Academy of Arts. A day later, the artist elaborated on his decision: "It is my conviction that art has nothing to do with politics or descent."[81] Two years later, Karl Scheffler, Liebermann's longtime friend and editor of the now-banned art journal, *Kunst und Künstler*, sadly remarked at the painter's gravesite, "We do not simply bury a great artist, but an entire epoch. He was the symbol of an epoch".[81] Liebermann's paintings were removed from the walls of museums and included in several exhibitions of "degenerate art"[81] held in the 1930s to highlight Nazi hatred of Jewish and avant-garde art. A year after Liebermann's death, the Jewish community held a memorial exhibition to honor his achievements.[82]

THE VISION OF LIBERALISM

On May 8, 1945, twelve years to the day after Liebermann resigned the presidency of the Prussian Academy of Arts, Nazi Germany surrendered to the Allies. The country was in ruins, including Liebermann's house directly to the north of the Brandenburg Gate. After the horrors of Nazism and the Holocaust, both East and West Germany wanted to restore Liebermann to the pantheon of artists. Between 1945 and 1949, his work was shown in the eastern and western zones of military occupation. Memorial exhibits to commemorate his birth in 1847 were held in Berlin and in Hannover in 1947.[83] Since the 1940s, numerous exhibitions have been mounted in Germany, Switzerland, and France. The early exhibitions promoted the vision of Liebermann's emancipatory efforts on behalf of internationalism and modernism in the arts—the very issues so roundly condemned by the Nazis.[84] Even during the Cold War, the German Democratic Republic and the Federal Republic of Germany embraced Liebermann and his art, which was considered progressive on both sides of the wall. While the German Democratic Republic could not claim Liebermann as a communist or socialist, his critical stance toward monarchial authoritarianism allowed him to be incorporated into its pantheon. Since the fall of communism and Germany's reunification in 1990, the number of Liebermann exhibitions has increased markedly. His summer home on the Wannsee has undergone renovation and currently houses the Max Liebermann Society. The site promotes his art through exhibitions and publications.[85]

Now that the European Union's cultural policies encompass Liebermann's liberal vision, his consistently articulated ideas about painting and politics may be seen to mark the beginning, not the end, of an era. His lifelong belief that art must remain both ecumenical and independent of organized politics is one that certainly resonates with the majority of Germans today. Thus, it can be argued that the volatile relationship between the artist and his homeland during the nineteenth and twentieth centuries can be measured in part by the degree to which Germany ultimately subscribed to Liebermann's liberal values.

NOTES

1. "Ich verabscheue…Dilettantismus in der Politik ebenso wie in der Kunst." Hans Ostwald, *Das Liebermann-Buch* (Berlin: Paul Franke Verlag, 1930), 290.

2. For biographies of Liebermann, see Erich Hancke, *Max Liebermann, sein Leben und seine Werke.* 2nd ed. (Berlin: Cassirer, 1923); Günter Busch, *Max Liebermann: Maler, Zeichner, Graphiker.* (Frankfurt am Main: S. Fischer, 1986).

3. For a perceptive overview of nineteenth-century German history, see David Blackbourn, *The Long Nineteenth Century: A History of Germany, 1780–1918* (New York: Oxford University Press, 1998).

4. David Large, *Berlin* (New York: Basic Books, 2000), 9.

5. For additional English language histories of Berlin, particularly during the imperial period, see Gerhard Masur's *Imperial Berlin* (New York: Basic Books, 1970) and Ronald Taylor's *Berlin and its Culture* (New Haven, CT: Yale University Press, 1997).

6. On early nineteenth-century Berlin neoclassicism, see David Watkin and Tilman Mellinghoff, *German Architecture and the Classical Ideal* (Cambridge, MA: MIT Press, 1987), 59–118. On early-nineteenth-century salons, especially the cultural relationships between Berlin elites and cultivated Jewish women, see Deborah Hertz, *Jewish High Society in Old Regime Berlin* (New Haven, CT: Yale University Press, 1988). See also Emily Bilski and Emily Braun, *Jewish Women and Their Salons: The Power of Conversation* (New York: The Jewish Museum, 2005).

7. For example, Liebermann wrote for such journals as *Pan* and *Kunst und Künstler*, exhibited at the Schulte and Cassirer galleries, and headed the Berlin Secession for over a decade.

8. Liebermann admired and quoted both writers frequently. In addition, he made a set of lithographs to illustrate an edition of Goethe's work. See Goethe, *Gedichte* (Berlin: Paul Cassirer, 1924–1926).

9. See "The Constitution of the German Republic, 1919," in *The Weimar Republic Sourcebook*, ed. Anton Kaes, Martin Jay, and Edward Dimendberg (Berkeley: University of California Press, 1994), 46–51.

10. Peter Paret, "'The Enemy Within'—Max Liebermann as President of the Prussian Academy of Arts," in *German Encounters with Modernity, 1840-1945* (Cambridge: Cambridge University Press), 185–201. The essay is a revised version of Paret's 1984 Leo Baeck Memorial Lecture of the same title.

11. See, for example, *Im Streit um die Moderne: Max Liebermann, Der Kaiser, Die Nationalgalerie*, ed. Angelika Wesenberg, Ruth Langenberg, and Sigrid Achenbach (Berlin: Nicolai and SMPK, 2001).

12. "Die ersten Eindrücke und Anschauungen bleiben. Ich unterhalte mich auch nicht sehr gern mit Politikern." Paul Eipper, *Ateliergespräche mit Liebermann und Corinth* (Munich: Piper, 1976), 20.

13. "Da ich 1847 geboren wurde, ist es nicht zu verwundern, daß meine politischen und sozialen Anschauungen die eines Achundvierzigers waren und geblieben sind. Obgleich ich oft genug leider vom Gegenteil überzeugt wurde, bilde ich mir ein daß—wie es in der Verfassung heißt—jeder Staatsbürger vor dem Gesetze gleich ist." Liebermann, "Autobiographisches," in *Die Phantasie in der Malerei: Schriften und Reden* (Frankfurt am Main: S. Fischer, 1978), 30. See Jonathan Sperber, *Rhineland Radicals, the Democratic Movement, 1848–1849* (Princeton, NJ: Princeton University Press, 1991).

14. "Ich habe mich nie in Politik gemischt. Sie ist eine Kunst wie jede andere, die ernsthafte Studien verlangt." Ostwald, *Das Liebermann-Buch*, 290.

15. "Ich verabscheue die Kaffeehaus- und Bierbankpolitiker und den Dilettantismus in der Politik ebenso wie in der Kunst." Ostwald, *Das Liebermann-Buch*, 290. Liebermann's allusion to beer-hall politicians could certainly be a reference to Adolf Hitler and the Nazis.

16. For a detailed history and genealogy of the Liebermann family, see Marina Sandig, *Die Liebermanns, Ein biographisches Zeit-und Kulturbild der preußisch-jüdischen Familie und Verwandtschaft von Max Liebermann* (Neustadt an der Aisch: Verlag Degener, 2005), 179–290.

17. Most parliamentarians subscribed to "unconditional equality" for Jews in Germany. See Brian Vick, *Defining Germany, The 1848 Frankfurt Parliamentarians and National Identity* (Cambridge, MA: Harvard University Press, 2002), 104.

18. See the discussion of political activity in Margaret Anderson's *Practicing Democracy, Elections and Political Culture in Imperial Germany* (Princeton, NJ: Princeton University Press, 2000).

19. "Am Küchentisch sitzen Kuhhirt, Mädchen, Knecht, Herrschaft alles beisammen und essen aus derselben Schüssel. Alles duzt sich wie eine große Familie." Liebermann, letter to his brother Felix, 1879. Quoted in Ostwald, *Das Liebermann-Buch*, 110. Recent scholars have questioned whether Liebermann had actually written this letter or, if he had written it, misdated it, since he apparently visited Zweeloo in 1882. But Liebermann was notorious for changing dates of events and his own art. See the following for questions about the letter's authenticity and date: Holly Richardson, "Landscape in the Work of Max Liebermann," Ph.D. dissertation, Brown University, 1991, 127, n. 239. See also, Matthias Eberle's catalogue, *Max Liebermann, Werkverzeichnis der Gemälde und Ölstudien*, vol. 1, *1847–1899* (Munich: Hirmer, 1995), 16, and David Katz, "Max Liebermann, Living History and the Cultivation of the Modern Elite," Ph.D. dissertation, University of Minnesota, 1997, 80.

20. He could never be characterized as a socialist, despite the attempts of his early critics to do so. He also disliked the turn-of-the-century avant-garde movements that challenged impressionism and, in particular, the expressionists.

21. Ferdinand Lassalle, "Open Letter to the National Labor Association of Germany," 1863, in *German Essays on Socialism in Nineteenth Century*, ed. Frank Mecklenburg & Manfred Stassen (New York: Continuum, 1990), 79–102.

22. "Ich habe Lassalle auch einmal persönlich gesehen in Berlin; er war strahlend schön wie ein junger Gott. So populär, daß jedermann auf der Straße erkannte." Eipper, *Ateliergespräche mit Liebermann und Corinth*, 21.

23. See the recent discussion of the changing role of artists in Charles E. McClelland, *Prophets, Paupers, or Professionals? A Social History of Everyday Visual Artists in Modern Germany, 1850-Present* (Oxford: Peter Lang, 2003). On the art unions, see Thomas Schmitz, *Die deutschen Kunstvereine im 19. und frühen 20. Jahrhundert: Ein Beitrag zur Kultur-, Konsum-und Sozialgeschichte der bildenden Kunst im bürgerlichen Zeitalter* (Neuried: Ars Una Verlagsgesellschaft, 2001).

24. See Emily Bilski et al., *Berlin Metropolis: Jews and the New Culture, 1890–1918* (Berkeley, CA: University of California Press, 1999) and Peter Paret, *The Berlin Secession* (Cambridge, MA: Belknap Press of Harvard University Press, 1980).

25. In a wonderfully lucid summary of modern art, Richard Brettell discusses the multiple roles of the city and of modern capitalism for the modern artist. Liebermann was inextricably bound up in the aesthetic politics of urban capitalism, especially the growing role of museums, exhibitions, private art galleries, and publicity through criticism and journal literature. See "Urban Capitalism" in Brettell, *Modern Art, 1851–1929* (Oxford: Oxford University Press, 1999), 51–63. See also Robert Jensen, *Marketing Modernism in Fin-de-Siècle Europe* (Princeton, NJ: Princeton University Press, 1994), 187–200.

26. Ostwald, *Das Liebermann-Buch*, 186.

27. See note 12.

28. "Denn da den Menchen einzig und allein die Arbeit glücklich machen kann, so scheint mir am wünschenwertesten, daß einem von der Vorsehung ein möglichst günstiges Terrain zur Arbeit gegeben wird, damit die Arbeit auch gut nutzbar sei," Liebermann, letter to his brother Felix, Munich, July 16, 1879, quoted in Ostwald, *Das Liebermann-Buch*, 112.

29. Vernon Lidtke, *The Alternative Culture, Socialist Labor in Imperial Germany* (Oxford: Oxford University Press, 1985), 7.

30. The notion of "invented" is taken from Benedict Anderson's now-famous idea of modern nationalism as a form of "imagined communities." Benedict Anderson, *Imagined Communities, Reflections on the Origin and Spread of Nationalism* (London: Verso, 1983). Prussia's provincial budget was larger than the federal budget in the postunification period. While there were many painters throughout imperial Germany whose works could be academic and monumental, von Werner, along with his Bavarian counterpart, Franz von Lenbach are usually seen to epitomize these tendencies. See, for example, *Aspekte der Gründerzeit, 1870-1890,* (Berlin: Akademie der Künste, 1974), 7–15, 45–52, and Peter Paret, *Art as History, Episodes in the Culture and Politics of Nineteenth-Century Germany* (Princeton, NJ: Princeton University Press, 1988), 165–180.

31. See Karen Lang, "Monumental Unease: Monuments and the Making of National Identity in Germany," in *Imagining Modern German Culture, 1889–1910,* ed. Françoise Forster-Hahn (Washington, DC: National Gallery of Art, 1996), 274–299.

32. See the recent accounts of cultural modernism in the provinces, Meike G. Werner, *Moderne in der Provinz, Kulturelle Experimente im Fin de Siècle Jena* (Göttingen: Wallstein, 2003), and Jennifer Jenkins, *Provincial Modernity, Local Culture and Liberal Politics in Fin de Siècle Hamburg* (Ithaca, NY: Cornell University Press, 2003).

33. For discussions on the relationship of provinces and cities to the national state, see Celia Applegate, *A Nation of Provincials, The German Idea of Heimat* (Berkeley: University of California Press, 1990) and Alon Confino, *The Nation as Metaphor, Württemberg, Imperial Germany, and National Memory, 1871–1918* (Chapel Hill, NC: University of North Carolina Press, 1997).

34. *Adolph Menzel, 1815–1905, Between Romanticism and Impressionism,* ed. Claude Keisch and Marie Ursula Riemann-Reyher (New Haven, CT: Yale University Press, 1996), 64. See also Matthew Jeffries, *Imperial Culture in Germany, 1871–1918* (Houndshill, UK: Palgrave Macmillan, 2003), 99–128.

35. Jeffries, *Imperial Culture in Germany*, 64.

36. For an overview of artistic life, from retrograde to avant-garde, see Robin Lenman's *Artists and Society in Germany, 1850–1914* (Manchester, UK: Manchester University Press, 1997).

37. "Gestern erhalte ich die angenehmste Nachricht, die mir noch je zugekommen ist. Sechs der allerberühmtesten französischen Maler organisieren für Januar künftiges Jahres eine internationale Ausstellung, zu der 20 Maler eingeladen werden, darrunter sechs Franzosen und 14 Ausländer. Italiener, Spanier, Schweden, Engländer, Russen. Als einziger Deutscher bin ich aufgefordert mit auszustellen, was viel ehrenvoller ist als die früheren Ausstellungen, die von Kunsthändlern organisiert waren. [Menzel und Knaus waren die einzigen deutschen Künstler, die dazu aufgefordert waren. Note by the editor, Hans Ostwald] Diese Einladung bewies mir, daß die Künstler meine Bilder besonders anerkennen. Und wenn ich diesmal die Medaille wieder nicht bekomme, so hat das politische Gründe," Liebermann, letter to his brother Felix, Zweloo, July 17, 1882. Quoted in Ostwald, *Das Liebermann-Buch*, 114.

38. Adolf Rosenberg, *Geschichte der modernen Kunst* (Leipzig: Fr. Wilhelm Grunow, 1894), III, 243–244.

39. Bernhard von Bülow, German chancellor at the turn of the century, later wrote: "I think few things damaged William more in the eyes of the cultured section of the German people than his one-sided, blind, and nearly always intolerant attitudes in matters of art." *Memoirs: From the Secretary of*

State to Imperial Chancellor, 1897–1903 (Boston: Little Brown, 1930), 204–205.

40. See the recent discussion of art journal criticism in Beth Irwin Lewis, *Art for All? The Collision of Modern Art and the Public in Late-Nineteenth-Century Germany* (Princeton, NJ: Princeton University Press, 2003), 48–49.

41. *Exposition Universelle de 1889, Catalogue Illustré des Beaux-Arts, 1789–1889* (Lille, 1889), 59–60.

42. See Anton von Werner's disparaging remarks in *Erlebnisse und Eindrücke, 1870–1890* (Berlin: Verlag Mittler und Sohn, 1913), 564–567.

43. Martin Stather, *Die Kunstpolitik Wilhelms II* (Constance: Hartung-Gorre Verlag, 1994), 69.

44. There are many accounts of Wilhelm's interference in art-related matters. See *The Berlin Secession; Imagining Modern German Culture, 1889–1910*; W. J. Mommsen, *Imperial Germany, 1867–1918: Politics, Culture and Society in an Authoritarian State* (London: Arnold, 1995), Paul Seidel, *Der Kaiser und der Kunst* (Berlin: Seemann, 1907). See Nicolaas Teeuwisse, *Vom Salon zur Secession* (Berlin: Deutscher Verlag für Kunstwissenschaft, 1986) for an aesthetic overview of Berlin cultural politics during the last three decades of the nineteenth century.

45. The emperor's speech, condemning "art from the gutter," at the opening ceremony of the Siegesallee has been quoted many times, in particular the passage directed at painters such as Liebermann. See "Rede zur Einwerkung des Siegesallee am 1812. 1901," *Die Reden Kaiser Wilhelm II*, vol. 3, *1901–1905*, ed. Johannes Penzler (Leipzig: Reclam, 1907), 60. The Siegesallee was the subject of many satiric cartoons in humor magazines like *Simplicissimus*.

46. Quoted in Stather, 69–70. On his thirty-fifth birthday, Wilhelm established a grant for the study of classical art; in 1902, he funded a Goethe prize for study in Rome.

47. Quoted in Barbara Tuchman, *The Proud Tower* (New York: Macmillan, 1966), 303.

48. On Wilhelm as a "symbol" of the nation, see Thomas A. Kohut, *Wilhelm II and the Germans, A Study in Leadership* (New York: Oxford University Press, 1991), 155–176.

49. This plea for freedom of thought and freedom for art generally can be seen during the Reichstag debates over an anti-obscenity bill, the Lex Heinze, in 1900. Liebermann, along with other liberal artists, vehemently protested the measure. See Robin Lenman, "Art, Society, and the Law in Wilhelmine Germany: the Lex Heinze," *Oxford German Studies* 7 (1973): 86–113.

50. "Jene vielbesprochene Kundgebung der 93 Intellektuellen habe auch ich unterschrieben, ich leugne es nicht. Heute allerdings würde ich erst eine ernste Prüfung vornehmen, ehe ich meinen Namen hergäbe. Zu Beginn des Krieges überlegte man aber nicht erst lange. Man war mit seinem Landes solidarische verbunden. Ich weiß wohl, daß die Sozialisten eine andere Auffassung haben. Für sie gibt es weder Franzosen, noch Belgier oder Deutsche, für sie gibt es eben nur Menschen. Ich bin nie Sozialist gewesen, und man wird es auch nicht mehr in meinem Alter. Meine ganze Erziehung habe ich hier erhalten, mein ganzes Leben habe ich in diesem Hause zugebracht, das schon meine Eltern bewohnten. Und es lebt in meinem Herzen auch das deutsche Vaterland als ein unantastbarer und unsterblicher Begriff." Liebermann, interview in *Berliner Zeitung am Mittag*, June 12, 1919. Quoted in Ostwald, *Das Liebermann-Buch*, 288–290.

51. For a balanced account of the war, see Roger Chickering, *Imperial Germany and the Great War, 1914–1918* (Cambridge: Cambridge University Press, 1998). See also Wolfgang Mommsen, "Artists, Writers, and Intellectuals and the Meaning of War, 1914–1918," in *State, Society and Mobilization in Europe during the First World War*, ed. John Horne (Cambridge: Cambridge University Press, 1997), 21–38, and Christard Hoffmann, "Between Integration and Rejection: The Jewish Community in Germany, 1914–1918," *State, Society, and Mobilization...*, 89–104.

52. Liebermann had family connections to those civilians close to the war effort. Walther Rathenau assumed early responsibility for a policy of wartime rationing and substitutions for scarce resources. See Gerhard Hecker, *Walther Rathenau und sein Verhältnis zur Militär und Krieg* (Boppard am Rhein: H. Boldt, 1983). Liebermann's only child, Käthe, was married to Kurt Riezler, assistant and secretary to the wartime Chancellor Theobald Bethmann Hollweg. His diary recorded the days of crisis during the conflict. Riezler's wartime diaries have become an important source of information because Bethmann Hollweg's papers were destroyed in 1945. See Fritz Stern, "Bethmann Hollweg and the War: The Limits of Responsibility," in *The Responsibility of Power, Historical Essays in Honor of Hajo Holborn*, ed. Leonard Krieger and Fritz Stern (Garden City, NY: Doubleday, 1969), 271–307.

53. A recent account of the enthusiasm of the "August Days" takes issue with the overall public support for the war: Jeffrey Verhey, *The Spirit of 1914, Militarism, Myth, and Mobilization in Germany* (Cambridge: Cambridge University Press, 2000). However, Verhey acknowledges that middle-class intellectuals did embrace solidarity in the opening days of war.

54. See "To the Civilized World: Manifesto of the German University Professors and Men of Science," in *The Fall of the German Empire*, vol. I, ed. R. H. Lutz (Palo Alto, CA: Stanford University Press, 1932), 74–77.

55. *The Fall of the German Empire*, 75.

56. See Marion F. Deshmukh, "German Impressionist Painters and World War I," *Art History* 4:1

(March, 1981): 66–79.

57. Liebermann, letter to Max Lehrs, December 25, 1917, Bodenheimer Collection, Leo Baeck Archives, New York, 847.

58. Richard Bessel, *Germany after the First World War* (Oxford, UK: Clarendon, 1993), chapter 1.

59. See the nuanced study of voting behavior in Stanley Suval, *Electoral Politics in Wilhelmine Germany* (Chapel Hill, NC: University of North Carolina Press, 1985), 232–241.

60. For a history of the area, known for the site of the infamous Wannsee Conference that planned the implementation of the "Final Solution," see *Villenkolonien in Wannsee, 1870–1945, Großbürgerliche Lebenswelt und Ort der Wannsee-Konferenz* (Berlin-Wannsee: Edition Hentrich, 2000), 24–39.

61. "[…] bin ich sicher, in einem alten Bekannten nicht einen Ententisten zu treffen? Oder gar einen Freund, der mich bemitleidet? Nein! Die ruhige Unbefangenheit, dieses erste Erfordernis zum reinen Genießen von Natur und Kunst, können wir vorerst nur zu Hause finden. Bis wir uns selbst wiedergefunden haben, müssen wir aufs Reisen—auch in Neutralien—verzichten." Liebermann, "Mit Rembrandt in Amsterdam," *Kunst und Künstler* 19 (1921): 261. Quoted in Margreet Nouwen, "Der Garten im Fluchtpunkt," in *Im Garten von Max Liebermann* (Berlin: Nicolai, 2004), 21.

62. See *Im Garten von Max Liebermann*, a recent exhibition that brought together many of Liebermann's late landscapes, and Anna Teut, *Garten Paradis am Wannsee* (Munich: Prestel, 1997).

63. "Was ich für die Kunst von einem Volkstaat erwarte? Nichts und Alles: Freiheit! Aber Künstlerische Freiheit ist nicht Gesetzlosigkeit; sondern die Kunst ist autonom….Kunst ist Gewissensache; es schaff jeder Künstler, so gut er's vermag, dann schafft er am besten für's Volk." Liebermann, interview in *Vorwärts*, November 17, 1918, Berlin, Landesarchiv, 252-2.

64. Paret, *German Encounters with Modernism*, 190.

65. See Christopher With, *The Prussian Landeskunstkommission, 1862–1911: A Study in State Subvention of the Arts*, vol. 6, *Kunst, Kultur und Politik im deutschen Kaiserreich* (Berlin: Gebr. Mann, 1986); Karl Ulrich Syndram, *Kulturpublizistik und nationales Sebstverständnis*, vol. 9, *Kunst, Kultur, und Politik im deutschen Kaiserreich* (Berlin: Gebr. Mann, 1989); and James J. Sheehan, *Museums in the German Art World: From the End of the Old Regime to the Rise of Modernism* (Oxford: Oxford University Press, 2000), chapter 4.

66. Elizabeth Grady, "The Politicization of Public Opinion on Modern Art at the National Gallery in Berlin, 1818–1933," Ph.D. dissertation, Northwestern University, 2002, 59.

67. Joan Weinstein, *The End of Expressionism, Art and the November Revolution in Germany, 1918–1919* (Chicago: University of Chicago Press, 1990), 42.

68. The literature on art and politics of the Weimar Republic is vast. Some helpful English-language volumes include *German Expressionism, 1915–1925, The Second Generation*, ed. Stephanie Barron (Munich: Prestel, 1988); John Willett, *Art and Politics in the Weimar Period* (New York: Pantheon, 1978); Beth Irwin Lewis, *George Grosz, Art and Politics in the Weimar Republic*, rev. ed. (Princeton, NJ: Princeton University Press, 1991); *German Expressionism, Documents from the End of the Wilhelmine Empire to the Rise of National Socialism*, ed. Rose-Carol Washton Long (New York: G. K. Hall, 1993); W. L. Guttsman, *Art for the Workers* (Manchester, UK: Manchester University Press, 1997)

69. See Dennis Crockett, "The Most Famous Painting of the 'Golden Twenties,' Otto Dix and the *Trench* Affair," *Art Journal*, Spring, 1992, 72–80.

70. In his letter to Dr. Secker, director of the Cologne Museum, commending him for purchasing the work for the museum, Liebermann wrote: "Dix's painting is, so to speak, the personification of war. It is not a dramatic episode as depicted for centuries until Horace Vernet and his epigone Anton von Werner in his war machines, but war as a terrible thing…without pathos…as a historian he simply arranges one fact after another…I consider Dix's painting one of the most significant works of the postwar period" [Das Bild von Dix is sozusagen die Personifizierung des Krieges. Nicht eine Episode des Dramas, wie sie seit Jahrhunderten bis auf Horace Vernet und seinen Epigonen Anton v. Werner in den großen Kriegsmaschinen dargestellt wurden und werden, sondern den Krieg als fürchterlichstes Ding an sich wollte der Künstler im Schützengrabenbilde veranschaulichen, ohne Pathos und ohne bengalisches Feuerwerk. Wie der Historiker reiht er einfach eine Tatsache an die andere….Ich halte das Bild von Dix für eines der bedeutendsten Werke der Nachkriegszeit.]. Ostwald, *Das Liebermann-Buch*, 196. The Prussian Academy of Arts exhibited it in 1924. However, Konrad Adenauer, then Lord Mayor of Cologne, rescinded the museum's purchase order; after the Nazis came to power, it was destroyed.

71. Quoted in Paret, "'The Enemy Within,'" 198.

72. For the earlier, unsettled period, see Gerald Feldman, *The Great Disorder: Politics, Economics and Society in the German Inflation, 1914–1924* (New York: Oxford University Press, 1993).

73. See Peter Gay's classic formulation in *Weimar Culture: The Outsider as Insider* (New York: Harper, 1968). Liebermann largely exemplified this status during the 1920s. In 1925, Liebermann was asked for whom he had voted in the presidential elections held that year after the death of the Social Democrat Friedrich Ebert. In his Berlin dialect, Liebermann admitted that he "did not vote

for him [Hindenburg], I am a democrat. But if he continues to conduct himself as he has these past six months, then I will also vote for him," quoted in Eipper, *Ateliergespräche mit Liebermann und Corinth,* 30. Hindenburg and Liebermann were the same age. For the two versions and two studies of the Hindenburg portraits, see Matthias Eberle, *Max Liebermann, 1847–1935: Werkverzeichnis der Gemälde und Ölstudien,* vol. 2, *1900–1935* (Munich: Hirmer, 1996), 1172–1175.

74 . See Irmgard von zur Mühlen, *Max Liebermann, Klassiker von heute, Revolutionär von gestern,* a documentary film, Chronos.

75. Louis Lochner, interview with Max Liebermann, May 5, 1928, Louis P. Lochner Papers, State Historical Society of Wisconsin, box 11, folder 22. Lochner, William Shirer, and others, were American reporters who lived for long periods in Germany during the 1920s and 1930s. Lochner also interviewed Hitler. Interred by the Germans after the United States entered the war, Lochner was allowed to return to the U.S. in 1942. In his observations about contemporary art, Liebermann may have been suggesting that German expressionist art, prominent in the pre-World War I and immediate postwar period, was on the wane. Liebermann's longtime dislike for German expressionist art was well known.

76. In addition to Hindenburg and Hitler, other coalitions and parties ran candidates. In the second election, Hitler gained votes, receiving 13,400,000 to Hindenburg's 19,300,000. The Communist candidate, Ernst Thaelmann, received 3,500,000. See the description of the last days of the Weimar Republic recounted by a very early opponent of Hitler, Konrad Heiden: *Der Fuehrer, Hitler's Rise to Power* (Boston: Beacon, 1944), 450.

77. *Weimar: Why Did German Democracy Fail?* ed. Ian Kershaw (New York: St. Martin's Press, 1990). See also Thomas Childers, *The Nazi Voter* (Chapel Hill, NC: University of North Carolina Press, 1983).

78. "Ich kann gar nicht so viel fressen, wie ich kotzen möchte." Bernd Schmalhausen, *"Ich bin doch nur ein Maler," Max und Martha Liebermann im "Dritten Reich"* (Hildesheim: Olms, 1998), 41.

79. See Paret's essay, "Modernism and the 'Alien Element' in German Art," which describes this attitude during the imperial period, in *Berlin Metropolis,* 32–57, and *German Encounters with Modernism, 1840–1945,* 60–91.

80. "Nach meiner Überzeugung hat Kunst weder mit Politik noch mit Abstammung etwas zu tun." Liebermann, "Erklärung," May 8, 1933, *Die Phantasie in der Malerei,* 295. See also Hermann Simon, "Jews during the Period of National Socialism," in *Jews in Berlin,* ed. Andreas Nachama, Julius H. Schoeps, and Hermann Simon (Berlin: Art Stock, 2002), 180–220.

81. Karl Scheffler, *Die fetten und die mageren Jahre* (Munich: Paul List, 1946), 354. See the information on the Liebermann family gravesite in Rosemarie Köhler and Ulrich Kratz-Whan, *Die Jüdische Friedhof Schönhauser Allee* (Berlin: Haude & Spener, 1992), 106–115. At the request of his widow, a death mask of Liebermann was prepared by Arno Breker, who became one of Hitler's favorite artists and the most prominent sculptor in Nazi Germany. After World War II, Breker attempted to use his connections to Liebermann during the denazification proceedings to lessen the possibility of punishment. On Breker's checkered career, see Jonathan Petropoulos, *The Faustian Bargain, The Art World in Nazi Germany* (Oxford: Oxford University Press, 2000), 218–254.

82. See the 1936 exhibition catalogue of the Jewish Museum, Berlin, reprinted in *Was vom Leben übrig bleibt, sind Bilder und Geschichten: Max Liebermann zum 150* (Berlin: Stiftung Neue Synagoge Berlin—Centrum Judaicum, 1997). See also Stephanie Barron, "Works of Art in the Galerie Fischer Auction, Grand Hôtel National, Lucerne, June, 30, 1939," in *"Degenerate Art": The Fate of the Avant-Garde in Nazi Germany* (Los Angeles: Los Angeles County Museum of Art, 1991), 162.

83. *Gedächtnisausstellung. Max Liebermann zum 100. Geburtstag. 20 Juli, 1947* (Berlin: Magistrat von Groß-Berlin, 1947) and *Max Liebermann und der deutsche Impressionismus* (Hannover: Landesmuseum, 1947).

84. Lothar Brauner, "Max Liebermann in Berlin und den beiden deutschen Staaten 1945–1989. Zur Rezeption seines Werkes im geteilten Deutschland. Ein Versuch," in *Max Liebermann und die französischen Impressionisten* (Düsseldorf: DuMont, 1997), 55–67.

85. In the last ten years, numerous exhibitions have been held at major German museums, including *"Nichts trügt weniger als der Schein": Max Liebermann der deutsche Impressionist* (Munich: Hirmer, 1995); *Max Liebermann: Jahrhundertwende* (Berlin: Nicolai and SMPK, 1997); *Im Streit um die Moderne: Max Liebermann, Der Kaiser, Die Nationalgalerie* (Berlin: Nicolai and SMPK, 2001); *Max Liebermann: Poesie des einfachen Lebens* (Künzelsau: Swiridoff, 2003). See www.max-liebermann.de for information on the Max Liebermann Society.

Max Liebermann:
German Painter and Berlin Jew

CHANA SCHÜTZ AND HERMANN SIMON

Translated by Claire Chandler Whitner

I was born a Jew and will die a Jew.[1]

IN 1866, LIEBERMANN'S CURRICULUM VITA recorded that "I, Max Liebermann, was born on July 20, 1847 in Berlin. My father, Louis Liebermann raised me faithful to the belidefs of his fathers in the Jewish religion."[2] He never denied his Jewish identity, and he often emphasized it. Yet, he also referred to himself as an "inveterate Jew," who "otherwise felt like a German."[3] Throughout his long life, this dual identity, as German painter and Berlin Jew, both defined his achievements and undermined them. Liebermann's life reveals what was possible—and what was not—for Jews in Germany during the late nineteenth and early twentieth century.

Throughout his long life, the painter expressed his pride at belonging to an established Berlin Jewish family. His grandfather had come to Berlin in 1823 from Märkisch-Friedland, a small city in West Prussia, and became prosperous in the cotton trade.[4] His shop with living quarters, which was to have included a small synagogue, was located at 30 Spandauer Street in the middle of Berlin's former business center. The Liebermann family's successful integration into Berlin society resulted in the city's granting citizenship to his grandfather and his father. Liebermann and his siblings were born citizens of Berlin, which guaranteed them certain rights in the growing metropolis.

Members of the Liebermann family were active within the Jewish community, serving on the board of directors for the official community and supporting Jewish welfare societies. During Liebermann's lifetime, tithing was required of people of all religions in Germany; membership in synagogues was not voluntary but a state requirement, and the tithes went to the community, which administered the synagogues and social service institutions. The Liebermanns were members of the Alte Synagoge, the oldest congregational synagogue in Berlin, whose congregation included many Jewish families who had lived in Berlin since the eighteenth and early nineteenth century and to a certain extent represented the city's Jewish nobility. In his old age, Max Liebermann recalled a visit to that synagogue on the Heidereutergasse, when he was about ten years old. During the service, the exquisite embroidery on the *parokhet* caught his attention. The beautiful curtain, which had been donated by his family, made a great impression on the young Max, who was proud to recognize their name embroidered on it.[5]

After the death of his parents, however, he rarely went to synagogue and his religion remained a private matter. "Actually," he told the readers of the Jewish newspaper *Central-Verein-Zeitung*, when he was in his eighties, "religion, it is

III.1 Max Liebermann in his studio, 1930

151

III.2 Torah curtain, a gift to the Jewish community by the artist's parents, Louis and Philippine Haller Liebermann, before 1892

III.3 Pair of candlesticks given to the Alte Synagogue on Heidereutergasse by the artist's grandparents, Joseph and Marianne Liebermann, in 1855/56

a personal issue. One cannot speak about it; either one feels it or one doesn't. Someone, who knew me well, once wrote that I had no piety, but that I was pious. That is completely true."[6] When Franz Landsberger, the director of the Berlin Jewish Museum[7] as of April 1935, visited the artist in 1927 at his house in Wannsee, Liebermann pointed to a cactus, "which had spines and silky hairs that joined together very artistically into a ball. He said: 'Anyone who looks at that and doesn't think about God is an ass.' After a short while, he added in a quiet voice: 'I believe in him.' With that, his eyes possessed a strange, warm shine."[8]

"I AM ONLY A PAINTER, AND A JEW CAN SURELY BE THAT, TOO."[9]

Opportunities for Liebermann's Jewish contemporaries were very different from their predecessors. While restrictions in certain professions (for example, university professors and high-level governmental and military positions) still existed, Jews of Liebermann's generation could pursue careers in fields outside the textile business or retail trade. Liebermann chose to become an artist. Certainly, he was not financially dependent on his art to earn money. The family's fortune and his own talent made it possible for him to lead an unconstrained artist's life.

On concluding his art studies in Weimar and Berlin, Liebermann aroused a scandal with the exhibition of *Women Plucking Geese*, which was shown in Hamburg in 1872. Although the painting was praised by Adolph Menzel and quickly sold for a sizable amount, one critic remarked on its "repellent hideousness enthroned in undisguised loathsomeness."[10] In Berlin's respected newspaper *Vossische Zeitung*, art critic Ludwig Pietsch spoke of the "raw, stunted pictures of people, distorted and ruined by the intrinsic hideousness, brought about by labor and age," showed in the painting. Yet, the critic had to admit: "He has, however, indisputably proven his great talent."[11]

After spending the next five years living and working in Paris, and taking frequent painting expeditions to Holland, Liebermann moved to Munich in 1879, where another controversy erupted—this time, related to his identity as a Jew. His painting, *The Twelve-Year-Old Jesus in the Temple with the Scholars*

III.4 Portrait of Louis Lieber-mann, 1891 (Study for portrait of Louis and Philippine Liebermann). Jüdisches Museum Berlin

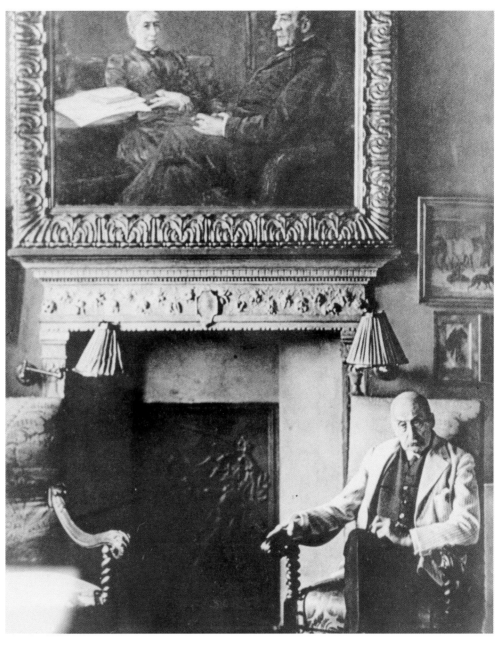

III.5 Max Liebermann in his house at Pariser Platz, July 20, 1922. Over the mantle hangs the portrait of his parents that he painted in celebration their fiftieth wedding anniversary in 1891.

(Figure III.6), created a stir at the third International Art Exhibition in Munich in 1879. Liebermann portrayed Jesus not as a divine being but as a child of the people who confronts the teachers in the temple with self-confidence. His realistic portrayal of the scene and his characterization of Jesus—making it clear that Jesus was Semitic—were considered especially offensive. Only a sketch for the original version of the painting remains (Plate 10): it shows a dark-haired boy with striking features, whose hair is uncombed and hangs down around his temples. Barefoot and in a disheveled robe, he confronts the teachers and gesticulates with his hands.[12]

The Crown Prince of Bavaria was outraged and the Bavarian Parliament felt compelled to debate the painting publicly. In his speech from January 15, 1880, before the Bavarian parliament, the representative from the Catholic Center Party, Dr. Balthasar Daller, stated:

> [it was actually] an issue for the entire artistic community to remove this nuisance. I do not want to step too close to the religious convictions of the painter, who as everyone knows is not a member of the Christian denomination. I do not want to compel him to view the subject of the painting, the divine savior, in whom we believe, as we do;...and I pronounce decidedly the most severe indignation as to the admission of a picture into a state, whose immensely large majority of inhabitants are devout Christians.

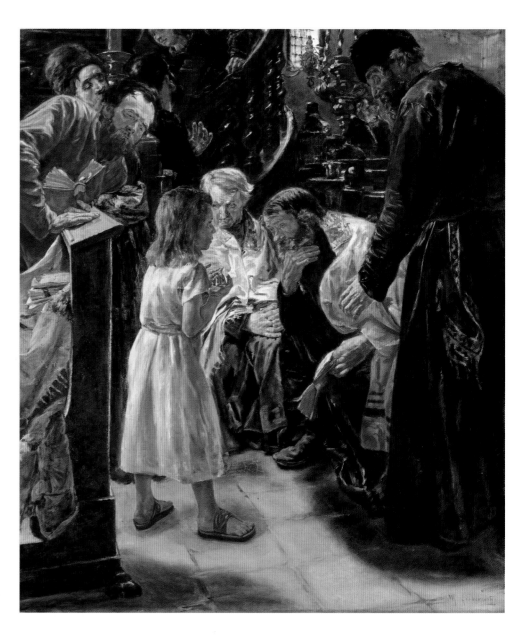

In conclusion, the speaker expressed his hope that, "the artistic community respect the religious convictions of the people from now on and no longer insult them so inconsiderately.[12] As a result of the debate over the painting, Liebermann understood that he had overstepped some boundary, for the critics who disapproved so strongly of his depiction of Jesus did not criticize the painting for its modernism. They simply objected to a Jew painting Jesus as a Jew. Fritz von Uhde, who later purchased the painting, became famous for representing scenes from Jesus' life in a setting of contemporary farmers and handworkers. However, von Uhde was not Jewish and was therefore granted a freedom, "which they did not condone with Liebermann the Jew," as the art historian Heinrich Strauss later commented.[13] Liebermann later changed the Semitic appearance of his Jesus, rendering him with blond hair and traditional dress. He also softened the facial features and downplayed his hand gestures. The altered painting was shown at an exhibition of Cercle des XV at the Galerie Georges Petit in Paris in 1883 and was also included in the 1906 exhibition of the Berlin Secession.

In a letter to Alfred Lichtwark, the director of the Hamburger Kunsthalle, more than thirty years after the scandal, Liebermann wrote that the presentation of the painting was followed by "the most revolting newspaper feuds"[14] and he decided "with all of the uproar, which made it almost impossible for the painting to be appreciated…never to paint a biblical subject again."[15] Liebermann

did not attempt a subject from the New Testament again and produced only few depictions from the Hebrew Bible.[16]

HOLLAND: THE POETRY OF THE SIMPLE LIFE

For forty years until the outbreak of World War I, Liebermann spent long periods of time in Holland every year and found his motifs in the lives of simple people in the austere flat landscape: weavers, farmers, net menders, scenes from orphanages and pensioners' homes, and street scenes, including several of Amsterdam's Jewish quarter. While he shifted his attention from scenes of peasants and workers to scenes of leisure and the world of the upper-middle class at the turn of the century, he also continued to depict the vibrant markets of the Jewish quarter in Amsterdam (Figures III.7, III.8).

The public spirit in Holland also fascinated him. For Liebermann, Holland served as a model for a classless civil society free of social pressures and conventions. In this society, the Jews were respected as citizens with equal rights, which may explain the artist's fascination with the Jewish quarter of Amsterdam. In Holland, the Jews had been integrated since the seventeenth century as a minority within the larger community. This was in stark contrast to Germany, where even Liebermann, who came from an upper-middle-class family, was aware that as a Jew, he would never really have equal rights. Walther Rathenau, once expressed it as follows:

> In the childhood of every German Jew, there is a painful moment, which he remembers for his entire life: When he becomes fully aware for the first time that he has entered the world as a second-class citizen and that no talent or accomplishment can liberate him from this situation.[17]

WELTBÜRGER CULTURE IN MODERN BERLIN

As the painter Wally Moes later commented, the austere and simple life in Holland that Liebermann depicted in his paintings was inconsistent with Liebermann's own worldly lifestyle. She remembered how one evening in a hotel dining room "a very interesting couple entered, he a very distinguished Jew with a piquant devilish face in the stage of advanced youth, she a noble Jewess, pretty, young, charming and elegant. Everything about them sparkled of refinement and newness, coats, luggage, including the immaculate wooden painter's box. They were Liebermann and his young wife."[18]

After the death of the artist's mother, the couple moved, with their daughter Käthe, into his father's house.[19] Near the Brandenburg Gate at Pariser Platz 7, the house was located in the midst of the stimulating cultural life of the imperial capital. One side of the house faced the Tiergarten, Berlin's largest park, with tall trees and lush boulevards. Pariser Platz and Unter den Linden, on the other side of the house, were the sites of a vibrant urban culture with shops, cafes, and magnificent public buildings. After living and traveling in many places in Europe, Liebermann was home: "I live in my parents' house, where I spent my childhood, and it would be difficult for me to live elsewhere. I also prefer Berlin as a permanent place of residence to any other city."[20]

At the end of the nineteenth century, the burgeoning capital of the newly unified Germany was international, enlightened, critical of all conceit, and ready to cast off the ballast of the past. The liberal society of Berlin—publishers and gallery owners, doctors and museum directors, critics and industrialists—was no longer dominated by the imperial court or the military. Private galleries and art dealerships established in the 1880s offered artists like Liebermann a new forum for their work. A jury's rejection could no longer keep an artist's work from popular view. The artists themselves could present their work directly

to the public. The Schulte Gallery near the Brandenburg Gate and the Fritz Gurlitt Gallery on Potsdamer Street actively presented exhibitions. In 1883, the first exhibition of works by French impressionists took place at the Fritz Gurlitt Gallery.[22] The art gallery of publisher Paul Cassirer (1871–1926) and his cousin Bruno (1872–1941), which opened in 1898 with an exhibition of works by Max Liebermann, Edgar Degas, and Constantin Meunier, became a particularly important venue. The cultural establishment of Berlin also changed in these years. For example, Hugo von Tschudi, an outspoken admirer of French modernist painting, was named the director of the National Gallery, which was to become one of the first significant collections of international modernist art. Modernist art collectors including patrons of the Berlin museums Eduard Arnhold, Robert von Mendelssohn-Bartholdy, and Hugo Oppenheim were involved in financing the acquisition of works by Gustave Courbet, Claude Monet, Edgar Degas, Paul Cézanne, and Paul Signac.

Like his neo-Baroque Hohenzollern palace, whose style contrasted with severe, Schinkel-school classicism of Liebermann's house, Wilhelm II had conservative tastes and a strong dislike of the foreign. For many years, the emperor had planned to tear down the residences on either side of the plaza so that the Brandenburg Gate could stand alone as a triumphal arch at the center of his empire. Citizen Liebermann, however, responded simply to the emperor's request, "Please tell his Majesty: Liebermann will only leave his home feet first."[23] The monarch's plan was thwarted. Later, when Liebermann planned to build a glass addition to the attic for use as a studio, the emperor dismissed the design as "hideous." It took numerous hearings but Liebermann finally succeeded in asserting his rights as a citizen of Berlin against the will of the emperor. The studio, designed by the Berlin architect Hans Grisebach, was completed in 1899.

Destroyed along with the rest of the house in the bombings of World War II, the studio is depicted in one of Liebermann's most beautiful works, a painting from 1902. The painter can be seen in a mirror in front of his easel. On one side of the painting, his wife and daughter, who are absorbed in their reading, are sitting on a sofa. Their dachshund, Männe, is shown curled up on a chair below the prominent studio window. Some of the modernist artworks that

Liebermann had acquired, notably works by the French impressionists, can be seen in this view of his studio. His collection included seventeen works—mainly still lifes—by Édouard Manet, pictures by Henri Toulouse-Lautrec, landscapes by Claude Monet, Paul Cézanne, Edgar Degas, and Vincent van Gogh, as well as works by Carl Blechen, Wilhelm Leibl, and Jozef Israëls.

The comfortable and cultured lifestyle of Liebermann at the turn of the century affirmed his ascendance in the world of art and culture in Germany. His identity as a Jew had not hindered him on his path to success as a painter or in asserting his artistic ideas, but his fame and success and his religion persistently placed him at the center of attacks on modernism: "I offered three points of attack: first, I was Jewish, secondly wealthy, and thirdly, had talent. One of them would have sufficed."[22] Ultimately, his Judaism became the focus.

In 1897, Walther Rathenau, who was his father's cousin and also a member of a wealthy Berlin business family, wrote an assimilationist pamphlet called *Hear, O Israel!* In a letter to Rathenau, Liebermann expressed his opposition to its "shrill, provocative passages borrowed from the dictionary of anti-Semitism":

> I view the Jews kindly or at least make an effort to do so: the poor ones—since the rich have themselves baptized—if they are flawed, are compelled to their flaws. Most Christians could also be reproached for the flaws, with which you reproach them. They are all just people anyway, and people are not so different from one another. They have also produced many respectable people: Jesus, the poet of the Psalms, Spinoza and—your cousin. Next time come so that I can cure you of your anti-Semitism.[23]

Whether Rathenau went, we do not know. Certainly, his text was repeatedly quoted by anti-Semites in coming years.

OPPOSITION TO THE ACADEMY

Throughout his entire life, Liebermann was committed to the German constitution and the rights of its citizens. His commitment to civil liberties was primarily expressed in his promotion of freedom, quality, and authenticity in art. In his first formal effort in opposition to the art establishment and in support

III.9 Max Liebermann with his wife Martha, daughter Käthe, and grandaughter Maria in his villa at Wannsee, about 1924

of freedom for artists, Liebermann joined a group of artists, who called themselves "The Eleven" in reference to their membership numbers, in founding a "free society for the organization of artistic exhibitions."[24] Their action was triggered by the closing of a large, one-person exhibition by the Norwegian artist Edvard Munch, at the Association of Berlin Artists because of protests from the more conservative art community, most notably the association's president Anton von Werner, who were not comfortable with Munch's expressive and deeply psychological art.

In a collection of essays called *Springtime for Berlin Art,* published in 1893, author Franz Servaes railed against the endless repetition of motifs, idealized depiction of landscapes, genre paintings, and historicized subjects to be found at the annual Great Berlin Art Exhibition. "Because," as Servaes stated in a dedication to Max Liebermann, "the basic idea of the modernist movement in literature, art, and mankind is that we want to walk around in the free air as free men, upright and unconstrained."[25]

In 1898, Liebermann was elected president of the Berlin Secession, a group of artists who left the Association of Berlin Artists to protest the rejection of Walter Leistikow's painting *Lake Grunewald* (Figure III.10) at the Great Berlin Art Exhibition. At its first exhibition, Liebermann stressed that the sixty-five members of the Secession were primarily concerned with an artist's freedom to determine his own work, unhindered by politics or ideology. "For the selection of works, only talent, how it revealed itself, was a decisive factor....For us, there is no single, redemptive school of art. For us, a work appears as a work of art, regardless of which school it may belong to, when it embodies a sincere emotion. Only the professional practice and the superficial shows of those, who only see art as a cash cow, are excluded."[26] Around 1909, at the height of its influence, the Berlin Secession had ninety-seven full members, including women, and 119 corresponding members including Claude Monet, Edgar Degas, Wassily Kandinsky, and Henri Matisse.

As an internationally known German painter, an erudite advocate for modernism, and president of the Secession, Liebermann was at the center of cultural life in Berlin. Yet, he found that at times his Jewish identity would isolate him from his modernist colleagues.

SUPPORT FOR JEWISH CAUSES

When Liebermann attempted to rally support for the victims of the 1903 Kishinev pogroms among his wide-ranging cultural circle, his longtime friends and colleagues were not forthcoming. He first contacted Wilhelm von Bode, the general director of the Royal Museums in Berlin. Bode's papers include a form letter printed by machine, which Liebermann sent to him and other important public figures. "To benefit the victims of Russia's Jewish pogroms," Liebermann wrote in this letter, "an exhibition of works by Christian and Jewish artists is being organized. The coordinators...invite you to join the committee and hope that you will gladly seize this opportunity to help stop this unprecedented misery and document...your disgust at this atrocity."[27] Liebermann added to this letter a handwritten postscript of approximately the same length

III.10 Walter Leistikow,
Lake Grunewald, ca. 1895.
Nationalgalerie, Staatliche Museen
zu Berlin

as the form letter, in which he personally asked Bode "to join the committee" or rather "lend his name" to it. The records do not contain Bode's reply, but the outcome is described in a letter Liebermann wrote to fellow artist Alfred Nossig three days later: "Bode declined to lend his name to the Committee to Benefit the Russian Jews. Herr von Tschudi, who had made his participation contingent upon Bode's decision, has subsequently also declined. I am very ashamed of having been so mistaken. After the refusal of both of these men, I don't know whether it is advisable to contact others. At any rate, I don't have the courage to do so."[28] There is no record that the exhibition promoted by Liebermann ever took place. It is also not known whether Liebermann acted privately on behalf of the Russian Jews.[29] It was undoubtedly a chilling realization for the artist who had achieved so much to find that his religion could isolate him from his closest colleagues.

NATIONALIST CONDEMNATIONS

For those who opposed modernism and emancipation, the Berlin Secession movement was synonymous with internationalism and anti-nationalism and consequently diminished the status of German artists. Liebermann's own identity as a German painter meant nothing: his Judaism and his cosmopolitanism made him foreign. Increasingly these attacks on anti-nationalist modernism were expressed in anti-Semitic terminology.

In 1905, the art historian Henry Thode delivered a series of highly popular lectures in Heidelberg, in which he presented his nationalist theories of German art. The lectures were planned by Thode to oppose the denigration of the work of artist Arnold Böcklin by critic Julius Meier-Graefe. For Thode, Böcklin was the prophet of a new German art and a bulwark against realism. The lectures, in which Thode railed against modern artists and the Berlin Secession, asserting that the artists, dealers, and critics were only interested in financial gain, were published in the *Frankfurter Zeitung*. Other critics followed Thode with more blatant anti-Semitic statements. Ernst Schnur, a musicologist and cultural critic, wrote that Meier-Grafe supported the German modernists only for his own financial interests and that the Berlin Secession itself was an "art movement of specifically Jewish character."[30] In a rebuttal letter also published in the *Frankfurter Zeitung,* Liebermann accused Thode of using veiled language to conceal

III.11 Liebermann with a plaster cast of his portrait bust, 1932.

his anti-Semitic views. He noted that Thode's derogatory remarks about "lack of national feeling," "aping the French, "lack of poesy" were "now fairly rusty weapons from the armory of anti-Semitism."[31] This letter was followed by an exchange of letters between Liebermann and Thode, that also were published in the newspaper.

In the next year, a well-known critic Lothar Brieger-Wasservogel published *The Case of Liebermann: On Virtuosity in the Visual Arts,* in which he criticized Liebermann and the Berlin Secession. Calling Liebermann weak and old-fashioned and tied to such academic traditions as the dependence on models, Brieger-Wasservogel further asserted that Liebermann was "the most destructive parasite of modern art" and that the Berlin Secession was no more than a commercial venture.[32]

In 1911, Carl Vinnen—a mediocre landscape painter angry over his lack of success—published a manifesto, *A Protest of German Artists,* which decried modernism and the influx of French art into Germany. Vinnen claimed that the art market was being manipulated in favor of foreign works and that the German artists who had been influenced by impressionism and postimpressionism had lost their German identity. Liebermann was among a group of artists who countered that German artists would earn more money if they were more talented.[33]

THE DOOR SHUTS

It would have been out of the question in imperial Germany for Liebermann to have found a position as a salaried instructor at the Royal Institute for Fine Arts: Jews were barred from such positions. Although Jews could be members of the Royal Academy of Arts, it would have been unthinkable for a Jew to become its president. After the war and the fall of the Wilhelmine Empire, the renamed Prussian Academy of Arts selected Lieberman to be its president. He had achieved what had been unthinkable just a few years before: a Jew had become the most important painter in Germany. During the brief life of the democratic Weimar Republic, Liebermann embodied the artistic and intellectual establishment like no other person in Germany.

In 1925, as president of the Prussian Academy of Arts and the most well-

known painter in Germany, Liebermann was asked by the *Jüdische Presszentrale* in Zurich about his views on Judaism for a publication on "Jewish personalities." No other statement from Liebermann is as clear and unequivocal:

> My dear sir, in response to your letter from March 5 (1925), I am very pleased that you want to include an article about me in your weekly publication. In reference to my views on Judaism, I am of the belief that I was born into it, raised in it, and have always remained faithful to it. All of my ideas proceed from the view that I was 'born to see.' Spinoza's 'Deus sive Natura' probably expresses my worldview the best.
>
> The anti-Semitism that arose in the 1870s made my feelings for Judaism exceptionally strong. I view it as slander, when those, who believe something different than I do, claim with alleged flattery that I am an exception among my people: 'Yes, if only all Jews thought as you do.' To which, I give Berthold Auerbach's reply: 'No, if only all Christians thought as I do.'
>
> Yours truly,
>
> Dr. Max Liebermann[34]

He was continually maligned by extremists and increasingly singled out and castigated for being a Jew. His Jewish heritage was exploited by both conservative and liberal factions. "If Liebermann is so enamored of militarism," opined the Communist newspaper *Rote Fahne* on May 25, 1932 when Liebermann painted a Prussian field marshal, "he ought to become the head of a new association of National Socialist Jews."[35] Beginning around 1930 his blatant anti-Semitic opponents within the Academy included the architect, Albert Gessner, and the sculptors Hermann Hosaeus, August Kraus, and Hugo Lederer. He was called "a Jewish swinger of paintbrushes, who had been awarded the title of Professor because he was circumcised."[36] Liebermann was called the "greatest enemy of the German spirit," by Hans Adolf Bühler, the organizer of the first degenerate art exhibition in 1933, who also claimed that Liebermann's tenure as president of the Academy was "the most sinister international conspiracy."[37] The rising tide of fascism left the artist increasingly powerless in the face of ever-increasing attacks.

The painter donated a self-portrait to the Jewish Museum, Berlin, on Oranienburger Strasse, for the opening on January 24, 1933. It differed markedly from all his known self-portraits; the painting shows not a successful painter in a proud pose but an old Jew, who had grown embittered and tired.

A Shattered Dream

When the National Socialists assumed power, it became clear that there was no longer room for Liebermann in Germany's intellectual life. Anticipating his imminent expulsion as a "non-Aryan," he resigned from the Prussian Academy of Arts on May 7, 1933, with the statement:

> Throughout my entire life, I have sought to serve German art with all of my strength. It is my conviction that art has nothing to do with politics or descent. I can, therefore, no longer belong to the Prussian Academy of Arts, whose respectable member I have been for more than thirty years and whose president I have been for twelve, because my point of view is no longer valid. At this time as well, I have resigned the honorary presidency conferred on me by the academy.[38]

In a 1933 letter to the Hebrew poet Hayyim Nachman Bialik, Liebermann, who had distanced himself from Zionism throughout his life, described his response to the events in Germany: "You, Mr. Bialik, perhaps recall the discussions we had on this subject, while I was working on your etching, during which I tried to explain why I distance myself from Zionism. I now think oth-

III.12 Pallbearers carrying Max Liebermann's coffin at his burial in the Jewish cemetery on Schönhauser Allee, 1935

III.13 Funeral wreath from the Association of Jewish Front Soldiers of World War I, 1935

erwise: As difficult as it was for me, I have awoken from the dream that I have dreamt my entire life."[39]

Liebermann died on February 8, 1935, and was buried, as he had wanted, at the Berlin Jewish Community Cemetery on Schönhauser Allee (Figure III.12). Less than a decade earlier, he had spoken to his artist friend Käthe Kollwitz fondly of this cemetery's personal and traditional significance: "It is a nice feeling to know that your grandparents are resting there and your parents and you will also rest there one day."[40]

"In proportion to Max Liebermann's artistic significance, too few mourners took part in the burial," wrote Ernst Braun, "That is not surprising, when one considers the time. However, it is alarming with regard to the degree to which humans can be influenced by pressure, violence and fear."[41] Still, not everyone was afraid. Abraham Pisarek took photographs during the funeral and afterwards: "At the end, when everyone was gone, I photographed the wreaths on the crypt."[42] One wreath came from the Association of Jewish Front Soldiers of World War I (Figure III.13).[43] Much political courage was also required for *Central-Verein-Zeitung*, the Jewish newspaper, to conclude its report on the funeral with the words: "Max Liebermann's mortal remains have now become a part of Berlin's soil, which was and will remain his homeland."[44] The obituary in *Haaretz* read: "What has ended here is more than a man's mortal coil—it is the conclusion of an epoch, the end of a rich, irretrievably lost time."[45]

Rabbi M. Warschauer led the funeral oration, during which he said that Liebermann was "so firmly anchored in German, Berlin, Jewish society…externally and internally, that it was his world…We separate from him with significant sadness: We know his equal will not appear again soon in the realm of art, in Germany and the Jewish community, the two of which converged in his world, as he belonged to both."[46]

NOTES

1. "Ich bin als Jude geboren und werde als Jude sterben." Liebermann in a conversation with Albert Einstein, quoted in Hans Ostwald, *Das Liebermann-Buch* (Berlin: Paul Franke Verlag, 1930), 19. According to Ostwald, Liebermann and Einstein had often discussed the Jewish situation.

2. "Ich, Max Liebermann, bin den 20. Juli 1847 zu Berlin geboren. Mein Vater, Louis Liebermann, erzog mich treu, dem Glauben der Väter, in der jüdischen Religion," quoted in Hans Ostwald, *Das Liebermann-Buch*, 42.

3. "eingefleischten Juden […] der sich im übrigen als Deutscher fühlt," letter from Max Liebermann to Richard Dehmel, Feb. 24, 1908, Staats- and Universitätsbibliothek "Karl von Ossietzky" Hamburg, Dehmel-Archive, L 332.

4. See Miriam Dytman, "Zur Geschichte der Familie Liebermann," in *Was vom Leben übrig bleibt, sind Bilder und Geschichten: Max Liebermann zum 150. Geburtstag: Rekonstruktion der Gedächtnisausstellung des Berliner Jüdischen Museums von 1936*, Stiftung Neue Synagoge Berlin—Centrum Judaicum; Museumspädagogischer Dienst Berlin (Berlin: Die Stiftung, Max-Liebermann-Gesellschaft, and Der Dienst, 1997), 47.

5. K[arl] Sch[warz], "Max Liebermann—Zum 85 Geburtstag am 20. Juli 1932," *Gemeindeblatt der Jüdischen Gemeinde zu Berlin*, July 1932, 164.

6. Überhaupt [...] die Religion, das ist eine innere Sache. Darüber kann man nicht sprechen; entweder man fühlt es oder man fühlt es nicht. Einer, der mich gut gekannt hat, hat mal geschrieben, ich hätte keine Frömmigkeit, aber ich wäre fromm. Das ist ganz richtig," Lise Leibholz, "Besuch bei Max Liebermann," *Central-Verein-Zeitung* , July 15, 1927, 399.

7. On the history of this museum, see Hermann Simon, *Das Berliner Jüdische Museum in der Oranienburger Strasse: Geschichte einer zerstörten Kulturstätte* (Teetz: Hentrich & Hentrich, 2000), 20.

8. "dessen Stacheln und seidige Behaarung sich höchst kunstvoll zu einer Kugel zusammenfügten. Dazu sagte er: Wer das sieht und nicht an Gott glaubt, der ist ein Esel.' Und er fügte nach einer kurzen Weile mit leiser Stimme hinzu: 'Ick glaube an ihn.' Dabei bekamen seine Augen einen ungewohnten warmen Glanz." Franz Landsberger, *Erinnerungen an Max Liebermann*, radio report, Südwestdeutscher Rundfunk, 1961. Typescript by Christine Chrapal and Anja Galinat, Centrum Judaicum Berlin.

9. "Ich bin doch nur ein Maler, und das kann ein Jude doch auch sein." Lise Leibholz, "Besuch bei Max Liebermann," *Central-Verein-Zeitung*, July 15, 1927, 339; reprinted in Katrin Boskamp, *Studien zum Frühwerk von Max Liebermann: mit einem Katalog der Gemälde und Ölstudien von 1866–1889* (Hildesheim and New York: Georg Olms, 1994), 53.

10. "die abschreckendste Hässlichkeit in unverhüllter Abscheulichkeit thront." A.J.M., "Die Hamburger Kunst-Ausstellung," *Beiblatt zur Zeitschrift für Bildende Kunst*, May 31, 1872, S. 312. Quoted in Matthias Eberle, *Max Liebermann, 1847–1935: Werkverzeichnis der Gemälde und Ölstudien,* vol. 1, *1847-1899* (Munich: Hirmer, 1995), 44.

11. "rohen, verkümmerten, durch angeborene, von Arbeit und Alter großgezogene Hässlichkeit, entstellten und verhunzten Menschenbildern [...] Aber sein großes Talent hat er unbestreitbar erwiesen." Ludwig Pietsch, "Die Kunst-Ausstellung im Akademiegebäude XIV," *Vossische Zeitung*, November 5, 1872, supplement. Quoted in Eberle, *Liebermann*, vol. 1, 44.

12. Liebermann, *The Twelve-Year-Old Jesus in the Temple with the Scholars*, crayon over pencil, 43.4 x 30.4 cm, Kupferstichkabinett, Staatliche Museen zu Berlin-Preußischer Kulturbesitz. See Plate 10.

13. [es wäre eigentlich eine] "Sache der ganzen Künstlerschaft gewesen, dieses Ärgernis zu entfernen. Ich will damit der religiösen Überzeugung des Malers, der ja bekanntlich nicht der christlichen Konfession angehört, nicht zu nahe treten, ich will ihn nicht zwingen, dass er den Gegenstand des Bildes, des göttlichen Erlösers, an den wir glauben, auch so betrachtet wie wir; [...] und ich spreche ganz entschieden die ernsteste Entrüstung aus über die Zulassung eines Bildes in einem Staate, dessen unendlich große Mehrheit der Einwohner doch gläubige Christen sind." [Er betonte, dass] "die Künstlergenossenschaft die religiöse Überzeugung des Volkes künftighin achtet und nicht mehr so rücksichtslos beleidigt." Verhandlungen der Kammer der Abgeordneten des bayerischen Landtages im Jahre 1879/80. Stenographische Berichte 103–155.

14. "die sie dem Juden Liebermann nicht hingehen ließen." Heinrich Strauss, "Judentum und deutsche Kunst. (Zum Problem Max Liebermann)," in *Deutsches Judentum. Aufstieg und Krise*, ed. Robert Weltsch (Stuttgart: Deutsche Verlags-Anstalt, 1963), 301.

15. "die ekelhaftesten Zeitungsfehden" and "von all dem Radau, den man jetzt angesichts des Bildes kaum mehr begreift, [...] nie mehr ein biblisches Sujet zu malen," *Künstlerbriefe aus dem 19. Jahrhundert*, ed. Else Cassirer (Berlin: B. Cassirer, 1919), 407.

16. On *Samson and Delilah*, 1893/94 and 1902, see Emily Bilski, "Der Koscherstempel: Jüdische Themen in Werk von Max Liebermann," in *Das Recht des Bildes: jüdische Perspektiven in der modernen Kunst*, ed. Hans-Günter Golinski and Sepp Hiekisch-Picard (Heidelberg: Edition Braus, 2003), 138; on *Die Heimkehr des Tobias*, 1934, see Chana Schütz, "Weil ich ein eingefleischter Jude bin...Zur Rezeption des Jüdischen im Werk von Max Liebermann," in *Was vom Leben übrig bleibt, sind Bilder und Geschichten*, 77.

17. "In den Jugendjahren eines jeden deutschen Juden gibt es einen schmerzlichen Augenblick, an den er sich zeitlebens erinnert: Wenn ihm zum ersten Mal voll bewusst wird, dass er als Bürger zweiter Klasse in die Welt getreten ist und dass keine Tüchtigkeit und kein Verdienst ihn aus dieser Lage befreien kann." Walther Rathenau, *Gesammelte Schriften in fünf Bänden*, vol. 1 (Berlin: S. Fischer, 1918), 188.

18. "ein sehr interessantes Paar eintrat, er ein gut distinguierter Jude mit pikantem Mephistokopf im Stadium fortgeschrittener Jugend, sie eine vornehme Jüdin, schön, jung, liebreizend und elegant. Alles an ihren glänzte von Feinheit und Neuheit, Mäntel, Gepäck, bis hin zur makellosen Malerkiste aus schönem Holz. Es waren Liebermann und seine junge Frau." Quoted in Barbara Gaethgens, "Holland als Vorbild" in *Max Liebermann: Jahrhundertwende*, 91.

19. For a recent biographical study, see Marina Sandig, *Die Liebermanns, Ein biographisches Zeit-und Kulturbild der preußisch-jüdischen Familie und Verwandtschaft von Max Liebermann* (Neustadt an der Aisch: Degener, 2005).

20. "Ich wohne in dem Hause meiner Eltern, wo ich meine Kindheit verlebt habe, und es würde mir schwer werden, wenn ich wo anders wohnen sollte. Auch ziehe ich Berlin jeder anderen Stadt als bleibenden Wohnsitz vor." Liebermann, "Autobiographisches," *Allgemeine Zeitung des Judentums* 74 (1910), 5.

21. See Peter-Klaus Schuster, "Max Liebermann: Jahrhundertwende," in *Max Liebermann: Jahrhundertwende*, 45.

22. "Ich bot ja auch drei Angriffsflächen: ich war erstens Jude, zweitens reich und drittens hatte ich Talent. Eines davon hätte doch genügt," quoted from Peter-Klaus Schuster, "Max Liebermann–Jahrhundertwende," in *Max Liebermann: Jahrhundertwende*, edited by Angelika Wesenberg, Cat. National Gallery Berlin, Berlin 1997, 58.

23. "Es waren vor allem die schrillen provozierenden, dem Wörterbuch des Antisemitismus entnommenen Passagen....Ich betrachte die Juden liebevoll oder bemühe mich wenigstens, es zu thun: die Ärmsten—denn die Reichen lassen sich taufen—sind, wenn sie fehlerhaft, zu ihren Fehlern gezwungen worden. Auch könnte man die Fehler, die Du ihnen vorwirfst, auch den meisten Christen vorwerfen. Au fond sind's alle Menschen, die sich gar nicht so sehr voneinander unterscheiden. Auch haben sie doch ganz respektable Leute hervorgebracht: Jesus, den Dichter der Psalmen, Spinoza u.— Deinen Vetter, Komm nächstes mal, damit ich Die Deinen Antisemitismus austreibe." Helmut F. Braun, "'Höre Israel!'—Antisemitismus und Assimilation," in Hans Wilderotter, *Walther Rathenau, 1867-1922: die Extreme berühren sich, eine Ausstellung des Deutschen Historischen Museums in Zusammenarbeit mit dem Leo Baeck Institute, New York* (Berlin: Argon and Deutsches Historisches Museum, 1933), 24. The letter quoted by Helmut F. Braun, is located in the Staatsbibliothek Berlin, Manuscript dept. Autogr I/2174-1. We quote from the original.

24. "[zu einer] freien Vereinigung zur Veranstaltung von künstlerischen Ausstellungen," according to the founding documents. Quoted in Dominik Bartmann "'...hinaus in die scharfe Luft.' Zur Institutionsgeschichte der Berliner Moderne," in *Berliner Kunstfrühling: Malerei, Graphik und Plastik der Moderne 1888-1918 aus dem Stadtmuseum Berlin,* (Berlin: G+H, 1997), 16, n. 29.

25. "Denn [...] das einzig ist der Sinn der modernen Bewegung in Literatur, Kunst und Menschentum, dass wir aufrecht und unbehindert einherschreiten wollen, in freier Luft als freie Menschen," Franz Servaes, *Berliner Kunstfrühling* [Springtime for Berlin Art] (Berlin: Speyer, 1893).

26. Dominik Bartmann, *Berliner Kunstfrühling*, 18

27. "Zu Gunsten der Opfer der russischen Judenmetzeleien wird eine Ausstellung von Werken christlicher und jüdischer Künstler vorbereitet. Die Veranstalter [...] gestatten sich, Sie zu ersuchen, dem Komitée beitreten zu wollen und erwarten zuversichtlich, daß Sie gern diese Gelegenheit ergreifen werden, dem unerhörten Elende steuern zu helfen und Ihren Abscheu gegen diese Greuel [...] dokumentieren." Liebermann, letter to Wilhelm von Bode, December 7, 1905, Staatliche Museen Berlin SPK, Central Archive, NL Bode 2787. We thank Angelika Wesenberg and Bernd Grabowski (both of Berlin National Gallery) for this information.

28. "dass Bode abgelehnt hat, seinen Namen dem Comite zu Gunsten der russischen Juden zu leihen. Auch Herr v. Tschudi, der seinen Beitritt von der Entscheidung Bode's abhängig gemacht hat, hat im Folge dessen abgelehnt. Ich bin sehr beschämt, mich so geirrt zu haben: ob es rathsam ist nach dem Refus dieser beiden Herrn sich an weitere Kreise zu wenden, vermag ich nicht zu sagen. Jedenfalls hätte ich nicht den Muth dazu." Liebermann, letter to Dr. Alfred Nossig, December 10, 1905, The Jewish National Library, Jerusalem; Schwadron autograph collection, Oxford Centre for Hebrew and Jewish Studies, Yarnton, England.

29. Liebermann did produce a lithograph titled "Kischinev," which was published by *Kriegszeit* on September 16, 1914, a few days after the outbreak of World War I.

30. Paret, *The Berlin Secession: Modernism and Its Enemies in Imperial Germany* (Cambridge, MA: Belknap Press of Harvard University Press, 1980), 177.

31. Paret, *Berlin Secession*, 178. See also Liebermann, "Der Fall Thode," in *Die Phantasie in der Malerei; Schriften und Reden*, ed. Günter Busch (Berlin: Buchverlag der Morgen, 1983).

32. Chana Schütz, "Max Liebermann as a "Jewish" Painter: The Artist's Reception in His Time," *Berlin Metropolis*, 153.

33. Peter Paret, *Berlin Secession*, 189f.

34. "Sehr geehrter Herr, in Beantwortung Ihres Briefs vom 5/3 [1925] freue ich mich sehr, dass Sie einen Aufsatz über mich in Ihrer Wochenschrift bringen wollen. Was meine Stellung zum Judentum betrifft, so bin ich dem Glauben, in dem ich geboren und erzogen bin, stets treu geblieben. 'Zum sehen geboren' gehen alle meine Vorstellungen von der Anschauung aus. Des Spinoza's 'Deus sive Natura' formuliert wohl am nächsten meine Weltanschauung.

Der Ende der 70er Jahre des vorigen Jahrhunderts einsetzende Antisemitismus mußte meine Gefühle für das Judentum außerordentlich stärken. Als Beleidigung fasse ich es auf, wenn Andersgläubige mich als Ausnahme unter meinen Glaubensgenossen mit der vermeintlichen Schmeichelei hinstellen: 'Ja, wenn all Juden so dächten wie Sie,' worauf ich die Antwort Berthold Auerbachs gebe: 'Nein, wenn alle Christen so dächten wie ich.' Ihr sehr ergebener, Dr. Max Liebermann," *Jüdische Presszentrale Zürich* and *Jüdisches Familienblatt für die Schweiz*, 8th year. July 2, 1925. We thank Mrs. Yvonne Domhardt, director of the library of the Israeli Cultural Society in Zurich for the preparation of a copy of this rare article. The original copy of the letter appears to have disappeared. The text, however, is reproduced and transcribed in the essay "Prof. Max Liebermann über seine Stellung zum Judentum," *Das Jüdische Magazin* (Berlin) 1: 2 (August 1929), 9. It is also printed, although without reference to the Central Press, in Matthias Bunge, *Max Liebermann als Künstler der Farbe, Eine Untersuchung zum Wesen seiner Kunst* (Berlin: Gebr. Mann, 1990) 223.

35. Paret, "'The Enemy Within'—Max Liebermann as President of the Prussian Academy of Arts," *German Encounters with Modernism, 1840–1945* (Cambridge: Cambridge University Press, 2001), 198, n. 30.

36. Paret, "'The Enemy Within,'" 198, n. 30.

37. Paret, "'The Enemy Within,'" 198, n. 30.

38. "Ich habe während meines langen Lebens mit allen meinen Kräften der deutschen Kunst zu dienen gesucht: Nach meiner Überzeugung hat Kunst weder mit Politik noch mit Abstammung etwas zu tun, ich kann daher der Preußischen Akademie der Künste, deren ordentliches Mitglied ich seit mehr als dreißig Jahren und deren Präsident ich durch zwölf Jahre gewesen bin, nicht länger angehören, da dieser mein Standpunkt keine Geltung mehr hat. Zugleich habe ich das mir verliehene Ehrenpräsidium der Akademie niedergelegt." Liebermann, *Vossische Zeitung* 219, May 9, 1933, Morning edition, 2.

39. "Sie, Herr Bialik, erinnern sich vielleicht der Gespräche, die wir, als ich sie radieren durfte, über diesen Gegenstand führten und in denen ich zu erklären suchte, warum ich dem Zionismus fern gestanden bin. Heut denk ich anders: So schwer es mir auch wurde, ich bin aus dem Traume, den ich mein langes Leben geträumt habe, erwacht." Liebermann, letter to Ch. N. Bialik and Meir Dizengoff, June 28, 1933. The letter is preserved in its original form at the History of Tel Aviv Museum, Dizengoff Archives, M.H.H.D.1.II.14, and reproduced in the catalogues of the Liebermann exhibitions in Tel Aviv from 1935 and 1943.

40. "Das ist ein feines Gefühl zu wissen, da ruhen deine Großeltern und da wirst du auch einmal ruhen." Lise Leibholz, "Besuch bei Max Liebermann," *Central-Verein-Zeitung*, July 15, 1927, 399.

41. "Im Verhältnis zu Max Liebermanns künstlerischer Bedeutung nahmen zu wenige Trauergäste an der Beisetzung teil. Das verwundert nicht, wenn man die Zeit bedenkt, doch es stimmt hinsichtlich menschlicher Beeinflußbarkeit durch Druck, Gewalt und Angst bedenklich." Ernst Braun, "Die Beisetzung Max Liebermanns am 11. Februar 1935: Umstände, Personen, Überlieferungen, Pressereaktionen," *Jahrbuch der Staatlichen Kunstsammlungen Dresden*, vol. 17 (1985), 168. Braun has worked intensively on the question of who attended the funeral.

42. "Zum Schluß fotografierte ich, als alle schon weg waren, an der Gruft die Kränze." Inge Unikower, *Suche nach dem gelobten Land* (Berlin: Verlag der Nation, 1978), 225.

43. Liebermann felt particularly connected to this group. He worked for them as an artist on numerous occasions and created many commemorative prints, one of which is dedicated to "the mothers of the twelve thousand." Another of these prints was published in 1935 in *The Fallen German Jews, Letters from the Front 1914–18*, edited by the Reich's Union of Jewish Front Soldiers. See Chana Schütz, "Das Denkmal der Berliner Jüdischen Gemeinde für die Gefallenen des Ersten Weltkrieges," in Sabine Hank and Hermann Simon, *"Bis der Krieg uns lehrt, was der Friede bedeutet": Das Ehrenfeld für die jüdischen Gefallenen des Weltkrieges auf dem Friedhof der Berliner Jüdischen Gemeinde* (Teetz: Hentrich & Hentrich, 2004), 30 and 32.

44. "Max Liebermanns sterbliche Reste werden nun Teil der Berliner Erde, die ihn Heimat war und bleibt," *Central-Verein-Zeitung*, February 14, 1935, 2.

45. *Haaretz*, February 15, 1935. *Haaretz* is the Hebrew daily newspaper in Israel.

46. "deutschen, berlinischen, jüdischen Bürgertum [...] äußerlich und innerlich so fest und tief verankert, das seine Welt war [...] Wir scheiden von ihm mit wissender Trauer: Wir wissen, seinesgleichen wird im Reiche der Kunst, wird dem deutschen Lande und dem Judentum, die in seiner Welt sich zusammenfanden, denen beiden er bewußt gehörte, so bald nicht wieder erstehen." Dr. M. Warschauer, "Gedächtnisrede für Max Liebermann," in Adolf Altmann, *Predigten an das Judentum von heute*. Bücher der Erneuerung, vol. 1 (Berlin: J. Goldstein, 1935), 98.

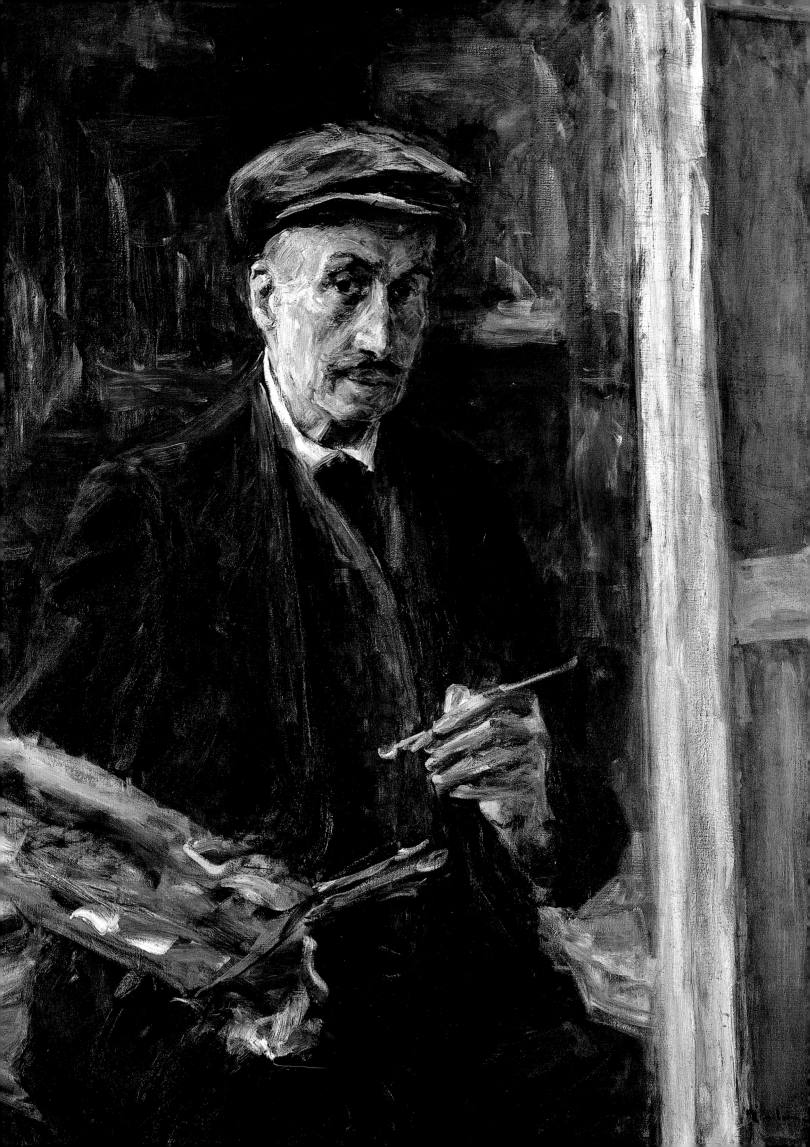

Gentleman's Agreement: Belief and Disillusionment in the Art of Max Liebermann

MASON KLEIN

LONG AFTER MAX LIEBERMANN SERVED as a loyal soldier in the culture wars of late-nineteenth-century Germany, he faced another struggle: a crisis of identity that centered on his German Jewish ancestry. Awakening from "the beautiful dream of assimilation" to the nightmare of Nazism, the painter, who always strove to depict people and objects as truthfully and objectively as possible, no longer "wanted to see this new world around me."[1] As a naturalist painter, Liebermann advocated sensitivity to the rural poor. As a Francophile and annual visitor to Holland, he was open to other cultures. And as an assimilated Jew, he respected more than one religion.[2] These were the worlds that he had once viewed clearly, but which he could now no longer see. What eclipsed them from his view was the inexorable convergence of the two entities he had for so long held apart: his art and his Jewishness. The shutters that he now drew to block the view of Nazi soldiers marching down Pariser Platz had already been symbolically closing for some time.

Liebermann's retreat from this reality had begun much earlier, with his revision of German genre painting, in which he distilled the virtue of labor as he dignified the working class. However contradictory to the innate naturalism of his art, this idealizing tendency had always elevated and tempered his work, even the grittiest of his realist paintings.[3] With his first important picture on the subject of work, *Women Plucking Geese*, 1872 (Figure I.4), he portrayed the peasantry directly, free of storytelling. For him, the straightforward presentation of those who toil under the burden of their lives, the uncompromising depiction of this burden, was subject enough. Critics saw otherwise. These naturalist paintings brought him instant notoriety, as the "painter of filth" and "apostle of ugliness," and kindled outrage in those who demanded that art maintain a romantic view of the German *Volk*.[4]

Beyond the obvious debt his early realist paintings owe to influences as diverse as Gustave Courbet and the Hungarian Mihály Munkácsy, Liebermann's handling of the theme of labor also reflects the equivocal and tenuous place of a Jew in Germany. His preoccupation with class, culture, and achievement was typical of Berlin Jews, for it was only in 1871, the year he began *Women Plucking Geese,* that full emancipation was granted to all citizens. Thus, while Liebermann would later tie his social and political views to those of the generation of the Revolution of 1848, his choice of laborers as subject—seen either in harmony or dissonance with nature—must be reconsidered in a broader

IV.1 *Self-Portrait with Cap*, 1925. Staatliche Museen zu Berlin, Nationalgalerie

sociological context, one that weighs the virtue of hard work for a newly emancipated German Jewish population.

Although born into a privileged, wealthy family, Liebermann's identification with the underclass, through the specific ethos of virtue, spoke to the widespread phenomenon, in the latter half of the nineteenth century, of the Jewish community's attainment of *Bildung*, or high culture. Thus endowed, Jews could feel certain of their full citizenry within the German nation. As a descendant of a family of cotton manufacturers, Liebermann was not supposed to become an artist. [5] Yet he very comfortably and devotedly pursued his vocation. His "true religion," as Amos Elon has defined it for Liebermann's generation of Berlin Jews, "was the bourgeois, Goethean ideal of *Bildung*."[6] The preservation of these ideals was more real to him than religion. It also underlay the aesthetic and ideological contradictions inherent to his work—his dream of assimilation and his quest for artistic independence in the name of individualism. It allowed him to espouse liberal doctrines, while seeking official sanction and reward. It permitted him to maintain a degree of naturalism, while he pursued pure painting. What can we make of a uniquely German impressionist, who sought to root his art in the present but avoided the ubiquitous metaphor of urban modernity as alienation? Who identified with the Revolution of 1848 but avoided political content? Who aspired to pure painting but struggled to achieve it because of his unconscious need, as a Berlin Jew, to paint a naturalistic space that defined and preserved his secure place in the world?

Liebermann's tendency toward cool and restrained imagery has been well noted. The historian Peter Paret writes: "Without editorializing, he retained this detachment....What fascinated him was the physical surface, and how light and shade affected it: what people looked like, not what they might stand for."[7] Liebermann portrayed workers as dignified and noble, demonstrating the values of order, reliability, and cooperation, while retaining a sense of self-containment, even solitude. The reticence of the workers in his paintings characterized an important aspect of the artist as well. In his personal life, Liebermann craved discretion and privacy, especially when it came to religion. In his art as well, he distanced himself from anything too ethnic or anything that might have undercut his more secular German Jewish identity.[8]

Liebermann's philosophical bent, intellect, and sense of fairness were kept whole by his wit, but he was also buoyed by his unquestioned sense of belonging to the greater German Jewish community and, possibly more importantly, to the haute bourgeoisie.[9] Prussian Jews had achieved such material advancement throughout the nineteenth century that, according to the historian Amos Elon, "theirs was perhaps the fastest and greatest leap any minority has experienced in modern European history. Jews had become the most upwardly mobile social group in Germany."[10] Although Liebermann was immune to this kind of repositioning because of his family's early success and wealth, such extreme assimilation and sudden German Jewish social inclusion were often the source of even more virulent anti-Semitism from Gentiles and disgust from Orthodox Jews. In trying to bridge the old and the new, both as a German Jew in Berlin conscious of his roots and as a European artist open to transcultural influences, he absorbed numerous influences from France and Holland, inflecting the fleeting movement and brushwork and vibrant colors of impressionism with his own stamp of German solidity: impasto, volumetric form, and defined local colors. These formal characteristics were wedded harmoniously to the serious, often isolated workers or reserved figures in his paintings.

The sense of detachment, already latent in Liebermann's personal impassivity, is manifested in his art by his inclination to depict people in groups as both engaged and solitary. Interdependent figures share in a specific activity, yet are preoccupied, busy at work, or lost in their own thoughts. Liebermann

stresses this sense through his particular spatial construction. In *At the Swimming Hole*, 1875–77 (Plate 6), a scene showing a group of boys gathered on a dock, he democratically allocates an equal amount of space for each youth. Such a spatial configuration accentuates the sense of individual preoccupation, which is further emphasized by the fact that virtually every boy is alone, withdrawn, with eyes closed or turned away from the viewer. This pairing of solitude and sociability, marking not only the group but also each figure, is especially evident in many of Liebermann's paintings of rural peasantry and in later portraits of the residents of orphanages and old-age homes.

In many of his paintings throughout the 1870s and 1880s, a common value is perceived—whether of diligence or merely the group's general contemplative nature. This objectification, specifically of an underclass depicted without sentiment and pathos or even the anecdotal elements typical of much Jewish painting of the period, confers a certain inherent respectability to a group that was rarely regarded as an autonomous subject. The subtle endowment of a group that otherwise lacked its own substantive reference challenged widely held class preconceptions and stereotypes. By aggrandizing a virtuous working class or a socially responsible one (albeit Dutch not German), Liebermann was, in effect, challenging the pervasive stereotype of Jews as unproductive and lazy.[11]

Before adopting the French style of plein-air painting, Liebermann returned during the 1890s to his darker palette and to the idealistic naturalism of his rural subjects. As a kind of a mid-career appraisal of his artistic identity, before he virtually withdrew from subject matter that could be read as radical (that is, socially minded, labor-oriented, and Jewish), he painted a series of major works that represent the apotheosis of his social consciousness.

When France commemorated the centennial of the Revolution by organizing an international art show in 1889, Germany refused to participate officially, but the French minister of fine arts, Antonin Proust, invited Liebermann to organize an unofficial exhibition of German artists. (See Françoise Forster-Hahn, this volume.) In defiance of his government's wishes, Liebermann curated the exhibition, inviting a group of artists whose work reflected the stylistic range in contemporary Germany, from the realist genre painting of Wilhelm Liebl (1844–1900) to the more alienated cityscapes of Lesser Ury (1861–1931). While the show fared well in Paris, with the naturalist painter Fritz von Uhde (1848–1911) and Liebermann receiving medals of honor, it also fueled German xenophobia toward a French-dominated art scene.[12]

For Liebermann, the exhibition served as an opportunity not only to evaluate German painting but also to take stock of his own varied production over the course of more than a decade. In search of his voice throughout the 1870s and 1880s, the painter had gradually appropriated foreign influences, notably the work of the Hague School, the Dutch counterpart of the French Barbizon School, which he had studied after traveling to Paris in 1872.[13] From these two strands of realism, he created a hybrid naturalism, absorbing them within the German tradition of romantic, heroic landscape that he had made his own.

For his own contribution to the 1889 exhibition, Liebermann selected two paintings—*Recess in the Amsterdam Orphanage*, 1882 (Figure IV.2), and *Women Mending Nets*, 1887–8 (Figure IV.3)—that encapsulated his synthesis of Dutch and French influences. The two vastly different, indeed antithetical, paintings pay homage to a range of influences—his friend Jozef Israëls (1824–1911), a preeminent member of the Hague School, and various French painters from Jean-François Millet (1814–1875) to Jules Bastien-Lepage (1848–1884). Thus, the artist implicitly revealed his cultural identity as complex and dualistic and rebuffed the tendency to reduce aesthetic cultural choices to the parameters set by bias or chauvinism. While both paintings strongly restate his social ideals,

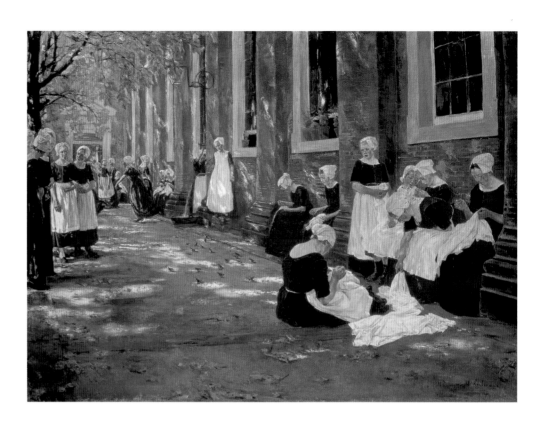

IV.2 *Recess in the Amsterdam Orphanage,* 1882. Städelsches Kunstinstitut, Frankfurt am Main

they do so in a way that reaffirms both his multicultural openness and his own artistic voice.[14]

Liebermann signaled his kinship with the impressionists in what is arguably the finest of his orphanage paintings, *Recess in the Amsterdam Orphanage.* It is also one of his most accomplished and luminous works, bathed as it is with dappled sunlight, filtered through the foliage of trees, which brilliantly activates the surface of the brick building and animates the assembled women. Unlike so many Parisian impressionist urban scenes, where the space is congested with the merging mass of humanity, here the women are seen as individuals, each exacting a different discrete pose. Their solidity, rather than the dissolution of form, is stressed, and the folds of the white linens they sew are more evocative of the baroque than the modern.

In contrast to the soft, contemplative afternoon light of the scene in the orphanage, *Women Mending Nets* is dominated in the foreground by the colossal presence of a young woman in Dutch costume holding the goods of her trade, her heroic dimension enhanced by the increasing diminution of her coworkers, who pepper the vast emptiness behind her in linear perspective. The woman braces herself against the scowling cold, clothed in a dark coat and white hat, which further dramatize the unrelenting grayness of the dominant wintry sky. Her weary but heroic bearing conveys her struggle to survive both the physical elements of nature and the psychological burden of daily worry over the return of the men at sea.

In this painting, Liebermann alludes to the grand romantic landscapes, invoking a quasi-religious reverence for nature (recalling early nineteenth-century German romanticism) while asserting an even more poetic idealization of community, work, and the social collective. Rather than dwarf his figures in the presence of the sublime or set them diminutively in symbolic trespass of the horizon, in the manner of Caspar David Friedrich (1774–1840), he has the viewer look up, literally and figuratively, at these humble people, whose indomitable spirit prevails against nature. Reminiscent of the melancholic Dutch landscape and Rembrandtesque atmospheric painting of Israëls, *Women Mend-*

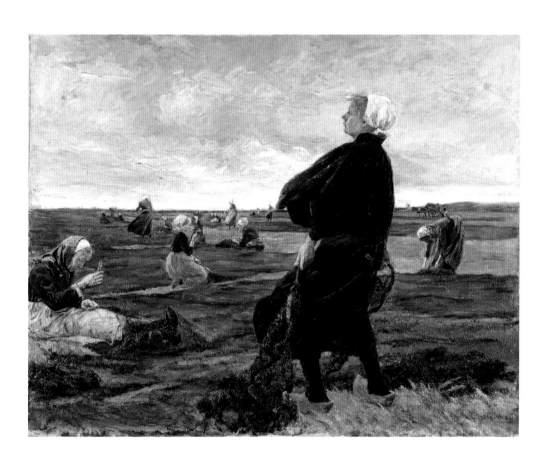

IV.3 *Women Mending Nets,*
1887–8. Hamburger Kunsthalle

ing Nets was one of a series of works that Liebermann produced after visits to the Netherlands in 1886 and 1887.

In *Flax Spinners in Laren*, 1887 (Figure IV.4), another monumental painting from this period, begun the same year as *Women Mending Nets*, Liebermann produces his most exalted homage to the work collective. This panorama of women—who feed long strands of raw flax to the looms, which are tended by children—conjures a spiritual quality in the meditative concentration of the women who conduct their intricate operations with almost musical precision.

This group of works marks a key moment of synthesis in Liebermann's painting. It reflects the culmination of the artist's naturalism and of his long-standing representation of the work ethic and points to the complexity of his multicultural self-identification. The iconic weight that this curious series of paintings carries in German museums today may lie in what the works could not signify in their own day: Liebermann's authentic German voice, at its most eloquent, that is, before he would begin to paint like a Frenchman.

Symbolic of this crossroads is *Old Woman with Goats*, 1890 (Figure IV.5), another large painting from the period that projects, again, a heroic affirmation of struggle and the work ethic in its depiction of an elderly woman traversing the scruffy grass-covered dunes of the Dutch coast with two goats. The woman is seen from below, framed alone against the windswept dunes and a starkly monochromatic bluish gray sky, her heavily impastoed face resembling one of Daumier's roughly molded clay caricatures.[15] Such an angle may have served to underscore the critical juncture that art posed at the time, both for the viewer as well as for the artist. The placement of the viewer in the animals' space seems to intensify the sense of her uphill struggle: one goat walks agreeably alongside her, while the other, on a rope, stubbornly resists. On another level, the woman's determined resistance to being pulled back—as well as the cleaving of the dunes—might allude to the different directions in which the artist himself felt pulled: the pure painting of the French, with its emphasis on the visually perceived and its glorification of modernity and the city, and the concrete naturalism of the German, with its rural settings promoting a more

northern, graphic symbolist accordance of mood and setting.[16] Liebermann presented this painting at the Salon of 1890 in Paris and it won the gold medal in Munich in 1891. Even more significantly, he contributed it, along with three of his first commissioned portraits—a telling juxtaposition—to an exhibition by "The Eleven" in the following year.[17] While the portraits signaled Liebermann's desire for public recognition, *Old Woman with Goats* revealed the deep artistic ambivalence that he was experiencing at this time.

During this intriguing phase in Liebermann's career, undertaken shortly before he redirected his attention to the more contemporary impressionist mode, which he had first essayed a few years earlier, he turned from one subject and painterly style to another. In the end, he would shun the world of the disempowered and set his gaze on the more familiar, socially integrated world of the bourgeoisie by depicting those who populated his world—families strolling in the park or sitting at cafés, polo and tennis players, horseback riders on the beach—before retiring to indulge his passion for painting his garden at Wannsee.

Art historians have rarely considered the degree to which the doubt, insecurity, and ambivalence with which he approached his Jewish identity contributed to Liebermann's aesthetic choices. Might this sensibility have contributed to the artist's disregard for the phenomenological recording of a more autonomous embodiment of vision (as explored by Paul Cézanne, by Liebermann's friend and colleague realist painter Adolph Menzel, or by the expressionists, whom he would reject) or for intellectual subjectivity?[18]

Liebermann, who aspired to pure painting but struggled to achieve it, was unable to free himself from naturalism, to lose himself and his control. His restraint, objectivity, and deadpan naturalist clarity precluded him from entertaining the spatial and perceptual ambiguity of, say, Édouard Manet, whose work he admired and collected. When compared with Manet's integration of politics and aesthetics or the work of a contemporary Berliner, Lesser Ury, who depicted urban alienation with a foreboding unthinkable in Liebermann's art, Liebermann's realistic depiction of the world was probably psychologically reassuring to him, as a member of the haute bourgeoisie.

Throughout his life, Liebermann, the Francophile and highly acculturated Berlin Jew, endured anti-Semitism. But he seemed scarcely to notice it. He turned inward to art, concentrated on absorbing artistic influences and on finding a hospitable reception in Germany for modernism—a euphemism at the time for foreign, mostly French and impressionist, art. During the imperial rule of Wilhelm II (1888–1918) when nationalism was frequently affirmed through anti-Semitism and xenophobia, he made a defiant effort to transcend the obsession with ethnicity and religion. Despite this secularized view, a question haunts Liebermann's life and work: to what extent did his status as a Berlin Jew inform and influence his work?

The artist publicly insisted that being a painter had nothing to do with being a Jew. Even in 1927, at the age of eighty, Liebermann was reluctant to acknowledge the political reality that would soon make these two identities inextricable for him. "A Hitler [newspaper] recently wrote," he said, "that it would be intolerable for a Jew to paint the Reich's president. A thing like that only makes me laugh. I am sure that if Hindenburg hears of it he will also laugh. After all, I am only a painter, and a Jew can surely be that, too." [19] While this statement hints at the artist's exasperation, it also reveals his inability to grasp, even this late, that the German Jewish cultural symbiosis was an illusion.[20]

Such was the degree of Liebermann's assimilation and his role as emissary of the new that it may be argued he was the first significant, fully emancipated German Jewish artist. Unlike Jewish artists who preceded him, such as the German Moritz Daniel Oppenheim, the English Solomon J. Solomon, and the Polish

Maurycy Minkowski, he felt no obligation to explore Jewish tradition or subject matter in his work. He was uninterested in reaching out to other contemporary Jewish painters like Maurycy Gottlieb, who in such works as *Jews at Prayer on the Day of Atonement,* 1878, searched for his roots in an attempt to establish himself as a Jewish artist and created a hybrid form of Jewish history painting.[21] Liebermann's resistance to identifying his art as Jewish was unwavering. Consider the scarcity—aside from his important and controversial paintings, *The Twelve-Year-Old Jesus in the Temple with the Scholars,* 1879, and *Samson and Delilah,* 1902—of religious subjects in Liebermann's work.[22] That both of these overtly Jewish paintings are anomalous within his oeuvre is telling.

Moreover, only in these two Jewish-identified paintings does Liebermann embrace the melodramatic feeling, voluptuous physicality, and emotionalism usually associated with such ethnic painting. German critics considered the dramatic use of the central figures' hands in *The Twelve-Year-Old Jesus in the Temple with the Scholars*—especially those of Jesus, whose animated gesture constitutes the focal point of the painting—disturbingly ethnic.

The artist was bewildered by the fierce response to these works and unwilling to understand the attacks as anti-Semitic, which underscores his excessive idealism. Liebermann's refusal to acknowledge such a cultural divide between Gentile and Jew revealed for the art historian Heinrich Strauss, "the lack of a live Jewish consciousness in [his] art."[23]

Liebermann saw his life and work as commensurate with the then-secular school of European enlightenment. He was less concerned with the toll that modernization had taken on the fabric of Jewish life than with the failure of German culture to embrace the spirit of modernism itself. Most art historians have argued that Liebermann was far less interested in the cultural and social well-being of German Jews than in the freedom and independence of German artists. Believing in the autonomy of art that "set its own laws," he strove for the realization of the "individual" artist, free "to follow his conscience," a cultural figure who would ultimately "benefit the [German] people."[24] Such was the simple idealism expressed by Liebermann and other painters and sculptors who, propelled by the activist painter Walter Leistikow (1865–1908), formed the Berlin Secession in 1898, as an alternative venue for modern art.[25] Throughout the last quarter of the nineteenth century when Franco–German relations were strained, Liebermann achieved prominence as writer, collector, and practitioner of aesthetic and international modernism in a Prussian culture stultified by its academic traditions. He was thus the Secession's most important and innovative voice. The Secession triumphed over the course of its first decade, although its relevance was ultimately superseded by expressionism, the first bona fide German modernist movement. The Secession's success necessitated overcoming deeply rooted xenophobic prejudices in the society and culture at large. "Despite the arguments of its opponents," as Paret has written, "the values that the Berlin Secession represented were German, [yet of]...a Germany that did not close itself off but sought its ideals in alien as well as in native soil."[26] Liebermann's alignment with internationalism had always rested on his belief that to become less retrograde, German painting would have to redefine itself and become less culturally specific and more open to universal ideas. His identification and support of such multicultural forces became grist for those who perceived him and his Franco-centrism as subversive to a pure German art. Such xenophobic—as well as increasingly and more transparently anti-Semitic—criticism rose during the Secession years. Such was the chauvinism to which French-influenced German art was subjected that the radical, even genuinely revolutionary, and often eroticized style of the expressionists was preferable to the art of the "disloyal" German impressionists.[27] The debates on race, culture, and aesthetics were highly convoluted, and the bizarre alignment of reactionary and subversive

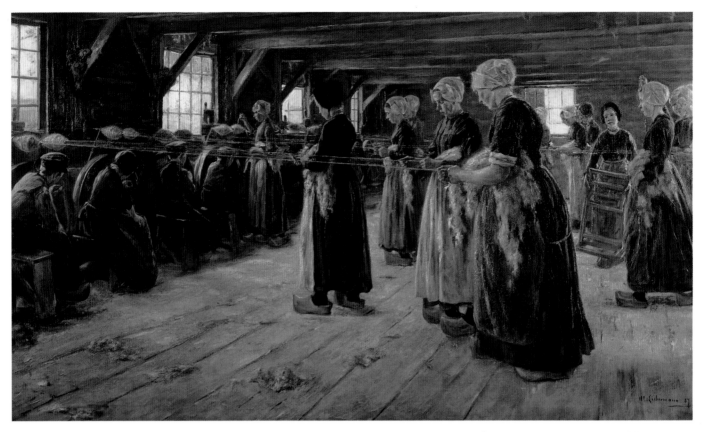

IV.4 *Flax Spinners in Laren*, 1887.
Staatliche Museen zu Berlin,
Nationalgalerie

forces suggests that a collective pathology of anti-Semitism was building. It is no wonder, then, that Liebermann's Jewish status cannot be easily separated from his art.

While Liebermann championed an open artistic dialogue during the last quarter of the nineteenth century, he failed to endorse the expressionist movement. The fatal blind spot in Liebermann's aesthetic and psychological perspective was his inability to understand his elitist rejection of the subjective in art—on the grounds of aesthetics or taste—at a time when right-wing ideologues were linking avant-garde alien cultural encroachment with Jewish influence. This impasse—and Liebermann's refusal to deal with questions about the need for objective cultural standards to define beauty—lay in his own need to maintain the standards of *Bildung*. By invalidating the expressionist Emil Nolde's subjectivity and by refusing to accept his expressionism, Liebermann demonstrated that he had learned his lesson well. After all, two decades earlier he was figuratively smacked on the hands for depicting a gesticulating young Jesus in disputation with his elders. Sadly, with the tables turned, Liebermann—now serving as judge and jury as part of the Secession—sided with the same forces of cultural reaction that had earlier chastised him.

German impressionism never became distilled as it would in France, where form was dissolved into the transience of color. One might ask why such a manifestation failed to appear in the north, evolving instead into the proto-expressionist, lushly erotic canvases of Lovis Corinth (1858–1925) or the psychologically nuanced work of Max Slevogt (1868–1932), both of whom were members of the Secession. Nowhere does one find in Liebermann's work the emotion, physicality, or psychological edge of either of these other German impressionists. The aesthetic that coalesces within Liebermann's late impressionist work encompasses safely observed public scenes, within a limited range of subject and context—people at the seaside, a Sunday equestrian, or the artist's own garden.

His restrained purview of his affluent, culturally elite world was, however, accompanied by numerous self-portraits, which reveal an increasing doubt and agitation. As Liebermann gained social status through his commissioned

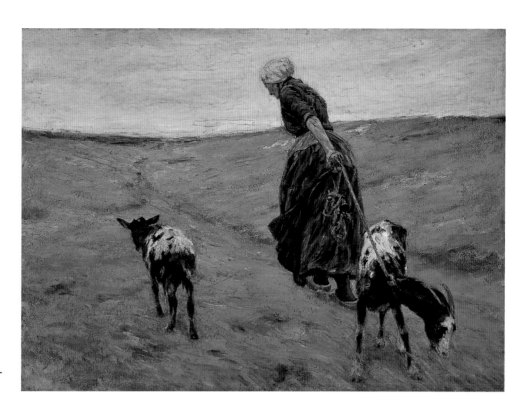

IV.5 *Old Woman with Goats,* 1890. Bayerische Staatsgemäldesammlungen, Neue Pinakothek, Munich

portraiture, his predilection for looking at his own image and his scrutiny of others increased his growing awareness of his complex identity and the issue of the individual in contemporary art. While he admired and celebrated the work of Edgar Degas (1834–1917), for example, he cited the artist's "colossal identity" as his Achilles' heel: such an elevation of individualism conflicted with his own hierarchical critical standards. [28] Liebermann's rejection of expressionist art was grounded in his elitism: "We want an art that is an expression of our time, [an art] that stands at the height of the culture of our time."[29] This myopic focus on the elevation of German culture resulted in the mass self-deception of a generation of German Jews. Liebermann's reverence for *Bildung* prevented him from seeing that the supposed objective perspective through which he viewed and rendered the world was, in fact, an uncritical continuation of bourgeois ideology.[30]

Liebermann's social status and his artistic point of view eventually became indistinguishable. His refusal, as a Secessionist, to condone subjectivity in art may be explained by his investment, as a Jew, in being socially secure. This need in part illuminates an aspect of his German manner of impressionism. His work shows constant vacillation, and sometimes awkwardness, in his effort to resolve the antithesis between the natural and the perceived. The need to protect and affirm his social status and his extreme need as a Berlin Jew to believe in a certain reality prevented him from seeing *à la mode française* and precluded his late, impressionist phase from ever getting past a certain rational order.

As polarization increasingly marked German politics throughout the 1890s— with such figures as Hugo von Tschudi, director of the National Gallery, Berlin, and the Francophile critic Julius Meier-Graefe contesting the reactionary nationalist forces who viewed their internationalism as diluting the very essence of German art—Liebermann changed his style of painting. He abandoned the existential monotony of peasantry for the lively flux of urbane pleasantry (Figure IV.6), thereby affirming the modern, rebuking the emperor, and advancing the case for diversity and tolerance. As he wrote in the catalogue for the Secession's first exhibition, the show's restriction to a survey of German art was not "a sign of parochialism." On the contrary, directing attention to German modernism

would encourage an assessment of German parochialism and a greater openness to international positions. Liebermann clarified the Secession's position: "We do not believe in a single, sacred direction in art."[31]

The public recognition Liebermann garnered in the first two decades of the twentieth century gave the artist greater opportunity to consider the aesthetic and painterly ideas that he had championed; he could now, however briefly, savor a modicum of victory. He could indulge himself in the milieu in which he was now esteemed, recognized with medals, and accepted by his peers. As he began to celebrate his fame with the first of many self-portraits that he would produce toward the end of his life, Liebermann also assumed the role of the genteel painter accepting portrait commissions from others.

Liebermann's increased preoccupation with portraiture and his steady withdrawal to his idyllic country villa outside Berlin reveal his waning importance in the German art scene. His immersion after 1900 in a more stereotypical French naturalism and the proliferation of his garden paintings—while often much freer in their exploration of new forms of spatial representation and composition, and their allowance of discontinuities and blurred distinctions—proved his allegiance to a rapidly fading past. All of this has, regrettably, obscured Liebermann's primary artistic legacy—the cultivation of an open dialogue that helped to destabilize the repressive cultural forces in his country and to lead the way for Germany by the time of World War I to rival France in articulating the avant-garde.

Many factors contributed to Liebermann's seeming lack of concern with his disenfranchisement as a Jew and his professed absorption with the liberation of a repressive, backward-thinking Prussian culture. He had long undertaken his role as emissary of the new not with the bravura of a bohemian or the strategic maneuvering of a politician but with the learned air and optimism (if not complacency) of the cosmopolitan. By 1870, more than 60 percent of Prussian Jews had attained "secure middle-class status."[32] This "Golden Age of Security" belies the disasters occurring elsewhere throughout Europe and Russia. As various historians remind us, this deceptively positive time is too often mined "only for the clues [it yields] to the catastrophe that was to follow…[which] produces an unfortunate distortion for, seen in its own right, the period between 1888 and 1914 was characterized by…institutional stability, technological progress, and economic prosperity."[33] Although this sense of personal security should not be overstated, an acknowledgment of the social stability enjoyed during the decades before World War I deepens our understanding of the complexity of Liebermann's era and of how he might have been affected by a sense of false complacency.[34]

Most alarming to the conservatives, though, were the rapid changes in society brought on by urbanization and industrialization. These tremors of disorder jeopardized the status quo, and they were felt throughout the political spectrum, even in the new national parliament, the Reichstag, built in 1889, whose party politics expressed an unusual level of dissension. Such dislocations of political forces were accompanied by potential economic empowerment, which rendered the ruling class less and less powerful, and transformed the pomp of government into theatrical pageantry. Despite the mobilization of the reactionaries in response to such shifts, evident on a daily basis, Liebermann's rationale and complacency—and his unwavering artistic style—were the norm among his class of Berlin Jews. As Hannah Arendt has written:

> The Jewish bourgeoisie, in sharp contrast to their German and Austrian equivalents, were uninterested in power, even of the economic kind. They were content with their accumulated wealth, happy in the security and peace which their wealth seemed to guarantee…. They crowded into the cultural occupations….

IV.6 *In the Tents,* 1900. Hamburger Kunsthalle

Had the Jews of western and central European countries displayed even a modicum of concern for the political realities of their times, they would have had reason enough not to feel secure.[35]

Liebermann had been responding to this anxiety, on some unconscious level, for a long time. In this sense, his ultimate mixture of oppositional styles in his idiosyncratic advancement from realism to impressionism may serve as a metaphor not only for his assimilation but also for his need to incorporate artistic and cultural difference within an overriding sense of natural order. However, it is precisely his manner and paradoxical handling of impressionism—employing the impressionist's spontaneous brushstroke and use of the palette knife to suggest form, while retaining a serious level of detail and spatial structure—that is at odds with French painting. The antithetical tension in Liebermann's work symbolizes the artist's many contradictions. Liebermann's affirmation of an aesthetic based on the outmoded objective criteria of a sensory registration of nature seems to reflect a psychological denial. His resistance to the kind of subjective dissociation of vision inherent to modernism kept his optics from becoming integrated with his intellect. As he retired to his garden at Wannsee and painted the endless blossoms there with a freedom he had hitherto struggled to attain, his eyes shut to the world.

NOTES

1. *Pariser Tageblatt,* March 15, 1935; quoted in Amos Elon, *The Pity of It All: A History of Jews in Germany 1743–1933* (New York: Henry Holt, 2002), 393

2. "In the meantime, I have given my wife the "otter" fountain by Gaul for Christmas." Liebermann, letter to Alfred Lichtwark, January 1, 1910, Hamburger Kunsthalle Archive 37.

3. The Munich painter Fritz von Uhde called himself the "first idealist of Naturalism," a title that I think Liebermann better deserves. Gert Schiff, "An Epoch of Longing: An Introduction to German Painting of the Nineteenth Century," in *German Masters of the Nineteenth Century: Paintings and Drawings from the Federal Republic of Germany* (New York: The Metropolitan Museum of Art and Harry N. Abrams, 1981), 35.

4. Critics are quoted in Erich Hancke, *Max Liebermann, sein Leben und seine Werke.* 2nd ed. (Berlin: Cassirer, 1923). Also see Matthias Eberle, "Max Liebermann zwischen Tradition und Opposition," in *Max Liebermann in seiner Zeit,* eds. Sigrid Achenbach and Matthias Eberle (Munich: Prestel, 1979), 16 and 25.

5. In his autobiography, Liebermann gives reasons for his parents' lack of support. See Liebermann, *Gesammelte Schriften von Max Liebermann* (Berlin: B. Cassirer, 1922), 10. According to Marion F. Deshmukh, his parents were concerned for his financial security if he chose such a vocation, but the family's affluence makes such a reason difficult to understand. See Deshmukh, "Max Liebermann: Observations on the Politics of Painting in Imperial Germany, 1870–1914," *German Studies Review* 3 (1980): 173.

6. Elon, *The Pity of It All*, 9.

7. Peter Paret, *The Berlin Secession: Modernism and Its Enemies in Imperial Germany* (Cambridge, MA: Belknap Press of Harvard University Press, 1980), 44. Not only did Liebermann honor the peasants' work ethic but as Irit Rogoff has put it, "[he made] the abstract concept of *work* the subject of the painting, positing it as the main unifying element in the making of a community governed by principles of mutuality and shared enterprise." Irit Rogoff, "Max Liebermann and the Painting of the Public Sphere," in *Art and Its Uses: The Visual Image and Modern Jewish Society*. Studies in Contemporary Jewry 6, ed. Ezra Mendelsohn and Richard I. Cohen (New York: Institute of Contemporary Jewry and Oxford University Press, 1990), 96.

8. Although he took enormous pride in his heritage, Liebermann's principal allegiance was to Germany and indeed to the Prussian empire. See Paret, *The Berlin Secession*, 43.

9. Liebermann was anything but bohemian, wearing his normalcy almost as a badge of honor. He often referred to the orderliness of his work habits: "I eat, drink, sleep, take walks, and work with the regularity of a town clock. I live in my parents' house, where I spent my childhood, and would find it difficult to live anywhere else." Hans Ostwald, *Das Liebermann-Buch* (Berlin: Paul Franke, 1930); quoted in Paret, *The Berlin Secession*, 48.

10. Elon, *The Pity of It All*, 206.

11. The Dutch were known for their enterprising and virtuous bourgeoisie.

12. In addition, Liebermann was given the Legion of Honor, a tribute that the Prussian government refused to allow him to accept. Paret, *The Berlin Secession*, 46.

13. In Paris, the artist first became acquainted with the work of Gustave Courbet and Jean-François Millet. He lived there between 1874 and 1878.

14. The studies for these works are loosely painted, not simply in a standard fashion, but as if Liebermann were experimenting with an alternative, impressionist manner before he would paint the works in a tightly finished manner.

15. Liebermann possessed a collection of Honoré Daumier's woodcuts. I thank Suzanne Schwarz Zuber for calling my attention to this fact.

16. The artist's essay "Die Phantasie in der Malerei," first published in 1904, basically aligned him with the French impressionist validation and pictorial transformation of things visible as an end in and of itself.

17. This group was formed out of dissatisfaction with the conservatism of the Berlin art establishment. See Paret, *The Berlin Secession*.

18. As he had earlier underscored the autonomy of peasants as an adequate subject, divorced from didactic academic narrative, he wished to further pare down the image to its essentials, albeit in the integrity of the visual. And for Liebermann, this reductive impulse was correlatively tied to the photographic, whose mechanical reproduction he viewed as antithetical to pure painting, understood as the artistic imagination. In numerous of his portraits of Dutch women and children, for example, Liebermann dramatically isolates his subjects, enclosing them in a raw patchwork of brushstrokes, which resembles the corona that surrounds the figure in many early photographic portraits.

19. Lise Leibholz, "Besuch bei Max Liebermann," *Jüdische Central-Verein-Zeitung*, July 15, 1927, 339; reprinted in Katrin Boskamp, *Studien zum Frühwerk von Max Liebermann: mit einem Katalog der Gemälde und Ölstudien von 1866–1889* (Hildesheim and New York: Georg Olms, 1994), 53.

20. Heinrich Strauss makes this point in "On Jews and German Art (The Problem of Max Liebermann)," *Leo Baeck Institute Yearbook II* (London: Secker and Warburg, 1957), 266. Liebermann's statement has been variously translated, first by Hans Ostwald in 1930 and later by others, as Chana C. Schütz makes clear. See Schütz, "Max Liebermann as a 'Jewish' Painter," in *Berlin Metropolis: Jews and the New Culture, 1890–1918*, ed. Emily D. Bilski (Berkeley: University of California Press, 1999), 152.

21. For more on Gottlieb, see Larry Silver, "Jewish Identity in Art and History: Maurycy Gottlieb as Early Jewish Artist," in *Jewish Identity in Modern Art History*, ed. Catherine M. Soussloff (Berkeley: University of California Press, 1999).

22. A painting of Job by the artist was destroyed.

23. "It had not occurred to him that the German public still would not permit a Jew the freedom it allowed non-Jews in portraying New Testament themes." Heinrich Strauss, "On Jews and German Art (The Problem of Max Liebermann)," 265–66.

24. *Vorwärts*, November 17, 1918; quoted in Paret, "The Enemy Within," *The Leo Baeck Memorial*

Lecture (New York: Leo Baeck Institute, 1984), 9. *Vorwärts* was a socialist newspaper.

25. Leistikow's quarrel with Werner and the establishment had begun with his dismissal from the Royal Academy of Arts. Paret states that "the driving force on the executive committee and of the secession as a whole was [Walter] Leistikow, the group's 'creator and most active member,'" quoting Liebermann himself. Paret, *The Berlin Secession*, 60.

26. Paret, *The Berlin Secession*, 246–47. Overcoming social, aesthetic, and political barriers involved major cultural shifts, such as the inroads made in art criticism by, for example, the aesthetic studies of Wilhelm Worringer and the critical observations of Julius Meier-Graefe.

27. Paret, *The Berlin Secession*, 215.

28. Liebermann published his first critical effort, an essay on Degas, in the 1896 issue of the art journal *Pan*.

29. Liebermann, *Gesammelte Schriften*, 232; quoted in Deshmukh, "Max Liebermann," 200.

30. Paret, *The Berlin Secession*, 102.

31. Paret, *The Berlin Secession*, 82–83.

32. See taxation figures in the *Leo Baeck Institute Yearbook* 28 (1983): 79–80, data compiled by Jacob Toury, "Der Eintritt der Juden ins deutsche Bürgertum," in *Das Judentum in der deutschen Umwelt, 1800–1850*, eds. Hans Liebeschütz and Arnold Paucker (Tübingen: Mohr Siebeck Verlag, 1977), 139–242. For a comprehensive account of this period and the history of Jews in Germany, see Elon, *The Pity of It All* and *Jüdisches Leben und Antisemitismus im 19. und 20 Jahrhundert*, ed. Shulamit Volkov (Munich: C. H. Beck, 1990).

33. See Gordon A. Craig, "The End of the Golden Age," *The New York Review of Books*, November 4, 1999, 13; quoted in Elon, *The Pity of It All*, 222. For other accounts, see Walter Benjamin, *One-Way Street and Other Writings*, trans. Edmund Jephcott and Kingsley Shorter (London: Verso, 1985), 328.

34. Stefan Zweig, *The World of Yesterday: An Autobiography* (Lincoln: University of Nebraska Press, 1964).

35. Hannah Arendt, *The Jew as Pariah*, ed. Ron H. Feldman (New York: Grove, 1978), 115.

Max Liebermann, the Outsider as Impresario of Modernism in the Empire

FRANÇOISE FORSTER-HAHN

In fact, the great masters of impressionism—for whose presentation we were once blamed as unpatriotic—already pass as classics, and what says even more, their works are being shown at academic exhibitions as masterworks.[1]

WHEN MAX LIEBERMANN made this emphatic statement at the opening of the Berlin Secession exhibition in 1907, he not only acknowledged the achievements of the Secession group after numerous controversies but also articulated his firm belief that impressionism was not merely a new direction in the visual arts but a *weltanschauung*, a philosophy of life that embraced complete individual freedom.[2] Nearly two decades would pass from the first exhibition of impressionist works in Berlin in 1883 before modern art, especially modern French art, began to gain broader appreciation—beyond a small circle of progressive artists, critics, museum directors, and collectors—in the German Empire. Even though his religion, his internationalist outlook, and his liberal democratic politics marked him as an outsider in German culture, in his roles as a painter, printmaker, theoretician, organizer of exhibitions, and collector, Liebermann placed himself at the center of these developments. Like many of his friends who promoted an international modernism in the visual arts, Liebermann constructed his identity as a cosmopolitan *Weltbürger* (citizen of the world), thereby masking his status as an outsider and merging his diverse affinities. It was perhaps this outsider status in Wilhelmine society that compelled Liebermann and his "modernist" friends into their passionate engagement on the international scene.

Liebermann's artistic activities and his political and aesthetic positions were shaped by his upbringing in a well-to-do Jewish family in Berlin and by the dramatic political and economic shifts in Germany and Europe during his life. In some autobiographical notes, he wrote how about the liberal democratic ideals of the (failed) revolution of 1848 shaped his early work: "My political and social outlooks were and remained those of the 'forty-eighters'? Even though unfortunately I have often been reminded of the opposing [point of view], I believe that every citizen is equal before the law, as is stated in the constitution."[3] His emphasis on the equality of every citizen before the law implicitly refers to his outsider status as a Jew. In contrast, the many self-portraits that Liebermann painted throughout his life display the self-confident pose of the successful artist who is seemingly well integrated into society (Figure V.1). It is not surprising therefore to find that in the same autobiographical essay he strongly identifies with the bourgeoisie and with his hometown: "In my life habits I am a perfect bourgeois: I eat, drink, sleep, walk, and work with the regularity of a church clock. I live in the house of my parents, where I spent my childhood....I also prefer Berlin to every other city as my permanent residence."[4] Affinity for the

V.1 *Self-Portrait*, 1909/10. Hamburger Kunsthalle

181

V.2 Building the Eiffel Tower for the World's Fair in Paris, 1889. *L'Exposition de Paris,* 1889, illustration 19.

political and social ideas of 1848 did not preclude his enjoyment of the lifestyle of the bourgeoisie. How then do these affinities relate to Liebermann's more radical engagement in modern art? In 1893—if only in a private letter—he pronounces his expertise as a "revolutionary in the arts."[5] Liebermann may echo here the widespread perception of himself as a revolutionary in his art-making as well as in his many other innovative projects. Identifying with these diverse roles—citizen of the German nation and especially of Berlin, Jew, bourgeois, and, perhaps above all, youthful radical and successful artist—he must have often felt the tension and ambivalence that these divergent affinities produced.

Liebermann's engagement in the politics of culture as well as in the aesthetic debates provoked by his work were intricately woven into the history of modern Germany. His productive career spanned four distinct periods in the German polity: the confederation, when Berlin was the modest capital of the Kingdom of Prussia; the Empire; the Weimar Republic; and the first years of Nazi rule. Since the rising nationalist attitudes after unification of the German states in 1871 embraced an all-pervasive Francophobia, all modernist art was associated with French culture. The critical reception of French impressionism was therefore deeply intertwined with political ideology. Moreover, coming from a wealthy Jewish family in Berlin, Liebermann was not only criticized for his cosmopolitan modernist position but also subjected to anti-Semitic insults.

Although the recognition of Liebermann's art was—at least until his fiftieth birthday—more positive and perceptive outside the Empire, his reputation and the market value of his paintings grew steadily in Germany. From the 1870s on, the relatively high prices of his paintings—which made them available only to the affluent bourgeoisie—confirm his rising position. *Women Plucking Geese,* 1872 (Figure I.4), his first large canvas exhibited in Hamburg, was sold to the railroad millionaire Bethel Henry Strousberg for 3,000 marks (about half the annual income of a university professor or twice that of a craftsman).[6] When in 1920 at the age of seventy-three he was elected president of the Prussian Academy of Arts in Berlin, he had not only built a brilliant career as a painter, writer, and entrepreneur of the arts but had also become a legendary figure in the capital. Four biographies—as well as numerous articles and polemics—were published during his lifetime.

Despite this recognition the critical reception of his role as a modernist artist and of his oeuvre were also after his death subjected to the violent disjunctions of history. Beginning in 1933, Nazi persecution violently disrupted and destroyed many lives, including that of Liebermann, and the regime replaced the historical narratives with their own mythology. The artist's persona and his

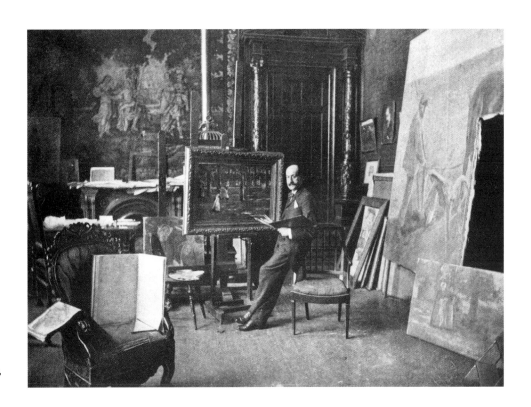

V.3 Max Liebermann in his studio, Berlin, 1905

work were erased from the official German histories of modern art. The division of Germany in 1945 and the Cold War that followed further complicated Liebermann's reception: exhibitions in West Germany during the 1950s and 1960s emphasized Liebermann's link with impressionism; a show organized by the [East] German Academy of Fine Arts in Berlin in 1965 firmly positioned Liebermann's work in the tradition of socialist art: "Only the liberation of the humanist German culture by the peaceful power of Socialism broke the spell that burdened Liebermann's memory."[7] While in East Germany impressionism was criticized as an art form favored by the bourgeoisie,[8] it was precisely the impressionist connection that was increasingly highlighted in the West. The first major step to reintegrate the painter into the history of modern art was the large retrospective exhibition held in West Berlin's National Gallery in 1979.[9] Reunification saw scholarly and public interest in Liebermann's life and work substantially revived: Matthias Eberle's catalogue raisonné of Liebermann's work, published in two volumes in 1995 and 1996, was the first scholarly enterprise to bring Liebermann's dispersed, partially lost, and destroyed oeuvre together in a thorough study.[10] Liebermann's 150th birthday in 1997 was celebrated with large exhibitions and comprehensive catalogues in Berlin, Hamburg, and Vienna.[11] In recent years, interest has focused on his house at the Brandenburg Gate and on his villa at Wannsee, the paintings of his garden[12] and on Liebermann's role as a promoter of modernism in Berlin.[13] The critical reception of Liebermann's oeuvre has clearly been profoundly shaped by historical circumstances.

THE FRENCH CONNECTION: THE GERMAN EXHIBITION AT THE 1889 WORLD'S FAIR IN PARIS

When his early realist paintings, such as *Women Plucking Geese*, 1872, and *Women Cleaning Vegetables*, 1872—both canvases representing women of the working class in monumental size—were harshly criticized in Germany, Liebermann looked toward France. With the earnings of the sale of *Women Plucking Geese,* he traveled to Paris in 1872 where he was deeply impressed by the paintings of Jean-François Millet, Charles Daubigny, and Gustave Courbet. In 1873, just two years after the Franco-Prussian War, when hostility against Germans and

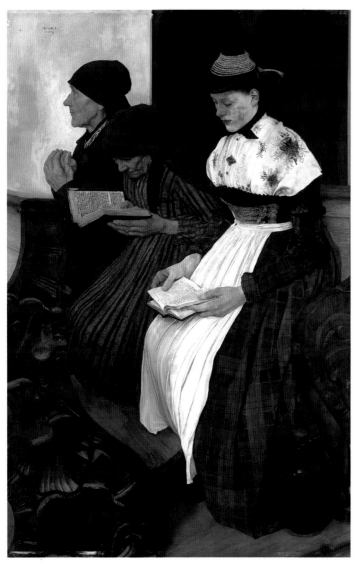

V.4 Wilhelm Leibl,
Three Women in Church, 1878–82.
Hamburger Kunstalle

the new Empire was widespread, Liebermann moved to Paris. Despite the anti-German atmosphere, from 1873 to 1878 he lived and worked between Paris, Barbizon, and Holland, establishing a network of international relationships and a thoroughly cosmopolitan attitude. Only the effect of the deeply disturbing Dreyfus Affair interrupted the artist's frequent visits to Paris from 1896 to 1912. This early familiarity with Paris and French art and the French recognition of his work established the connections that would place him in 1889 into the prominent and controversial position of main organizer of the German art exhibition at the World's Fair in Paris.

In 1889, the relationship between the French Republic and the German Empire had so far deteriorated that Wilhelm II's government vehemently refused official participation. Herbert von Bismarck, the secretary of state in his father's foreign ministry, explained to the French ambassador, who had come to invite participation by the German Empire one more time, that France was presently, "the most inhospitable of all civilized countries, at least in regard to Germany. It was far less dangerous for Germans to travel to Africa than to expose themselves to the so-called French hospitality."[14] As is evident from the comments of Bismarck's father in the margins of this report, the chancellor completely agreed with his son's blunt remarks. The official justification was in line with other European monarchies: this "Exposition Universelle Internationale à Paris" in their interpretation was less a world's fair and more a centenary commemoration of the French Revolution. Since 1886 when General Georges Boulanger came to power in France and incited aggressive reactions from Bismarck, the relations between the two countries had become increasingly hostile and driven by nationalism and a desire for vengeance. In this tense political environment, Liebermann was invited by the French to stage an exhibition of German art *hors de concours*, that is, outside the official competition, and he agreed.[15]

A government-sponsored exhibition of German art at the 1878 World's Fair in Paris served as the model. Although the Empire did not officially participate then, it decided very shortly before the opening to send an art exhibition—outside all official competition—as a gesture of political conciliation. Wilhelm I and Bismarck commissioned Anton von Werner (1848–1915) to organize the exhibition, with the generous support of the government. The popular success of this previous exhibition must have inspired the French government to invite Liebermann to organize a similar display. Whereas the 1878 exhibition was sanctioned and financed by the Wilhelmine government, the exhibition in 1889 was an independent enterprise organized by the artists in resistance to Bismarck's politics. It is not clear who financed the exhibition; hostile polemics in the press referred to "Jewish bankers." Most likely, progressive Berlin collectors and some of Liebermann's friends supported the project.

In March of 1889, German art journals reported that Liebermann had been selected to the jury of the Fair's international section of fine arts.[16] When the artist arrived in Paris in the spring, a French delegation under Antonin Proust, in charge of fine arts at the World's Fair, asked Liebermann to organize an

exhibition of German art. After agreeing, Liebermann formed a committee of fellow German artists and quickly began to prepare. In April, Fürst Münster, the German ambassador in Paris, reported to Berlin that a group of German artists including Liebermann and Gotthardt Kühl were participating in the World's Fair and that preparations for the exhibition were in full swing.[17] The correspondence between the embassy in Paris and the foreign ministry in Berlin and the heated rhetoric in the press and art journals reveal the extremely political reaction to Liebermann and the exhibition. It was criticized as a "deeply embarrassing circumstance for German patriots...that our collective artistic world includes elements that are so lacking in all national pride, all sentiment for national tact, that they let works of their brushes parade in front of our declared political adversaries on the occasion of the Paris jubilee exposition."[18] In Berlin, the government forbade all participation by artists who were Prussian civil servants.[19] In their diplomatic correspondence to the home office, the German embassy sent lists of artists, collectors, and institutions that had loaned works, along with copies of the catalogue and reviews of the German exhibition from French newspapers.[20] Liebermann was criticized for his aesthetics and became a target in the politics of confrontation.

Liebermann's political gesture was audacious, and the aesthetic concept and display of the art in the exhibition were equally innovative. In contrast to the heterogeneous and primarily academic German art presented in 1878, the exhibition in 1889 was coherently focused on the anti-academic pleinairism of the 1880s.[21] Liebermann and the committee selected works by the younger generation of German artists. Next to Wilhelm Leibl (1844–1900), who showed, among other canvases, *Three Women in Church,* 1878–1882 (Figure V.2), *Portrait of Countess Treuberg,* 1877/78, and other canvases, and Fritz von Uhde's *Children's Procession in the Rain,* 1887, there were pictures by Wilhelm Trübner (1851–1917), Leopold von Kalckreuth (1855–1928), Lesser Ury (1882–1934), Franz von Stuck (1863–1928) and Franz Skarbina (1849–1910), and six gouaches by Adolph Menzel (1815–1905). The most spectacular display, however, were the six large canvases by Liebermann himself, including *Recess in the Amsterdam Orphanage,* 1882 (Figure IV.2); *Old Men's Home in Amsterdam,* 1880; *Cobbler's Workshop,* 1881; and *Women Mending Nets,* 1887–8 (Figure IV.3). The large canvases by Leibl and Liebermann dominated the display and were most often discussed in the French reviews.[22]

Because political polemics have dominated the discourse about the 1889 exhibition, the effect of Liebermann's large canvases on the audience is often disregarded. In contrast to the dark paintings of the 1870s, such as *Women Plucking Geese* and *Women Cleaning Vegetables,* the monumental figures are now liberated from oppressive boxlike interiors and placed instead in sun-lit landscapes or light interior spaces. While these plein-air scenes of workers, peasants, children, and old people are frequently seen as icons of German realism, the French critics who wrote about the German exhibition perceived, above all, a solemn melancholy and cerebral reflection. Trying to define the typically German character of the display, one critic wrote, "the boldness of plein-air painting...tempered by cautious and serious spirituality—and, above all this, an accent of sadness that is particularly German."[23] Most German critics saw these paintings as realist scenes in the Dutch and French traditions, but some also recognized their poetic quality. Analyzing the relationship of image, frame, and spectator, one critic formulated: "Their whole content is often nothing but a representation of the shimmer and gleam of the midday sun...one imagines it is possible to look through the frame into the bright sunny day."[24] *Women Mending Nets,* the canvas that Lichtwark purchased for the Hamburger Kunsthalle, especially intrigued the French and German reviewers. The intertwining of human figure and nature, of collective work and solitude, and, above

all, the pervasive mood of solemn contemplation gave this picture its promi-nence. According to one contemporary critic, the "heroic" relationship of the monumental figure in the foreground to the wide flat landscape suggests that she reflects on the meaning of life and so elevated the scene to the status of a history painting.[25]

While French critics remarked on the typically German character of the art, in Berlin, Anton von Werner excoriated the exhibition's aesthetic. The organizer of the German art display at the 1878 World's Fair caustically acknowledged that this display of modernist German art marked a turning point in the his-tory of German art; the exhibition signaled, he wrote, "the date of the official proclamation of the new gospel...producing the effect, at least in Germany, of trumpet blasts advertising its glory."[26] Thus, the first coherent exhibition of German modernist art not only took place outside the Empire but also in the capital of its principal political adversary.

Twenty-four of the forty-five artists in the German exhibition were awarded medals by the jury. Liebermann himself was honored with the Legion of Honor, but the Prussian government would not allow him to accept it. In a speech at an official dinner in Paris organized by Antonin Proust in May of 1889, Lieber-mann ignored the controversies and praised the "confraternité artistique." The German newspapers immediately accused the artist of "peacemaking," a coded phrase meaning a lack of patriotism.[27] Politics and art were so intertwined that the multiple layers of ideological and aesthetic discourse concealed the historical role of the actual exhibition. Liebermann, nevertheless, continued to express his idealistic belief in the confraternity of the arts beyond national borders. He wanted to prove to his Berlin detractors, as he wrote to Proust, that "the senti-ment of confraternity in the arts exists as much in Paris as at home [in Berlin] outside all political consideration."[28] This utopian belief in the separation of art and politics, shared by many at the time, was to be brutally shattered at the end of Liebermann's life.

The effect of the exhibition in Paris must have convinced Liebermann of the power of public displays of art. The conception and design of his exhibition not only formulated a modernist aesthetic, it moved the modernist project from the fringes to the center of public discourse in Berlin. That city's first exhibi-tion of impressionist paintings had been organized by Fritz Gurlitt's gallery in 1883 and consisted mainly of the private collection of Carl and Felicie Bern-stein supplemented by some works from the Paris dealer Paul Durand-Ruel. Liebermann was introduced to the Bernsteins and their cosmopolitan circle of German, Jewish, Russian, and French friends in 1885 or 1886; it was there—not in Paris—where he first came to appreciate fully the new concept of making pictures and to develop a passionate affinity for it. The widespread effect of the Bernstein's collection, their taste, and their salon has been well documented. Their small but carefully selected collection of impressionist art elicited both hateful comments colored by chauvinism and enthusiastic response by those who recognized the innovative concept of the art. Liebermann succinctly de-scribed the ambiance: "One did not only feel transplanted into another house, but into another city: to Paris."[29]

During the 1890s Liebermann continued to be passionately engaged in the promotion of modern art and its controversies. In 1892 he participated in the founding of "The Eleven"[30] and in the organization of their exhibitions. Li-ebermann also began to collect, and persuaded others to collect, impressionist paintings. After having inherited a substantial fortune after the death of his father in 1894, he began to buy works by Manet, Degas, and Monet, and after 1900 also works by Cézanne and van Gogh.[31] He supported the modernist journal *Pan*, which wad funded by wealthy collectors and subscribers and founded

under the editorship of writer/poet Otto Julius Bierbaum and art critic Julius Meier-Graefe in 1895. That Liebermann decided to publish his first major critical essay—on Degas—in *Pan* in 1896, during the second year of its existence, demonstrates not only his talent for communication, but also his shrewd use of text as a necessary tool in the promotion of the new art.

His perceptive study on Degas—who had received the German artist in his Paris studio the same year, 1896—reveals Liebermann's keen understanding of the impressionist concept as well as his highly personal and deft writing style with an unmistakable local Berlin coloring. While focusing on Degas as the most original and daring of the French modern painters, he also seizes the opportunity to analyze the picture-making of the impressionists, Manet and others, in general. "Degas's paintings on the other hand," Liebermann writes, "give first the impression of a snapshot. He knows how to compose in such a way that it no longer has the look of being composed."[32] Analyzing how completely Degas transforms an often-trivial theme into form and color, Liebermann uses the French academic term *la mise en toile*—the staging of a scene on canvas—thus alluding to the performative element in the creative process. He admires Degas's pointed selection of an original segment from nature, an "extract," thereby overcoming and eliminating any novelistic and anecdotal elements. While he then thought that Degas could never become a truly popular artist because of his intellectual approach, Liebermann nevertheless concluded with an unambiguous statement of Degas's modernity: "No one of all modern painters was more talented than Degas to lead the new art forward on the path cultivated by Manet, toward the goal of all art: toward style."[33] In this early essay Liebermann established his personal mode of art criticism: grounded in his own picture-making, the writing fuses the concise visual analysis of an image with his conception of the artist's imagination—the "Phantasie"—that transforms the observation of nature into a work of art.[34]

In 1899 Liebermann was elected president of the Berlin Secession, a position that placed him prominently at the forefront of modernist activities.[35] When reflecting upon the ten years of Secession exhibitions, he acknowledged that its founding was the result of "a mood of battle" and emphasized the "necessity—of its existence."[36] The intense activities for the Secession from 1899 to 1911 embraced Liebermann's talents at producing and displaying art and at articulating the aesthetic that guided both. In his speeches for the opening of the annual Secession exhibitions, he formulated the cultural politics he and his friends advocated, the aesthetic theories they believed in, and the educational role they ascribed to exhibitions.

The first exhibition in the spring of 1899 included only German works, and Liebermann argued for this limitation to "national art" by explaining that the organizers wanted to give first a survey of the present state of German art.[37] After the exhibition had proven a great success and surpassed all expectations of the founders (one-quarter of the exhibited works were sold), the second in the spring of 1900 included French works by Monet, Meunier, Rodin, Cézanne, Sisley, and Pissarro, thereby signaling the international outlook of the Berlin Secession. This emphasis on the cosmopolitan nature of modern art was actually reinforced in the staging itself: German and French paintings were displayed together—just as Liebermann would later do in his homes.

Like his friend Alfred Lichtwark, director of the Hamburger Kunsthalle, Liebermann recognized that the display of art is also a pedagogical enterprise: "Every presentation of works of art," he articulated in one of his opening addresses, "has to shape the taste of the spectator."[38] On the occasion of the tenth anniversary of the Secession, he declared "it [the Secession] will continue to be necessary, as long as there are artists, who want to replace with their own views

V.5 Exhibition of the Berlin Secession, 1901. Sculpture *The Kiss* by Fritz Klimsch. Pictured from left to right: Franz Skarbina, Max Liebermann, Paul Cassirer, Oscar Frenzel, unknown, Walter Leistikow, unknown.

grounded in the present, those dominant aesthetic criteria that are abstracted from works of the past and are therefore more historic." [39] For Liebermann and the founders, that contemporary "view" was in essence the "impressionist" (in the very broadest sense) enterprise. Although Liebermann's critical writing lacked a coherent, concisely formulated theory, it did position the "view grounded in the present" at the center of his texts and exhibitions. He also keenly acknowledged that those who "are considered the moderns today, will perhaps be consigned already tomorrow to the rubbish heap by even more modern ones." [40] This insight was prophetic, for shortly thereafter the "even more modern ones" caused the first serious internal conflict in the Secession, which ultimately led to its breakup.

For some time the clash between the older generation and the younger expressionists had marked the making of art as well as its critical discourse, especially after Erich Heckel, Ernst Ludwig Kirchner, and Karl Schmidt-Rottluff founded Die Brücke in Dresden, published a manifesto, organized exhibitions, and energetically articulated a new programmatic aesthetic. When in 1910 the jury of the Secession rejected twenty-seven artists, the expressionists Emil Nolde and Max Pechstein among them, Nolde responded with an insulting letter to Liebermann. The artists whose works had been refused reacted by founding the New Secession in April of 1910. [41] As a consequence, Liebermann withdrew from his position as president in 1911. The year 1911 was in many respects a turning point for modernism. The Worpswede artist Carl Vinnen launched his attack in a pamphlet, *A Protest of German Artists Against the Threatening Import of French Art Wares,* in reaction to Gustav Pauli's purchase of Van Gogh's *Poppy Field* for the Bremer Kunsthalle. [42] Vinnen's vicious polemic, which was supported by many artists, became a rallying point for the modernists, especially the Secessionists, who responded with their own sharply formulated position. Liebermann was among those who contributed to the counteroffensive.

But 1911 was also the year when several of the expressionists moved from Dresden to Berlin. The Blue Rider group, under the leadership of Wassily Kandinsky and Franz Marc, organized its first exhibition in Munich. Even though he was elected honorary president of the Berlin Secession, Liebermann must

have realized that its role had been superseded by the dynamic activities of the expressionists. Or had he forgotten his own statement: "We are all children of our time, and it is only natural, when the young want to occupy the position of the old"?[43] If the founding of the Secession had been primarily compelled by the antagonistic cultural atmosphere, then its breakup was caused by deep conflicts within. Yet, Liebermann's entrepreneurial role—as creative artist, as organizer of exhibitions, public speaker, author of art critical texts, and collector—surely provided a model for the younger avant-gardes.

THE OUTSIDERS

Even though the artist always identified with the status and lifestyle of the bourgeoisie, he was nonetheless aware of the radical nature of his engagement in promoting modernism in the arts. The abrupt shifts between acceptance and rejection and between tolerance and hostility characterized his entire career. So it was perhaps no surprise that despite his role as an internationally recognized artist and very visible member of Berlin's cultural elite, Wilhelm II refused to approve a retrospective exhibition at the Academy in celebration of Liebermann's sixtieth birthday. This imperial rejection in 1907 stood in stark contrast to the celebration of the artist's fiftieth birthday.

When Max Liebermann turned fifty in 1897, the Royal Academy of Arts in Berlin celebrated his birthday with a special exhibition, the award of the Great Gold Medal and a professorship at the Academy. The artist, who had been viciously attacked in 1892 as an "apostle of ugliness"[44]—both for his paintings and his promotion of modernism—now seemed to move from the periphery, the limited terrain of modernism, into the mainstream of the visual arts world. However, the Empire's recognition was but a single gesture. As Alfred Lichtwark (1852–1914), the energetic and progressive director of the Hamburger Kunsthalle and a close friend of Liebermann's, sharply observed: "Strangely, Liebermann, Uhde, Olde are still being considered everywhere as the 'young' and actually are forty or more. This speaks volumes about our artistic conditions."[45] At age of fifty, Liebermann was still defined by the painterly innovations of his early career and with youthful rebellion—even though he was by then an artist of international reputation, who had also made his mark as an organizer of exhibitions and as a critic and collector.

Of the same generation as Anton von Werner (1843–1915), the director of the Royal Academy of Arts since 1875 and a staunch defender of academic tradition in the production of art as well as in its management, Liebermann also belonged to the same generation as French artists he admired, collected, and wrote about—Paul Cézanne (1839–1906), Claude Monet (1840–1926), Auguste Renoir (1841–1919), Auguste Rodin (1840–1917)—and he was only fifteen years younger than Édouard Manet (1832–1883). After discovering their work, he felt throughout his life a close affinity to their artistic conception as well as to their picture-making. His rather large collection of impressionist paintings; his perceptive essays on Degas, Manet, Monet, and others;[46] and, most of all, his own paintings after 1900 earned him the label "the German Manet."[47] His work was central in the ongoing debates over whether there was indeed a German impressionism.

As Liebermann attained a prominent position within the complex network of the visual arts in the Empire, he moved in the circle of artists, museum directors, critics, collectors, publishers, and gallery owners who energetically promoted modern art and championed a thoroughly international perspective, including Alfred Lichtwark and the Swiss Hugo von Tschudi (1851–1911), who in 1896 was named director of Berlin's National Gallery and who had been in close contact with Liebermann since the 1880s.[48] Shortly after his

appointment in 1896 to the museum, Tschudi traveled with Liebermann to Paris, where during their visit, the new director bought the first French impressionist paintings for the museum. Other friends and colleagues included the critic Julius Meier-Graefe (1867–1935), who, after closing his gallery, La Maison Moderne, returned from Paris to settle in Berlin in 1904 and who, around 1905, planned to write a book on Liebermann but then gave up the project;[49] Harry Graf Kessler (1868–1937), the son of a Swiss-German banker and an Irish aristocrat, was a true cosmopolitan with pied-à-terres in London and Paris and homes in Berlin and Weimar, where he briefly acted as director of Weimar's Grand Ducal Museum for Fine and Applied Art (1903–6); the Belgian Henry Van de Velde (1863–1957), Kessler's colleague in Weimar; and Walther Rathenau (1867–1922). All moved in the same liberal intellectual circles and collaborated on various modernist projects.

Rathenau—industrialist, economist, writer, and politician—theorized about the political structure and economic system of the modern state, defining modernity in a thoroughly international context. Besides promoting modern art movements, Lichtwark formulated the role of the public museum as an enlightened institution of education. Kessler, a constant wanderer not only between countries but also among languages and cultures, firmly integrated the crossing of borders into his life's fabric. Meier-Graefe was instrumental in transferring the ideas of French impressionism and postimpressionism to Germany through his pivotal text *The History of Modern Art*, first published in three volumes in 1904. Tschudi's *German Centennial Exhibition (1775–1875)* at the National Gallery in Berlin in 1906 was another crystallizing event where the many ideas and strategies of modernist art converged. Liebermann knew them all, collaborated and quarreled with them, and played an always active and sometimes combative role in the circle.

Inspired by the centennial exhibition of French art at the 1900 World's Fair in Paris, the *German Centennial Exhibition (1775–1875)* was the result of collaboration between several museum directors and critics, with Tschudi in the leading role and Lichtwark and Meier-Graefe as the two other main protagonists.[50] The exhibition's goal was defined as a "rehabilitation" of German nineteenth-century art and presented for this purpose more than two thousand objects—paintings, sculptures, drawings—assembled from collections from all over the Empire. The concept that the organizers implemented in design, display, and text was anchored in a thoroughly modernist aesthetic. The architect Peter Behrens designed the catalogue and posters in a discreet geometric Jugendstil manner and completely masked the patriotic interior decoration of the National Gallery with a beige-colored fabric that formed a continuous light background for the art. A band of geometric Jugendstil pattern winding around the upper portion of the walls further helped to unify the galleries. The selection and arrangement of the art told the story of a hundred years of German art with a strong emphasis on its development toward the modern. The sensational rediscovery of Caspar David Friedrich and the coherent display of Adolph Menzel's early so-called preimpressionist paintings had a powerful effect upon the public. Critic Karl Scheffler wrote that the exhibition had "strong impressionist tendencies."[51]

Although Liebermann was not directly involved in the arrangement of the exhibition, he certainly participated in an indirect manner, since he was engaged in a continuous exchange in all matters of modern art with its organizers. Tschudi included eight of Liebermann's paintings, all illustrated in the catalogue, including *Women Plucking Geese*, a sketch of the Amsterdam Orphanage, and *Old Men's Home in Amsterdam*, 1875. As Tschudi wrote in the catalogue, Liebermann's early paintings not only assimilate the art of Munkácsy, Millet, and Hals but also proceed toward a light color scheme and

V.6 Portrait of Hugo von Tschudi, before 1908. Pen drawing. Kupferstitchkabinett, Staaliche Museen zu Berlin

"the beginnings…of an impressionistic color potential."[52] In this interpretation the development of Liebermann's painting paralleled the narrative of the entire exhibition: the progression of art toward an impressionist aesthetic, the modern. The centennial exhibition invented a novel narrative of modern art: a progressive history leading toward "impressionism" while anchoring modernism in German tradition—thereby mediating between the cosmopolitan and patriotic positions. Both the modernist project and its fervent advocates thus negotiated the distance between the periphery and the center on the Empire's cultural-political map.

Liebermann's portraits of his colleagues in the promotion of modernism perceptively reveal their complicated roles in the cultural politics of the time. The portrait of Tschudi, most probably sketched shortly before 1908, translates a well-known photograph of the museum director into a pen drawing of nervous intensity (Figure V.6). While the photographer depicts Tschudi in a calm, contemplative pose, his head resting on his right hand, his eyes intently gazing through his black-rimmed glasses at the viewer, Liebermann reveals a tense and nervous energy, with a dense network of black lines conveying his friend's restless but focused intellectuality. At the time when Liebermann portrayed him, Tschudi's health was already declining and his career as director of the National Gallery in Berlin was heading toward an abrupt end. Because of the controversy surrounding his purchase of some paintings by artists of the Barbizon School (including works by Corot, Delacroix, and Troyon), Tschudi was asked to take a leave in 1908, a political maneuver that led to his forced departure. When Tschudi died in November of 1914, Liebermann, Meier-Graefe, and Kessler attended the memorial service. In addition to Meier-Graefe, Liebermann was chosen to speak for Tschudi's friends, giving the eulogy at the Prag-Cemetery in Stuttgart.[53]

In 1912 Liebermann produced three versions of a portrait drawing of his father's cousin Walther Rathenau, who was then building his image as a writer. Rathenau gave one of the drawings as a gift to the Nobel Prize–winning playwright Gerhart Hauptmann for his fiftieth birthday.[54] In contrast to the many more formal portraits—paintings, drawings, and photographs—of Rathenau, Liebermann's knee-length study depicts the ambitious industrialist-writer in a relaxed, almost spontaneous pose, perhaps conveying their familial relationship.

A long relationship also connected Liebermann with Kessler: they were among the founders in 1903 of the German Artists' Association, which was launched in Weimar under the Count's energetic initiative as an open protest against Wilhelm II's conservative cultural position.[55] Kessler despised the government's cultural politics but identified fully with his role as a Prussian officer.[56] Sent back from the battlefields at Verdun in 1916, Kessler spent some time in Berlin where he sat for his portrait. In the pastel drawing, the artist portrayed Kessler, then in his mid-forties, in the officer's uniform of the Ulanen-Regiment. The outfit imbues him with an earnest gravity, distancing him from the viewer and giving him a remote appearance that betrays nothing of Kessler's restless and hyperactive temperament. Liebermann captured what most of Kessler's friends considered his most outstanding and often irritating characteristic, emotional reserve.

Although the members of Liebermann's circle all acted as *Weltbürger*, they also saw themselves as German patriots. Negotiating the gap between political and cultural positions must have required a constant struggle. Kessler valued his role as Prussian officer and attempted to mediate the tension between his patriotic and international convictions. In a diary entry from 1897, he envisaged how such contradictory identities could be merged: "The goal to achieve today in Germany: to link the philosophical culture of Goethe with the political one of Bismarck and the fin-de-siècle aesthetic one."[57] Similarly, when Meier-Graefe

published his book on the 1900 World's Fair in Paris, his ambivalent review alternates between praise for modern French painting and pride in German achievement.[58] As the writing of Lichtwark, Kessler, Liebermann, and even Meier-Graefe disclose, the most avant-garde texts often betray an underlying patriotic loyalty.

While being seemingly integrated into the cultured elite and under the surface of brilliant careers in the public sphere, these *Weltbürger* were profoundly aware of their fragile existence and ultimately of their role as outsiders: Kessler, Van de Velde, and Tschudi were foreigners; Liebermann and Rathenau were of Jewish descent; and Meier-Graefe was aggressively Francophile.[59] When in 1903 the Prussian ambassador in Weimar described the city's modernist activities in a report to Wilhelm II, he wrote in the typical vocabulary of contempt, using the dismissive term "elements" and complaining that "the more recent and newest German art epoch should be created and promoted by elements that are by birth no Germans and are therefore lacking the finer sensibility for German character."[60] Contempt for the foreign was matched with disdain for Jews. In 1911, when Liebermann painted portraits of Rathenau and his father Emil, Walther Rathenau expressed how that hostility was perceived by a Jew:

> In the childhood of every German Jew, there is a painful moment, which he remembers for his entire life: when he becomes fully aware for the first time that he has entered the world as a second-class citizen and that no talent or accomplishment can liberate him from this situation.[61]

The numerous caricatures aimed at Liebermann throughout his life reveal the anti-Semitism that pervaded the criticism of modern art.[62] The debates on modernity and aesthetics were intricately linked to ideology and national prejudices.

As the diplomatic correspondence of 1889 and the polemics in the press reveal, an international orientation in the arts, like Liebermann's formulation of a confraternity of the arts beyond national consideration, sharply conflicted with the Empire's definition of a nationalistic state: "cosmopolitan artists and bankers" were frequently criticized as "unpatriotic."[63] Seen in the context of these discourses on nationalism and the opposing definitions of national identity, the "Thode Affair" poignantly demonstrates the political subtext to the aesthetic disputes. In the summer semester of 1905, Henry Thode, professor of art history at the University of Heidelberg, presented a series of lectures protesting "against that artistic view—mainly coming from Berlin—that proclaims the exclusively foreign that is to be forced upon Germany."[64] Recognizing that these attacks were not merely an aesthetic polemic but went to the core of a *weltanschauung,* Liebermann published three articles in the *Frankfurter Zeitung,* where he succinctly singled out Thode's attacks of a "lack of national sensibility," "imitation of the French," and "lack of poetry" as weapons coming "from the arsenal of the anti-Semites."[65] The struggle for a broader definition of national identity or, as Kessler formulated, "a good European," was inseparable from the discourses on modernity. These divergent positions—a national ideology versus a cosmopolitan vision—and any possible mediation between the two were at the core of cultural politics during Liebermann's lifetime. Whereas the historian Friedrich Meinecke in his classic book of 1907, *Cosmopolitanism and the National State,* insisted on a glorification of an extreme and exclusive nationalism,[66] Liebermann's ally in the promotion of modernism, Harry Graf Kessler, articulated a conciliatory definition in his essay "Nationalität" of 1906. "There is also no contrast," Kessler wrote, "between being a good German and a good European: a conflict between national and international does not exist."[67] This enlightened vision would only be further developed in the peace movement and the League of Nations during the years of the Weimar Republic,

but Kessler's essay indicates that even during the decade preceding World War
I, the sharp divisions began to be somewhat blurred.[68]

By 1933 the Third Reich put a brutal end to all forms of liberal culture.
Rathenau has been murdered by militant nationalists in 1922; Kessler and
Meier-Graefe were exiles in France; and Liebermann was completely isolated
in Berlin. At the time of his forced resignation from his position at the Prussian
Academy of Arts and under the pressure from the Nazi regime, Liebermann
once more declared his belief in the separation of art and politics: "It is my
conviction that art has nothing to do with politics or descent."[69] In this brief
statement from May of 1933, it seems as if—under the shock of Nazi terror—he
needed to restate the utopian ideals of his early career.

Like Liebermann, Max Beckmann (1884–1950) hoped also to declare the
separation of art and politics in introducing the 1938 exhibition of modern
German art in London—which was intended to counterbalance the exhibition
of "degenerate art" organized a year earlier by the Nazis to vilify modern in
art. In his speech, "On my Painting," he said: "I assume, though, that there are
two worlds: the world of spiritual life and the world of political reality. Both are
manifestations of life which may sometimes coincide but are very different in
principle."[70] Beckmann, too, seemed to withdraw from the public sphere into the
"different" world of creative work. Under Nazi persecution, both Liebermann
and Beckmann found their only safe haven in their professional domains.

When Fritz Eschen photographed Liebermann in his studio in 1931 (Figure
V.7), he captured the self-reflective nature and multiple facets of the artist's
persona. In the photograph, Liebermann's image appears three times: in a
formal dark suit, brush in hand; in the reflection of a mirror; and in his *Self-
Portrait Wearing a Panama Hat*, which is shown behind his back. The mirror
stands on an easel in front of a wall with a display of pictures, half concealing
a painting by Manet on the upper right side. Liebermann's eyes in the painted
self-image gaze intently upon the artist's "real" persona, his physical presence
in the picture, but the boundaries between real, reflected, and painted are
deeply blurred. Different inventions of the self are brought into the picture: a
"revolutionary" in the arts who insisted on the separation of arts and politics;
a German who "tried to serve German art throughout my long life with all my

energy";[71] and a Jew—conflicting, infinitely layered, and intertwined affinities as if the photographer had fixed Liebermann's resistance to settling into a single identity.

AUTHOR'S NOTE: I gratefully acknowledge an extramural grant of the University of California for research abroad and the generous support of my work in Berlin by the staff of the Kunstbibliotekh; Dr. Angelika Wesenberg, Alte Nationalgalerie, Staatliche Museen-Preussischer Kulturbesitz, Berlin and Dr. Annegret Janda. My thanks go to my colleagues in Germany and the United States with whom I have shared many inspiring discussions and to Barbara Wotherspoon for her expert clerical assistance. An earlier version of this essay was delivered as a paper at New York University in May of 2002.

NOTES

1. "Tatsächlich gelten die grossen Meister des Impressionismus, für deren Vorführung wir einst als vaterlos gescholten wurden, bereits als Klassiker, und—was mehr sagt—ihre Werke werden auch auf akademischen Ausstellungen als Meisterwerke gezeigt." Liebermann, speech at the opening of the Secession, Spring, 1907, in *Die Phantasie in der Malerei: Schriften und Reden* (Berlin: Buchverlag der Morgen, 1983), 177.

2. Liebermann, "Ten Years Secession," in *Die Phantasie in der Malerei*, 185. For a good historical summary of the discussions regarding Liebermann and impressionism, see Thomas W. Gaehtgens, "Liebermann und der Impressionismus," in *Max Liebermann: Jahrhundertwende*, ed. Angelika Wesenberg (Berlin: Nicolai and SMPK, 1997), 141–152.

3. "...dass meine politischen und sozialen Anschauungen die eines Achtundvierzigers waren und geblieben sind. Obgleich ich oft genug leider vom Gegenteil überzeugt wurde, bilde ich mir ein, dass—wie es in der Verfassung heisst—jeder Staatsbürger vor dem Gesetz gleich ist." Liebermann, "Autobiographisches," in *Die Phantasie in der Malerei*, 15.

4. "Ich bin in meinen Lebensgewohnheiten der vollkommenste Bourgeois: Ich esse, trinke, schlafe, gehe spazieren und arbeite mit der Regelmässigkeit einer Turmuhr. Ich wohne in dem Haus meiner Eltern, wo ich meine Kindheit verlebt habe,...Auch ziehe ich Berlin jeder anderen Stadt als bleibenden Wohnsitz vor." Liebermann, "Autobiographisches," 15.

5. "...da ich ja ein geeichter Revolutionär in der Kunst [bin]." Liebermann, letter to Hans Grisebach, March 3, 1893. Jenns E. Howoldt kindly alerted me to this source.

6. Peter Gay, "The Cost of Culture. On Liebermann, Lichtwark, and Others," in *From the Berlin Museum to the Berlin Wall, Essays on the Cultural and Political History of Modern Germany,* ed. David Wetzel (Westport, CT: Praeger, 1996), 31–41.

7. "Erst die Befreiung der humanistischen deutschen Kultur durch die Friedensmacht des Sozialismus löste den Bann, der auf Liebermanns Andenken lag." Wolfgang Langhoff, "Introduction," in *Max Liebermann* (Berlin: Deutsche Akademie der Künste, 1965), unpaginated.

8. For a critical Marxist reception of impressionism, see Richard Hamann and Jost Hermand, *Impressionismus*, 2nd rev. ed. (Berlin: Akademie-Verlag, 1966).

9. *Max Liebermann in seiner Zeit*, eds. Sigrid Achenbach and Matthias Eberle (Munich: Prestel, 1979).

10. Matthias Eberle, *Max Liebermann 1847–1935: Werkverzeichnis der Gemälde und Ölstudien,* vol. 1, *1847–1899,* vol. 2, *1900–1935* (Munich: Hirmer, 1995–1996).

11. *Max Liebermann: Jahrhundertwende; Was vom Leben übrig bleibt, sind Bilder und Geschichten. Rekonstruktion der Gedächtnisausstellung des Berliner Jüdischen Museums von 1936,* ed. Hermann Simon (Berlin: Stiftung Neue Synagoge Berlin—Centrum Judaicum, 1997); *Max Liebermann. Der Realist und die Phantasie,* eds. Jenns E. Howoldt and Birte Frenssen (Hamburg: Hamburger Kunsthalle, 1997); and *Max Liebermann und die französischen Impressionisten,* eds. G. Tobias Natter and Julius H. Schoeps (Düsseldorf: DuMont, 1997).

12. *Im Garten von Max Liebermann* (Hamburg: Hamburger Kunsthalle and Berlin: SMPK, 2004); *Zurück am Wannsee. Max Liebermanns Sommerhaus,* eds. Nina Nedelykov and Pedro Moreira (Berlin: Transit, 2003).

13. *Im Streit um die Moderne: Max Liebermann. Der Kaiser. Die Nationalgalerie,* eds. Angelika Wesenberg, Ruth Langenberg, and Sigrid Achenbach (Berlin: Nicolai and SMPK, 2001).

14. "Frankreich sei gegenwärtig das 'ungastlichste aller zivilisierten Länder', wenigstens soweit Deutschland in Frage käme. Es sei für Deutsche weniger gefährlich, nach Afrika zu fahren, als

sich der sogenannten französischen Gastfreundschaft auszusetzen." *Acten betreffend die Pariser Weltausstellung im Jahre 1889*; the diplomatic correspondence and other documents regarding the German art exhibition at the 1889 World's Fair in Paris are in the Archives of the German Foreign Ministry. See also Françoise Forster-Hahn, "'La Confraternité de l'art': Deutsch-französische Ausstellungspolitik von 1871 bis 1914," *Zeitschrift für Kunstgeschichte* 4 (1985): 506–537, esp. 522. For a revised version of the article in English, see "Constructing New Histories: Nationalism and Modernity in the Display of Art," in *Imagining Modern German Culture: 1889–1910*, ed. Françoise Forster-Hahn (Washington, DC: National Gallery of Art, 1996), 71–89. For the reception in France of the German naturalist painters and the critical reception of Liebermann's art, see Rachel Esner, "Art Knows No Fatherland: The Reception of German Art in France, 1878–1900." Ph.D. dissertation, City University of New York, 1996. Liebermann's relationship to France is most recently discussed by Knut Helms, "Esquisse d'un réseau libéral Franco-Allemand: Max Liebermann et la confraternité de l'art," in *Distanz und Aneignung: Kunstbeziehungen zwischen Deutschland und Frankreich 1870-1945 = Relations artistiques entre la France et l'Allemagne 1870-1945*, eds. Alexandre Kostka and Françoise Lucbert (Berlin: Akademie-Verlag, 2004), 60–87.

15. Forster-Hahn, "'La Confraternité de l'art,'" 521–531.

16. *Kunstchronik* 24 (21 March 1889): 397; *Kunst für Alle* 5 (15 March 1889): 256.

17. For the participating German painters, see "Allemagne" in *Exposition Universelle Internationale de 1889 à Paris*, vol. 1 (Paris: Lille, 1889), 143–147. Liebermann's paintings are nos. 28 to 33 on page 144.

18. "Leider wird dadurch im übrigen an dem für deutsche Patrioten tief beschämenden Umstande wenig geändert, dass unsere vaterländische Künstlerschaft Elemente in ihren Reihen zählt, welche so sehr alles nationalen Stolzes, alles Gefühles für nationalen Takt bar sind, um gelegentlich der Pariser Jubiläumsausstellung Werke ihres Pinsels bei unseren erklärten politischen Widersachern antichambrieren zu lassen." Anonymous, "Zur Betheiligung deutscher Künstler an der Pariser Weltausstellung," *Kunstchronik* 32 (16 May 1889). Quoted in Forster-Hahn, "'La Confraternité de l'art,'"524.

19. See Liebermann, "Menzel," in *Die Phantasie in der Malerei*, 147.

20. Forster-Hahn, "'La Confraternité de l'art,'" 524–526.

21. To my knowledge, no photographs of the display have been discovered.

22. For a discussion of the critical reception in France, see Françoise Forster-Hahn, "Ce que les Allemands ont présenté, ce que les Français ont vu: L'art allemand aux Expositions Universelles de Paris de 1855 à 1900," in *De Grünewald à Menzel*, eds. Uwe Fleckner and Thomas W. Gaehtgens (Paris: Maison des sciences de l'homme, 2003), 321–347, esp. 336–339.

23. "Les hardiesses du plein air tempérées par un tour d'esprit discret et sérieux…et sur tout cela un accent de tristesse spécialement germanique." Maurice Hamel, "Exposition Universelle de 1889. Les Ecoles Etrangères. Allemagne," *Gazette des Beaux Arts* XXIII (1889): 240–252, esp. 252.

24. "Ihr ganzer Inhalt ist oft nichts weiter als die Wiedergabe des Schimmerns und Scheinens der Mitagssonne….durch die Rahmen hindurch glaubt man in den lichten Sonnentag hinaus zu blicken." Georg Voss, "Die deutschen Künstler auf der Pariser Weltausstellung," *National Zeitung*, May 14, 1889.

25. Hermann Helferich [Emil Heilbut] in a review of an exhibition at the Gurlitt Gallery in 1888, quoted in Holly Richardson, "Landschaftsmalerei ist die schwerste Kunst," in *Max Liebermann: Der Realist und die Phantasie*, eds. Jenns E. Howoldt and Birte Frenssen (Hamburg: Hamburger Kunsthalle, 1997), 25.

26. "Das Datum der offiziellen Verkündigung des neuen Evangeliums…und wirkte jedenfalls in Deutschland' als 'Reklameposaunenstösse für seine Herrlichkeit.'" Anton von Werner, speech, July 17, 1897. Quoted in Forster-Hahn, "'La Confraternité de l'art,'" 526.

27. See also Erich Hancke, *Max Liebermann, sein Leben und seine Werke* (Berlin: B. Cassirer, 1914), 266.

28. "Que le sentiment de la confraternité de l'art existe aussi bien à Paris que chez nous en dehors de toute considération politique." Liebermann, letter (in French) to Antonin Proust, May 1889, Archives, Staatliche Museen-Preussischer Kulturbesitz, Berlin.

29. "Man fühlte sich nicht nur in ein anderes Haus, sondern in eine andere Stadt versetzt: nach Paris." Liebermann, "Meine Erinnerungen an die Familie Bernstein," in *Die Phantasie in der Malerei*, 88. For a detailed discussion of the Bernstein's collection and their central role as collectors, see Peter Krieger, "Max Liebermanns Impressionisten-Sammlung und ihre Bedeutung für sein Werk," in *Max Liebermann in seiner Zeit*, eds. Sigrid Achenbach and Matthias Eberle (Munich: Prestel, 1979), 60–71.

30. "The Eleven" was a group of Berlin artists who joined together to organize exhibitions outside the official exhibitions of the Royal Academy of Arts and the Association of Berlin Artists. Walter Leistikow was also a member.

31. The first comprehensive study of Liebermann's collection and based on a thorough investigation of sources is Karl-Heinz Janda and Annegret Janda, "Max Lieberman als Kunstsammler," *Forschungen*

und Berichte 12 (1973): 105–149. For an updated study, which includes the dispersal of the collection after 1933, see Annegret Janda, "Max Liebermann's Kunstsammlung in seinen Briefen. Versuch einer Chronologie," in *Max Liebermann und die französischen Impressionisten*, 225–254. Also see Claude Keisch "Liebermann, Künstler und Kunstfreund. Die Sammlung," in *Max Liebermann: Jahrhundertwende*, 221–232.

32. "Degas' Bilder dagegen machen zuerst den Eindruck einer Momentaufnahme. Er weiss so zu komponieren, dass es nicht mehr komponiert aussieht." Liebermann, "Degas," in *Die Phantasie in der Malerei*, 55–63, esp. 59–60.

33. "Keiner aber von allen modernen Malern war begabter als Degas, um auf dem von Manet urbar gemachten Wege die neue Kunst weiterzuführen, zu dem Ziele einer jeden Kunst: zum Stil." Liebermann, "Degas," 62–63.

34. For a recent discussion of Liebermann's theoretical writings, see Ruth Langenberg, "Die Autonomie der Kunst. Zu den Quellen der kunsttheoretischen Ansichten Liebermanns und Tschudis," in *Im Streit um die Moderne*, 29–34.

35. The classic text on the Berlin Secession is Peter Paret, *The Berlin Secession: Modernism and Its Enemies in Imperial Germany* (Cambridge, MA: Belknap Press of Harvard University Press, 1980). For a broad discussion of Secessionism, the impressionist *weltanschauung* and Meier-Graefe's engagement in modernism, see Robert Jensen, *Marketing Modernism in Fin-de Siècle Europe* (Princeton, NJ: Princeton University Press, 1994)

36. "Die Berliner Sezession wurde vor zehn Jahren aus einer Kampfesstimmung heraus gegründet… .so wäre sie [die Sezession] doch schon längst im Strome der Zeit untergegangen wenn sie nicht *notwendig* gewesen wäre" (emphasis in original). Liebermann, "Zehn Jahre Sezession," in *Die Phantasie in der Malerei*, 183.

37. Liebermann, "Reden zur Eröffnung von Ausstellungen der Berliner Sezession," in *Die Phantasie in der Malerei*, 171–192; on the first exhibition, see "Frühling 1899," 171–172.

38. "Eine jede Vorführung von Kunstwerken soll den Geschmack der Beschauer bilden." Liebermann, "Spring 1900," in *Die Phantasie in der Malerei*, 173.

39. "Und sie [die Sezession] wird notwendig bleiben, solange es Künstler geben wird, die an die Stelle der herrschenden ästhetischen Kunstanschauungen, die, als aus den Werken der Vergangenheit abstrahiert, mehr historisch sind, ihre eigenen Anschauungen, die in der Gegenwart wurzeln, setzen wollen." Liebermann, "Zehn Jahre Sezession," 183.

40. "Die wir heute als die Modernen gelten, werden vielleicht morgen schon von noch Moderneren zum alten Eisen geworfen." Liebermann, "Zehn Jahre Sezession," 183.

41. For the conflict between the impressionist and expressionist groups and a discussion of Nolde's anti-Semitic polemic, see Roland März, "Max Liebermann—'ein Torwart der modernen Malerei?' Die Expressionisten und der Impressionismus," in *Im Streit um die Moderne*, 35–42.

42. Vinnen's pamphlet, *Ein Protest deutscher Künstler gegen den bedrohlichen Import französischer Kunstware*, is discussed in the recent exhibition catalogue, *Van Gogh: Fields: the Field with Poppies and the Artists' Dispute*, ed. Wulf Herzogenrath and Dorothee Hansen (Bremen: Hatje Cantz, 2002), 2

43. "Wir sind alle Kinder unserer Zeit, und es ist ganz natürlich, wenn die Jungen den Platz der Alten einnehmen wollen." Liebermann, "Zehn Jahre Sezession," in *Die Phantasie in der Malerei*, 183.

44. With reference to Adolf Rosenberg's dismissive article in *Kunstchronik* on April 14, 1892, see Margreet Nouwen, "Vom 'Apostel des Hässlichen' zum Porträtmaler des Bürgertums," in *Max Liebermann: Jahrhundertwende*, 239–244, esp. 239.

45. "Merkwürdig: Liebermann, Uhde, Olde gelten überall noch als die 'Jungen' und sind dabei vierzig oder darüber. Das spricht Bände über unsere künstlerischen Zustände." Alfred Lichtwark, January, 19, 1897. Quoted in *Max Liebermann in seiner Zeit*, 131. On Lichtwark, see Carolyn Kay, *Art and the German Bourgeoisie: Alfred Lichtwark and Modern Painting in Hamburg, 1866–1914* (Toronto: University of Toronto Press, 2002).

46. Liebermann's essay on Degas appeared in *Pan* in 1896; his essay "Die Phantasie in der Malerei" in 1904; his first article on Manet in *Kunst und Künstler* in 1910, the second in an exhibition catalogue of the Galerie Matthiesen, Berlin, in 1928. The article on Claude Monet was published in *Zeitschrift für Kunst und Künstler* in 1927. For a recent edition of Liebermann's writings, see *Vision der Wirklichkeit: ausgewählte Schriften und Reden*, ed. Günter Busch (Frankfurt am Main: Fischer Taschenbuch Verlag, 1993).

47. Stefan Pucks, "Max Liebermann–Vom 'Apostel der Hässlichkeit' zum 'Manet der Deutschen,'" in *Max Liebermann und die französischen Impressionisten*, 40; see also E. Bénézit's *Dictionnaire critique et documentaire des peintres, sculpteurs, dessinateurs et graveurs de tous les temps et de tous les pays*, vol. 6 (Paris: Gründ, 1976), 656.

48. See Bernhard Maaz, "Max Liebermann Briefe an Hugo von Tschudi," in *Max Liebermann: Jahrhundertwende*, 305–316; Angelika Wesenberg, "Max Liebermann, der Kaiser, die Nationalgalerie," in *Im Streit um die Moderne*, 21–28; and Barbara Paul, *Hugo von Tschudi und die moderne französische*

Kunst im Deutschen Kaiserreich (Mainz: P. von Zabern, 1993).

49. Julius Meier-Graefe, *Kunst ist nicht für Kunstgeschichte da. Briefe und Dokumente*, ed. Catherine Krahmer with Ingrid Grüninger (Göttingen: Wallstein, 2001), 33 and 347.

50. See *Ausstellung deutscher Kunst aus der Zeit von 1775 bis 1875 in der Königlichen Nationalgalerie*, Vol.1, *Auswahl der hervorragendsten Bilder mit einleitendem Text von Hugo von Tschudi*, vol. 2, *Katalog der Gemälde* (Munich: F. Bruckmann, 1906). The collaboration of Meier-Graefe is only mentioned in Lichtwark's preface. For the complicated history of the exhibition and an analysis of its important role, see Sabine Beneke, *Im Blick der Moderne: "Die Jahrhundertausstellung deutscher Kunst (1775-1875)" in der Berliner Nationalgalerie 1906* (Berlin: Bostelmann and Siebenhaar, 1999); Barbara Paul, *Hugo von Tschudi und die moderne französische Kunst im Deutschen Kaiserreich,* (Mainz: Philipp von Zabern, 1993), 238–252; Angelika Wesenberg, "Impressionismus und die 'Deutsche Jahrhundert-Ausstellung Berlin 1906," in *Manet bis Van Gogh. Hugo von Tschudi und der Kampf um die Moderne*, eds. Johann Georg Prinz von Hohenzollern and Peter-Klaus Schuster (Munich/ New York: Prestel, 1996), 364–370; and Françoise Forster-Hahn, "Die Inszenierung von Kunst. Choreografien und Zeremonielle in der alten Nationalgalerie: 1876, 1906, 1955," in *Einführung in die Kunstwissenschaft*, eds. Thomas Hensel and Andreas Köstler (Berlin: Dietrich Reimer, 2005), 179–196, esp. 185–188.

51. Scheffler termed the exhibition "eine impressionistische Tendenzausstellung." Quoted in Beneke, *Im Blick der Moderne,* 211.

52. "Man freut sich, in diesen ersten *konsequenten* Schritten die Anfänge einer mit stetiger Sicherheit zur impressionistischen Farbenpotenz hinführenden Entwicklung zu erkennen." *Ausstellung deutscher Kunst aus der Zeit von 1775 bis 1875,* XXXVI.

53. Liebermann, "Hugo von Tschudi," in *Die Phantasie in der Malerei,* 110–116.

54. *Die Extreme berühren sich: Walther Rathenau, 1867-1922,* ed. Hans Wilderotter, (Berlin: Deutsches Historisches Museum and Argon: [1993]), 294 and 297.

55. Deutscher Künstlerbund was founded—as a protest against repressive state arts policy and to promote freedom for young artists—in Weimar in 1903 by Harry Graf Kessler. Members included Lovis Corinth, Max Liebermann, Alfred Lichtwark, Max Slevogt. It was abolished by the Nazis in 1936.

56. Serving first at the Eastern Front during World War I, Kessler was transferred to the battlefields of Verdun in 1916; there he seems to have suffered a nervous collapse from his experiences of the horrors of trench warfare. Sent back to Berlin, he engaged in intense political debates conducted in semi-official and private circles, including some that Rathenau also frequented. During his leave in Berlin, Kessler also reconnected to recent artistic and literary developments and sat for his portrait by Liebermann. Peter Grupp, *Harry Graf Kessler, 1868–1937,* 2nd ed. (Munich: Beck, 1996), 167.

57. "Zu erstrebendes Ziel heute in Deutschland: die philosophische Goethesche Kultur mit der Bismarckschen politischen und der fin-de-siècle ästhetischen zu vereinigen." Grupp, *Harry Graf Kessler,* 162. Kessler's personality was all the more complicated as he concealed his homosexuality; see Laird McLeod Easton, *The Red Count: The Life and Times of Harry Kessler* (Berkeley: University of California Press, 2002).

58. *Die Weltausstellung in Paris 1900: mit zahlreichen Photographischen Aufnahmen, farbigen Kunstbeilagen und Plänen,* ed. Julius Meier-Graefe (Paris and Leipzig: F. Krüger, 1900).

59. I first formulated the idea of the outsiders promoting modernism in the German Empire in an address at the opening of the Liebermann exhibition at the Hamburger Kunsthalle in 1997, which was published as *Max Liebermann: Der Aussenseiter als Entrepreneur der Künste* (Hamburg: Hamburger Kunsthalle, 1997). See also Peter Gay, *Freud, Jews and Other Germans: Masters and Victims in Modernist Culture* (New York: Oxford University Press, 1978) and *Weimar Culture: The Outsider as Insider* (New York: Harper and Row, 1968).

60. "Dass die neuere und neueste deutshe Kunstepoche hauptsächlich von Elementen hevorgerufen und gefördert werden soll, die von Geburt keine Deutschen sind und denen deshalb die feinere Empfindung für deutsche Eigenart abgeht." Grupp, *Harry Graf Kessler,* 111

61. "In den Jugendjahren eines jeden deutschen Juden gibt es einen schmerzlichen Augenblick, an den er sich zeitlebens erinnert: wenn ihm zum ersten Male voll bewusst wird, dass er als Bürger zweiter Klasse in die Welt getreten ist, und dass keine Tüchtigkeit und kein Verdienst ihn aus dieser Lage befreien kann." Walther Rathenau, "Staat und Judentum (1911)," in *Gesammelte Schriften,* vol. 1, *Zur Kritik der Zeit, Mahnung und Warnung* (Berlin: S. Fischer, 1925), 185–207 and 188–189. This passage is also quoted in Harry Graf Kessler, *Walther Rathenau: Sein Leben und sein Werk* (Berlin: Klemm A.G., 1928), 32. Kessler, in preparing this biography in commemoration of Rathenau's death and dedicating the volume to him, wrote of Rathenau "as a representative of the European, indeed the cosmopolitan idea" (49). For an English translation of the biography, see Count Harry Kessler, *Walther Rathenau. His Life and Work* (New York: Howard Fertig, 1969). See also Fritz Stern, "Walther Rathenau and the Vision of Modernity," in *From the Berlin Museum to the Berlin Wall.*

62. See Immo Wagner-Douglas, "Realist, Secessionist, Jude und Patriarch: Liebermann in der Karikatur," in *Max Liebermann: Jahrhundertwende,* 267–276. See also Beth Irwin Lewis, *Art for*

All? The Collision of Modern Art and the Public in Late-Nineteenth-Century Germany (Princeton and Oxford: Princeton University Press, 2003).

63. *Berliner politische Nachrichten* 112 (15 May 1889).

64. Meier-Graefe, "Kunst is nicht für Kunstgeschichte da," 48–49 and 357. Meier-Graefe writes to Kessler on July 15, 1905, about the Thode case that the editors contextualize in a detailed footnote. The German text about the motivation of the lectures reads: [aus] "Protest gegen jene einseitige das Fremde proklamierende Kunstauffassung, die vornehmlich von Berlin aus Deutschland aufgezwungen werden soll."

65. "...wie 'Mangel an nationalem Empfinden', 'Nachahmen der Franzosen,' 'Poesielosigkeit' und andern aus der Rüstkammer der Antisemiten entnommenen...Waffen..."Liebermann, *Die Phantasie in der Malerei*, 161.

66. Friedrich Meinecke, *Weltbürgertum und Nationalstaat; Studien zur Genesis des deutschen Nationalstaates* (Munich: R. Oldenbourg, 1908); an English translation was published as *Cosmopolitanism and the National State* (Princeton, NJ: Princeton University Press, 1970).

67. "Deschalb ist es auch kein Kontrast, ein guter Deutscher und ein 'guter Europäer' zu sein; ein Konflikt zwischen national und 'international' existiert nicht." Harry Graf Kessler, "Nationalität," *Die Zukunft* (7 April 1906): 17–27. Reprinted in *Gesammelte Schriften in drei Bänden*, vol. 3, *Künstler und Nationen: Aufsätze und Reden, 1899–1933*, eds. Cornelia Blasberg and Gerhard Schuster (Frankfurt am Main: Fischer Taschenbuch-Verlag, 1988), 117–130.

68. During the years of the Weimar Republic (1919–1933), Kessler worked tirelessly for the peace movement and acted as a diplomatic counsel to Walther Rathenau, who negotiated for the new republic as its foreign minister. Kessler and Rathenau not only wrote about their definition of modernity, nation, and nationality within an international context but also actively pursued their ideals as diplomats; Liebermann remained primarily in the sphere of the arts.

69. "Nach meiner Überzeugung hat Kunst weder mit Politik noch mit Abstammung etwas zu tun." Liebermann, May 8, 1933, in *Die Phantasie in der Malerei*, 321.

70. Max Beckmann, *On My Painting*, with a foreword by Mayen Beckmann and an afterword by Sean Rainbird (London: Tate Publishing, 2003), 11.

71. "[Ich habe während meines langen Lebens] mit allen meinen Kräften der deutschen Kunst zu dienen gesucht." Liebermann, declaration of resignation from the Academy, in *Die Phantasie in der Malerei*, 321.

Chronology

Suzanne Schwarz Zuber

	Max Liebermann	Art/Culture	Jewish History	Politics/Science
1847	Born July 20 in Berlin, the second of Louis and Philippine (née Haller) Liebermann's four children. The Liebermanns raise their children in the Jewish faith and with a strong emphasis on education and social welfare. Louis is a prosperous businessman and city councilman whose social policies focus on care of the poor and homeless.	Founded in 1696, the Royal Academy of Arts is the official arts organization in Prussia. Members are nominated for life by the government or academy members. The Association of Berlin Artists, a private association of artists founded in 1841, organizes, with the Academy, the annual official art exhibition in Berlin. Royal Institute for the Fine Arts oversees art education.	Period (1840s–1920s) sees a revival of Jewish nationalism, which leads to the first major European Jewish immigration to Eretz Israel (Land of Israel), the revival of vernacular Hebrew, and modern literature in Hebrew and Yiddish.	Population growth and economic depression foster discontent across Europe. German Confederation, a union of 39 independent states dominated by Austria, has ruled Germany since the defeat of Napoleon. Since 1840, Prussia has been ruled by the reactionary and authoritarian Friedrich Wilhelm IV.
1848		In Berlin, founding of the Association of Fine Artists, which is independent of the Academy and other art establishments. Theories of realism originate at gatherings of artists, writers, and thinkers, which include Gustave Courbet, Camille Corot, Honoré Daumier, Charles Baudelaire, and the socialist philosopher Pierre Joseph Proudhon.	During the postrevolutionary period in Germany, the national assembly in Frankfurt approves the "Basic Rights of the German People," which guarantee that rights are not conditional on belonging to a particular religious faith.	Called the Revolution of 1848, a series of independent uprisings take place in France, Germany, the Austrian Empire, and parts of Italy. Causes include demands for constitutional government, voting rights, and social reform. Although the revolution suffers defeat, European rulers are forced to accede to some liberal reforms. In Germany, the manorial system, which oppressed the peasantry, is abolished. In *The Communist Manifesto*, Karl Marx and Friedrich Engels predict that industrial Europe will experience economic and social collapse because of the defects inherent in capitalism and call for the working class to dismantle the capitalist system.

	MAX LIEBERMANN	ART/CULTURE	JEWISH HISTORY	POLITICS/SCIENCE
1849		Jean-François Millet settles in Barbizon, the hamlet in the Fontainebleau Forest where a new approach to landscape painting is created. Courbet's *A Burial at Ornans* defines a realist approach to painting by rejecting any sort of idealization, both in subject matter (ordinary people and activities) and in his way of painting.	Gold rush in California attracts many European Jews.	First telegraph lines between Berlin and Frankfurt am Main.
1851		At the Salon in Paris, Millet's *The Sower* and Courbet's *Stonebreakers* and *A Burial at Ornans* attract critical attention.	When the ruling nobility is restored throughout the German states, "Basic Rights of the German People" are rescinded.	Throughout Germany, members of communist organizations are subjected to arrest.
1852		Jakob and Wilhelm Grimm publish the first part of their *German Dictionary*.	Jewish ghetto in Prague is officially abolished.	Louis Napoleon declares Second Empire in France and proclaims himself Emperor Napoleon III.
1853		World's Fair in Paris. Neue Pinakothek opens in Munich. Text of Richard Wagner's *Ring of the Nibelung* published privately.	*Inequality of the Human Races*, by French diplomat Comte Joseph de Gobineau, asserts the superiority of the Germanic, or Aryan, race. Publication of first modern Hebrew best-selling novel, *Love of Zion*, by Abraham Mapu.	Crimean War is the third conflict between Russia and the Ottoman Empire in this century; it ends in 1856 with victory for Ottoman Turks.
1854		Glass Palace exhibition hall is built in Munich. As Germany's largest exhibition space at the time, it will house groundbreaking exhibitions of both historical and contemporary art.		General German Industrial Exhibition held in the newly built Glass Palace in Munich.
1855		Adolph Menzel inspired by Courbet's Pavillion of Realism at World's Fair in Paris.		Alexander II becomes czar and institutes economic reforms to strengthen Russia as a world power.
1856	Liebermann & Co expands by acquiring two ironworks in Silesia.	Newly founded General German Art Association seeks to transform official art exhibitions by involving independent artists in local chapters.	Committee for the Organization of the Jews is appointed by Alexander II to seek ways to foster assimilation of the Jews into Russian society.	
1857		Millet paints *The Gleaners*.		Series of labor strikes in Germany.
1858		Courbet exhibits in Frankfurt.	Emancipation for the Jews in England.	Prince Wilhelm becomes regent in Prussia and initiates some reforms. First transatlantic telegraph cable.
1859	Liebermann family moves to Pariser Platz 7, near the Brandenburg Gate.	Gustave Flaubert, praised and condemned as the high priest of realism, publishes *Madame Bovary* and is tried for violation of public morals. Publication of Baudelaire's *Les Fleurs du Mal*.	Beginning of the limited easing of restrictions on Jews living outside the Pale of Settlement in Russia.	J.S. Mill theorizes in *On Liberty* that public policy should seek to promote the general happiness. Charles Darwin's *On the Origin of Species by Means of Natural Selection*.

	MAX LIEBERMANN	ART/CULTURE	JEWISH HISTORY	POLITICS/SCIENCE
1860	Liebermann & Co. acquires the Dannenberg calico factory, a leading textile manufacturer.	Premiere of Richard Wagner's *Tannhäuser* in Paris.	Alliance Israélite Universelle is founded in Paris with the goal of protecting Jewish rights and promoting educational and professional development worldwide.	Giuseppe Garibaldi's efforts to win an independent and unified Italy spark nationalist movements throughout Europe.
1861		Banker Joachim H.W. Wagener bequeaths a collection of 262 paintings to Wilhelm II as the core for the collection of the future National Gallery, Berlin.	Zion Society formed in Frankfurt am Main.	Wilhelm I becomes King of Prussia. German Progress Party is formed and supports liberal policies. Achieving a unified Germany under Prussian leadership is one of its goals.
1862	Becomes interested—along with some classmates—in the persona and nonconformist political views of Ferdinand Lassalle, who has begun to give public speeches on labor rights.	First volume of Theodor Fontane's *Wanderings through the Mark of Brandenburg* published. This popular series, celebrating the Prussian landscape and its people, appears in eight parts over the next two decades, fostering a strong national pride.	Jews are given equal rights in Poland. Rabbi Zevi Hirsch Kalischer writes *Derishat Ziyyon* (Longing for Zion), declaring the settlement of Palestine by Jewish farmers a religious commandment.	Otto von Bismarck appointed prime minister of Prussia. His military reforms will make the Prussian army one of the most powerful in the world.
1863	Takes art lessons from Eduard Holbein (until 1864).	Works from the Barbizon School are exhibited at the Kunstverein in Munich. Édouard Manet exhibits *Déjeuner sûr l'herbe* and other paintings at the first Salon des Refusés, a exhibition set up for artists whose work had been rejected by the jury of the official Salon. Munich chapter of the General German Art Association gains independent authority from the academy over annual exhibitions.	In the *Life of Jesus*, a highly successful book published in France, Joseph-Ernest Renan asserts the inferiority of Semites.	Prussia allies with Russia to suppress revolt in Poland. Lassalle co-founds the socialist General German Workers' Association, which believes that social and economic reforms should be carried out through governmental means. Other socialists, like August Bebel, believe that workers should instigate reform.
1864		Leo Tolstoy's *War and Peace* published in segments between 1864 and 1869. Claude Monet, Alfred Sisley, and Pierre Auguste Renoir paint plein-air landscapes in the forest of Fontainebleau.		First Geneva Convention creates standards for the humane treatment of civilians, prisoners, and wounded persons in wartime. First labor unions in Germany.
1865	Paints a portrait of his brother Felix, his earliest extant oil painting.	International Photography Exhibition opens in Berlin. Manet's *Olympia* and *Christ Mocked* exhibited at Paris Salon; Edgar Degas and Claude Monet make first appearances.	Establishment in Berlin of the Central Committee for Jewish Settlements in Palestine.	First International brings together socialists from many countries at its first congress in London. Lassalle dies in a duel.
1866	Graduates from the Gymnasium. Studies philosophy at Berlin University. Apprentices with his former teacher, Berlin painter Carl von Steffeck. His sketchbook from this time includes drawings after Titian, Ingres, and Menzel. Paints his first self-portrait, now lost.	Monet's *Camille* and Courbet's *Woman with Parrot* exhibited at the Paris Salon. Courbet's paintings meet with great approval. Fyodor Dostoevsky's *Crime and Punishment* published.	Completion of the Moorish-style New Synagogue in Berlin; designed by Eduard Knoblich, it is the largest Jewish house of worship in Germany. Emancipation of the Jews in Switzerland.	Prussia instigates, defeats Austria in Seven Weeks' War. Bismarck dissolves German Confederation, establishes North German Confederation under Prussian leadership. Werner von Siemens uses electrodynamic principles to develop electric motors.

	MAX LIEBERMANN	ART/CULTURE	JEWISH HISTORY	POLITICS/SCIENCE
1867	As an student in the artist's studio, works on Steffeck's painting *King Wilhelm I Greeted by His Warriors after the Battle of Königgrätz*, 1869.	Retrospective of Millet's work at World's Fair in Paris. Menzel is made a knight of the Legion of Honor. Paintings by Camille Pissarro, Renoir, Sisley, and Monet are rejected by the Paris Salon.	Final emancipation (equality before law) of the Jews in Austria-Hungary.	Austria and Hungary establish the Dual Monarchy, to consolidate power against the threat of Prussia. First volume of *Das Kapital* by Karl Marx published. First industrial production of dynamite.
1868	Enrolls at Weimar Academy of Art, directed by the realist painter Leopold von Kalkreuth. Studies with Jozef Pauwels, Charles Verlat, and Paul Thumann. Makes regular visits to the Sunday salons of his professor, the Nazarene artist Peter von Cornelius, where the young Felix Mendelssohn performs.	Manet, Degas, Pissarro, Monet, Sisley, and Berthe Morisot, exhibit at the Paris Salon. Millet is made a knight of the Legion of Honor.	Benjamin Disraeli, baptized into the Church of England at age 13, becomes the first and only person of Jewish descent to become prime minister of Great Britain.	Bebel founds trade union cooperative in Germany.
1869		Courbet's work exhibited at Munich's first International Art Exhibition. Several of the Munich realists subsequently visit Courbet in Paris.		Bebel and Wilhelm Liebknecht found the Social Democratic Workers' Party in Germany.
1870	Exempt from the draft because of a badly healed broken arm, serves as a civilian volunteer at the Johannite Order.	Many French artists, including Monet and Pissarro, seek refuge in London from the Franco-Prussian war. Excavation of the ruins of Troy by Heinrich Schliemann.	Abolition of the ghetto in Rome and final emancipation of Jews in Italy. Mikveh Israel is first agricultural school established by Charles Netter, head of the Alliance Israélite Universelle.	France declares war on Prussia. Prussian army besieges Paris. Napoleon III deposed. During the war, the four southern German states agree to join a united German nation under Prussian leadership.
1871	Visits Hungarian realist painter Mihály Munkácsy in Düsseldorf, where he admires the painting *Making Lint*. Visits the Rijksmuseum on his first trip to the Netherlands; admires the Dutch school of painting, especially the works of Frans Hals. Begins work on *Women Plucking Geese*.	Monet settles in Argenteuil after spending fifteen months in England and Holland. James McNeill Whistler paints *Arrangement in Grey and Black—Portrait of the Artist's Mother*.	After Alsace-Lorraine territory is annexed by the German Empire, thousands of Alsatian Jews emigrate to France. Jews emancipated and given full rights by the new constitution of unified Germany.	Wilhelm I crowned emperor of German Empire; appoints Bismarck chancellor. Royalist-dominated National Assembly is elected in France to conclude peace with Prussia, which stipulates harsh reparations. Revolt by republicans in Paris (called the Paris Commune), who fear the restoration of the monarchy, is suppressed.
1872	*Women Plucking Geese* is exhibited in Hamburg in May and sold to Berlin industrialist Henry Bethel Strousberg. With proceeds of sale, travels to Paris, where he first sees the work of Millet and Courbet. Rudolf Lepke, Berlin's most prominent art dealer, offers to represent Liebermann. Debuts at the annual autumn exhibition of Berlin's Royal Academy of Arts with *Women Plucking Geese*. Its unidealized depiction creates public controversy and bad press, but he is commended by Menzel.	Monet paints *Impression, Sunrise*. When it is displayed two years later, a critic uses its title to define the movement: "They are impressionists in the sense that they render not the landscape but the sensation produced by the landscape." Menzel begins *Iron Rolling Mill* for Max Liebermann's uncle, a banker. Painting depicts the manufacture of railroad tracks in the most modern iron rolling mill on the continent. Eadweard Muybridge captures first moving pictures, showing a horse in motion.	An anti-Semitic series, reviving the *Wucherjude* (Rampant Jew) stereotype of Jewish expertise in financial affairs, first appears in the family magazine *Die Gartenlaube* (The Garden House).	End of German occupation of France. Conflict escalates between the secular state and the Catholic minority in southern Germany. *Kulturkampf* (Culture War) over separation of church and state begins with a series of laws legalizing civil marriage, limiting the movement of the clergy, and dissolving religious orders. At the same time, the liberal press and socialism are identified with the "unacceptable face" of modernism.

	MAX LIEBERMANN	ART/CULTURE	JEWISH HISTORY	POLITICS/SCIENCE
1873	Paints *Self-Portrait with Kitchen Still Life*. Moves to Paris, drawn by Barbizon painters, especially Millet. Isolated from the circle of French painters by strong anti-German sentiment, associates with Munkácsy. Frequents the Dutch galleries at the Louvre and paints copy of Frans Hals's *Bohémienne*.	First color photograph taken by Louis Ducos du Hauron, who invented the process.	Series of articles blames Jewish liberalism for the Kulturkampf and the general financial crisis in Europe. First installments of English novelist George Eliot's *Daniel Deronda*, which offers the Zionist dream as a solution to persecution of the Jewish people, published. Final installments appear in 1874.	Stock market crash in Vienna begins a financial crisis that spreads across Europe. Germany, Austria, and Russia form the Alliance of the Three Emperors.
1874	Exhibits *Women Plucking Geese* at the Salon in Paris. Does not visit the first impressionist exhibition at the studio of writer/photographer Nadar. Lives at an inn in Barbizon, in close proximity to Millet, who refuses any contact. Paints peasants picking potatoes, completing *Potato Harvest in Barbizon* in Paris.	First of eight exhibitions by the impressionist group shows works by Monet, Renoir, Pissarro, Degas, Morisot, and Paul Cézanne. Corot and Manet are among the invited artists who do not participate in any of this group's shows. Munich's second International Art Exhibition.	Hebrew Union College (Reform rabbinic academy) opened in Cincinnati, Ohio.	
1875	Returns to Barbizon, then travels to Zandvoort in the Netherlands for the summer. Visits Haarlem often to see the works of Frans Hals. Works on *Children Playing*, *The Siblings*, and *Workers in a Turnip Field* in his studio at 75, Boulevard de Clichy, Paris.	Anton von Werner becomes the director of the Berlin Academy of Fine Arts. Manet's *Argenteuil* shown at the Paris Salon. Paul Heyse's novel *In Paradise* portrays the flourishing artistic life of Munich.		After a period of political instability following its defeat by Prussia, France declares Third Republic. Constitution grants universal male suffrage. Berlin's population reaches 1 million. German Social Democratic Party (SPD) is founded.
1876	Exhibits *Workers in a Turnip Field* at the Paris Salon in May. Travels to Düsseldorf and then visits his parents in Berlin. Spends five months in Holland. Copies many of Franz Hals's works; visits Amsterdam and its Jewish quarter with the painter August Allebé. Paints interior views of the historic Portuguese synagogue. Paints plein-air studies in the courtyard for *Recess in the Amsterdam Orphanage*. Creates first version of *Sewing Class at the Amsterdam Orphanage* in his studio.	Opening of National Gallery in Berlin. Richard Wagner founds the Bayreuth Festival; the Festival Theater opens with his *The Ring of the Nibelung*. Second impressionist exhibition opens in Paris. Edmond Duranty's pamphlet *The New Painting* comments positively on impressionists' use of color, line, and choice of modern motifs.	Heinrich Graetz's eleven-volume *History of the Jews* is the first standard work in the field. Abraham Goldfadden establishes Yiddish theater in Romania.	Thomas Edison invents phonograph. In the German elections, the Social Democrats gain more than half a million votes.
1877	Exhibits the second version of *Sewing Class* at the Paris Salon and *At the Swimming Hole* in Amsterdam. *Workers in a Turnip Field* and *Gossip*, exhibited at the Royal Academy of Arts, are condemned by the Berlin critics. His sister buys *Workers*.	Monet paints seven views of the Gare Saint-Lazare, which are shown at the third impressionist exhibition. William Morris begins a series of lectures calling for the elimination of the machine and the revival of handcrafts to improve modern life, inspiring what will become known as Arts and Crafts Movement.	New Hampshire becomes the last state in the United States to give Jews equal political rights.	Another conflict between Russia and the Ottoman Empire begins and ends in 1878 with the victory of Russia, which also regains its dominant position in the Balkans.

	MAX LIEBERMANN	ART/CULTURE	JEWISH HISTORY	POLITICS/SCIENCE
1878	Stay in Berlin is prolonged by injury; travels to Venice via Tyrolia to recuperate. Makes studies of peasants at work, Venice street scenes, and views of the Sephardic synagogue. Paintings, including *The Siblings,* shown at the Royal Academy of Arts in Berlin, are heavily criticized in the press. Encouraged by Franz von Lenbach and other Munich painters, moves to Munich.	After years of boycotting the Paris World's Fair, the Royal Academy of Arts in Berlin participates, with full governmental support. Menzel's *Iron Rolling Mill,* one of the first representations of an industrial scene in German art, is included.	Adolf Stoecker, a protestant cleric, conservative politician, and reformer, founds the German Christian Social Party and promotes political anti-Semitism.	At the Congress of Berlin, European colonial interests are apportioned, with resultant shifts in European alliances. In Germany, socialist organizations are outlawed and activities supporting workers' rights made illegal.
1879	Exhibits *The Twelve-Year-Old Jesus in the Temple with the Scholars,* along with *Women Plucking Geese* and *Workers in a Turnip Field* in Munich. Jury praises *The Twelve-Year-Old Jesus,* but the Crown Prince of Bavaria objects. Criticism in press escalates into an anti-Semitic campaign. Gains friendship of realist painter Wilhelm Leibl, who admires his talent. Spends summer in a village near Dachau. Begins second versions of *Children's School* and *Women Cleaning Vegetables* on his return to Munich.	At the Paris Salon, Manet's *Boating* and *In the Conservatory* are shown, as well as Renoir's *Madame Charpentier and her Children.* Fourth impressionist exhibition includes works by the American Mary Cassatt. Renoir does not participate; his works are shown at the official Salon. Henrik Ibsen, living in Munich, writes his realist play, *A Doll's House.*	Wilhelm Marr's *The Victory of Judaism over Germanicism* introduces the term "anti-Semitism," which defines opposition to Jews on ethnic rather than religious grounds; he also founds the League of Anti-Semites, a political organization that fails to gain popular support. In his article *Our Prospects,* Prussia's leading historian Heinrich von Treitschke prescribes anti-Semitism as a remedy for the young nation of Germany.	Austria and Germany become allies. Thomas Edison invents the electric light bulb. Connected differential arc lamps are installed at Berlin Trade Fair.
1880	Shows *Children's School* and *Women Cleaning Vegetables* at Salon in Paris. Travels to Dongen in the Netherlands. Begins *Old Men's Home in Amsterdam,* the painting that initiates phase of light-infused, intimate realism in his work.	Manet's *Execution of the Emperor Maximilian,* 1867, exhibited in New York and Boston. Fifth impressionist exhibition includes for the first time works by Paul Gauguin. Cézanne, Monet, Renoir, and Sisley exhibit at the Salon. Auguste Rodin begins *The Gates of Hell,* inspired by both Dante's *Divine Comedy* and Baudelaire's *Les Fleurs du Mal.*	Statement signed by seventy-five Berlin notables protests recent wave of racism. Mobs—mostly members of recently founded Nationalist Student Clubs—rush through the streets of Berlin shouting "Out with the Jews" and assaulting Jewish café patrons. Petition drive in the German press collects over 200,000 signatures favoring reversal of Jewish emancipation.	During the 1880s in Germany, accident and old-age insurance as well as a form of socialized medicine are introduced and implemented by Bismarck's government, in an effort to forestall the spread of socialism.
1881	Awarded an honorable mention at the Salon in Paris for *Old Men's Home* and *Old Woman Darning by the Window,* the first German since the war of 1870 to be so honored. Glowing reviews in the French press; both paintings sold to Léon Maître. During summer in the Netherlands, meets and begins lifelong friendship with the Dutch realist painter Jozef Israëls. Finishes *Recess in the Amsterdam Orphanage.*	In Vienna, the Ringtheater is destroyed during a fire. Sixth impressionist exhibition is organized by Degas and Pissarro, who takes over after Monet's withdrawal. Cézanne, Renoir, and Sisley decline to participate.	First modern Russian pogrom. Three waves of organized massacres of Jews by Christians occur in this period: 1881–4, 1903–6, and 1917–21. Each is greater in scope and savagery than its predecessor. Conservative Antisemitic Alliance is second most successful party in German national elections. About 2½ million Eastern European Jews emigrate to the U.S. (1880–1920). Beginning of first *Aliyah* (going up), a major wave of Jewish immigrants intent on building a homeland in Palestine.	Triple Alliance—Austria, Germany, and Italy—is formed. Alexander II of Russia is killed by a terrorist's bomb in St. Petersburg. In response, Alexander III, his son, limits freedom of the press and of the universities and reduces the powers of local governments. In Berlin, electric tram designed by Siemens goes into service.

	MAX LIEBERMANN	ART/CULTURE	JEWISH HISTORY	POLITICS/SCIENCE
1882	Honored with membership in the artists' association Cercle des XV in Paris, which includes Jules Bastien-Lepage and Alfred Stevens. *Recess in the Amsterdam Orphanage* and *Cobbler's Workshop* praised at the Salon in Paris and bought by the popular composer Gabriel Fauré. Liebermann's images of Dutch social institutions gain fame in Paris, but reception in Germany is lukewarm. Spends August through October in the remote Dutch village of Zweelo where he finds plein-air motifs for *Bleaching Linens, The Weaver.*	Seventh impressionist exhibition is presented by art dealer Paul Durand-Ruel, who rents the space. Manet's *Bar at the Folies-Bergère* and *Spring* are shown at the Paris Salon.	Anti-Semitic May Laws, which severely limit the rights of Jewish citizens, are instituted in Russia. In response to the pogroms in Russia, Judah Leib Pinsker's *Auto-Emancipation! A Challenge to his People from a Russian Jew* dismisses assimilation and influences the formation of secular Zionist groups.	Liebermann's uncle, Emil Rathenau, acquires the rights to use Edison's patents in Germany. Siemens installs first permanent electric street lighting in Berlin. Georg Meisenbach patents process for half-tone printing.
1883	Exhibits *Recess in the Amsterdam Orphanage* and *Cobbler's Workshop* in Munich. *Cobbler's Workshop* is nominated for a gold medal but fails to win support of the history painter Karl Becker, who is the new president of the Academy in Munich. Begins work on *Munich Beer Garden.*	Durand-Ruel inaugurates solo shows for individual impressionists. Monet settles in Giverny. Nietzsche's *Thus Spoke Zarathustra* is published. Gurlitt Gallery in Berlin shows French impressionist works for the first time.		Rathenau founds AEG, which becomes Berlin's generator of electricity and also manufactures motors.
1884	Marries Martha Marckwald (September 14). The honeymooners visit Jozef Israëls in Scheveningen in the Netherlands, where Liebermann creates studies for *Women Mending Nets* and the first of his Jewish street scenes. Exhibits *The Twelve-Year-Old Jesus* with the Cercle des XV at the Galerie Georges Petit in Paris, for the first time since the 1879 controversy. He has altered the boy's features, gestures, and clothing, transforming him into a blond, angelic figure characteristic of traditional depictions of Jesus in Christian art.	A year after his death, a retrospective exhibition of Manet's work is held in Paris. First Salon des Indépendants is held in Paris with works by Cézanne, Gauguin, Toulouse-Lautrec, van Gogh, and Seurat. National Gallery, Berlin, holds first major retrospective of Menzel's work.	In the Reichstag elections, Paul Singer, a Jewish candidate, defeats his anti-Semitic opponent by a majority of votes. Singer later becomes co-chair of the Social Democratic party.	Germany establishes colonies in Africa and on islands in the Pacific Ocean. Hiram Maxim patents recoil-operated machine gun.
1885	Birth of daughter Käthe (August 19). Joins the Association of Berlin Artists, with the help of Anton von Werner, director of the Royal Academy of Arts. Introduced to Carl and Felicie Bernstein and joins their salon, which showcases impressionism.	Pissarro meets Paul Signac and Seurat and begins to paint in their new manner, which is later called "neo-impressionism." Van Gogh paints *Potato-Eaters.* Cézanne continues his series of paintings depicting Mont Sainte-Victoire.		German engineer Karl Benz produces the first automobile powered by an internal-combustion engine.

	Max Liebermann	Art/Culture	Jewish History	Politics/Science
1886	*Study for Recess in the Amsterdam Orphanage* and *Old Men's Home* are exhibited at the largest international exhibition ever mounted in Berlin, in new gallery spaces at the Royal Academy of Arts. These works are praised by the public and prestigious critics, especially Friedrich Pecht in Munich, whose earlier condemnation of *The Twelve-Year-Old Jesus* was anti-Semitic. Makes studies from life at the painters' colony at Laren in the Netherlands and begins *Flax Spinners in Laren.*	At the eighth and last impressionist exhibition, neo-impressionist paintings by Seurat and Signac and symbolist paintings by Odilon Redon and Gauguin are shown. Monet and Renoir decline to participate. Vincent van Gogh arrives in Paris and meets Henri de Toulouse-Lautrec, Émile Bernard, Paul Gauguin, and some of the impressionists.	Publication of Édouard Drumont's best-selling two-volume anti-Semitic study, *La France Juive* (Jewish France). Jewish Theological Seminary for Conservative Judaism established in New York.	Statue of Liberty, a gift from France to the United States, dedicated in New York harbor.
1887	*Flax Spinners in Laren* praised at the Paris Salon but goes unsold. "Study on Naturalism and Max Liebermann," an essay by Hermann Helferich published in art journal *Die Kunst für Alle,* marks first public acceptance. Begins work on *Women Mending Nets,* a large-scale painting for which he made studies during his summer in Katwijk.	Nietzsche writes *On the Genealogy of Morals.* Anton von Werner, director of the Royal Institute for the Fine Arts, is elected chairman of the Association of Berlin Artists, and so controls both fronts of the Berlin art establishment.	Liebermann's cousin Willy Liebermann creates sensation in Germany: When he is denied the title of reserve officer (a privilege from which Jews are excluded), he challenges his commanding officer to a duel. Neither is injured.	Bismarck arranges the (secret) Reinsurance Treaty with Russia, stipulating that each would remain neutral if the other became involved in a war with another great power and that it would not apply if Germany attacked France or if Russia attacked Austria. It lasts three years. End of Kulturkampf. Most anti-Catholic legislation has been repealed or softened.
1888	*Flax Spinners in Laren* wins the small gold medal at the International Art Exhibition in Munich. Wilhelm II awards small gold medal to *Still Work* at the Royal Academy of Arts, Berlin. *Flax Spinners in Laren* is acquired by the National Gallery, Berlin, for a nominal fee, becoming Liebermann's first work in a museum collection. Wilhelm von Bode, on the staff of the National Gallery, Berlin, proclaims Liebermann the arbiter of a new German art in an article in the newspaper *Kölnische Zeitung.*	Theodor Storm's historical novel *Der Schimmelreiter* hails the heroic qualities of the German character. The Hague School of painting continues to flourish in the Netherlands.		After the death of his father Wilhelm I, the terminally ill Frederich III dies after reigning for only 99 days. Wilhelm II becomes emperor. Period of stability and progress begins in Germany. George Eastman introduces the first simple Kodak camera. Nikola Tesla, a pioneer in the study of electromagnetism, invents the three-phase AC motor.

	MAX LIEBERMANN	ART/CULTURE	JEWISH HISTORY	POLITICS/SCIENCE
1889	Accepts invitation to join the Société des Beaux Arts, which manages the Paris Salon. Hamburger Kunsthalle acquires *Women Mending Nets;* a close collaboration and friendship with Alfred Lichtwark, the museum's director, begins. Accepts invitation to assemble an independent exhibition of German art at the World's Fair in Paris. His involvement is strongly criticized in both France and Germany, but many in France accept Liebermann as the leader of a new movement in German painting that embraces naturalism.	Munich Art Association, building on the success of its quadrennial exhibitions, holds its first annual. Menzel exhibits work at the World's Fair in Paris in spite of Bismarck's prohibition. Gurlitt Gallery holds first exhibition of Lesser Ury's work.	Ferdinand von Saar's *Seligmann Hirsch* published in his collection *Fates*. Its pathos elucidates the failure of emancipation for Jews. First Zionist student association is formed in Berlin. French journalist and anti-Semitic leader Édouard Drumont founds *La Libre Parole* (Free Speech). It becomes a bastion of anti-Dreyfusard propaganda.	Eiffel Tower is completed for the World's Fair in Paris, which celebrates the centennial of the French Revolution. Germany boycotts this event, considering it hostile to monarchies. Henri Bergson's *Time and Free Will* and William James's *The Principles of Psychology* define the notion of "stream of consciousness."
1890	Exhibits the just-completed *Old Woman with Goats* at the New Salon, a secessionist exhibition held in Paris.	In Berlin, the Free Stage Association, a members-only theater group created for workers and exempt from censorship, presents new plays. Among its founders are Otto Brahm, the leader of the modern German theater movement, and Samuel Fischer, a Jewish publisher and arts patron. Van Gogh commits suicide. Ibsen writes *Hedda Gabler*.	Odessa Committee (Society for Agricultural Workers and Craftsmen in Syria and Palestine) is founded to facilitate Jewish settlement in Palestine. Term "Zionism" is coined and defined as a movement supporting the return of the Jewish people to their homeland in Eretz Israel.	Graf Leo von Caprivi becomes chancellor after Bismarck is forced to resign. Wilhelm II's personal rule begins. Legislation outlawing socialist organizations expires and is not renewed. Social Democratic Party, which had continued to operate as an underground organization, becomes one of Germany's strongest parties.
1891	Munich Art Association mounts a Liebermann exhibition in January. *Old Woman with Goats* wins the large gold medal at Munich's International Art Exhibition and is acquired by the Neue Pinakothek, Munich. First major portrait commission: Mayor Carl Friedrich Petersen of Hamburg. Portrait is rejected by the sitter and his family, who forbid its display.	Rodin commissioned to create monument to Balzac by French Writers' Association. Posthumous retrospective exhibitions on van Gogh are held in Brussels and Paris. Seurat paints *The Circus*. Gauguin settles in Polynesia, where he creates a significant body of work. Publication of Oscar Wilde's *Picture of Dorian Gray*.	More than 10,000 Jews are expelled from Moscow, and 110,000 Russian Jews leave Russia. Through his negotiations and funding, Baron Maurice de Hirsch enables the mass emigration of Jews to Argentina within the next twenty-five years.	Triple Alliance between Germany, Austria-Hungary, and Italy is renewed. Pan-German Association is founded and promotes radical German nationalism. Social Democratic Party in Germany endorses the orthodox Marxian Erfurt Program, which calls for the elimination of classes and class rule. Prussia sets up first modern income tax regime.

	Max Liebermann	Art/Culture	Jewish History	Politics/Science
1892	Founds the secessionist group, "the Eleven," with Walter Leistikow; displays *Portrait of Carl Friedrich Petersen* at the first exhibition and is hailed as one of the best talents. Denied the large gold medal for *Women Mending Nets* and *Old Woman with Goats*, he abstains from the Royal Academy of Arts exhibitions in Berlin for the next several years. Acquires a still life by Manet and buys a pastel by Degas, beginning his private collection of impressionist works. Returns to Berlin from Paris because his mother is ailing; when she dies, moves with his wife and daughter into the house at Pariser Platz.	More than 100 artists, dissatisfied with the mass market and conservatism of the official art exhibitions, form the Munich Secession. Its opening exhibition features naturalist and symbolist works. Solo exhibition of works by Munch at the Association of Berlin Artists is closed within a week after protests from conservative members.	Publication of Ludwig Jacobowski's *Werther the Jew* and Israel Zangwill's *Children of the Ghetto*. In the press, the scandal surrounding the French attempt to build a canal in Panama centers on the Jewish Baron Jacques de Reinach. For anti-Semitic factions, this scandal seems to confirm financial conspiracy theories.	In an effort to stabilize markets and the economy of Europe, Austria-Hungary joins with Germany, Italy, Belgium, and Switzerland in commercial treaties, which reduce tariffs. Last major outbreak of cholera in Germany kills 9,000 in Hamburg. Rules for the control of epidemics of cholera are formulated by pioneering bacteriologist Robert Koch and approved by the major European nations in 1893.
1893	Travels to northern Italy, then visits Rosenheim, where he paints studies for *Beer Garden in Brannenburg*; this work introduces a new phase in his painting: leisure-class motifs rendered in impressionist style.	Poet Richard Dehmel's collection of writings *But [the Greatest of These is] Love* published. This ode to positive philosophy ruminates on the equality of art with love discusses the challenges facing emancipated Jews.	In Berlin, the Central Union of German Citizens of the Jewish Faith founded as a national lobby to counteract growing anti-Semitism and to promote full civil rights. Anti-Semitic parties gain 250,000 votes in German elections.	France and Russia form a military alliance against Germany. Currency crisis in Germany. Rudolf Diesel develops high-pressure oil combustion engine.
1894	At the death of his father in April, Liebermann inherits a great fortune and the house at Pariser Platz. Hires architect Hans Grisebach to redesign the home in clean, modern style. *Women Plucking Geese* goes to the National Gallery, Berlin, in a bequest from Louis Liebermann. In Vienna, Liebermann receives the large gold medal for *Old Woman with Goats*. Paints the large canvas *Striding Peasant* entirely from life while in Katwijk during his annual stay in Holland. Creates two oil studies depicting Samson and Delilah.	Gustave Caillebotte's bequest of his impressionist collection is rejected by the French government and accepted by Musée du Luxembourg. Free Stage in Berlin presents Hauptmann's naturalist drama *The Weavers*, which had been censored the year before. It dramatizes a breakdown of industrial relations. It is popular with the avant-garde for its criticism of the establishment.	Captain Alfred Dreyfus, the only Jew on the general staff of the French army, is wrongly accused of treason, found guilty, and sentenced to life imprisonment on Devil's Island. Dreyfus Affair galvanizes the French public against its Jewish population. Because Dreyfus was from Alsace and had allegedly spied for the Germans, anti-Semitism in France is linked to anti-German sentiment.	Nicholas II becomes czar in Russia. Germany and Russia sign a commercial treaty. Prince Hohenlohe becomes chancellor of Germany. First mass-produced vehicle, the Velo, is manufactured by the Benz Patent Motor Car Co.
1895	Joins committee for the first Venice Biennale; receives Province of Venice Prize at the exhibition. Paints the first versions of *Young Boys Swimming* and *Seated Peasant in the Dunes*. Musée du Luxembourg acquires *Beer Garden in Brannenburg*, his first work to be purchased by a French institution.	Max and Emil Skladanowsky introduce movie technology, which marks the beginning of the German film industry. Etching of Käthe Kollwitz's *A Weaver's Uprising* is published. *Pan*, an art journal founded by Dehmel, Julius Meier-Graefe, and Otto Julius Bierbaum, promotes the aesthetic of art nouveau and symbolism.	The public degradation of Dreyfus in the courtyard of the École Militaire in Paris is witnessed by reporter Theodor Herzl.	Japan wins its war against China, gaining dominance in the region. Wilhelm C. Roentgen discovers the X ray.

	MAX LIEBERMANN	ART/CULTURE	JEWISH HISTORY	POLITICS/SCIENCE
1896	Awarded the French Legion of Honor for the second time; the German government allows him to accept. Accompanies Hugo von Tschudi—new director of the National Gallery, Berlin—to Paris and advises him on impressionist art. Second, expanded version of *Young Boys Swimming* garners Degas' praise in Paris. Writes an article on Degas for *Pan*, later published in book form by Cassirer.	In Munich, first publication of the satirical journals *Simplicissimus* and *Jugend*, which gives Jugendstil, the German art nouveau movement, its name. Von Tschudi acquires paintings and sculptures by French artists, including Manet and Rodin, for the National Gallery, Berlin.	Herzl publishes a pamphlet, *The Jewish State: An Attempt at a Modern Solution to the Jewish Question*, which argues against futile attempts to assimilate and marks the rise of the Jewish national movement in Germany. Nathan Birnbaum publishes the literary magazine *Modern Jews*, which includes literature in Hebrew and Yiddish.	Wilhelm II's telegram to President Paul Kruger of the South African Republic, congratulating him on defeating the British-led Jameson Raid, arouses British hostility against Germany. Guglielmo Marconi receives his first patent for wireless telegraphy.
1897	Fiftieth birthday honors include a retrospective at the Royal Academy of Arts in Berlin where he is awarded the gold medal and a professorship.	Vienna Secession founded by Gustav Klimt, Hans Hoffmann, and others. Work of artists and designers of the Jugendstil movement shown in Munich.	First World Zionist Congress is held in Basel. Walther Rathenau publishes an article favoring assimilation for Jews in *Die Zukunft* (The Future), Berlin's leading political magazine.	Paul Ehrlich pioneers the commercial manufacture and distribution of diphtheria antitoxins.
1898	Awarded membership in the Royal Academy of Arts in Berlin. Writes a critical study on the art of Jozef Israëls. Included, along with Constantin Meunier and Degas, in an exhibition inaugurating Cassirer Gallery.	When Leistikow's painting *Grünewald Lake* is rejected by the jury and Kollwitz's *Weavers' Uprising* is passed over for a gold medal, artists within the Royal Academy of Arts request separate space and jury. When refused by its director, they found the Berlin Secession and pledge to boycott the official exhibition. Deutsche Mutoskop & Biograph film production company established in Berlin.	Émile Zola publishes his second public letter in defense of Dreyfus, titled *J'accuse*, in a French newspaper. Four days later, anti-Semitic riots break out in a number of French towns. Wilhelm II visits Palestine, meets with Herzl. Although the emperor favors establishing a Jewish national home in Palestine as a German protectorate, Germany abandons support, because of alliance with Turkey.	U.S. defeats Spain and takes over the Spanish possessions of Guam, the Philippines, and Puerto Rico. Germany begins to build a battle fleet. Ferdinand Graf von Zeppelin files the patent and begins building the forerunner to the modern airship.
1899	Elected president of the Berlin Secession; Leistikow becomes first secretary. Rooftop studio at Pariser Platz completed.	Wilhelm II demands approval of all new acquisitions of the National Gallery, Berlin. Berlin Secession presents its first exhibition. Among works exhibited is Max Slevogt's modern religious painting *The Lost Son*. Berlin Secession becomes synonymous with impressionist art.	After the discovery that forged documents were used against Dreyfus, a second court-martial finds him guilty "with extenuating circumstances" and the French president issues a pardon.	The Hague peace conference establishes an International Court of Arbitration. In October, the second Boer War breaks out between Great Britain and the Boers in South Africa. When it ends in 1902, South Africa becomes a British colony.
1900	Exhibits *Young Boys Bathing* at the Berlin Secession. Describes transition from working-class motifs to scenes of the leisure class in letter to a friend: "I have entered a new phase: during the three months in which I was in Holland, I've shed my skin again, I'm painting horses and naked women."	Sigmund Freud's *The Interpretation of Dreams*, the founding document of psychoanalysis, is published in Vienna. At its second exhibition, the Berlin Secession exhibits a markedly international selection of works. Included are Monet, Meunier, Rodin, Cézanne, Sisley, and Pissarro.		Germany's industrial production matches that of Great Britain. Arms race begins, as European nations initiate military reforms. Max Planck outlines the quantum theory of energy. First Zeppelin airship is flown.

	MAX LIEBERMANN	ART/CULTURE	JEWISH HISTORY	POLITICS/SCIENCE
1901	Paints scenes of the Amsterdam Zoo and horse riders on the beach in Holland. Martin Buber's book *Jewish Artists* includes an essay on Liebermann's art.	Phalanx association and art school established in Munich by Wassily Kandinsky. At its spring exhibition, the Berlin Secession introduces the work of van Gogh to Germany. Wilhelm II officially presents the city of Berlin with gift of monumental sculptures depicting Prussian emperors.	At the fifth World Zionist Congress in Basel, the Jewish National Fund for the settlement of the Land of Israel is established. An exhibition of Jewish art is also presented. Berlin's Relief Organization of German Jews provides charitable and educational assistance to Jews in Eastern Europe and Palestine.	Marconi transmits wireless signals across the Atlantic for the first time. Socialist Revolutionary Party is formed in Russia. Private motorcars operate on Berlin streets. First Nobel Prizes awarded.
1902	*Samson and Delilah* exhibited at the fifth Secessionist exhibition. Creates *Parrot Man* from studies made at the Amsterdam zoo. Invited to Hamburg by Lichtwark; paints *Garden Terrace in the Restaurant Jacob*. Begins a series of self-portraits after the Uffizi in Florence commissions a self-portrait for their collection of famous artists.	Bruno Cassirer establishes the modern art journal *Kunst und Künstler*, which becomes the unofficial publication of the Berlin Secession. Initiated by Liebermann, work by Edvard Munch is shown at the Secessionist exhibition along with a controversial series of symbolist friezes dealing with love and death. A scandal ensues; sixteen members leave the Secession in protest. Aby Warburg founds his library for the history of European art and culture in Hamburg.	Herzl's *Altneuland* published; through his efforts, a Royal Commission on Alien Immigration is appointed in Britain. In Berlin, the Society for the Promotion of the Science of Judaism is founded, and a group of cultural Zionists establish The Jewish Publishing House. Jacob Julius David's family saga *The Transition* describes the upward mobility of many assimilated Jews and documents the process of Jewish emancipation.	Triple Alliance is renewed between Germany, Austria, and Italy. German Society for Woman's Suffrage is founded. First transpacific telegraph cable. Two Germans receive Nobel Prizes: Historian Theodor Mommsen for literature and Emil Fischer for chemistry. Bosch spark plug invented.
1903	Resigns from the Association of Berlin Artists. Joins the German Artists' Association, which is initiated by Harry Graf Kessler to protest state-controlled arts policy and to protect artistic freedom. Publishes an essay, "Die Phantasie in der Malerei," on his art in the *Neue Rundschau* journal.	Gauguin exhibits at the first Salon d'Automne in Paris; Klimt retrospective in Vienna. At the XVI exhibition of the Vienna Secession, entitled *Development of Impressionism in Painting and Sculpture*, Liebermann is represented as an impressionist artist.	More anti-Jewish pogroms in Russia.	Wright Brothers are first to fly an engine-driven, heavier-than-air machine. Pierre and Marie Curie and A.H. Becquerel share the Nobel Prize for physics for discoveries related to radioactivity.
1904	Paints portrait of Wilhelm von Bode. Wilhelm II blocks participation by the artists of the Berlin Secession at the World's Fair in St. Louis.	Meier-Graefe's *The History of Modern Art* published in three volumes. The pivotal text is instrumental in disseminating in Germany the ideas of French impressionism and postimpressionism.	Hayyim Nahman Bialik gains fame for his poem "In the City of Slaughter," which concerns a pogrom in Kishinev, Russia. Second Aliyah, with settlers determined to create a Jewish working class, begins and lasts for ten years. Sholem Asch achieves international recognition for his Yiddish novel, *A Shtetl*.	Russo-Japanese War begins, establishing Japan as a major world power and weakening the Russian monarchy. Entente Cordiale concluded between Britain and France.

	MAX LIEBERMANN	ART/CULTURE	JEWISH HISTORY	POLITICS/SCIENCE
1905	Begins a second version of *Samson and Delilah.* Art historian Henry Thode attacks Liebermann in the *Frankfurter Zeitung* as "anti-national" for endorsing impressionism and posits greed as motive for the founding of the Secession. Begins series of Jewish street scenes in Amsterdam. Summers in remote Noordwijk, Holland. *Max Liebermann*, a biography by Karl Scheffler, published.	Works of van Gogh and Seurat exhibited at the Salon des Indépendants in Paris. The Fauves, or "wild beasts," as Henri Matisse and André Derain are labeled by critic Louis Vauxcelles, exhibit together at the Salon d'Automne in Paris. Die Brücke (The Bridge), an expressionist association of artists with the common goal of breaking new boundaries in art, founded in Dresden. Kollwitz and Emil Nolde are among its members.	Particularly severe pogroms rack the Jewish population in Odessa and other cities throughout Russia. *Protocols of the Learned Elders of Zion*, a tract purportedly detailing Jewish and Freemason plans for world domination but in actuality an anti-Semitic forgery created by the Russian secret police, published in Russia. In the next few years it is translated and published in German, French, English, and other European languages.	First Moroccan Crisis, over Tangier, between Germany and France. Germany and Russia sign a pact for mutual military assistance. As a result of the unpopular war with Japan, thousands of unarmed Russian workers march on the czar's palace, demanding reform. Albert Einstein publishes papers on the photoelectric effect, Brownian motion, and the special theory of relativity.
1906	Scathingly criticized by the Jewish critic Lothar Brieger-Wasservogel in *The Case of Liebermann: On Virtuosity in the Fine Arts* for importing foreign influences. As member of the Secession jury, rejects Max Beckmann's *Young Men at the Ocean* for annual exhibition. Joins committee to promote home industry and crafts for Jews in Palestine; donates painting to the newly established Bezalel School of Arts and Crafts in Jerusalem.	Von Tschudi's *German Centennial Exhibition (1775–1875)* at the National Gallery in Berlin contributes significantly to the understanding of modernist art in Germany. Max Reinhardt's Chamber Theater opens in Berlin with a performance of Ibsen's *Ghosts* with sets designed by Munch. Beckmann's *Young Men at the Ocean* rejected by the jury of the Secession, indicating the organization's reluctance to embrace the newest trends in German art.	Dreyfus' guilty verdict annulled by the French court of appeals. His rank is reinstated and he is made a knight of the Legion of Honor. The victory of the Dreyfusards makes many French citizens suspect a Jewish conspiracy. Martin Buber's *Tales of Rabbi Nachman* includes Hasidic tales translated from Yiddish and Hebrew. In Jerusalem, the Bezalel School of Arts and Crafts founded to develop useful arts and crafts among Palestinian Jews.	Election of first Russian parliament.
1907	On his sixtieth birthday, the Berlin Secession and the art associations in Frankfurt and Leipzig mount major retrospectives. Shows *The Twelve-Year-Old Jesus* at the thirteenth exhibition of the Berlin Secession. In article for *Kunst und Künstler*, Wilhelm von Bode, director-general of the Royal Museums of Prussia, declares that Liebermann is Germany's leading painter.	Pablo Picasso completes *Les Demoiselles d'Avignon* in Paris. Art connoisseur Daniel Henry Kahnweiler opens his gallery in Paris with the first cubist exhibition. Major posthumous retrospective of Cézanne's work—from the last three decades of his life—at the Salon d'Automne in Paris.	Arthur Schnitzler's novel *The Road into the Open* addresses the anti-Semitism of his day. Buber writes *Legend of the Baal-Shem*, a collection of stories that teach the principles of Hasidism.	Chemist Leo Baekeland invents plastic.
1908	*Samson and Delilah*, 1902, displayed at the Secessionist exhibition. Richard Dehmel's essay "Talent und Rasse" in the journal *Der Tag* portrays a fictional dialogue between a German writer (Dehmel) and a Jewish painter (Liebermann) on whether great art is enabled by racial diversity.	After Leistikow's death, friction between the older and younger generation of artists within the Berlin Secession intensifies. Amedeo Modigliani exhibits in public for the first time, with *La Juive* at the Salon des Indépendants.	Georg Hermann's popular novel *Henriette Jacoby* portrays Jewish family life in Berlin.	Prussian Law of Association repealed; women and persons over the age of 18 can now engage in public political activity. Austria-Hungary annexes Bosnia-Herzegovina, and the Bosnian crisis erupts. German scientist Paul Ehrlich wins Nobel Prize in medicine for his research on immunity.

	Max Liebermann	Art/Culture	Jewish History	Politics/Science
1909	Moves part of his impressionist collection to his villa being constructed at Wannsee, a lakeside community located between Berlin and Potsdam.	Ludwig Justi, a supporter of German expressionism, succeeds von Tschudi as director of National Gallery in Berlin.	First all-Jewish city, Tel Aviv, founded in Palestine. Jewish entrepreneur Paul Davidson opens Berlin's first movie cinema, the Union Theater.	Louis Blériot makes first airplane flight across the English Channel. Women are first admitted to German universities.
1910	Works on a second version of *Samson and Delilah*. In poor health and recovering from an operation, creates the study *The Good Samaritan*. Nominated for an honorary professorship by Heinrich Wölfflin, a professor of art at Berlin University, but not confirmed. Completes a self-portrait for the Hamburger Kunsthalle and a number of portrait commissions mediated by Lichtwark. Villa at Wannsee, where he will paint a series of impressionist garden scenes, is completed.	Conflict within the Berlin Secession escalates when the jury refuses twenty-seven entries by expressionist artists. *Der Sturm*, avant-garde art journal, features reproductions of expressionist graphics and woodcuts. Roger Fry coins the term "postimpressionism" in connection with exhibition of works by Cézanne, Gauguin, and van Gogh.	Another wave of anti-Jewish pogroms takes place in Russia. Hermann Lons' anti-Semitic novel *The Werewolf* published.	Kaiser Wilhelm Society for Advancement of Science founded.
1911	Resigns as president of the Berlin Secession and is succeeded by Lovis Corinth. Retains title of honorary president. Completes large-scale version of *The Good Samaritan*. Attends the funeral of Jozef Israëls in The Hague. *Max Liebermann: The Master's Paintings* published by Gustav Pauli.	Carl Vinnen's pamphlet *A Protest of German Artists*, and Thomas Alt's book *The Devaluation of German Art by the Partisans of Impressionism*, attack Secessionist art and the influence of French art in Germany.	In *The Jews and Modern Capitalism*, German historian Werner Sombart articulates the alien status of the Jews in Germany. Yiddish author Sholem Aleichem, whose works highlight the dignity, generosity, and shrewdness of his Russian Jewish characters, publishes *Tevye the Dairyman*.	International crisis provoked by the arrival of a German gunboat at Agadir in Morocco. Germany renounces influence in Morocco and receives several French colonies in the Congo. First use of aircraft as offensive weapon in Turkish-Italian War. Chinese Republic proclaimed after revolution overthrows Manchu dynasty. Sun Yat-sen named president.
1912	Showered with awards in his sixty-fifth year: an honorary doctorate and professorship from the Berlin University; a membership in the Senate of the Royal Academy of Arts; honorary membership at several academies in Europe; and the Order of Oranje-Nassau from Holland. Designs sets for Gerhart Hauptmann's play *Gabriel Schilling's Flight*; paints Hauptmann's portrait. Paints more scenes of beaches and riders in Noordwijk. Donates sixty-five woodcuts by Daumier from his collection to the Berlin Kupferstichkabinett.	Popular summer exhibition of Berlin Secession features works by impressionists and expressionists. Picasso and Braque first use the technique of *papier collé* (collage); Albert Gleizes and Jean Metzinger publish *On Cubism*. *The Blue Rider* almanac details the artist group's new subject matters and modes of expression, which are driven by the need to "give artistic form to inner nature." German dramatist Gerhart Hauptmann wins Nobel Prize for literature. First futurist exhibition at the Galerie Bernheim-Jeune.	In the journal *Kunstwart*, Moritz Goldstein's article "The German-Jewish Parnassus" provokes a debate on the paradox of Jewish assimilation in Germany. The anti-Semitic social register *Semi-Gotha Almanach* "uncovers" 1,540 converted Jewish families within the German nobility.	Social Democrats are the largest German party in the German parliament. First Balkan war breaks out, involving Bulgaria, Serbia, Montenegro, and Turkey. Germany, Austria, and Italy renew their alliance. Major labor strikes in England and the U.S. Carl Gustav Jung writes *Wandlungen und Symbole der Libido* (published first in English as *The Psychology of the Unconscious* in 1916).

	Max Liebermann	Art/Culture	Jewish History	Politics/Science
1913	Resigns from the Berlin Secession along with Slevogt, Beckmann, Paul Cassirer, and others, to found the Free Secession.	Ernst Lubitsch acts in his first films for Berlin's Biograph Studio.	Anti-Defamation League, an organization founded to oppose anti-Semitism, established in Chicago.	Zabern Affair causes civil unrest and increases Franco-German tensions when an Alsatian is ridiculed by a Prussian lieutenant during a drill.
1914	Signs, along with ninety-two other intellectuals, a manifesto supporting his country's decision to wage the war. Creates patriotic lithographs for Cassirer's *Kriegszeit Kunstlerblatter* (Wartime Artist Newspaper). *Millions and Millionaires. How Vast Fortunes are made* features Liebermann as one of Berlin's richest artists. *Max Liebermann: His Life and Works*, a comprehensive biography by Erich Hancke, includes a catalogue of works in public collections.	German Werkbund exhibition in Cologne debates whether artistic individualism or standardized types are the future of modernism. Blue Rider group disperses with the beginning of the war: Kandinsky flees to Russia via Switzerland; Münter goes to Sweden; Macke, Marc, and Klee serve on the front (Macke and Marc are killed).	University of Frankfurt founded with a mandate that prohibits religious discrimination in faculty appointments. Zionist Organization of America founded. In reaction to wartime anti-Semitism, Buber founds the Berlin journal *The Jew*. French government confiscates the collection of the German Jewish art dealer D.H. Kahnweiler.	Archduke Franz Ferdinand of Austria-Hungary assassinated in Sarajevo by the Serbian terrorist Gavriol Princip; World War I begins. War causes inflation, food shortages, and political unrest in Germany. New war technologies are introduced, including the machine gun, airplane, submarine, poison gas, powerful explosives, flame-throwers, hand grenades, accurate long-range artillery, and tanks.
1917	Honors for Liebermann's seventieth birthday include a medal for Art and Science of the First Order, and the largest ever exhibition of his work. The retrospective at the Royal Academy of Arts in Berlin includes 191 paintings. Grandaughter Maria born.	Review *De Stijl* founded in Amsterdam. Sergei Diagalev's troupe, Les Ballets Russes, performs *Parade*, with music by Erik Satie and set and costumes by Picasso.	Balfour Declaration conveys British support for a Jewish national homeland in Palestine. Gustav Meyrink bases his novel *The Golem* on Jewish folk tales of a creature made by a sixteenth-century rabbi to protect the Jews of Prague from persecution.	U.S. and China enter war against Germany. February Revolution in Russia ends with abdication of the czar. After the October Revolution, Bolsheviks under Lenin control government and sign armistice with Germany.
1918	Watches the November Revolution firsthand from the window of his atelier; paints a view of the vanquished troops as they arrive through the Brandenburg Gate. Also sees the capitulation of soldiers who had been posted in his house by the old regime. Opening of gallery dedicated to his art at the National Gallery in Berlin.	Le Corbusier and Amedée Ozenfant publish *After Cubism*, a treatise on purism. Inspired by the November Revolution, Bruno Taut establishes the Workers' Art Council. Members include Walter Gropius, Ludwig Meidner, and Lyonel Feininger.	German Imperial Army orders the Judenzählung, a census of Jewish soldiers at the front.	World War I causes unprecedented destruction in Europe. Nearly 10 million soldiers die and about 21 million are wounded. Germany alone suffers 1.75 million casualties. More than 10 million are killed in worldwide influenza epidemic. November Revolution marks the defeat of Germany. Wilhelm II abdicates. Armistice signed between Germany and Allied Powers.
1919	Becomes popular portraitist among the upper class, garnering many commissions.	Bauhaus, with Gropius as director, founded in Weimar. Justi opens Museum for Contemporary Art in the Crown Prince's Palace at the National Gallery in Berlin. First exhibition includes the impressionists, Liebermann, Hans Thoma, Wilhelm Trübner, and the expressionists.	Hugo Preuss, professor of law and leader of the Berlin Jewish community, becomes Minister of the Interior and drafts a constitution for the Weimar Republic. After Russian Revolution, all anti-Jewish laws are abrogated, Jews are granted equal rights, and the Pale of Settlement is abolished. Third Aliyah begins.	Treaty of Versailles reorganizes boundaries in Europe, limits the size of German army, and requires substantial reparations. German voters, including women for the first time, elect a national assembly to write a constitution. Friedrich Ebert is first president of the Weimar Republic. Spartacist Revolt in Berlin fails; its leaders, Rosa Luxemburg and Karl Liebknecht, assassinated.

	MAX LIEBERMANN	ART/CULTURE	JEWISH HISTORY	POLITICS/SCIENCE
1920	Elected president of Berlin's Academy—now called the Prussian Academy of Arts. During his twelve-year leadership, Liebermann will encourage open-mindedness toward new art.	Reinhardt directs Hugo Hofmannsthal's *Jedermann* at the first Salzburg Festival. First International Dada Fair held in Berlin.	American Jewish Congress founded. Academy for the Science of Judaism is founded in Berlin, establishing the academic study of Judaism and Jewish culture. *Protocols of the Learned Elders of Zion* published in German. Britain granted provisional mandate over Palestine.	Establishment of League of Nations and Permanent Court of International Justice. Economic crisis and political unrest weaken the Weimar Republic. Adolf Hitler formulates Nazi Party's 25-point program.
1921			Philip Graves of the *Times* in London publishes proof that *Protocols of Zion* is fraudulent.	Albert Einstein wins Nobel Prize in physics.
1922	Learns of Rathenau's assassination by extremists; later warns fellow Jews of the danger of playing too prominent a role in German society. Awarded Dreber Prize at Venice Biennale. Paints portrait of Albert Einstein for the Royal Society, London.	Publication of James Joyce's *Ulysses*. First Russian Art Exhibition in Berlin. Kandinsky, who has returned from Russia to settle in Weimar, participates. Constructivists hold congress in Weimar.	British mandate over Palestine officially approved by the League of Nations.	Assassination of Walther Rathenau, Minister of the Exterior, by members of the nationalist Consul organization. Union of Soviet Socialist Republics created under the leadership of Stalin, General Secretary of the Communist Party in Russia. Fascists march on Rome; Mussolini named prime minister of Italy.
1923		William Butler Yeats wins Nobel Prize for literature.	Jewish factory workers in Poland are subjected to methodical dismissal.	Hitler attempts to instigate an insurrection against the Weimar Republic but fails and is imprisoned.
1924			Fourth Aliyah begins.	
1925		Franz Kafka's *The Trial* published.	Hebrew University opens in Jerusalem.	Friedrich Ebert, president of the German republic, dies. Paul von Hindenburg elected. Hitler's *Mein Kampf* published.
1927	Prussian Academy of Arts celebrates Liebermann's eightieth birthday with a major exhibition of one hundred works. He is named "citizen of honor" of Berlin. Liebermann paints two commissioned portraits of Paul von Hindenburg.	Hilla Rebay moves from her native Germany to America and begins her mission to encourage the wealthy industrialist Solomon Guggenheim to collect non-objective art, introducing him to Kandinsky and other artists of the European avant-garde.		
1928		Premiere in Berlin of Bertolt Brecht and Kurt Weill's *Three Penny Opera*, a satire of German bourgeois capitalism.		Nonaggression Kellogg-Briand Pact signed by fifteen nations, including Germany, France, and Great Britain.
1929	Entry on Liebermann in Philipp Stauff's *Semi-Kürschner* criticizes the artist—as a Jew and cosmopolitan—for corrupting German culture.	Thomas Mann wins Nobel Prize for literature.	Fighting between Jews and Arabs begins in Palestine. Publication of new edition of Philipp Stauff's *Semi-Kürschner* (1913), an anti-Semitic lexicon of prominent Jews. Fifth Aliyah begins.	French government ratifies a liberal law on the naturalization of foreign immigrants. German pacifist Ludwig Quidde wins Nobel Prize for peace. U.S. stock market crash begins a ten-year worldwide economic depression.

	MAX LIEBERMANN	ART/CULTURE	JEWISH HISTORY	POLITICS/SCIENCE
1930		Brecht and Weill's opera *Rise and Fall of the City of Mahagonny* premieres in Leipzig. The controversial and popular parody of capitalism later gives rise to protests by the Nazis and is banned in Germany.		Stalin decrees forced collectivization in Soviet Union. Unemployment reaches 6 million in Germany.
1932	Declines reappointment as president of the Prussian Academy of Arts; elected honorary president. Paints portrait of prominent surgeon Dr. Ferdinand Sauerbruch; also paints portrait of former prime minister Otto Braun.	Exhibition in the Crown Prince's Palace at the National Gallery, Berlin, on van Gogh and Munch. Leni Riefenstahl directs her first movie, *The Blue Light*, in which she also stars.	Founding of *Palestine Post*, later *Jerusalem Post*, first English-language newspaper in Palestine.	World Conference on Disarmament convened by League of Nations in Geneva. Coup d'état engineered by Nazis in Prussia. France begins building the Maginot Line as a fortified defense against Germany.
1933	From the roof of his house, watches the celebrations of Hitler's chancellorship. Terminates his position as honorary president of the Prussian Academy of Arts and cancels his membership; sends part of his art collection to the Kunsthaus in Zurich. Many of his paintings are removed from public collections. Accepts the nomination as honorary president of the Cultural Association of German Jews. Gallery in Tel Aviv Museum named after him.	Kollwitz and Heinrich Mann are forced to leave the Prussian Academy of Arts. Oskar Kokoschka, in exile in Paris, is the only person to support Liebermann in public. His letter of protest is published in the *Frankfurter Zeitung*. Bauhaus is closed. Justi is suspended from his position as director of the National Gallery, Berlin, by the Nazis.	Jewish population in Palestine reaches 175,000; emigration by German Jews increases. Hitler institutes a series of anti-Semitic actions, including organized violence. Jews are barred from civil service. Foundation of the Cultural Association of German Jews, which is initially tolerated by the National Socialists but meets with more and more restrictions. Dachau, first concentration camp for "political prisoners," is set up by the Nazis. Establishment of The Jewish Museum in Berlin.	Hitler named chancellor in Germany. An arson attack on the parliament building allows him to declare martial law and create Third Reich, outlawing freedom of the press, labor unions, and all political parties except the Nazis.
1935	Dies in his house at Pariser Platz 7 (February 8); buried (February 11) in the family plot at the Jewish Community Cemetery in Schönhauser Allee.	Kandinsky flees to Paris.	Nuremberg Laws deprive Jews of their civil rights.	Nazis repudiate Treaty of Versailles, introduce compulsory military service, and begin to re-arm Germany.

Checklist

1. *Self-Portrait with Kitchen Still Life*, 1873
(Selbstbildnis mit Küchenstilleben)
Oil on canvas
33.5 x 54.7 in (85.5 x 139 cm)
Städtisches Museum Gelsenkirchen
PROVENANCE: The artist's parents,
Berlin; Prof. Felix Liebermann, Berlin
(died 1925); Cäcilie Liebermann,
Berlin (1926); Fischer Gallery, Lucerne
(1956); Paffrath Gallery, Düsseldorf
(1961); acquired by the Städtisches
Museum Gelsenkirchen (1962)

2. *Self-Portrait with Brush and Palette*,
1913
(Selbstbildnis mit Pinsel und Palette)
Oil on canvas
35 x 28.5 in (89 x 72.4 cm)
Gemäldegalerie, Stiftung museum
kunst palast, Düsseldorf
PROVENANCE: Max Liebermann, Berlin
(sold to Paul Cassirer on February 27,
1915); Paul Cassirer, Berlin (1915,
PC number 2446); Thannhauser
Gallery, Munich (acquired from Paul
Cassirer on Oct. 16, 1915, 1923);
private ownership; Grosshennig Gallery,
Düsseldorf (until 1957); acquired by
the Kunstmuseum Düsseldorf (1957)

3. *Self-Portrait with Brushes and Palette*,
1933
(Selbstbildnis mit Pinseln und Palette)
Oil on canvas
30 x 21.6 in (76 x 54.8 cm)
Stiftung Neue Synagoge Berlin—
Centrum Judaicum
PROVENANCE: Max Liebermann, Berlin
(1933); Jewish Museum, Berlin (since
1933, as a gift from the artist at the
opening); In storage in Berlin after the
seizure of the museum's inventory;
Israel Museum, Jerusalem (until 1987);
Steiglitz Gallery, Tel Aviv (1987); Villa
Grisebach, Berlin (1991); Sotheby's,
Tel Aviv (1992); private ownership

4. *Portrait of Felix Liebermann
(1851–1935)*, ca. 1865
(Bildnis Felix Liebermann)
Oil on canvas
18.5 x 18.5 in (47 x 47 cm)
Anonymous
PROVENANCE: Felix Liebermann, Berlin
(1914–1925); Otto Fischer Art Gallery,
Bielefeld, Germany (1960)

5. *Vegetable Vendor – Market Scene*, 1874
(Gemüsehändlerin – Marktszene)
Oil on canvas
33 x 23.2 in (84 x 59 cm)
Wallraf-Richartz-Museum-Fondation
Corboud, Cologne
PROVENANCE: Bernheim Jeune, Paris
(sold to Paul Cassirer on Nov. 19,
1906); Paul Cassirer, Berlin (1906,
PC number 7261); Emil Meiner,
Leipzig (acquired from Paul Cassirer on
June 16, 1906); Mrs. Emma Meiner,
Leipzig (1911, 1917); E. Meiner
(heir), Leipzig; Kunsthandlung Karl
Haberstock, (Berlin, until 1928); 1928
acquired by the Wallraf-Richartz-
Museum, Cologne

6. *At the Swimming Hole*, 1875–77
(Im Schwimmbad)
Oil on canvas
70.8 x 88.5 in (180 x 225 cm)
Dallas Museum of Art
PROVENANCE: Gustav Rochlitz, Berlin/
Paris; Ernst Fischer, Berlin (1924,
1929); private ownership, Lucerne
(1979, 1985); Whitford and Hughes,
London; Herman Schickman, New
York

7. *The Siblings*, 1876
(Die Geschwister)
Oil on canvas
38.6 x 56 in (98 x 142 cm)
Galerie Neue Meister, Staatliche
Kunstsammlungen Dresden
PROVENANCE: Bernheim, Paris (1876);
private collection, Brussels (until
1919); Belgian art dealer Nicolai,
Berlin (1921–1924); 1924 acquired
by the Gemäldegalerie Neue Meister,
Dresden

8. *Table with Pieces of Meat*, 1877
(Tisch mit Fleischstücken)
Oil on canvas
16.9 x 20 in (43 x 51 cm)
Neue Pinakothek, Munich
PROVENANCE: Max Liebermann,
Berlin (sold to Paul Cassirer, March
18, 1913); Paul Cassirer, Berlin (PC
number 8703); Neue Pinakothek,
Munich, acquired from Paul Cassirer
1913

9. *An Old Woman with Cat*, 1878
(Alte Frau mit Katze auf dem Schoss)
Oil on canvas
37.8 x 29.1 in (96 x 74 cm)
The J. Paul Getty Museum, Los
Angeles
PROVENANCE: Dr. G. Heilbut,
Hamburg (1911–1914); Edouard
Arnhold, Berlin (1917); 1982 painting
offered for auction at Christie's in
London by Arnhold's heirs; 1986
Hauswedall & Nolte, Hamburg; Galerie
Nathan, Zürich (1986–1987); J. Paul
Getty Museum (1987)

10. *The Twelve-Year-Old Jesus in the
Temple with the Scholars*, 1879
(Der Zwölfjährigen Jesus im Tempel
unter den Schriftgelehrten)
Crayon over graphite
17 x 11.9 in (43.4 x 30.4 cm)
Staatliche Museen zu Berlin,
Kupferstichkabinett

11. *Study Head of a Man (Sephardic Jew with a Prayer Shawl, Facing Left)*, 1878
(Männlicher Studienkopf)
Oil on cardboard
9.4 x 12.2 in (24 x 31 cm)
Kunsthaus Zürich,
Legat Richard Schwarzenbach
PROVENANCE: Richard Schwarzenbach, Zürich (1920); Kunsthaus Zürich, acquired September, 1920 (legacy of R. Schwarzenbach)

12. *Study for Samson and Delilah*, 1894
(Simson und Delila – Studie)
Oil on canvas
15.2 x 21.8 in (38.5 x 55.4 cm)
Jüdisches Museum Berlin
PROVENANCE: Seidel and Son, Schloss Ahlsen; Dr. Fritz Nagel, Stuttgart (1960); Tamme, Berlin (until Jan. 16, 1987); acquired by the Staatliche Museen zu Berlin with funds from a lottery

13. *Samson and Delilah*, 1910
(Simson und Delila)
Oil on canvas
49.2 x 68.8 in (125 x 175.8 cm)
Städtisches Museum Gelsenkirchen
PROVENANCE: Paul Cassirer, Berlin (1911, 1914, 1916); Museum of Fine Arts Leipzig (1919 acquired from the artist) inv. number 1123; in 1936 given away in exchange for a painting from Adriaen van de Velde (inv. number 1272); Matthiesen Gallery, Berlin (1936); Christoph Czwicklitzer, Cologne (until 1959); Acquired on April 2, 1959 by the Städtisches Museum Gelsenkirchen

14. *Study for Recess in the Amsterdam Orphanage – View of the Inner Courtyard*, 1876
(Freistunde im Amsterdamer Waisenhaus. Ansicht des Innenhofes)
Oil on canvas
25.4 x 34.6 in (64 x 88 cm)
Staatliche Museen zu Berlin, Nationalgalerie
PROVENANCE: General Director Berlin Museums, Dr. Wilhelm von Bode, Berlin (1906, 1907, 1911, 1914, 1923); 1923 acquired by the Alte Nationalgalerie, Berlin

15. *Study for Old Men's Home in Amsterdam*, 1880
(Studie zum Altmännerhaus in Amsterdam)
Oil on canvas
27 x 9.5 in (53 x 70 cm)
Staatsgalerie Stuttgart
PROVENANCE: Galerie Henneberg, Zurich (1902); Gemäldegalerie Stuttgart (acquired 1903, gave up in 1937); Kunsthandlung Karl Haberstock, Berlin (1937); Dr. W. Feilchenfeldt, Zürich; Franz Resch, Gauting near Munich (1953); Staatsgalerie Stuttgart, reacquired in 1953

16. *Brabant Lacemakers – Study with Three Figures*, second version, 1882
(Brabanter Spitzenklöpplerinnen–Studie mit drei Figuren, 2. Fassung)
Oil on canvas on wood
8.7 x 12.8 in (22 x 32.5 cm)
Von der Heydt-Museum, Wuppertal
PROVENANCE: Acquired by the Von der Heydt-Museum in 1913 through a bequest from Fritz Reimann, Elberfeld

17. *The Weaver*, 1882
(Der Weber)
Oil on canvas
22 x 30.3 in.(56 x 77 cm)
Städelsches Kunstinstitut, Frankfurt am Main
PROVENANCE: Privy Councilor Rathenau, Berlin (1890, 1897, 1911, 1917, 1924); Städelsches Kunstinstitut Frankfurt (acquired in 1926 with help from the mother of Walter Rathenau in memory of her son)

18. *Dutch Farmhouse with Woman*, 1882
(Holländisches Bauernhaus mit Frau)
Oil on wood panel
10.5 x 14.3 in (26.7 x 36.2 cm)
Frye Art Museum, Seattle, WA
PROVENANCE: Captain Lieutenant Kuthe (sold to Paul Cassirer on May 8, 1914); Paul Cassirer, Berlin (PC number 13140 "Hofinterieur", probably sold to Stransky on May 8, 1914); Josef Stransky, New York (1914, 1916); Frye Art Museum, Seattle

19. *Girl Sewing with Cat – Dutch Interior*, 1884
(Nähendes Mädchen mit Katze–Holländisches Interieur)
Oil on paintboard
23.2 x 20.5 in (59 x 52 cm)
Anonymous
PROVENANCE: Fritz Gurlitt, Berlin (until 1902); Rudolph Lepke, Berlin (1902); Grosshennig Gallery, Düsseldorf (1961)

20. *Portrait of Privy Councilor Benjamin Liebermann (1812–1901)*, 1887
(Bildnis des Geheimen Kommerzienrates Benjamin Liebermann)
Oil on canvas
52 x 37.8 in (132.2 x 96.2 cm)
Leo Baeck Institute, New York
PROVENANCE: Sponsoring Friends Society (Unterstützende Gesellschaft der Freunde), Berlin (1914); Jüdisches Museum, Berlin (1936 seized); number 139 on the list of found artworks from the Jewish Museum; 1960 given to the Leo Baeck Institute, New York, as a gift from the Jewish Restitution Successor Organization

21. *Portrait of his Father Louis Liebermann (1819–1894)*, 1891
(Porträt seines Vaters Louis Liebermann)
Charcoal and graphite on paper
18.8 x 12.2 in (47.8 x 31 cm)
Jüdisches Museum Berlin
PROVENANCE: Wilhelm Weick, art dealer (1976); donation to the Society for the Jewish Museum Berlin, 1976

22. *Beer Garden in Brannenburg*, 1893
(Biergarten in Brannenburg)
Oil on canvas
27.9 x 41.3 in (71 x 105 cm)
Musée d'Orsay, Paris
PROVENANCE: Acquired from the artist for the Musée du Luxembourg in 1895

23. *The Artist's Wife at the Beach*, 1895
(Die Gattin des Künstlers am Strand)
Oil on canvas
39.4 x 47.2 in (100 x 120 cm)
Stiftung Weimarer Klassik und Kunstsammlungen, Schloßmuseum
PROVENANCE: Großherzoglich Sächsisches Museum, Weimar, acquired in 1898; Weimar, Ehrensaal (1914, 1923)

24. *Winter*, 1898
Oil and colored chalk over charcoal on cardboard
14.4 x 35 in (36.6 x 89.1 cm)
Professor Marion F. Deshmukh, Bethesda, Maryland
PROVENANCE: Rudolph Lepke, Berlin (1900); Dr. Ernst Amman, Winterthur (acquired in the Aktuaryus Gallery on Feb. 2, 1934); Aktuaryus Gallery, Zurich (1945); private collection, Switzerland (until 1994); Kunsthaus Lempertz, Cologne (1994); private collection

25. *Country House in Hilversum*, 1901
(Landhaus in Hilversum)
Oil on canvas
25.5 x 31.4 in (65 x 80 cm)
Staatliche Museen zu Berlin, Nationalgalerie
PROVENANCE: Max Liebermann (sold on October 3, 1903) to P. Cassirer; Paul Cassirer, Berlin (1903, PC number 495); Albrecht Guttmann, Berlin (acquired on Oct. 3, 1903 from Cassirer, 1905, 1907, 1911, 1914, 1917); Cassirer-Helbing, Berlin (1917); Eduard Arnhold, Berlin (until 1918, then gift to the Alte Nationalgalerie, Berlin)

26. *Tennis Game by the Sea*, 1901
(Tennisspieler am Meer)
Oil on cardboard
11.8 x 18.1 in (30 x 46 cm)
Niedersächsisches Landesmuseum
Hannover
PROVENANCE: Eduard Fuchs, Berlin-Zehlendorf (1914, until 1937); Rudolph Lepke, Berlin (1937); Dr. jur. Conrad Doebbeke, Berlin Wannsee (until 1949); 1949 acquired by the Niedersächsisches Landesmuseum

27. *Study for Parrotman*, 1900
(Papageienmann – Studie)
Oil on canvas
33 x 24 in (84 x 61 cm)
Kunsthaus Lempertz
PROVENANCE: Purchased by the grandfather of the present owner in the 1920s.

28. *Ropewalk in Edam*, 1904
(Seilerbahn in Edam)
Oil on canvas
39.8 x 28 in (101 x 71.1 cm)
Lent by the Metropolitan Museum of Art, Reisinger Fund, 1916
PROVENANCE: Paul Cassirer, Berlin (acquired from Max Liebermann on November 7, 1904, PC number 607, 1911, 1914); Josef Stransky (until 1914); purchased from Stransky by the Metropolitan Museum of Art, New York in 1916

29. *Jewish Quarter in Amsterdam*, 1905
(Judengasse in Amsterdam)
Oil on canvas
15.7 x 21.7 in (40 x 55 cm)
Kaiser Wilhelm Museum Krefeld
PROVENANCE: Wife of Prof. Muther, Breslau (1914) (?); Ernst Arnold Gallery, Dresden (sold to Paul Cassirer on May 31, 1916); Paul Cassirer, Berlin (1916, PC number 2695); Paul Schmitz, Bremen (acquired from Paul Cassirer on July 8, 1916, 1917, 1926, 1927, in possession of his heirs until 1949); Slg. Gontard, Düsseldorf (1949); Abels Gallery, Cologne (1952); Acquired by the Kaiser-Wilhelm-Museum Krefeld, from the Abels Gallery on July 31, 1952

30. *Jewish Quarter in Amsterdam*, 1905
(Judengasse in Amsterdam)
Oil on canvas
16 x 21 in (40.6 x 53.3 cm)
Private collection, United States
PROVENANCE: By descent from family of original owner

31. *Vegetable Market in Amsterdam*, 1908
(Gemüsemarkt in Amsterdam)
Oil on canvas
29.1 x 33.7 in (74 x 85.5 cm)
Staatliche Kunsthalle Karlsruhe
PROVENANCE: Ed. Schulte, Berlin (1914) (?); Galerie Georg Caspari, Munich (until 1928); 1928 acquired by the Staatliche Kunsthalle Karlsruhe

32. *Promenade on the Dunes at Noordwick*, 1908
(Dünenpromenade in Noordwijk)
Oil on wood
24.6 x 29.1 in (62.5 x 74 cm)
Kunsthalle Bremen
PROVENANCE: General Consul M. Pickenpack, Hamburg (1911, sold to Paul Cassirer on May 12, 1914); Paul Cassirer, Berlin (1914–1916, PC Nr. 2402); Kunsthalle Bremen (acquired from Paul Cassirer on April 6, 1916)

33. *Bathers*, 1909
(Badende Knaben)
Oil on canvas
31.5 x 23.6 in (80 x 60 cm)
Kunsthaus Zürich
PROVENANCE: Paul Cassirer, Berlin (1914); H. Wismer, Winterthur (until 1923); For sale in Zurich in 1923; acquired by the Zurich Art Society from the Liebermann Exhibit in Zurich in October, 1923

34. *Horserace at Cascina*, 1909
(Pferderennen in den Cascinen)
Oil on wood
20.7 x 29.1 in (52.5 x 74 cm)
Kunstmuseum Winterthur. Presented by Georg Reinhart, 1924
PROVENANCE: Max Liebermann, Berlin (sold to Paul Cassirer on October 11, 1909) (?); Paul Cassirer, Berlin (1909, PC number 1271) (?); Caspari Gallery, Munich (acquired from Paul Cassirer on November 1, 1909) (?); Thannhauser Gallery, Munich (until May 1, 1914); George Rheinhart, Winterthur (from May 1, 1914, 1923, until 1924); 1924 given as a gift to the Winterthur Art Society (Kunstverein) by G. Reinhart; Kunstmuseum Winterthur

35. *Horseback Rider on the Beach, Facing Left*, 1912
(Reiter am Meer nachs links)
Oil on paperboard on canvas
19.3 x 15.6 in (49 x 39.5 cm)
Niedersächsisches Landesmuseum Hannover
PROVENANCE: Max Liebermann, Berlin. Beyer & Son Auction House, Leipzig (1913); Otto H. Class, Königsberg (1914, sold on May 1, 1916 to Paul Cassirer); Paul Cassirer, Berlin (1916, PC number 2605); Th. Stoperan, Berlin (acquired from Paul Cassirer on Dec. 10, 1917); Paul Graupe, Berlin (1928)

36. Selections from *Kriegszeit Künstlerblätter* (Wartime Artist Newspaper), 1914–1915
Lithographs on wove paper
Dimensions listed below; sheet dimensions open: 19.2 x 26 in (48.7 x 66 cm)
The Los Angeles County Museum of Art, The Robert Gore Rifkind Center for German Expressionist Studies
a. "Untitled," cover of *Kriegszeit* 1 (31 August 1914), 10.1 x 9.4 in (25.7 x 24 cm) [page 139]
b. "The Kaiser" (Der Kaiser), cover of *Kriegszeit* 2 (7 September 1914) 19.2 x 26 in (48.7 x 66 cm)*
c. "To my beloved Jews" (An meine lieben Juden), *Kriegszeit* 3 (1914): 3, 13 x 10 in (33 x 25.6 cm)*
d. "Entry of the Russians" (Einzug der Russen), cover of *Kriegszeit* 4 (23 September 1914), 11 x 10.1 in (28 x 25.7 cm)
e. "Hercules-Hindenburg," *Kriegszeit* 6 (1914): 4, 12.2 x 9.3 in (31.9 x 23.7 cm)
f. "The English miscalculation" (Der Englishe Rechenfehler), *Kriegszeit* 7 (7 October 1914): 4, 13.6 x 9.8 in (34.6 x 25 cm)
g. "The Samaritan" (Samariter), *Kriegszeit* 10 (28 October 1914): 3, 13.6 x 11.5 in (34.5 x 29.3 cm)*
h. "Our Boys in Blue," (Unsere blauen Jungen), *Kriegszeit* 13 (18 November 1914): 3, 16.6 x 6.9 in (42.2 x 17.6 cm)
i. "Germany's battle song" (Deutschlands Fahnenlied), cover of *Kriegszeit* 14 (25 November 1914), 13.2 x 9.2 in (33.5 x 23.6 cm)
j. "March, march, hurrah!" (Marsch, Marsch, Hurrah!) cover of *Kriegszeit* 18/19 (24 December 1914), 12.1 x 11.3 in (30.9 x 28.9 cm)*
k. "Untitled" (wounded soldier), *Kriegszeit* (17 February 1915): 4, 13.7 x 7 in (34.8 x 18 cm)

37. *Evening at the Brandenburg Gate*, 1916
(Abend am Brandenburger Tor)
Oil on canvas
21.7 x 33.5 in (55 x 85 cm)
Collection Deutsche Bank
PROVENANCE: Max Liebermann, Berlin (sold to Paul Cassirer on Dec. 28, 1916); Paul Cassirer, Berlin (1916, PC number 15901); A. Rothermundt, Dresden (acquired from Paul Cassirer on Dec. 28, 1916); private collection, Frankfurt am Main (1963); Deutsche Bank AG, Frankfurt am Main

38. *Outdoor Garden on the Havel, Nikolskoe*, 1916
(Gartenlokal an der Havel, Nikolskoe)
Oil on canvas
28.1 x 34 in (71.5 x 86.5 cm)
Staatliche Museen zu Berlin,
Nationalgalerie
PROVENANCE: Max Liebermann, Berlin
(sold to Paul Cassirer on Oct. 18,
1916); Paul Cassirer, Berlin (1916,
PC number 14778); Max Emden,
Hamburg (acquired from Paul Cassirer
on Oct. 10, 1916); Graphisches
Kabinett, Bremen (1927); J.F.
Schröder, Bremen; Marianne Neuberg,
Berlin (until 1992); Acquired in 1992
as a legacy from Marianne Neuberg,
Berlin; Nationalgalerie, SMPK Berlin

39. *Beach Scene in Noordwijk* , 1916
(Strandleben)
Oil on canvas
26 x 31.5 in (66 x 80 cm)
Private collection, Beverly Hills
PROVENANCE: Thannhauser Gallery,
Munich (1917); collection of Paul von
Bleichert, Klingar i.S. (until 1929);
Hugo Helbing, Munich (1929)

40. *Concert in the Opera House*, 1921
(Konzert in der Oper)
Oil on canvas
20 x 25.6 in (51 x 65 cm)
Jüdisches Museum Berlin
PROVENANCE: Herbert Hankel, Berlin
(1975?)

41. *Portrait of the Painter Lovis Corinth
(1858–1925)*, 1899
(Bildnis des Malers Lovis Corinth)
Oil on canvas
34.6 x 24.4 in.(88 x 62 cm)
Collection Deutsche Bank
PROVENANCE: Max Liebermann, Berlin
(sold on February 21, 1916 to Paul
Cassirer); Paul Cassirer, Berlin (1916,
PC number 14528); Hugo Cassirer,
Berlin (acquired on Feb. 18, 1916 from
Paul Cassirer, died 1920); Kurt Meissner
Gallery, Zürich; Deutsche Bank AG,
Frankfurt am Main (1979, 1994)

42. *Portrait of Bertha Biermann (1840–
1930)*, 1908
(Bildnis Frau Kommerzienrat Bertha
Biermann)
Oil on canvas
43.7 x 27.6 in (111 x 70 cm)
Gerhard Hirschfeld
PROVENANCE: Leopold O.H. Biermann,
Bremen (1908, 1911, 1917, 1922,
1923, 1924, 1930); private collection,
Germany

43. *Portrait of Adele Wolde (1852–1932)*,
1910
(Bildnis Adele Wolde)
Oil on canvas

44 x 36.2 in (112 x 92 cm)
Kunsthalle Bremen
PROVENANCE: Mrs. Georg Wolde,
Bremen (1911, 1914); St. Magnus near
Bremen (1926); heirs of Georg Wolde,
Bremen (1954); Dr. Ludwig Wolde;
heirs of Dr. Ludwig Wolde; Grisebach
Auction 105, Nov. 30, 2002, number
130; Gift from the Deutsche Bank
Bremen (2003)

44. *Portrait of the Publisher Bruno
Cassirer (1872–1941)*, 1921
(Bildnis des Verlegers Bruno Cassirer)
Oil on canvas
29.7 x 22.2 in (75.5 x 56.5 cm)
Kunstkreis Berlin GbR
PROVENANCE: Galerie Ludorff,
Düsseldorf (1989); Neumeister,
Munich (1990); Galerie Tableau, Berlin
(until July 8, 1992); private ownership,
Berlin (1992/1993); Kunstkreis Berlin
GbR (since 1993)

45. *Portrait of Siegbert Marzynski (1892–
1969)*, 1922
(Bildnis Siegbert Marzynski)
Oil on canvas
19.6 x 14.9 in (50 x 38 cm)
Collection of Dr. Toni Marcy,
Beverly Hills
PROVENANCE: Siegbert Marzynski,
Berlin-Beverly Hills; private ownership

46. *Portrait of Heinrich Stahl (1868–
1942)*, 1925
(Bildnis Heinrich Stahl)
Oil on canvas
43.7 x 34.2 in (111 x 87 cm)
Leo Baeck Institute, New York
PROVENANCE: Mrs. Bruno Stahl, New
York (until 1969); Gift to the Leo
Baeck Institute, New York (1969)

47. *Portrait of the Surgeon Dr. Ferdinand
Sauerbruch (1875–1951)*, 1932
(Bildnis des Chirurgen Dr. Ferdinand
Sauerbruch)
Oil on canvas
46.1 x 35.1 in (117.2 x 89.4 cm)
Hamburger Kunsthalle
PROVENANCE: Gerstenberg Collection,
Berlin (1932); Kirstein Collection,
Leipzig; Grange, London (1950);
P. Graupe, Paris (1950); private
ownership, Reinbek (until 1951);
acquired by the Hamburger Kunsthalle
in 1951

48. *The Garden Bench*, 1916
(Die Gartenbank)
Oil on canvas
28 x 33.9 in (71 x 86 cm)
Staatliche Museen zu Berlin,
Nationalgalerie
PROVENANCE: Acquired in 1917 by the
Nationalgalerie, SMPK Berlin, as a gift
from Robert von Mendelssohn and

Mrs. Oppenheim on the occasion of the
artist's seventieth birthday

49. *The Artist's Garden in Wannsee:
Birch Trees by the Lake*, 1918
(Der Garten des Künstlers in
Wannsee: Birken am Seeufer)
Oil on canvas
27.5 x 35.5 in (70 x 90.3 cm)
Hamburger Kunsthalle
PROVENANCE: Max Liebermann, Berlin
(sold to Paul Cassirer on Jan. 2, 1919);
Paul Cassirer, Berlin (1919, PC number
16622); On Jan. 2, 1919 at the Ham-
burger Kunsthalle in exchange for a study
of *Sommerabend an der Alster* (1909),
that is now in the Museum Düren.

50. *The Flower Terrace in the Wannsee
Garden, Facing Northwest*, 1921
(Die Blumenterrasse im
Wannseegarten nach Nordwesten)
Oil on canvas
15.5 x 19.7 in (39.5 x 50 cm)
Städtisches Museum Gelsenkirchen
PROVENANCE: Thannhauser Gallery,
Munich (1923); Jaehn Collection,
Berlin; Abels Gallery, Cologne (1952,
until 1953); Acquired by Städtisches
Museum, Gelsenkirchen on February
18, 1953

51. *The Kitchen Garden in Wannsee
Toward the Southeast*, 1923
(Nutzgarten in Wannsee nach
Südosten)
Oil on canvas
21.9 x 30 in (55.5 x 75.8 cm)
Collection Deutsche Bank
PROVENANCE: Rudolf Bangel, Frankfurt
am Main (1927); Deutsche Bank,
Frankfurt am Main

52. *Cabbage Field*, 1923
(Kohlfeld)
Oil on canvas
19.8 x 27.3 in (50.2 x 69.4 cm)
Leo Baeck Institute, New York, Gift
of Clara Wolf, New York, in memory
of Simon Wolf, 1975
PROVENANCE: Private collection,
Frankfurt am Main (1927); Lempertz,
Cologne (1928); Simon and Clara
Wolf, Mannheim, Germany?, New York
(until 1975); acquired by the Leo Baeck
Institute, New York (1975)

53. *Flower Terrace in the Wannsee Garden
facing east*, 1924
(Die Blumenterrasse im
Wannseegarten nach Nordosten)
Oil on board
17.5 x 21.5 in (44.4 x 54.6 cm)
Collection of Judah L. Magnes
Museum, anonymous gift
PROVENANCE: Kunsthaus Lempertz,
Cologne (1933)

54. *The Circular Bed in the Hedge Garden with a Woman Watering Flowers,* 1925
(Das Rondell im Heckengarten mit Blumensprengerin)
Oil on canvas
28.1 x 36.6 in (71.5 x 93 cm)
Swiss Collection
PROVENANCE: Max Liebermann, Berlin (sold to Paul Cassirer on September 18, 1925); Paul Cassirer, Berlin (1925, PC number 18946); Wiltchek Gallery (acquired from Paul Cassirer on September 4, 1924); private ownership, New York (1948); private ownership, Switzerland; since 1982 on long-term loan to the Kunstmuseum Winterthur

55. *Circular Flower Bed in the Hedge Garden,* 1927
(Rondell im Heckengarten)
Oil on canvas
22.4 x 33.9 in (57 x 88 cm)
Anonymous

56. *Tree-Lined Avenue with Two Horseback Riders,* 1922
(Allee mit zwei Reitern, rechts Passenten)
Oil on canvas
28 x 23.6 in (71 x 60 cm)
Private collection
PROVENANCE: By descent from family of original owner

57. *The Artist Sketching in the Circle of His Family,* 1926
(Der Künstler skizzierend im Kreis seiner Familie)
Oil on canvas
37.4 x 44.5 in (95 x 113 cm)
Stiftung Stadtmuseum Berlin
PROVENANCE: Grant Pick, Chicago (until 1969); Christie's, London (1969); Mendel Rauch (until 1971); acquired by the Stiftung Stadtmuseum Berlin, 1971

58. *The Artist's Wife and Granddaughter,* 1926
(Die Gattin und Enkelin des Künstlers)

Oil on canvas
44.9 x 37.8 in (114 x 96 cm)
HUC Skirball Cultural Center, Los Angeles
PROVENANCE: Max Böhm, Berlin (until 1931); Rudolph Lepke, Berlin (1931, 1932); private ownership, Berlin (1937); Jewish Museum, Berlin (seized, number 143 on the list of found art works from the Jewish Museum); given to the Skirball Museum in Los Angeles from the Jewish Restitution Successor Organization (1954)

59. *Self-Portrait in a Straw Hat,* 1929
(Selbstporträt mit Strohhut)
Oil on canvas
19.7 x 15.6 in (50 x 39.5 cm)
Jüdisches Museum Berlin
PROVENANCE: Dr. Josef Grünberg, Berlin (died 1932); Inherited by Dr. Janos Plesch; sold by heir of Dr. Plesch in England, late 1960s; acquired by the Jüdisches Museum Berlin (1970)

60. *The Atelier in Wannsee,* 1932
(Das Atelier in Wannsee)
Oil on canvas
15.7 x 19.8 in (40 x 50.4 cm)
Private collection
PROVENANCE: Sven Simon, Hamburg; Kunstsammlung Axel Springer

61. *Self-Portrait in Smock with Hat, Brush, and Palette,* 1934
(Selbstbildnis im Malkittel mit Hut, Pinsel und Palette)
Oil on canvas
36.3 x 28.9 in (92.1 x 73.3 cm)
Tate Collection, London
PROVENANCE: Acquired in 1934 by Lord Marks at the Leicester Gallery's exhibition *Max Liebermann* in London; given as a gift to the Tate Collection, London (1935)

62. *To the Mothers of the Twelve Thousand,* ca. 1935
(Den Müttern der Zwölftausend)
Lithograph on paper
31.4 x 14.9 in (80 x 58 cm)
Leo Baeck Institute, New York

Selected Bibliography

SELECTED WRITINGS OF MAX LIEBERMANN

"Autobiographisches." *Über Land und Meer* (1889).

"Degas." *Pan* (1896).

"Das Zeichnen nach Gips, Ein Gutachten." *Die Gegenwart* (1897).

"Künstlerischer Bilderschmuck für Schulen, Zwei Briefe." *Hamburgischer Correspondent* (1897 und 1898).

Degas. Berlin: B.U.P. Cassirer, 1899.

Jozef Israels: Kritische Studie. Berlin: B. Cassirer, 1901.

"Die Phantasie in der Malerei." Series of articles in *Neue Rundschau* and *Kunst und Künstler* from 1904 to 1916.

"Der Fall Thode." *Frankfurter Zeitung,* 1905.

"Zwei Holzschnitte von Manet." *Kunst und Künstler* (1905).

"Review of Wilhelm Bode's *Rembrandt und seines Zeitgenossen.*" *Kunst und Künstler* (1907).

Gustav Schiefler das graphische Werk. Berlin: B. Cassirer, 1907.

"Meine Erinnerungen an die Familie Bernstein, aus Carl und Felicie Bernstein, Erinnerungen ihrer Freunde." 1908.

"Walter Leistikow." Funeral speech, 1908

"Erinnerungen au Steffeck." *Kunst und Künstler* (1910).

"Autobiographisches." *Allgemeine Zeitung des Judentums* 74 (1910), 5.

"Hugo von Tschudi." *Kunst und Künstler* (1912).

"Mein Austritt aus der Kunstdeputation." *Berliner Tageblatt* (1912).

"Maler und Dichter, Antwort auf eine Rundfrage." *Berliner Tageblatt* (1913).

"Hans Grisebach." *Kunst und Künstler* (1916).

Die Phantasie in der Malerei. Berlin: B. Cassirer, 1916.

"Alfred Lichtwark." *Der Tag* (1917).

"Woldemar Rössler." *Der Tag* (1917).

Jozef Israels. Berlin: B. Cassirer, 1918.

"Über Kunstschulen, Eine Denkschrift." 1920.

"Karl Blechen, Programm zur Ausstellung der Akademie der Künste," 1921.

"Mit Rembrandt in Amsterdam." *Kunst und Künstler* 19 (1921), Heft 7.

"Claude Monet." *Jahrgang* 25 (1921), Heft 5.

"August Gaul." Funeral speech, 1921

Gesammelte Schriften von Max Liebermann. Berlin: B. Cassirer, 1922.

"Gasquets Cézanne-Buch." *Jahrgang* 28 (1930), Heft 4.

"Justi und seine Sachverständigen-Kommission," *Jahrgang* 31 (1932), Heft 5.

Siebzig Briefe. Edited by Franz Landsberger. Berlin: Schocken Verlag, 1937.

Die Phantasie in der Malerei; Schriften und Reden. Edited by Günter Busch. Foreword by Karl Hermann Roehricht. Epilogue by Günter Busch. Berlin: Buchverlag der Morgen, 1983.

Briefe. Selected by Franz Landsberger. New edition by Ernst Volker Braun. Stuttgart: G. Hatje, 1994.

LIFE AND ART OF MAX LIEBERMANN

Achenbach, Sigrid, ed., *Max Liebermanns Arbeiten für den Fritz Heyder Verlag.* Exh. cat. Potsdam: Vacat, 2002.

Achenbach, Sigrid, and Matthias Eberle, eds. *Max Liebermann in seiner Zeit.* Exh. cat. Munich: Prestel, 1979.

Berchtig, Frauke. *Max Liebermann.* Munich: Prestel, 2005.

Bertuleit, Sigrid. *Max Liebermann und Barbizon: Landleben, Naturerlebnis.* Exh. cat. Hannover: Niedersächsisches Landesmuseum. 1994.

————. *Max Liebermann: Gemälde 1873–1918.* GalerieHandBuch. Niedersächsisches Landesmuseum, 1994.

Bie, Oskar, ed. *Holländisches Skizzenbuch [von] Max Liebermann.* Berlin: Bard, 1911.

Boskamp, Katrin. *Studien zum Frühwerk von Max Liebermann: mit einem Katalog der Gemälde und Ölstudien von 1866–1889.* Hildesheim and New York: Olms, 1994.

Brauner, Lothar. *Max Liebermann. In der Reihe: Welt der Kunst.* Berlin: Henschel, 1986.

Bröhan, Nicole. *Max Liebermann.* Jaron Verlag, 2002.

Bröhan, Nicole, and C. Sylvia Weber, eds.. *Max Liebermann: Poesie des einfachen Lebens.* Exh. cat. Künzelsau: Swiridoff, 2003.

Bunge, Matthias. *Max Liebermann als Künstler der Farbe: Eine Untersuchung zum Wesen seiner Kunst.* Gebr. Mann, 1990.

Busch, Günter. *Max Liebermann: Maler, Zeichner, Graphiker*. Frankfurt am Main: S. Fischer, 1986.

Busch, Günter, ed. *Max Liebermann, Vision der Wirklichkeit: ausgewählte Schriften und Reden*. Frankfurt am Main: Fischer Taschenbuch, 1993.

Dettmer, Frauke, Margret Schütt, and Guratzsch, Herwig. *Max Liebermann, Ich bin doch nur ein Maler*. Doessel: J. Stekovics, 2002.

Eberle, Matthias. *Max Liebermann, 1847–1935: Werkverzeichnis der Gemälde und Ölstudien*, vol.1, *1847–1899*, vol. 2, *1900–1935*. Munich: Hirmer, 1995–1996.

Eipper, Paul. *Ateliergespräche mit Liebermann und Corinth*. Munich: Piper, 1976.

Elias, Julius. *Max Liebermann zu Hause; mit 2 Originalradierungen u. 68 Familienzeichnungen des Künstlers in Facsimiledruck*. Berlin: Cassirer, 1918.

———. *Max Liebermann*. Berlin: Neue Kunsthandlung, 1921.

Friedländer, Max J. *Max Liebermann*. Berlin: Propyläen, 1924.

Galliner, Arthur. *Max Liebermann, der künstler und der führer*. Frankfurt am Main: J. Kauffmann, 1927.

Görgen, Annabelle , and Sebastian Giesen. *Ein Impressionismus für Hamburgs Bürgertum: Max Liebermann und Alfred Lichtwark*. Exh. cat. Hamburg: Dölling und Galitz, 2002.

Graphik der Gegenwart: Max Liebermann, Hans Meid, Anders Zorn, Max Slevogt, Emil Orlik, Ernst Stern, Lesser Ury, Käthe Kollwitz, Heinrich Zille. Berlin: J. Singer Verlag, [1900–9].

Gronau, Dietrich. *Max Liebermann: eine Biographie*. Frankfurt am Main: Fischer Taschenbuch, 2001.

Goethe, Johann Wolfgang von. *Goethe Gedichte*. Vol. 2. Illustrations by Max Liebermann. Frankfurt am Main: Insel, 1994.

Hancke, Erich. *Max Liebermann, sein Leben und seine Werke*. 2nd ed. Berlin: B. Cassirer, 1923.

Hansen, Dorothee, ed. *Nichts trügt weniger als der Schein: Max Liebermann, der deutsche Impressionist*. Exh. cat. Munich: Hirmer, 1995.

Heiderose Leopold Filproduktion Berlin. "'To make the invisible visible': the impressionist Max Liebermann." Television documentary. *Images of Germany: Past and Present*. Series II, 4. Berlin: Deutsche Welle TV, 1995.

Heine, Heinrich. *The Jewish Stories and Hebrew Melodies*. Illustrations by Max Liebermann. Masterworks of Modern Jewish Writing Series. New York: M. Wiener Pub, 1998.

Howoldt, Jenns Eric, and Andreas Bau, eds. *Max Liebermann in Hamburg: Landschaften zwischen Alster und Elbe 1890–1910*. Exh. cat. Ostfildern-Ruit bei Stuttgart: Gerd Hatje, 1994.

Howoldt, Jenns E., and Birte Frenssen, eds. *Max Liebermann: Der Realist und die Phantasie*. Hamburg: Hamburger Kunsthalle, 1997.

Howoldt, Jenns E., and Uwe M. Schneede, eds. *Im Garten von Max Liebermann*. Exh. cat. Hamburg: Hamburger Kunsthalle and Berlin: Nationalgalerie, Staatliche Museen, 2004.

Hundert Meisterwerke Teil 6. Documentary film. Hamburger Kunsthalle.

Juranek, Christian, ed. *Max Liebermann (1847–1935): Licht, Phantasie und Charakter*. Exh. cat. Halle: J. Stekovics, 2001.

Küster, Bernd. *Max Liebermann: ein Maler-Leben*. [Hamburg]: Ellert & Richter, 1988.

Lenz, Christian. *Max Liebermann, "Münchner Biergarten."* Exh. cat. Munich: Hirmer, 1986.

Leppien, Helmut Rudolf, ed. *Der Zwölfjährige Jesus im Tempel von Max Liebermann*. [Hamburg]: Kulturstiftung der Länder, 1989.

Lichtwark, Alfred. *Briefe an Max Liebermann*. Edited by Carl Schellenberg. Hamburg: Trautmann, 1947.

Lieberman: La Malmaison, 21 Janvier–29 Avril 1996, Cannes. Exh. cat. Cannes: Musées de la ville de Cannes, 1996.

Liebermann, Max. *Fünfundzwanzig Zeichnungen in Lichtdruck*. [Berlin]: P. Cassirer, 1899.

———. *A B C*. Text by Richard Graul. Berlin, K.W. Mecklenburg, 1908.

———. *Sieben Radierungen*. Text by Oscar Bie. Berlin: Cassirer, 1909.

———. *Eine Kunstgabe von vierzehn Bildern*. Foreword by William F. Burr. Mainz: J. Scholz, 1910.

———. *Zeichnungen von Max Liebermann: Füngzig Tafeln mit Lichtdrucken nach des Meisters Originalen*. Introduction by Hans Wolfgang Singer. Leipzig: A. Schumann's, 1912.

———. *Max Liebermann: acht farbige Wiedergaben seiner Werke*. Introduction by Hans Wolff. Leipzig: E.A. Seemann, 1917.

———. *Bilder ohne Worte*. Introduction by Willy Kurth. Berlin: Verlag Fritz Heyder, 1920.

———. *Graphische Kunst*. Edited by Max J Friedländer. Arnolds graphische Bücher 1. Dresden: E. Arnold, 1920.

———. *Die Handzeichnungen Max Liebermanns*. Selected with an introduction by Julius Elias. Berlin: P. Cassirer, 1922.

———. *Zeichnungen*. Text by Hans Wolff. Arnolds graphische Bücher 2 Dresden: E. Arnold, 1922.

———. *Liebermann Mappe*. Munich: G.D.W. Callwey, 1923.

———. *Die Zeichnungssammlung des Herrn L., Berlin*. Berlin: Cassirer, 1925.

———. *Das erste Skizzenbuch*. Berlin: Transit Buchverlag, 2005.

Ludwig, Horst-Jörg, Harri Nündel, and Werner Schade, eds. *Für Max Liebermann, 1847-1935*. Exh. cat. [East Berlin]: Die Akademie, 1985.

Maks Liberman: 1847–1935: ta`arukhat zikaron. Exh. cat. Tel Aviv: Muze'on Tel-Aviv, 1935.

Max Liebermann. Exh. cat. Hannover: Landesgalerie, 1954.

Max Liebermann: Der Aussenseiter als Entrepreneur der Künste. Hamburg: Hamburger Kunsthalle, 1997.

Max Liebermann 1847–1935, Ausgewählte Werke. Exh. cat. Bremen: Graphisches Kabinett Kunsthandel Wolfgang Werner, 1991.

Max Liebermann: Bilder, Aquarelle, Pastelle. Exh. cat. Munich: Moderne Galerie/ Thannhauser, 1923.

Max Liebermann: Gedanken und Bilder. Exh. cat. Munich: Delphin Verlag, 1923.

Max Liebermann: 40 graphics and 7 drawings. Exh. cat. Johannesburg: Cassirer, 1980.

Max Liebermann; Gedächtnisausstellung der Jüdischen GemeindeBerlin, Februar-März 1936, zur Erinnerung an den Todestag am 8. Februar 1935. Preface by Franz Landsberger. Exh. cat. Berlin: Jüdisches Museum, 1936.

Max Liebermann: Impressionen–Impressions. Munich: Prestel, 1997.

Max Liebermann, Memorial Exhibition, June 1944. Exh. cat. New York: Galerie St. Etienne, 1944.

Max Liebermann: Pastelle, Zeichnungen, Graphik. Exh. cat. Munich: Moderne Galerie/Thannhauser, 1924.

Max Liebermann: Stationen eines Malerlebens. Exh. cat. Rüsselsheim: Opel-Villen, 1999

Melcher, Ralph. *Max Liebermann. Zeichnen heißt weglassen-Arbeiten auf Papier.* Exh. cat. Ostfildern: Hatje Cantz Verlag, 2004.

Menzel, Adolph. *Das graphische Werk.* Selected by Heidi Ebertshäuser, with a preface by Jens Christian Jensen, and an essay by Max Liebermann. Munich: Rogner & Bernhard, 1976.

Meissner, Günter. *Max Liebermann.* Leipzig: E. A. Seemann, 1974.

Mühlen, Irmgard von zur. *Max Liebermann, Klassiker von heute, Revolutionär von gestern.* Documentary film. Chronos Film Archive. http://chronos-media.de/web/en/Filmarchiv.html

Natter, Tobias G., and Julius H Schoeps, eds. *Max Liebermann und die französischen Impressionisten.* Düsseldorf: DuMont, 1997.

Nedelykov, Nina, and Pedro Moreira, eds. *Zurück am Wannsee. Max Liebermanns Sommerhaus.* Berlin: Transit Buchverlag, 2003.

Ostwald, Hans, *Das Liebermann-Buch.* Berlin: Paul Franke Verlag, 1930.

Pauli, Gustav. *Max Liebermann: des Meisters Gemälde in 304 Abbildungen hrsg. von Gustav Pauli.* Stuttgart-Leipzig: Deutsche Verlags-anstalt, 1911.

Perica, Blazenka, ed. *Max Liebermann: Stationen eines Malerlebens.* Exh. cat. Rüsselsheim: Opel-Villen, 1999.

Pflugmacher, Birgit. *Der Briefwechsel zwischen Alfred Lichtwark und Max Liebermann.* Hildesheim: Olms, 2003.

Posener, Julius. *Eine Liebe zu Berlin: Künstlersalon und Gartenatelier von Max Liebermann.* Munich: Bayerische Vereinsbank, 1995.

Printed Graphics: Max Liebermann, 1847–1935, Max Slevogt, 1868–1932, Lovis Corinth, 1858–1925. Exh. cat. Stuttgart: Institut für Auslandsbeziehungen, 1979.

Püschel, Walter, ed. *Anekdoten über Max Liebermann.* Hanau: Dausien Verlag, 1986.

Read, Sir Herbert Edward. "Max Liebermann." *A Coat of Many Colours: Essays.* 2nd ed. London: Routledge & Paul, 1956

Roller, Stefan, ed. *Liebermann, Corinth: Zeichnungen und Graphik aus dem Bestand der Staatlichen Kunsthalle.* Karlsruhe: Das Kunsthalle, 1997.

Rosenhagen, Hans. *Max Liebermann.* Künstler-Monographien 45. Bielefeld-Leipzig: Velhagen & Klasing, 1900

Sandig, Marina. *Die Liebermanns, Ein biographisches Zeit-und Kulturbild der preußisch-jüdischen Familie und Verwandtschaft von Max Liebermann.* Neustadt an der Aisch: Degener, 2005.

Scheffler, Karl. *Max Liebermann.* Munich: Piper, 1922.

Schiefler, Gustav. *Max Liebermann: Sein graphisches Werk, 1876–1923.* San Francisco: Wofsy, 1991.

Schmalhausen, Bernd. *"Ich bin doch nur ein Maler": Max und Martha Liebermann im 'Dritten Reich'.* 3rd ed. Hildesheim and New York: Olms, 1998.

Schütz, Chana C. *Max Liebermann: impressionistischer Maler, Gründer der Berliner Secession.* Jüdische Miniaturen 3. Teetz: Hentrich & Hentrich, 2004.

Sillevis, John, Nini Jonker, and Margreet Mulder. *Max Liebermann en Holland.* ['s-Gravenhage]: Staatsuitgeverij: Haags Gemeentemuseum, 1980.

Simon, Hermann, ed. *Was vom Leben übrig bleibt, sind Bilder und Geschichten: Max Liebermann zum 150. Geburtstag: Rekonstruktion der Gedächtnisausstellung des Berliner Jüdischen Museums von 1936.* Berlin: Stiftung Neue Synagoge Berlin—Centrum Judaicum, 1997.

Teut, Anna. *Garten Paradis am Wannsee.* Exh. cat. Munich: Prestel, 1997.

———. *Max Liebermann, Grandseigneur am Pariser Platz.* Berlin: Nicolai, 2005

Weissgärber, Helga, ed. *Max Liebermann, 20. Juli 1847–8. Februar 1935.* Exh. cat. Berlin: Deutsche Akademie der Künste zu Berlin, 1965.

Wesenberg, Angelika, and Sigrid Achenbach, eds. *Max Liebermann: Jahrhundertwende.* Exh. cat. Berlin: Nicolai and SMPK, 1997.

Wesenberg, Angelika, Ruth Langenberg, and Sigrid Achenbach, eds. *Im Streit um die Moderne: Max Liebermann, der Kaiser, die Nationalgalerie.* Berlin: Nicolai and SMPK, 2001.

General Art and History

Barron, Stephanie, and Wolf-Dieter Dube, eds. *German Expressionism: Art and Society 1909–1923.* London: Thames and Hudson, 1997.

Barron, Stephanie, and Peter W. Guenther, eds. *"Degenerate Art": The Fate of the Avant-Garde in Nazi Germany.* Exh. cat. Los Angeles: Los Angeles County Museum of Art, 1991.

Bartmann, Dominik, ed. *Berliner Kunst-fruhling: Malerei, Graphik und Plastik der Moderne 1888–1918 aus dem Stadtmuseum Berlin.* Exh. cat. Berlin: Stadtmuseum Berlin, 1997.

Bilski, Emily D., ed. *Berlin Metropolis: Jews and the New Culture 1890–1918.* Berkeley and Los Angeles: University of California, 1999.

Dreimal Deutschland: Lenbach, Liebermann, Kollwitz. Exh. cat. Hamburger: Die Kunsthalle, 1981.

Forster-Hahn, Françoise, ed. *Imagining Modern German Culture: 1889–1910.* Washington, DC: National Gallery of Art, 1996.

———. *Spirit of an Age: Nineteenth-Century Paintings from the National Galerie, Berlin*, with contributions by Christopher Riopelle, Birgit Verwiebe. Exh. cat. (London: National Gallery Company, 2001)

Forster-Hahn, Françoise, Claude Keisch, Peter-Klaus Schuster, and Angelika Wesenberg. *Spirit of an Age: Nineteenth-Century Paintings from the Nationalgalerie, Berlin.* Exh. cat. London: National Gallery Company, 2001.

Gaehtgens, Thomas W. *L'art sans frontiers: les relations artistiques entre Paris et Berlin.* Paris: Livre de poche, 1999.

Gay, Peter. *Weimar Culture: The Outsider as Insider.* New York: Harper and Row, 1968.

———. *Freud, Jews and Other Germans: Masters and Victims in Modern Culture.* New York: Oxford University Press, 1978.

Gay, Ruth. *The Jews of Germany, A Historical Portrait.* New Haven, CT: Yale University Press, 1992.

Gilman, Sander L., and Jack Zipes. *Yale Companion to Jewish Writing and Thought in German Culture, 1096–1996.* New Haven and London: Yale University Press, 1997.

Goodman, Susan Tumarkin, ed. *The Emergence of Jewish Artists in Nineteenth-Century Europe.* Exh. cat. London: Merrell and The Jewish Museum, New York, 2001.

Hamann, Richard, and Jost Hermand. *Impressionismus*, 2nd ed. Berlin: Akademie-Verlag, 1966.

Hertz, Deborah. *Jewish High Society in Old Regime Berlin.* New Haven, CT: Yale University Press, 1988.

Jefferies, Matthew. *Imperial culture in Germany, 1871–1918.* Houndmills, England: Palgrave Macmillan, 2003.

Junge, Henrike, ed. *Avantgarde und Publikum: Zur Rezeption avantgardischer*

Kunst in Deutschland 1905–1933. Cologne: Bohlau, 1992.

Kaes, Anton, Martin Jay, and Edward Dimendberg, eds. *The Weimar Republic Sourcebook.* Berkeley: University of California Press, 1994.

Lenman, Robin. *Artists and Society in Germany, 1850–1914.* Manchester, UK: Manchester University Press, 1997.

Lewis, Beth Irwin. *Art for All? The Collision of Modern Art and the Public in Late-Nineteenth-Century Germany.* Princeton and Oxford: Princeton University Press, 2003.

Makela, Maria. *The Munich Secession, Art and Artists in Turn-of-the-Century Munich.* Princeton, NJ: Princeton University Press, 1990.

März, Roland. *Kunst in Deutschland 1905–1937: Gemälde und Skulpturen aus der Sammlung der Nationalgalerie.* Exh. cat. Berlin: Mann, 1992.

Museum zu Allerheiligen. *Deutsche Impressionistem: Liebermann, Corinth, Slevogt.* Exh. cat. Schaffhausen: Meier, 1955.

Nachama, Andreas, Julius H. Schoeps, and Hermann Simon, eds. *Jews in Berlin.* Translated by Michael S. Cullen and Allison Brown. Berlin: Henschel, 2001.

Paret, Peter. *The Berlin Secession: Modernism and Its Enemies in Imperial Germany.* Cambridge, MA: Belknap Press of Harvard University Press, 1980.

———. *Art as History, Episodes in the Culture and Politics of Nineteenth-Century Germany.* Princeton, NJ: Princeton University Press, 1988.

———. *German Encounters with Modernism, 1840–1945.* Cambridge: Cambridge University Press, 2001.

Paris/Berlin: Rapports et contrastes France-Allemagne 1900–1933. Exh. cat. Paris: Centre Nationale d'Art et de Culture Georges Pompidou, 1978.

West, Shearer. *The Visual Arts in Germany, 1890–1937: Utopia and Despair.* New Brunswick, NJ: Rutgers University Press, 2001.

Wirth, Irmgard, ed. *Berliner Maler, Selbstzeugnisse, Menzel, Liebermann, Slevogt, Corinth.* Berlin: Berlin Verlag, 1964.

Zweig, Arnold. *Herkunft und Zukunft, zwei Essays zum Schicksal eines Volkes. Mit Bildern von Max Liebermann, Marc Chagall, u.a.* Vienna: Phaidon-Verlag, 1929.

The Mission of the Skirball Cultural Center

Skirball Cultural Center is dedicated to exploring the connections between four thousand years of Jewish heritage and the vitality of American democratic ideals. It welcomes and seeks to inspire people of every ethnic and cultural identity. Guided by our respective memories and experiences, together we aspire to build a society in which all of us can feel at home. Skirball Cultural Center achieves its mission through educational programs that explore literary, visual, and performing arts from around the world; through the display and interpretation of its permanent collections and changing exhibitions; through scholarship in American Jewish history and related publications; and through outreach to the community.

Photo Credits

Index

MAX LIEBERMANN: FROM REALISM TO IMPRESSIONISM
is published on the occasion of an exhibition of the same title
organized by the Skirball Cultural Center.

EXHIBITION DATES:
Skirball Cultural Center, Los Angeles
September 15, 2005–January 29, 2006

The Jewish Museum, New York
March 10–July 9, 2006

Library of Congress Control Number: 2005903444

MAX LIEBERMANN: FROM REALISM TO IMPRESSIONISM
was produced for the Skirball Cultural Center
by Perpetua Press, Santa Barbara
Edited by Tish O'Connor and Brenda Johnson-Grau
Designed by Dana Levy
Printed in China by Toppan Printing Co.

First printing, 2005

ISBN: 0-9704295-6-8
Distributed by University of Washington Press

COVER:
Ropewalk in Edam (Seilerbahn in Edan), 1904
Metropolitan Museum of Art, New York

BACK COVER:
The Artist's Wife at the Beach, 1895
(Die Gattin des Künstlers am Strand)
Stiftung Weimarer Klassik und Kunstsammlungen Schloßmuseum